CINEMA 4D 10 Workshop

CINEMA 4D 10 Workshop

Arndt von Koenigsmarck

ELSEVIER

AMSTERDAM • BOSTON • HEIDELBERG • LONDON
NEW YORK • OXFORD • PARIS • SAN DIEGO
SAN FRANCISCO • SINGAPORE • SYDNEY • TOKYO

Focal Press is an imprint of Elsevier

Acquisitions Editor:	Paul Temme
Publishing Services Manager:	George Morrison
Project Manager:	Paul Gottehrer
Assistant Editor:	Georgia Kennedy
Marketing Manager:	Christine Degon Veroulis
Cover Design:	Alan Studholme
Cover Illustration:	Marco Lindenbeck, webwo GmbH, mlindenbeck@webwo.de
Translation:	Frank Wagenknecht
Composition:	Multiscience Press, Inc.

Focal Press is an imprint of Elsevier
30 Corporate Drive, Suite 400, Burlington, MA 01803, USA
Linacre House, Jordan Hill, Oxford OX2 8DP, UK

∞ Recognizing the importance of preserving what has been written, Elsevier prints its books on acid-free paper
whenever possible.

Library of Congress Cataloging-in-Publication Data
Application submitted.

British Library Cataloguing-in-Publication Data
A catalogue record for this book is available from the British Library.

ISBN 13: 978-0-240-80897-0
ISBN 10: 0-240-80897-5

For information on all Focal Press publications
visit our website at www.books.elsevier.com

07 08 09 10 11 5 4 3 2 1

Printed in Canada

Contents

Introduction

As of October 2006, Maxon Computer GmbH is in its 20th year of operation. This seems half an eternity in this fast-paced industry.

How fitting that on this anniversary, version 10 of CINEMA 4D is introduced to the market.

Maxon was very busy and has consequently improved its flagship 3D software in many areas.

Many client wishes were incorporated yet again, such as the request to have a more powerful animation module.

In this regard, the complete timeline was redesigned and actualized. However, for the CINEMA 4D user it still feels like home, even with all these improvements.

The reason is that in the most frequently used areas, such as modeling, texturing, and rendering, not a lot of new features were added.

When it comes to the changed appearance of the interface, it might be a different story for some users. Maxon worked feverishly right up to the last minute on the new look of the icons and a functional color range.

I would like you to note at this point that, even though I took great care, there might be a discrepancy between the colors of the images in this book and the official program.

It was also decided that by default there should be additional text labels in the icon menus (see letter A in the following figure).

For new users, these labels will be a big help in the beginning. However, old-timers may regard them as a waste of space.

Therefore, the following image will show you how to change the icon palettes back to the familiar look of older versions of CINEMA 4D.

Choose EDIT PALETTES in the WINDOW menu and right click on the icon group that should be changed. The group with the NURBS objects was used as an example in the following figure.

Choose UNFOLD COMMAND from the context menu. A separate window will appear with all the icons of the group (see letter B in the figure).

Right click again on one of the icons in this new window and deactivate the TEXT option in the context menu. In addition, the order of the icons can be changed in the ROWS/COLUMNS entry and the TRANSPOSE option in the context menu.

Now the icons have to be connected to a group again. This is done by right clicking on the first icon of the group and using the FOLD PALETTE command. Then double click on the old NURBS group in the layout to delete it and pull the new command group to the desired place in the layout. This is shown at the letter D.

After this procedure is done with the other icon groups, use EDIT PALETTES in the WINDOW menu again to leave this mode.

Now the old appearance of the icon groups is restored. The upper figure shows the familiar look toward the very bottom, near letter E.

Let me give you a short preview of the themes dealt with in this book.

In the first chapter, we start with a comprehensive overview of the interface and the most important managers and commands.

This is not at all a dry listing of the functions, but rather a series of several examples. These will help you learn to use the most important tools.

You will model a computer housing and, by way of that, learn a large portion of the most important work techniques.

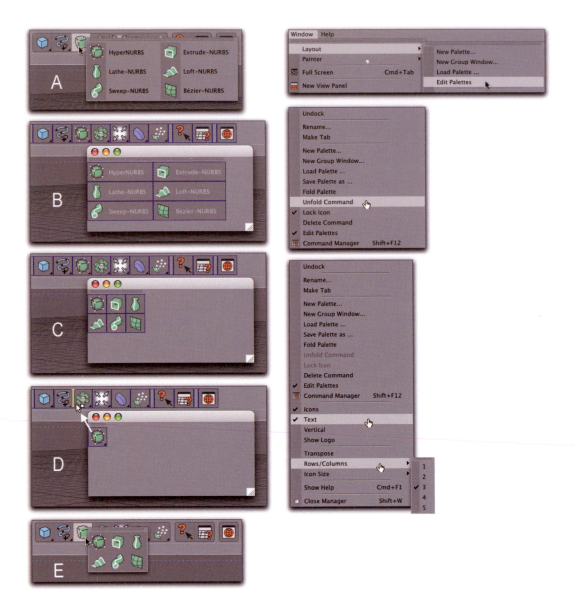

— Figure 1: Changing the appearance of the icons.

The second chapter introduces you to working with textures and materials. At that point we will also take a look at BodyPaint 3D.

Here we enhance the learning process by means of several examples. We will model and texture a realistic CD and construct a palm tree and apply materials to it.

The computer model from the first chapter will also play a role.

As a side effect you will be introduced to working with the renderer and light sources. By the end of the chapter you will have experienced the entire process multiple times, from modeling, creating, and applying textures to the lighting and rendering of an image.

In the third chapter you will expand your knowledge by working on a complex model of a sports car, step by step, and showcasing it.

You will also learn the use of advanced render methods such as HDRI lighting and rendering.

A comprehensive chapter did not fit into the book. Therefore, you can find it as a bonus chapter in PDF format on the DVD accompanying this book.

There you will learn how to insert 3D objects into photos with the help of the Photo-Match plug-in, which is also included in the book. An additional workshop movie explains the use of this plug-in with an example.

If you are interested in 3D compositing, then the manufacturer of this plug-in offers you an update to the full version. This can be purchased for a reduced rate on their website www.vreel-3d.de.

In the second part of this bonus chapter you will model and texture a comic character that will be needed in the last chapter of the book.

In this last chapter we cover the subject of animation. There you will learn the use of the powerslider, the timeline, and the new functions of the MOCCA module.

Working with the XPresso port will also be shown in an example.

All subjects and examples were chosen so that beginners, as well as advanced users, will get good use out of this book. With it you will get a comprehensive introduction into the program and also a compact overview of the most significant improvements made in this version.

All that is left is to wish you a lot of fun and success with reading and working through this book.

As always, I look forward to your feedback and training requests at:

arndt@vonkoenigsmark.de.

Getting Started

Even though CINEMA 4D is very easy to use and, compared to other 3D software packages, very intuitive, it is still very complex. Just the explanation of all the options, functions, tools, and objects would fill several books. The continuously increasing content of the CINEMA 4D manuals and the growing number of modules show this.

This book is not meant to be a replacement for the manual. Instead it enables us to quickly get started with the software and to get used to the main functions for everyday use.

We will cover all relevant areas of CINEMA 4D. This includes the different types of objects, tools, materials, lighting, animation, and rendering. By the end of the book you should be well prepared for future projects.

This introduction is not only helpful for beginners but also for the experienced user since there are multiple changes and additions in v10, especially in the organization of scene elements and animation.

Apple Macintosh users will be happy to hear that CINEMA 4D is now universal-binary, which means that version 10 runs on the new Intel Macs and older PowerPCs. I mention this because it may be possible that your old plug-ins will not function with CINEMA 4D v10. They have to be updated to a universal-binary version in order to work. Contact the distributor of the plug-in to see if there is an update available.

Downward compatibility is—as in previous versions of CINEMA 4D—for the most part implemented. We can still open and work on older scenes with the new version.

Let's start with a look at the most important functions in CINEMA 4D.

1.1 What Is "3D"?

Even beginners who have years of practice with graphics programs will experience difficulty in the first steps of 3D software. There are new terms to learn as well as a new way of working. In the past you were able to sketch an idea or a draft with a couple of fast strokes on a graphics tablet. Working in a three-dimensional space requires far more planning and knowledge of the mode of operation of 3D programs.

Everything that has to appear in the finished picture or animation has to be built in the three-dimensional space. This shows the first problem, as the optical connection to the software, which is the monitor, is only able to portray a flat image. The interface of 3D programs is therefore different from other software such as drawing programs.

In order to build objects in a three-dimensional space and to view them from multiple sides it is necessary to have different views of the same object. There are views that simulate a perspective distortion as that which occurs with cameras.

This view is very helpful when we want to see the distance between different objects in a three-dimensional space or to find a position for the camera. However, it should not be used to construct objects, as the perspective distortion might create optical illusions like the proportions compared to each other.

An example is shown in Figure 1.1, which portrays cubes as viewed from two different directions. In the top viewport the cubes seem

to be almost the same size, whereas on the bottom they look different from each other.

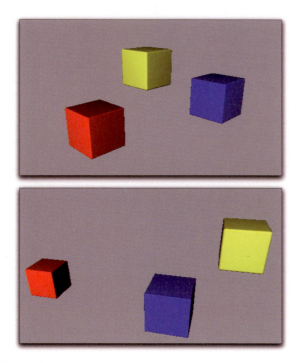

— Figure 1.1: The same objects viewed from different sides.

To prevent these optical illusions there are standardized views available that show objects without perspective distortion more like a technical drawing. In our example we can see that the cubes have different sizes and only appear to be of the same dimensions because of the spacing between them (Figure 1.2).

Figure 1.2 shows the cubes from two standardized directions. The upper viewport shows the scene from the front. We can see that the cubes are positioned on one level.

The lower viewport shows the cubes from the top and completes the information on how they are located in the depth of the room.

This technical view might take time to get used to but is necessary as we will find out when we start working with 3D objects. Another obstacle is the structure of the surface. All objects are made out of a thin hull built out of so-called polygons. These are simple faces with three to four corner points, basically triangles and quadrangular with straight lines between the corner points.

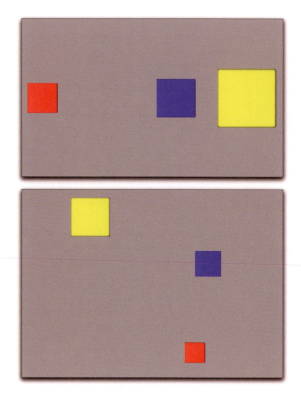

— Figure 1.2: Standardized views without perspective.

This means for us that if we want to create a rounded surface we have to use multiple polygons. The more finely we subdivide the surface, the smoother the object will appear.

We know now that all 3D objects are hollow and consist of an indefinite thin hull. We will be able to check this later by deleting a polygon of a cube object and by looking inside the cube.

A variation of the triangle and quadrangle polygons is the N-Gon. The N-Gon contains multiple points and can be curved. Creation of these N-Gons can be difficult to control, especially if there are curves involved. For the manual creation of polygons it is better to stick with triangular or quadrangle polygons.

Light and Shadows

When the desired object is created, a material will be applied to it. This can simulate a certain surface texture or color. We will get to this complex theme later in the book.

After the materials are applied the lights will be placed in the scene. They enable us to simulate a spotlight or the sun, for example. With lights we can create different moods just like a photographer. The software takes the position of the light and the direction of the light beam relative to the illuminated surfaces and calculates the brightness of each surface and resulting shadows.

The polygons play an important role in lighting too. Polygons not only give the object its shape, they also influence the shading when light hits the surface.

The software uses the surface normal of the polygons for these calculations. A surface normal is a vector, a mathematical term for a direction, which is—unless changed by applying certain materials—always perpendicular to the polygon. Through calculation of the angle of the incoming light and the surface normal, the brightness of the surface is determined (Figure 1.3).

There is one thing to remember though. Triangular or quadrangular polygons have two sides, but the surface normal only appears once and is located upright on top of the polygon.

When the polygon is selected the surface normal is displayed as a short line, which ends in a dot on the surface. CINEMA 4D helps us by displaying the two sides with different colors. The top of a polygon has a yellow tint while the bottom is blue.

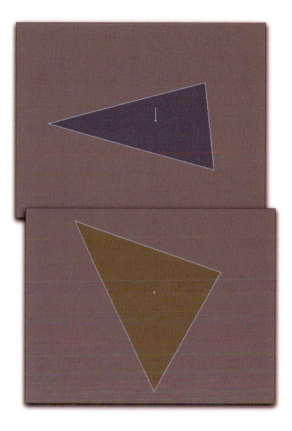

Figure 1.3: Different displays of the top and bottom side of a polygon.

The next example shows the importance of the orientation.

Figure 1.4 shows a 3D model of a sphere. As previously mentioned, curved polygon surfaces have to be more finely subdivided so they appear round. One of the polygons has the wrong orientation, as indicated by the differently colored polygon.

This does not influence the shape of the sphere but results in strange effects in lighting. The wrongly oriented polygon does not get the same lighting as the surrounding polygons and appears to be much darker.

As you can see beginners already have to master a couple of difficulties. Let's see what we have covered so far. All surfaces consist of simple faces, so-called polygons. The more a surface is curved, the more polygons it has to contain to create a high-quality shape.

There are different views available for working with 3D objects. Some have a perspective distortion, whereas others resemble technical standard views. The standard views without perspective are used for constructing

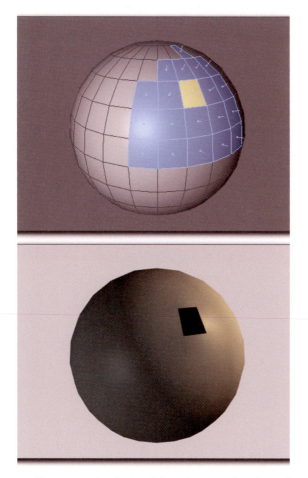

— Figure 1.4: A sphere with an incorrectly oriented polygon.

objects and to place them in three-dimensional space. The perspective view shows the three-dimensional shape of the object and is used to position a camera, for instance.

It is important to keep the orientation of the surface normals uniform to achieve the correct lighting of the object, as it can cause irregularities on the surface.

1.2 Setting up CINEMA 4D

Let's get away from the theory and take a look at CINEMA 4D.

When you install CINEMA 4D the first time, you have to type in some serial numbers. The quantity of serial numbers varies depending on the additional modules you purchased along with the base version.

Note that these are only temporary serial numbers. These numbers will expire after a certain time. Contact Maxon as soon as possible and request the final serial numbers to avoid being surprised one day by not being able to start the program.

The Interface Construction Kit

CINEMA 4D adjusts to your work habits and also to the existing hardware in your computer. It is possible to assign keyboard shortcuts to almost all commands, choose a color for the interface, or spread the display over several monitors.

It is up to you to get used to the menus or to work with your own individual icon palettes.

It will take a while working with CINEMA 4D until you find out which layout best suits your purposes. Maybe you are only interested in modeling. If so, turn off all animation features.

Maybe you are interested in modeling, texturing, and animation. In this case it might be useful to create different layouts for each of these steps and to activate the one that you need at that moment.

Instead of showing a certain type of layout, I'll demonstrate the different options so you will be able to develop your own layout over time.

Activating and Modifying Layouts

CINEMA 4D already has a few layouts set up for you to use. These layouts can be found by clicking on the layout icon in the left upper corner in the start layout (see Figure 1.5).

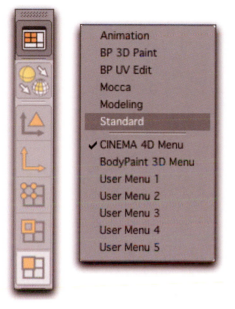

— Figure 1.5: Standard layouts.

The start layout of CINEMA 4D includes all important display and modification windows and will be used throughout the following examples.

Feel free to try the other preset layouts. Some have windows that are not visible in the start layout.

Also interesting are the different themes for the look of the interface. They can be set in the menu EDIT>PREFERENCES...>COMMON at SCHEME.

Generally all windows can be opened through the WINDOW menu of CINEMA 4D. It is different for all the commands. Because of the large number of functions, it is not always possible to find all of them through menus. You can see an example when you switch to one of the BodyPaint layouts (BP 3D PAINT or

— Figure 1.6: Separating windows.

BP UV EDIT). Menus will appear that are not available in other layouts.

Within each layout are different windows combined in tab groups. Figure 1.6 shows the combined OBJECT MANAGER and STRUCTURE MANAGER.

One click on the name of the window will put the accompanying window in the fore-

ground. If you need to use a specific window more often and if you have additional space on your screen, it may be worthwhile to separate the windows and put them next to each other.

Select the window you want to separate and click on the screened square in the upper left corner.

The CONTEXT menu has a command called UNDOCK, which allows the window to be separated and moved to a new location like a second monitor (see Figure 1.6).

In the same CONTEXT menu is the command to create tabs. You simply drag the window by the screened square onto the name of a tabbed window.

Figure 1.7 shows this process. The window that we previously separated can be integrated back into the tabbed windows group with the OBJECT MANAGER. Just pull the screened square between two tab titles or to the left or right of the tab name.

— Figure 1.7: Integration of a separate window into a tabbed group.

Remember it is always possible to return to the previous layout by selecting the standard layout from the preset layouts.

If you like a modified layout and want to use it more often, you need to save it or else CINEMA 4D will switch to the standard layout when you restart the program.

The layout can be saved by selecting LAYOUT>SAVE LAYOUT AS... in the WINDOW menu of CINEMA 4D. Give the layout a meaningful name and save it in the folder *library/layout*. All the other preset layouts are saved in the same folder.

Now you can select your layout under the layout icon or in the menu WINDOW>LAYOUT.

If you want your layout to be the startup layout use the command LAYOUT>SAVE AS STARTUP LAYOUT in the WINDOW menu.

The Full-Screen Mode

Not everybody has a big monitor or multiple monitors to place all the windows on the screen. This can be particularly annoying if the viewport size is crowded by all the surrounding windows.

In this case the full-screen mode is a lifesaver. It temporarily enables you to maximize the currently selected window and to take advantage of the whole screen.

You can activate this mode by pressing CTRL + TAB or by clicking on the zoom icon located on the upper right, just under the title bar of CINEMA 4D.

A third possibility is to make use of the context menu by clicking on the screened square. As shown in Figure 1.6 there is a button for the full-screen mode.

This function is available in almost all the windows, but is mainly of use when modeling in the editor window. First memorize the most important keyboard shortcuts to manipulate objects, as all the icons disappear as well in the full-screen mode.

Remember that the currently selected window will be maximized. It is recognizable by the grayscale band in the title bar.

Scaling the Individual Windows

All the windows in CINEMA 4D have different purposes. For example, there is a window that shows the position of active objects in the workspace. Another one shows all the objects in a scene. Yet another window shows the objects on their layers, which makes it easier to organize them.

Some windows are more important than others depending on what you are working on and thus should take more space. You do not have to create another layout just for this reason. It is enough to place the mouse pointer onto the line between two windows. The pointer changes to a vertical or horizontal double arrow, depending on which side of the window you are at (Figure 1.8).

— Figure 1.8: Changing the window size.

The size of the surrounding windows can be changed by holding down the mouse button and pulling in different directions.

If the mouse pointer is at a meeting point of multiple windows, in the middle of the editor windows, for example, you can change the height and width at the same time. At these positions you will see a quadruple arrow.

Assigning Custom Keyboard Shortcuts

Many of the commands in CINEMA 4D already have keyboard shortcuts assigned to them.

Depending on your habits, you can ignore these completely and only use icons and menus or memorize the most important ones.

If you are already accustomed to certain keyboard shortcuts from other programs, you can adjust them individually.

Open the COMMAND MANAGER at the WINDOW menu of CINEMA 4D (see Figure 1.9).

— Figure 1.9: Looking for available commands and giving them keyboard shortcuts.

Then type the first letter of the command in the NAME FILTER search field of the COMMAND MANAGER. There will be a list of all commands that start with this letter. On the right of the list are the already assigned keyboard shortcuts. Often there are multiple shortcuts assigned to a command, for example, just a keyboard shortcut and an additional keyboard shortcut in combination with the middle mouse button.

In order to assign an individual keyboard shortcut, click on the name of the command in the list and then click in the SHORTCUT field in the lower part of the COMMAND MANAGER. Every keyboard combination pressed from now on will be displayed inside the field.

As soon as you press the ASSIGN button in the COMMAND MANAGER the program checks if this particular shortcut is already assigned to another command or if it is available. If the shortcut is already assigned you have the option to override it and assign it to the new command.

Customizing Menus

Maybe the concept of using keyboard shortcuts is too confusing or you are already used to certain shortcuts in other programs. If so, then you might be interested in creating your own custom menus. Open the MENU MANAGER in the menu WINDOW>LAYOUT (see Figure 1.10).

In the drop-down menu on top of the manager, take a look at the already existing CINEMA 4D menus.

You might find out at some point that you do not use certain commands. With the MENU MANAGER it is possible to remove these commands or rearrange them.

Use the button in the lower half of the manager to do this and do not forget to save when you are done.

The Pop-up Menu

The pop-up menu is a cross between the keyboard shortcut and a menu. By pressing the V button, the pop-up menu opens around the location of the mouse pointer. It gives you fast access to all the important commands without having to move the mouse to a menu.

This menu can also be configured to your needs with the MENU MANAGER.

This menu can be found under the name M_GLOBAL_POPUP (see Figure 1.11).

— Figure 1.10: Customized menus.

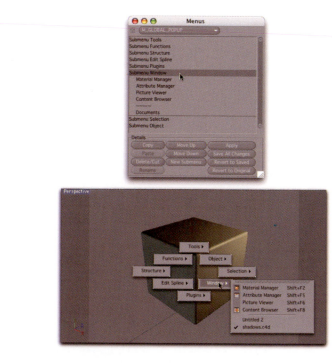

Figure 1.11: Pop-up menu.

The submenus become visible when you double click on the name of the main category. New submenus can be inserted or deleted when they are not needed.

The COMMAND MANAGER must be open in order to integrate new commands into the menu. Look for the command and drag and drop it in place in the MENU MANAGER. It is a paradise for individualists!

Integrating and Organizing Icons

The same concept applies to the icons inside the layout. The COMMAND MANAGER lets you pull a command directly into an icon palette.

— Figure 1.12: Integration of icons in the layout.

This only makes sense when the command actually has an icon assigned to it (Figure 1.12).

Activate the option EDIT PALETTES on top of the COMMAND MANAGER and all the icon palettes are editable. You can move them to different places or delete the new icon again by double clicking on it.

Grouped Icons

Some icons have a black triangle in the lower right corner. These are grouped icons, which can be unfolded by holding the mouse button while on top of the icon. In this way thematic-related functions can be combined into groups.

To create icon groups by yourself you have to create a new icon palette first. The command is located in the WINDOW menu of CINEMA 4D at LAYOUT>NEW ICON PALETTE....

You can pull multiple icons from the COMMAND MANAGER into the new palette. After you are done select the first icon in the palette and right click on it. In the CONTEXT menu select FOLD PALETTE (see Figure 1.13).

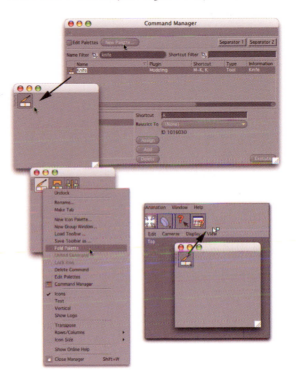

— Figure 1.13: Grouping icons and integrating them into the layout.

This groups all the icons and creates the black triangle to indicate that it is a group.

This group icon can be integrated into a layout like a single command. Remember to activate the EDIT PALETTES option in the COMMAND MANAGER before doing this.

Deactivate the EDIT PALETTES option when you are done with the icon modifications and save the new layout under a name or as STARTUP LAYOUT at the menu WINDOW>LAYOUT.

— Figure 1.14: Ripped-off menu.

Command IDs

Here are some final words about the COM-MAND MANAGER before moving onto the next subject. When you select a certain command in the list not only a keyboard shortcut appears but also the command-ID in the lower part of the dialog box.

IDs come in handy when you get into the scripting language of CINEMA 4D. They can be integrated into macros or programs in order to access these functions or commands.

Ripped-off Menus

This title may seem dramatic but it describes exactly what happens. All menus can be disconnected by pulling on the screened headline on top of the menu.

Figure 1.14 shows this on the STRUCTURE menu. You can place the menu anywhere on the screen.

Disconnected menus do not disappear out of the layout of CINEMA 4D. You can close them anytime without losing the original menu.

Display Options for Menus

In addition to these drastic changes to icons, menu entries, layouts, and shortcuts, more settings can be changed under PREFERENCES. PREFERENCES are found under the EDIT menu of CINEMA 4D.

Let's go over the most important settings. In the section INTERFACE there are options to turn on the additional display of icons and key-

— Figure 1.15: Removing icons and keyboard shortcuts from menus.

board shortcuts in menus. Deactivate this option if you like it simpler or need more space on the screen (see Figure 1.15).

OpenGL

The more complex and polygon-heavy the objects are, the slower the display in the editor will become.

For this reason CINEMA 4D supports the OpenGL standard. It also supports different surface attributes such as bump and normal mapping or the display of shadows.

You can run a test in the PREFERENCES under VIEWPORT to find out if your video card is able to take advantage of this feature.

— Figure 1.16: OpenGL settings and test.

Use the button SHOW OPENGL CAPABILITIES shown in Figure 1.16. A new window opens up with a list of all the results.

If the results are equal or larger than the presets, activate the ENHANCED OPENGL option at VIEWPORT>OPENGL SHADING. Otherwise, work with OPENGL SHADING alone.

The third option; SOFTWARE SHADING; deactivates the acceleration of the video card almost completely and would be the slowest option. Choose this option only if you have an old video card that causes display errors or even crashes CINEMA 4D.

If you experience these problems, hold down the Shift key while starting CINEMA 4D.

This will deactivate the OPENGL acceleration, making it possible to start CINEMA 4D again.

When many OPENGL options are activated, the faster the display will be, for example, to see a shadow in real time inside the editor.

Determining the Number of Undos

When you are not certain in the use of CINEMA 4D or if you want to try out some functions without knowing if they lead to the desired result, you will appreciate the possibility of multiple undos.

The number of undos is limited, as all steps need to be saved.

Determine the maximum number of undos in the PREFERENCES window under DOCUMENT (see Figure 1.17).

— Figure 1.17: Changing the number of undos.

If you are a beginner, set the UNDO DEPTH higher than the standard value, 20 for example. When you become more secure in working with CINEMA 4D you can reduce the number again.

Another possibility is to save copies of your projects at certain intervals. This way you can go back and open an older version in case something happens along the way.

Units of Measure and Color Systems

When we work with objects later on we will make use of numerical values, which determine the size of objects or distances.

We are not going to talk about measurements, as we will not work within a physical space that can be measured in meters or yards.

Therefore, do not be confused by the measurement display in CINEMA 4D. Only the numerical value is important. You can change the attached unit in PREFERENCES under UNITS (see Figure 1.18).

— Figure 1.18: Determining units.

The units are only meant to be an optical aid when building a model from a technical drawing. An object that is built in CINEMA 4D with a height of 16 miles is the same size as an object with a height of 16 inches. Only the numerical value is important.

Just as confusing in the beginning might be the different color systems. Various color systems can be selected in PREFERENCES under UNITS. I personally like to work with the HSV COLORED system because I can quickly change the color value, saturation, and brightness. You might like the RGB system better.

If you work in prepress or if you are used to working with exact color values, you need to know that the colors in the final renderings hardly look like the ones originally chosen.

The reason is that the surfaces will rarely be displayed without the influence of a light source. As soon as a light beam hits a surface the brightness changes and highlights appear. Additionally, object properties such as reflec-

tions and transparencies also influence the appearance.

Choose a color system that you are comfortable with instead of one that is based on exact color values. Regardless of which one you choose the lower part of the UNITS page gives you a preview of the color selector the way it would appear in the layout.

Settings for Your Current Project

In addition to these settings, which are saved automatically and are available when you start CINEMA 4D, PROJECT SETTINGS can also be opened in the EDIT menu (Figure 1.19).

— Figure 1.19: Project settings.

In this dialog box only the value for the FRAME RATE is of interest when you are planning to create animations in CINEMA 4D. This value should be adjusted based on the output medium rate.

An animation for a PAL DVD or PAL video should have a FRAME RATE of 25. A movie production should be set to 24 frames, while the NTSC format requires 30 frames per second.

Changing the FRAME RATE after completing the animation is possible but could cause problems or at least would require additional work. Make sure this value is set before you start the animation.

This concludes the most important settings that are behind the scenes of CINEMA 4D. Now we can concentrate on the workflow of CINEMA 4D.

1.3 Creating and Manipulating Objects

The easiest way to create an object is to open a premade one. CINEMA 4D offers a series of primitive objects, which you can open by clicking on the blue cube symbol in the icon palette (see Figure 1.20).

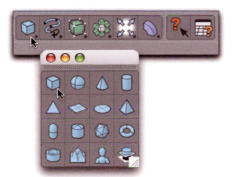

— Figure 1.20: Parametric objects.

As you can see in Figure 1.20 there are a sphere, a cylinder, various rings, and some other exotic shapes, such as the landscape object.

We will look into the advantages of having these objects a bit later. Right now we will see how CINEMA 4D handles these objects and what possibilities there are to interact with them.

Select the cube shape from the icon palette. You can also create these basic objects by clicking on the menu OBJECTS > PRIMITIVE.

Object Display in the Viewports

After you select the cube it will appear in your scene and the viewports. Figure 1.21 shows a possible scenario with four different viewports.

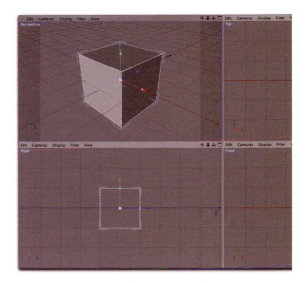

Figure 1.21: Editor viewports.

Selecting Views and Enlarging Them

The number of visible viewports is very flexible. Each one can temporarily be maximized to cover the rest of the viewports. You can control this effect with the small icons in the title bar of each viewport.

If you have only one viewport at the moment instead of the four shown in Figure 1.21, you will need to click on the far right icon in the title bar. It looks like a stylized window and toggles between the maximized window and the four viewport layout.

Try to toggle between the maximized viewport and the four viewport layout. This will be helpful when you have to do some precision work and need to enlarge a certain area.

Navigation inside the Viewports

The three remaining icons work on the same principle.

Put the mouse pointer onto an icon and hold the mouse button while pulling the mouse.

The first icon with the four arrows lets you move around in the scene. It actually looks like

the cube is moving and it might even disappear out of view.

However, you do not really move the cube. You are the one moving around in your scene. The cube is still at the same position as before. This move icon has another function. If you use the right mouse button instead of the left one you can move toward the cube or farther away.

The second icon with the stylized triangle activates the zoom function, which at first looks similar to the effect of using the right mouse button with the move icon. You can see the difference in the perspective viewport in Figure 1.21.

Using the zoom icon results in a change of the focal lengths, which are used to calculate the perspective view. If you zoom in too far it might distort the view like a wide-angle camera lens. You should use the move icon when you want to zoom into the perspective viewport.

The zoom icon works fine in the other three viewports.

You can also use the scroll wheel of your mouse to zoom in or out without using the zoom icons at all. This does not change the focal length.

The third icon is only active in the perspective viewport and lets you rotate around a selected object. Combined with the right mouse button, the camera can be rotated 180°, which gives an upside down view.

In case you get lost while working in the viewports, there are several options under the EDIT menu of each viewport that will help, such as the display of the object you are working on or showing the whole scene.

The function FRAME DEFAULT resets the viewport back to the default view that you get when CINEMA 4D is started. The center of this viewport is the world system, the origin of the three-dimensional coordinate system that we will work with.

Only the perspective viewport shows all three axes of this world system: the red X, the green Y, and the blue Z.

The other three viewports show a view along one of these axes. The FRONT viewport displays a view along the Z axis and only shows the X and Y axes. The names of the viewports are shown in the upper left corner.

Additionally there is another stylized coordinate system in the lower left corner of all viewports. This shows you the actual position of the world system.

Because you can't use the rotate icon other than in the perspective viewport, you won't be able to change the direction in the remaining viewports. The only exception is the possibility of rotating the viewport by 180°. Instead of looking down the front of a viewport (along the Z axis), you can also look along the Z axis from the back.

Use the CAMERAS menu in the front viewport and choose BACK. Now you are looking in the opposite direction. In the CAMERAS menu all active viewports can be adjusted. The same view can be applied to multiple viewports, such as different perspectives at CAMERAS > PERSPECTIVE.

Display Options

You will soon find out that when working with three-dimensional objects it makes sense to be able to choose different display options, such as having a solid-looking object to test the effects of light on its surfaces.

When you want to work on polygons instead it would be better to see the exact details of the object.

For this reason there are different modes in the DISPLAY and FILTER menus of each viewport that let you choose different kinds of displays. Figure 1.22 shows these menus.

Let me give you some information on the first two entries in the DISPLAY menu. The LEVEL OF DETAIL defines the number of polygons that will be displayed in NURBS objects and all the parametric primitive objects. Leave this setting at HIGH, as it might be difficult to know if, for example, rounded edges are the way they are shown in the viewport.

Lower settings reduce the number of the displayed polygons and make the object ap-

Figure 1.22: Display options for objects.

pear rough. This only makes sense if you have a large number of objects in your scene, which causes the editor display to slow down a lot.

The second entry in the DISPLAY menu concerns the direction of the so-called default light. This DEFAULT LIGHT works like a light source and illuminates our objects even if you haven't created a 3D light yet.

After you select DEFAULT LIGHTING, a small window opens, which contains a shaded sphere. You can click on this sphere and, by moving the mouse, change the direction of the light source.

This function is not meant to be used for the final lighting because it cannot generate shadows. In addition, you cannot generate multiple DEFAULT LIGHTS to create complex lighting setups.

The different object types and entries in the FILTER menu let you turn them off temporarily.

Select, for example, GENERATOR and uncheck it in the menu and our cube will disappear because it is part of the generator objects.

Turning off finished objects in a complex scene can be very helpful in order to get a better overview.

Gouraud Shading

This is the highest quality display of objects and it incorporates the lights without having to render the scene.

This mode can be combined with an overlay of WIREFRAME or ISOPARMS lines on the surface of objects. Which one you will want to use is defined in the third segment of the DISPLAY dialog.

Wireframe is a display of the contours that border the polygons. ISOPARMS also follow the contours but leave some lines out to make it easier to see more of the surface. You can see a comparison of both in Figure 1.23.

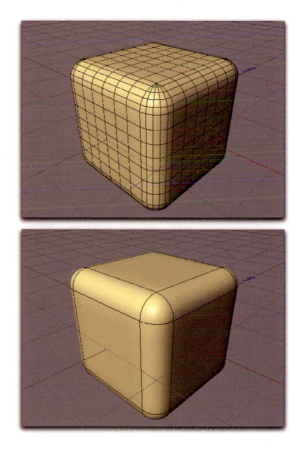

— Figure 1.23: Wireframe (top) and Isoparms (bottom) overlays.

Quick Shading

The next lower display quality is Quick Shading. Here you can use Quick Shading alone or Quick Shading (Lines) with an additional overlay of Wireframe or Isoparms lines.

The Quick Shading mode only calculates the direction of the light beams of the Default Light and ignores all other light sources in your scene.

The advantage of this mode is the much faster calculation and the fact that you can still get a good impression of the structure of the surfaces.

Constant Shading

In this setting all light sources and effects are ignored and the surface is simply filled with color. If you want to use this mode you should pick Constant Shading (Lines) to at least get an idea of the surface (see Figure 1.24).

— Figure 1.24: Constant shading with overlaying Isoparms lines.

Hidden Line and Lines

In these two modes, surfaces are not shown. Depending on your choice, only Isoparms or Wireframe lines are displayed. The upper row of Figure 1.25 shows the Hidden Line mode with Wireframe and Isoparms lines. Both kinds of lines in Lines mode are shown underneath the image.

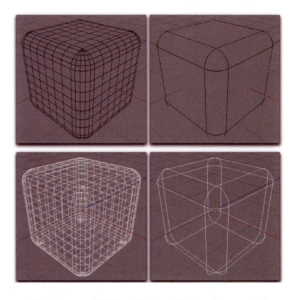

— Figure 1.25: Hidden Line and Lines in comparison.

You will notice here that the Lines mode lets you see also the back of the object.

Box

In box mode every object is displayed only as a cube. This form of display does not show you the actual form of the object but rather its size and position in space. This can be helpful in complex scenes if, for example, you just want to set up an animation.

Skeleton

I also want to mention the skeleton mode. Objects are reduced to the display of their center, and hierarchical relations between elements are suggested by lines. Form or size of the object cannot be seen anymore.

Operating Modes

Objects consist of different elements that can be manipulated separately. You are already familiar with the polygons used to create surfaces.

Every polygon is bordered by lines. These lines are drawn between two points. A surface therefore consists of points, edges, and polygons.

In addition to these elements, each object has a local coordinate system to which the position of all elements is related. If this coordinate system is moved, scaled, or rotated, the whole object will move, scale, or rotate as well.

The local coordinate system can also be moved relative to the points, edges, and polygons.

Depending on which element of an object you want to influence, you first have to tell CINEMA 4D which of the operating modes you want to use.

You can find these operating modes as icons on the left side of the layout. In Figure 1.26 the icons are marked with the letters A through E.

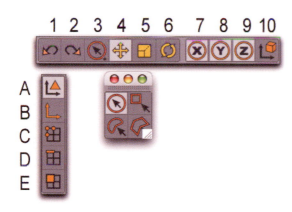

— Figure 1.26: Operating modes and tools.

Next to the letter A is the model mode. When this mode is active you can move or scale the whole object.

Next there is the axis mode. This mode allows you to move the previously mentioned coordinate system independent of the points,

edges, and polygons of the object. This only works with polygon and point objects. The coordinate system of parametric basic objects cannot be moved independently of the points, edges, and polygons.

Modes with the letters C through E activate, from top to bottom, point, edge, and polygon modes. These modes also only work with objects that contain editable elements. Again, this excludes parametric basic objects.

Tools and Functions

Creating Selections

Once you have chosen the desired mode for an action, you must tell CINEMA 4D what elements you want to select. Therefore, you will need to pick a selection tool, which can be found at the icon shown at number 3 in Figure 1.26.

You will find some familiar icons here, such as rectangle, lasso, or freehand selection, which are similar to those used in common graphics programs.

When the selection tool is activated, you will be able to select the elements in the editor viewport. Depending on the operation mode, this could be points, polygons, or complete objects.

All selection methods have additional options that can be set in the ATTRIBUTE MANAGER. There you can, for example, change the selection radius around the mouse pointer or define if you want to select only the elements in the front of objects or if you also want to include the back. We will talk about these options later.

When you have selected the elements or objects, you can use the icons at numbers 4, 5, and 6 to define if they should be moved, scaled, or rotated.

Let's use the cube, which should still be in your scene, as an example. If the cube is to be moved, you need to activate the model mode first. After you do that make sure the cube is actually selected. To be sure, select the tool

LIVE SELECTION in the selection tool group. The icon looks like a mouse cursor inside a circle.

Move the mouse pointer to any of the editors and click on the cube object. You should see additional red corners on the cube if you did everything right. These corners always mark selected elements in the editor viewports.

You also can see now the local coordinate system with its X, Y, and Z axes inside the cube. The X axis is displayed in red, the Y axis in green, and the Z axis in blue.

Figure 1.27 compares selected and unselected cubes.

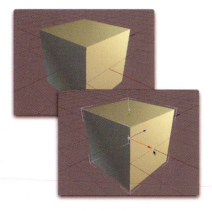

— Figure 1.27: Unselected (top) and selected (bottom) cubes.

Moving, Rotating, and Scaling

Now you need to select the desired action using the icons 4 through 6 in Figure 1.26. Try out the move mode by clicking on icon number 4.

After that, move the mouse pointer into any of the editor viewports and hold down the left mouse button while you move the mouse.

Now you should be able to move the cube and put it anywhere in the room. Zoom out a bit using the scroll wheel or using the navigation icons in the editor to get a better overview and more space in the viewport.

The other modes (scaling and rotating) work similarly. In all three modes it's not necessary to place the mouse pointer directly onto the cube to start moving. As long as the

cube is selected you can manipulate it from anywhere in the editor.

It is important that you hold down the mouse button. A simple mouse click in the editor would deselect the cube.

As easy as the manipulation of objects might be, most of the time you will need more control. This is especially true concerning the direction of a move or rotation.

Imagine that the cube is supposed to be a door. We would have very tight guidelines as to the maximum opening angle, especially the direction of the rotation. The hinges only allow one direction of rotation.

This kind of restriction can be realized in different ways. First there are the icons at numbers 7, 8, and 9, which are shown again in Figure 1.28. These work like a toggle switch and can be used in any kind of combination.

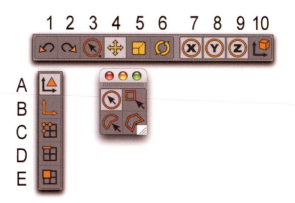

— Figure 1.28: Operating modes and tools.

You will be able to move or scale the selected element along or rotate around the X axis if the X icon is active and highlighted.

You get the same effect when you click and hold the mouse button at the end of one of the axes of the local coordinate system. For example, click and hold the arrow tip of the red axis at the cube. Now you can only manipulate it along this axis.

A double click on the end of an axis locks it permanently even if the mouse pointer does not rest on it anymore. The end of the axis will

be marked in yellow. Another double click in the empty editor deactivates the lock.

World and Object System

When an object is rotated, you have another choice as to which direction an action will be executed. You have already heard of the world system in the center of the 3D space and also learned about the local axis system of objects.

With the system button you choose which system you would like to use.

You can select if you want to use the world system or the object system for moving in the X direction of the X axis. These directions do not have to be the same for both systems.

The icon works like a toggle switch and therefore switches with every click between the world system, represented by a globe, and the object system, which is shown as a cube.

Handler

Maybe you have already noticed the three orange spheres on the axes of the cube. These are the so-called handlers through which you can change the shape of the cube directly (see Figure 1.29).

Figure 1.29: Grabbing points at a cube basic object.

These are only visible on the selected cube. You need to be in model mode at this point.

Activate the move mode, place the mouse pointer on top of one of the handlers, and hold down the left mouse button. The handler changes its color and, with the movement of the mouse, controls the scaling of the cube along the corresponding axis.

If this does not work, check to see if the axis where the handler is located hase been locked.

The handler is a characteristic element of parametric basic objects. It allows the simple manipulation of the shape of an object in addition to the control of other parameters, such as the size of a radius.

You need to know that parametric objects are based on formulas that calculate the shape of a sphere, a cylinder, or a cube.

This gives the advantage of not having to create a sphere from scratch out of hundreds of polygons. It is enough to determine the radius and CINEMA 4D will take care of the perfect placement of the points, edges, and surfaces.

Because the placement of all points, edges, and surfaces is controlled by formulas, it is not possible to manipulate individually in order to delete a polygon to create a hole, which is why we couldn't use the axis, point, edge, and polygon modes yet.

However, parametric objects have other advantages, the details of which we will get into later.

Object Manager and Attribute Manager

Let's move from the editor viewports to the right of the standard layout. There you will find the OBJECT MANAGER and the ATTRIBUTE MANAGER (see Figure 1.30).

The OBJECT MANAGER shows you an overview of all elements in your scene and lists the existing objects. You should be able to see your cube as an entry.

In addition to a variety of functions, which we will talk about later, the OBJECT MANAGER

In the BASIC column of the attributes of an object you can find the name of the object and its connection to layers, as well as other display options important for the editor viewports.

The tab COORDINATES shows in P values the actual position of an object, separated by X, Y, and Z axes. This data will always be shown in the object system. You will learn in a moment what the meaning of that is. The S values determine the lengths of the axis in the local system. The standard length is 1 in all directions. The r value describes the rotation angle in the heading/pitch/bank system.

For animation systems, this kind of conversion is more suitable than the separate display of angles for the X, Y, and Z axes of an object, as the HPB angles are independent from the order of applied rotations.

A little test will illustrate this. Figure 1.31 shows differently colored cubes that have the same position and direction.

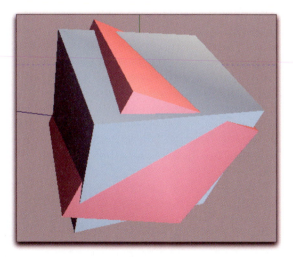

— Figure 1.30: The Object Manager and the Attribute Manager.

allows you to select objects. Just click on the name or the icon that precedes the object name. The name will be highlighted as an indication that the object has been selected. A double click on the name of the object makes it editable. You can give objects individual names to find them again easily later on.

The ATTRIBUTE MANAGER located below the OBJECT MANAGER has multiple functions. It shows available options of an active tool or the parameter of a selected parametric object.

This data is often sorted thematically by tabs and can be selected easily by clicking on the name in the headline of the ATTRIBUTE MANAGER (see Figure 1.30).

— Figure 1.31: Different order of rotations.

The blue cube was first rotated around the X axis and then around the Y axis. The red cube uses the exact same rotations but in opposite order. The final positions are totally different from each other.

This cannot happen in the HSB system because the order of angle rotations does not change the result. The only disadvantage of

this system is that readability suffers from the conversion. As a result you cannot see how many degrees an object actually rotated.

The column OBJECT PROPERTIES shows all the parameters of the calculation and the formulas of an object.

A part of these parameters can be controlled directly with handlers; however, it is more difficult to set an exact value. Handlers are meant to be used for intuitive work with the object and when an exact measurement or value is not necessary.

If you want to be sure that your cube is exactly 231.5 units in height, then you should enter this value directly into the field for SIZE Y.

SEGMENT values define the partitioning of the object with polygons. What that does to an object you can see best when you activate the WIREFRAME lines in the editor. The shape of the object will not be changed, but the number of polygons can be adjusted.

The SEPARATE SURFACES option is hardly ever needed and therefore will not be discussed. It separates the cube sides after the conversion of the object to a polygon object. We will see later what that means.

Much more interesting is the FILLET option, which adds roundness to the edges of the cube. The value for the FILLET RADIUS defines the size of the rounding, and FILLET SUBDIVISION sets the number of polygons in the rounding.

As you already know the number of polygons determines the quality of a rounded surface. The higher the number of subdivisions, the smoother the rounding will be.

You should keep an eye on the number of polygons used in your scene. Every polygon, even if only a tiny one, needs memory and can cause in worst-case scenarios a slowdown of the editor or extended render times. Therefore, use polygons as economically as possible.

As you can see in Figure 1.32, the preset five FILLET SUBDIVISION already creates numerous additional polygons.

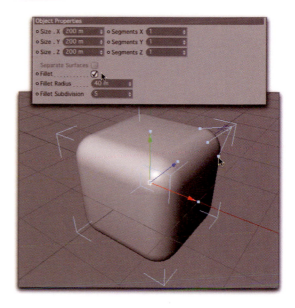

— Figure 1.32: A cube with rounded edges.

Phong

The last column is the PHONG TAG. Tags generally organize additional parameters or functions that define the behavior or the look of objects. The PHONG TAG controls the surface shading.

If the function is set right, the rounded surfaces will look more detailed than the actual number of surfaces might lead you to believe.

As an experiment, lower the value of the PHONG ANGLE drastically. Notice how the separate polygons stand out and are much defined (see Figure 1.33). A properly adjusted PHONG value will result in a rounding of the surface. This effect is based on the angle of neighboring polygon normals.

If the value of the normal angle is lower than the angle preset in the PHONG TAG, a gradual reduction of brightness across polygons is calculated. The hard edge between polygons will be smoothed out.

However, if the angle between two normals is greater than the PHONG ANGLE value, then the edge between the surfaces stays visible. This often happens on purpose. Just think

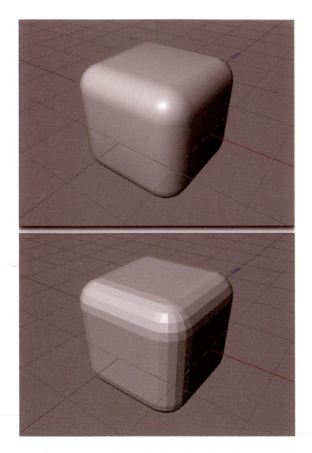

Figure 1.33: Adjusted value (top) and too small of a value (bottom) of a Phong Angle.

of the polished edges of jewels or a clearly visible edge of technical components.

It is therefore not advisable to increase the PHONG ANGLE indefinitely. This value should be adjusted based on the shape of the object.

Tags often appear as small icons next to the objects in the OBJECT MANAGER. You can see the PHONG TAG in Figure 1.34 surrounded by a red frame. A click on this symbol will show all relevant settings of the phong effect in the ATTRIBUTE MANAGER, even if the object hasn't been selected before.

Figure 1.34: The Phong tag in the Object Manager.

Structuring Objects and Controlling Visibility

In order to learn more about the functionality of the OBJECT MANAGER, we should create a second object. This time select the sphere object in the menu with the parametric basic objects.

Make sure that you are in model mode and then move the existing cube and the new sphere so that you can see both clearly (see Figure 1.35). First click on the cube in the OBJECT MANAGER and activate the move icon. Move the cube to the desired position and do the same with the sphere.

As soon as the sphere is selected take a look at the ATTRIBUTES MANAGER. In the OBJECT column you can see the parameters of the sphere. This is primarily the RADIUS of the sphere, which you can also control with the handler, and the number of polygons.

Additionally in the TYPE menu you can choose different kinds of arrangements of the polygons on the surface of the sphere. Select them sequentially and watch in the editor how the wireframe lines change.

With such a characteristic shape, such as a sphere, irregularities and inaccuracies will be especially noticeable. We would have to subdivide the sphere many times in order to get a smooth surface even at extreme zoom-ins.

In order to avoid this there is an option called RENDER PERFECT. If this option is activated, the sphere will be calculated perfectly, even if we only use a low number of polygons.

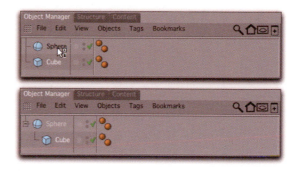

Figure 1.36: Group objects.

Figure 1.35: Creating a second object.

sphere a new symbol has appeared. Figure 1.36 shows this procedure and the result.

You have just created an object group. The sphere is now the highest object in this group and assumes a certain amount of control over all subordinate objects. From now on it is possible to move, rotate, or scale the sphere and the subordinate cube will follow.

Because of the control of the upper object over the subordinate object, this relationship of the objects to each other is called the parent/child relationship.

Use this function whenever possible to structure your objects and to create a better overview in the OBJECT MANAGER. You can expand and contract the hierarchy anytime by clicking on the box in front of the sphere.

However, you will only be able to see this effect after the picture is rendered. You will find out later how this works.

Creating Groups

Let's imagine that the cube and the sphere are parts of a complex model.

In this case it would make sense to connect these objects with each other so that they can be moved or scaled together. This is called grouping of objects.

Activate the cube by clicking on it in the OBJECT MANAGER and keeping the mouse button pressed down. Move the mouse pointer in a drag and drop action on top of the name of the sphere in the OBJECT MANAGER. You can see that the mouse pointer changes into a plus sign, including a downward arrow. Release the mouse button to finish the drag and drop action.

The cube is now indented under the sphere in the OBJECT MANAGER and in front of the

Controlling Parametric Calculations

As already mentioned, there are calculations running permanently, which, with the help of parameter entries in the ATTRIBUTE MANAGER, calculate the three-dimensional appearances of parametric basic objects.

The hook next to the object in the OBJECT MANAGER controls whether these calculations take place or not.

When you click on the hook it turns into a cross (see letter A in Figure 1.37). This deactivates the calculation and the object disappears out of the editor viewports. Only the local axis system, including the handler, stays visible and can be manipulated further.

Figure 1.37: Deactivate basic objects and control of visibility.

Another click on the cross activates the calculation of the object again.

The two gray dots behind each object in the OBJECT MANAGER work in a similar manner. These change their color with each click, first from gray to green, then to red, and back again to gray.

The coloring of the upper dot controls the visibility of the object in the editor viewports. The lower dot controls the visibility during the render process. We will get to this later.

The gray coloring represents a neutral position. A green dot shows a visible object. A red dot represents an invisible object.

For example, when you turn the upper dot to red by clicking on it twice, the object will disappear from the editor viewport (see letter B in Figure 1.37).

Control becomes a bit more complex within groups. Therefore, turn the visibility of the cube back to gray and set the upper dot of the sphere to red. The highest object in the hierarchy takes over the control of the subordinate objects. Both objects disappear out of the editor viewports (see letter C in Figure 1.37).

This is possible because the cube has a neutral gray dot and therefore takes on the state of the superior objects.

We can change this by setting the cube to green, as you can see at letter D in Figure 1.37. Its own setting of red or green will overwrite the setting of objects that are higher in the hierarchy.

1.4 Configuration of Editor Viewports

We have already learned about multiple possibilities when it comes to changing the layout or displaying objects. However, there are even more options available on this subject that can be applied to all viewports or separate to each individually.

We will only talk about them briefly, as these options can be found in other places as well. In addition, these functions are of minor importance and are not essential for the work done with CINEMA 4D.

In order to see the available editor options, open EDIT>CONFIGURE ALL... in any viewport (also see Figure 1.38).

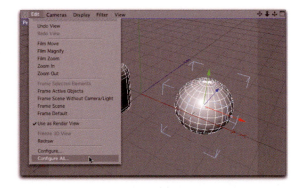

— Figure 1.38: Opening of editor settings.

All the functions we will talk about are available in the ATTRIBUTE MANAGER.

Display Options

Here you control the display quality of all objects in the viewports. Some of the new options also appear in the DISPLAY menu of each viewport.

Also worth mentioning are the options SEL.:BOUNDING BOX and SEL.:WIREFRAME. These refer to the display of selected objects (Figure 1.39).

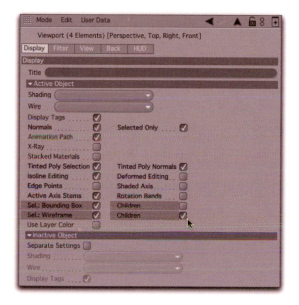

Figure 1.39: Display options.

The bounding box is the group of small red corners that appear around selected objects. We talked about this already in connection with selection. If the object is selected the corners will be displayed when this option is activated.

The next option CHILDREN expands this bounding box automatically to all subordinate objects. I do not think that this is particularly helpful and recommend that this option not be used.

The option SEL.:WIREFRAME automatically overlays the selected object with a wireframe, even if this display option is not activated in the viewport. Decide for yourself if you need this overlay or not. The CHILDREN option ex-

tends this wireframe to the subordinate objects if they consist of polygons.

Filter Options

You can also find all these options in the FILTER menu of every viewport. If the option of an object group is not selected then they won't appear in the viewports.

The same menu is also accessible through the icon shown in Figure 1.40 in the layout of CINEMA 4D.

Figure 1.40: The display filter.

Making HUD Elements Visible

HUD is short for Head Up Display and describes the possibilities of showing additional information inside the viewports (see Figure 1.41).

Some of these HUD elements you unconsciously already know. The titles *Perspective* and *Front*, which are seen in the upper left corner of the viewports, are two of them.

Other options are, for example, display of the frame number of the animation or the name of the selected object. As tempting as it is to use these options, you should restrict them to a bare minimum so as not to clutter the viewports.

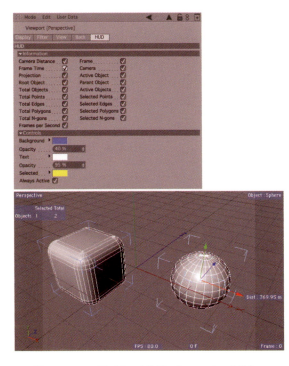

Figure 1.41: Making HUD elements visible.

Figure 1.42: Incorporating a parameter into HUD.

In addition to these standard elements you can also integrate various parameters directly from the ATTRIBUTE MANAGER into the HUD.

Now you can test this option. Click on the name of the sphere in the OBJECT MANAGER. Then right click on the word RADIUS in the OBJECT tab of the ATTRIBUTE MANAGER.

In the context menu select ADD TO HUD. The radius parameter of the sphere will now be displayed in the viewport (see Figure 1.42).

When you hold down the CTRL key in addition to the mouse button you can move the new HUD element. This is shown in the lower part of Figure 1.42.

When you click on the HUD element with the right mouse button a menu with more options opens up. The FOLLOW option, for example, makes sure that the HUD element follows the movement of the object. The SHOW>OBJECT ACTIVE option shows the HUD element only when the object is selected (see Figure 1.43).

HUD elements are not only informative but can also be used to change the parameters directly. You can change the numerical value of the radius by placing the cursor over it and holding down the mouse button while moving the mouse to the left or right.

This works similarly to a handler but adds the numerical value. This kind of use of the HUD element is shown in Figure 1.43.

Show the slide controller if you want another method of changing the value. Right click on the HUD element and select DISPLAY>WIDGET.

When you click on the small arrow, which appears behind the numerical value, a controller opens.

By moving the controller you can set the values. In my experience it is more precise to do this without using the controller, as the value range is very large and the value change

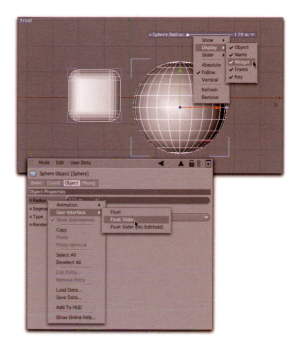

— Figure 1.44: Adding controllers to value fields.

— Figure 1.43: Configuring and controlling HUD elements.

can be huge even with small controller adjustments.

Even if you do not like to use HUD, you can improve the display through the ATTRIBUTE MANAGER.

As shown in Figure 1.44 there is the possibility of activating a controller by right clicking on a parameter in the menu USER INTERFACE. There are enough ways to enter values to suit anyone's taste.

Additional Viewport Options

Let's go back to the CONFIGURE menu and take a look at the VIEW section in the ATTRIBUTE MANAGER.

Interesting to note is the setting of SAFE FRAMES. It refers to the darkened area in the perspective viewport and limits the visible area in the rendered picture. The size of the visible area depends on the render resolution

— Figure 1.45: Viewport settings.

for the rendered picture. You will learn how to adjust them in the next chapter.

In addition to the RENDER SAFE bar there are other border lines that can be activated, such as TITLE SAFE and ACTION SAFE. The distance of these frames from the outer edge of the picture can be controlled by SIZE values.

These additional frames can be helpful when producing animations for television or cinema.

This output media trims the edges and makes the picture smaller. It is important to have a safe distance to the edge of the picture, especially if titles have to be shown or if other objects have to be completely visible.

The TITLE SAFE and ACTION SAFE frames can help you in this case. They are only visible in the perspective viewport and will be turned off automatically at the final rendering.

Rotation Bands

On the VIEW page of the CONFIGURE menu are the settings for rotation bands (see Figure 1.45). These colored bands are displayed when the rotation command is used. You can control the rotation by clicking on one of these bands.

The size of these bands can be adjusted with the ROTATION SCALE percentage value in the VIEW dialog page. Values over 100% are permissible here.

If you like it simpler you can deactivate these bands. Then only the axes that are used in the move and scale mode are shown (see Figure 1.46). You can do this by deactivating the option ROTATING BANDS on the display page.

Enhanced OpenGL

We already talked about the accelerated display in the editor views and the improved quality of surfaces using OPENGL. In order to get increased speed in all view ports, activate ENHANCED OPENGL in the lower part of the VIEW settings in the PREFERENCES dialog.

Shadows, transparencies, and post effects can be activated too. These settings may also be accessed in the DISPLAY menu of every viewport individually.

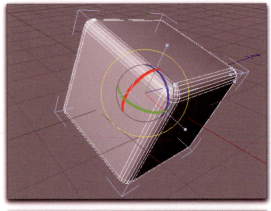

Figure 1.46: Showing rotation bands.

Point Size

Later on, when working with objects in point mode, it might be useful to change the size of polygon or spline points. You can find this value at the entry POINT HANDLE SIZE on the VIEW page of the dialog (see Figure 1.45).

Making Pictures Visible inside the Editor

The final item regarding this topic is the BACK tab of the CONFIGURE dialog. In order to make use of these settings, you should only use this menu in a viewport without perspective. Not all options are available when you open CONFIGURE ALL… as not all settings work in a perspective viewport.

In the lower part of the dialog page you control the grid widths, which are also shown in the viewports (see Figure 1.47).

— Figure 1.47: Showing background images.

These grid lines are especially helpful inside the perspective viewport to strengthen the 3D impression. The grid is also positioned at the origin of the world system and gives the impression of a floor in an otherwise empty 3D space. However, this is only an optical aid. You can still place objects above and beneath this grid.

If you wish to model objects based on images or sketches, it can be helpful to show the image in the editor viewport. This can be done by using the button with the three dots behind the IMAGE field (see mouse pointer in Figure 1.47).

Then a file dialog opens where the desired picture or animation can be selected. The OFFSET value allows the loaded picture to be moved horizontally and vertically in the viewport. The SIZE value allows the image to be scaled.

The selected picture can be loaded in every viewport except the perspective viewport. Just open the CONFIGURE menu again in each viewport and load the picture. This option is not available in the perspective viewport.

Later I will discuss another way of showing images inside the viewports. This will allow selected pictures to work in the perspective viewport.

1.5 Polygon Tools: A Work Example

So far we have used premade basic objects, adjusted them with their parameters, and learned to move, scale, and rotate them.

Now we will increase the complexity of the manipulation and take a look at all the polygon tools.

I would like to show you these techniques with the help of a specific work example.

Do not get confused by the colors of polygons and points that may be different from the standard theme.

This change improves the color contrast of the images in the book. These settings can be changed at INTERFACE>COLORS and VIEWPORT>COLORS in the PREFERENCES dialog.

In this example I intentionally avoid shortcuts because I want to demonstrate different techniques and point out problems that can arise while working with polygon tools.

The object that we are about to model is the housing of an Apple PowerMac computer. Its form has enough structure and detail, which will make the modeling process more interesting.

Creating the Basic Form

For the basic shape of the housing we start with a cube object, commonly used in modeling. Create a basic cube object and resize it to 205 units for the width in the X direction, 510 units along the Y height, and 475 for the depth in the Z direction.

Color the cube to see it better by using the setting at DISPLAY COLOR of the BASIC settings of the cube in the ATTRIBUTE MANAGER.

The use of this color is set to AUTOMATIC so the color is automatically turned off when we apply a material. Figure 1.48 summarizes these settings.

The cube is now the same size as the housing. The position shouldn't be changed yet. We can take advantage of the symmetry of the housing because objects are created at the origin of the world coordinate system.

Figure 1.49 shows the current shape and position of the cube in the 3D space.

Figure 1.48: Settings for the cube object.

If you are familiar with such a computer housing then you know that the most noticeable elements are the curves and the handles at the top and at the bottom.

It will be easy to round the edges by using the settings of the cube.

I will set the curvature to 30 units and keep the default setting of 5 for the subdivision.

Figure 1.50 shows this step and the result.

Converting Basic Objects

We have used all possible ways of manipulating the basic cube object. For more individual editing of the shape we have to access the points and polygons.

The command that makes this possible is called MAKE OBJECT EDITABLE and can be found as an icon with two stylized spheres in the vertical icon palette on the left. Alterna-

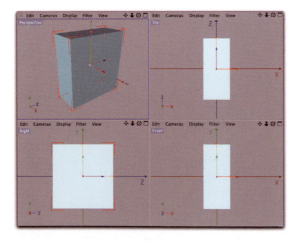

Figure 1.49: The cube in the editor viewports.

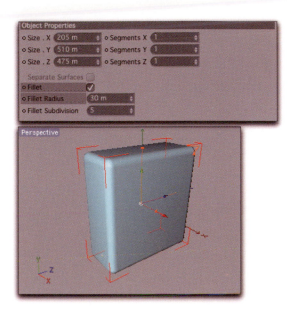

Point	X	Y	Z
0	-72.5	-255	-207.5
1	72.5	-255	-207.5
2	72.5	-255	207.5
3	-72.5	-255	207.5
4	-72.5	-253.532	-216.771
5	72.5	-253.532	-216.771
6	75.365	-253.532	-216.317
7	77.949	-253.532	-215
8	80	-253.532	-212.949
9	81.317	-253.532	-210.365
10	81.771	-253.532	-207.5
11	81.771	-253.532	207.5
12	81.317	-253.532	210.365
13	80	-253.532	212.949
14	77.949	-253.532	215
15	75.365	-253.532	216.317
16	72.5	-253.532	216.771

— Figure 1.51: Conversion of a basic object to a polygon object.

— Figure 1.50: Rounding the cube edges with the cube parameter.

tively you can use the C key or choose MAKE EDITABLE in the FUNCTIONS menu of CINEMA 4D. Be sure that the cube is selected when executing these functions.

A series of changes will occur when converting the basic cube object into a polygon object, as seen in Figure 1.51.

Notice the icon used for this conversion.

First it is noticeable that the icon of the cube in the OBJECT MANAGER has changed. It turned into a triangle. This symbol is the same for all polygon objects. When you see this new symbol you will be able to edit in point, edge, or polygon mode.

The ATTRIBUTE MANAGER shows the second change: All parameters are gone. It becomes impossible to change the curve of the edges or to deactivate them. Therefore a conversion to a polygon object has to be well considered. Going back to the basic object can be accomplished by using the UNDO function.

The STRUCTURE MANAGER shows additional changes (see Figure 1.51).

The Structure Manager

In this window is a list of data concerning the active polygon object. In the MODE menu it can be determined which data will be displayed. If the entry POINTS is selected the manager will show all point coordinates in a list. A double click on a coordinate makes this value editable and the exact position of the point can be determined.

Which point it concerns will be indicated by the number in front of the coordinate in every line. This is the number of the point.

A click on the number will, at the same time, select the point and color it in the editor viewports. To see this point selection you should be in point mode.

The second mode of the STRUCTURE MANAGER is the POLYGON mode and does not show coordinates but rather rows of numbers.

In these rows the sequential numbers come first and indicate the number of the polygon. A click selects the polygon, colors it, and displays it in the editor.

The groups of numbers in each row display the numbers of the points that form the corners of the respective polygon. Because there

can be polygons with three or four corners you may find three or four values.

In addition to the Polygons mode there is an N-Gons mode, which works on the same principle. There you will see polygons with more than four points.

The two remaining modes in the Structure Manager inform about the existing UVW co-ordinates of the single polygons and the intensities of applied vertex maps. We will hear more about that later.

UVW coordinates determine the order of materials on the surface of the object. Normally the UVW coordinates would not be created and manipulated manually but rather with the BodyPaint module.

If you can't get enough of these statistics you might want to select the Selection/Structure Info in the Window menu of CINEMA 4D.

In the Attribute Manager a new dialog opens with several columns pertaining to the structure of the objects.

Selection/Structure Info

The Objects column shows you the quantity of points and polygons in the selected object. When the option Calculate Children is active, the subordinate objects will be included. At the end of the table the memory requirement of the object is displayed.

The column Cache shows the values of the points and surfaces of the not yet converted basic and NURBS objects.

At the Selection page of the dialog the points and polygons currently selected are listed. There is another column dedicated to those elements that are partially hidden.

The third column shows the total of all elements. This information is partly redundant with data on the Object page.

The Structure column changes its appearance depending on which operating mode is active in CINEMA 4D. Figure 1.52 shows, in

Figure 1.52: Selection/structure information.

addition to the others, the Structure column in point mode.

The first number stands for the number of polygons that are connected with this point. The corner points of a cube are each part of three polygons. A simple cube object therefore shows eight points where each is part of three polygons.

You can select or deselect the elements in the editor with the plus and minus keys.

If we are working in the polygon mode, the Structure column informs us of the different numbers of triangular, quadranglular, and N-Gon polygons.

In the Structure column you could also search for distorted or bent polygons where the corner points are not in a two-dimensional level.

The TEXTURES column will be interesting as soon as we work with materials and loaded images.

All paths of used pictures are listed and examined in these columns to see if the path still corresponds with the path stored in the material. Missing images can cause errors in the rendering process and can even make it impossible to render.

Over the appropriate button at the end of the dialog the lost files can be marked and reloaded.

After so many statistics, it is now time to return to our cube.

Live Selection

Go through the different display modes of CINEMA 4D. In point mode you will be able to see the points of the cube for the first time. They are especially concentrated at the rounding and at the corners.

We will need new subdivisions to create the handles on the top and bottom of the housing. This requires cutting the edges.

First we switch into edge mode and select LIVE SELECTION. Do you remember the mouse pointer in the icon menu with the different selection tools?

Make sure that the option ONLY SELECT VISIBLE ELEMENTS in the ATTRIBUTE MANAGER is deactivated in the settings of the LIVE SELECTION. We also want to select the edges in the back of the cube.

After that, change to the side viewport and move the mouse pointer while holding down the mouse button. Move across all horizontal lines. The selected edges are now red (see Figure 1.53).

Make sure that you didn't forget any edges. You can hold the Shift key and move over these edges again to add them to your selection.

You can deselect wrongly selected edges with the LIVE SELECTION while holding the CTRL key.

— Figure 1.53: The cube in point mode with selected edges.

Also check the back of the cube by rotating around the cube in the perspective viewport.

Cutting Edges

Now we will use the EDGE CUT tool to divide the edges even further and to create additional points and polygons. You will find these and all other tools in the STRUCTURE menu of CINEMA 4D.

Figure 1.54 shows this menu separated from the layout and marks the EDGE CUT command with the mouse pointer.

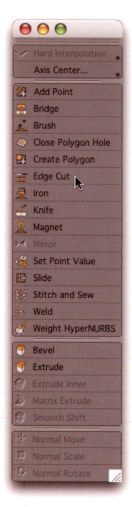

— Figure 1.54: The Structure menu.

— Figure 1.55: Adding additional subdivisions with the Edge Cut tool.

The EDGE CUT command has some available settings in the ATTRIBUTE MANAGER, as shown in Figure 1.55. These enable you to set how many cuts will be made.

The cuts always have the same distance from each other. The OFFSET and SCALE values do not always work properly with all objects and should be used carefully. Their function is to control the distance between the cuts and the distance to the end of the cut edges. The preset values are 50% for OFFSET and 100% for SCALE. These values always work well and center the cuts on the edges.

First we need two cuts, which will appear as new edges. Deactivate the CREATE N-GONS option and set SUBDIVISIONS to 2.

The actual action is executed on the TOOL page of the ATTRIBUTE MANAGER by pressing the APPLY button. You can still change the settings after you have applied them and watch them happening live in the editor by activating the REAL TIME option. This only works until you select another tool or another action.

The NEW TRANSFORM button executes a new function, which means that you can, for example, cut edges multiple times with different tool settings.

The RESET VALUES button resets all settings of the tool back to the standard values.

You can find these three buttons in the exact same form at almost all the tools. The necessary work steps are therefore always the same.

First you select the elements that need to be manipulated and then you select the tool. After all the settings are complete, execute it by pressing the APPLY button. If you do not like what you see you simply correct your settings.

With the REAL TIME UPDATE option you are able to make changes later.

Loop Selection

We now have created two additional subdivisions and, in the second step, have moved them to the right position. This is a good opportunity to try out the LOOP SELECTION. In many cases it is easier to use the LOOP SELECTION than to manually select the surrounding points, edges, or polygons with the LIVE SELECTION tool.

You can find this and many other tools in the SELECTION menu of CINEMA 4D. Figure 1.56 shows this menu and the use of LOOP SELECTION.

Figure 1.56: Creating a Loop Selection.

After activating the LOOP SELECTION tool, move the mouse pointer across the new edges of the cube. All edges that form a circumferential line will change their color. Click on the edge to select it. We will use the COORDINATE MANAGER to place the selected edges correctly (see Figure 1.56).

The COORDINATION MANAGER not only shows you the current position, size, and rotation of objects, but also that of selected points, edges, and polygons.

In our case we can enter the value +152.5 / −152.5 for the Z position and transfer this value to the edges by clicking on the APPLY button in the COORDINATE MANAGER. The plus and minus signs of the Z position depend on if you want to move the edge loop in the left or right viewport. There is still a gap of 55 units up to the edge rounding, which is the desired width of the handles on the housing.

The lower part of Figure 1.56 shows the new position of the edges.

Deleting Selected Elements

Points, edges, and polygons can also be deleted. In our case we want to get rid of the polygons at the rounding of the front and back of the housing.

The polygons are very close together and there is the possibility that you will also select surrounding polygons by accident. Turn on the point mode and activate the rectangle selection. Make sure that the selection of hidden points is possible by checking the setting in the ATTRIBUTE MANAGER. Drag a rectangle selection around the points at the rounding in the front of the cube.

Hold down the Shift key and repeat the rectangle selection at the rear rounding of the cube. Figure 1.57 shows both selections.

Because the focus is not on points (all connecting polygons would also be deleted if we would delete the points now) but rather on the polygons, we have to convert the point selection into a polygon selection.

— Figure 1.57: Selecting points with the Frame Selection.

Therefore, hold down the CTRL key and change from point mode to polygon mode. All polygons appear that were made exclusively from the selected points. Alternatively, you could also have used the CONVERT SELECTION function in the SELECTION menu but our method is much faster.

You can now delete the selected polygons by pressing the Delete key. Which elements to be deleted are determined by the mode selected. Select polygons with the LIVE SELECTION and use the Delete key to delete these selected polygons.

If you click in the OBJECT MANAGER after the selection and then use the Delete key, the whole object will be deleted.

Use the STRUCTURE MANAGER if you want to be sure that you delete the right elements independent from the currently active manager and operation mode.

Activate the mode that you selected the elements in—in our case the polygon mode—and choose the DELETE command in the EDIT menu of the STRUCTURE MANAGER. Figure 1.58 shows the result.

— Figure 1.58: Deleting polygons with the Structure Manager.

Points are the only type of element that can exist independently from the others. Edges and polygons are not able to exist without points, which is why points still exist after the deletion of polygons, as shown in Figure 1.59.

— Figure 1.59: Optimizing objects.

Check it yourself and switch into point mode.

In order to delete these unnecessary points you have to use a function that is called OPTIMIZE found in the FUNCTIONS menu of CINEMA 4D.

Deselect all points before you use this function to make sure that it will affect the entire object and not just the selection. Use the command DESELECT ALL in the SELECTION menu.

You can see the dialog of the OPTIMIZE commands in Figure 1.59. The different options determine which elements to check or to optimize.

The activated POLYGON option looks for surfaces that are exactly the same and deletes the duplicate.

The option UNUSED POINTS looks for points without any connection to polygons and deletes them. This is exactly the kind of function we need.

The POINTS option takes the TOLERANCE value in the same dialog and looks for points with a smaller distance between each other than the TOLERANCE value. These points will be combined into one.

Basically all options could be left activated. It does not hurt to avoid all possible errors and to keep the object optimized at all times. Only the TOLERANCE value has to be watched in case your model is built in a very small scale and

therefore the points might be very close to each other. However, this does not happen very often.

All the separated points should be gone after you have clicked on the OK button.

Only the surfaces between the handles are still in the way. Switch to polygon mode and use the LIVE SELECTION tool to select these surfaces. Then use the Delete key to delete these surfaces. This now looks like Figure 1.60.

— Figure 1.60: Deleting additional surfaces on top and bottom.

Creating Polygons Manually

The area between the handles needs to be closed again. Switch to point mode and choose CREATE POLYGON in the STRUCTURE menu. Click

— Figure 1.61: Creating polygons manually.

on the points in sequential order where the new polygon has to be built (see Figure 1.61).

Switch to the perspective viewport to get a better look if the points cannot be seen well.

Lines represent the edges of the new polygon. It will be finished as soon as you double click on the last point. It is up to you if the polygon should have three, four, or more corner points.

Pay attention to the order in which you click on the points. The best way to do this is to select the points either clockwise or counterclockwise so that you do not cross edges.

Repeat this step in the lower part of the housing so that we have a new polygon between these handles too.

Adjusting Normals

We already talked about surface normals and their purpose earlier. Especially when creating polygons manually it happens that the direction of the new normal is not the same as the one of surrounding polygons.

In order to check this, select the new polygon with the Live Selection tool and also some surface from the original cube.

It might look like Figure 1.62. The polygon that you created has a color different from the original cube face color.

— Figure 1.62: Checking the direction of normals.

This means that the normal of the new polygon is on the opposite site and needs to be corrected.

An easy solution for this is the function Align Normals in the Functions menu. This function checks the normals of all selected polygons and corrects the wrong ones. Select all the polygons if you want to check the whole object or deselect them all. Both methods have the same effect and can be found in the Selection menu.

Alternatively, you can click next to the object with the Live Selection tool or the move tool. The object will then be selected.

You can also select the polygons directly and use the command Function > Reverse Normals if you know exactly which ones are pointing in the wrong direction.

Closing Holes Automatically

The crossover between the handles on the computer is curved and not straight like our current model.

In preparation for this curve we will close the hole inside the handles. One of these holes is marked yellow in Figure 1.63.

Use the tool Structure > Close Polygon Hole to close the hole. Move the mouse pointer to the edge of the area that needs to be closed. Click as soon as you see the new colored polygon appear. Repeat this step at the opposite side of the housing.

Next, change to edge mode and select the inner edge on the bottom of the handle. This can be seen marked red in Figure 1.63. Then use Structure > Bevel to round this edge (see Figure 1.64).

Rounding Edges

This tool allows you to bevel or round the edges. You can set the radius of the rounding at Inner Offset. The Subdivisions control the additional inserted elements in order to display these elements correctly. Rounding the edges of a basic cube object uses the same principle as the parameters.

The Create N-Gons option combines the newly created surfaces in one single N-Gon.

Finally the Type menu of the Bevel tool controls the shape of the rounding; for example, it can be linear, concave, or convex. We will set the Inner Offset to 7.5 with the Type Convex.

Figure 1.63: Closing holes automatically.

— Figure 1.64: Chamfering an edge.

After using the Aᴘᴘʟʏ button, evaluate the rounded edge and change the values if needed.

The curve reaches almost all the way to the upper edge of the handle on the original housing. We are not able to create the curve to this extent, as we can set the radius only as big as needed to get the smallest subdivision on the handle. A larger radius would cause an overlap with the polygons at the side of the handle.

We have to think about another way of solving this problem.

Use the Uɴᴅᴏ button to remove the edge rounding again. We will look into a more individual approach and will use spline objects along with the snapping function.

Spline Objects

Splines, short for spline objects, use points to create curves. These curves can be created manually by setting points or by opening an already created spline.

All available splines and shapes can be reached in the upper icon palette of the layout (see Figure 1.65).

The two columns of splines on the left side display the different types of interpolations of these splines.

You can create a spline by first selecting the desired interpolation and then clicking in the editor. Only the first icon in the icon palette is an exception because it starts the freehand mode for drawing a spline.

— Figure 1.65: Diverse spline objects.

To do this, move the mouse over the editor viewport while holding the mouse button, thereby drawing the spline, which will be displayed as soon as you release the button. You can use this mode to trace the contours of an image with a graphics tablet and to convert it into a spline.

We will first start with a prefabricated spline. These objects work like parametric basic objects, which means that you can scale the splines or round the edges in the ATTRIBUTE MANAGER.

Interesting for us is the rectangle spline, which was selected with the mouse pointer in Figure 1.65. After creating the spline by clicking on the icon in the icon palette, scale and rotate the spline into the right direction.

The reason for this action is to create a reference for the size of our housing. By deleting the curves on the front and back of the housing, we have changed its size and it does not correspond with the original anymore.

Use the PLANE menu to adjust the rectangular frame of the spline so that it is visible in the side viewport.

This is the case when the spline lies on the Z and Y axes of the world coordinate system. Select ZY for the PLANE.

The width of the frame should be 475 units to get the exact depth of the housing. This was the original size of the cube.

You can choose your own height. Just make sure that it extends the housing on top and bottom. I put in a value of 580 for the HEIGHT.

Because you didn't change the position of the housing, it should still be centered.

Change to the point mode and choose the rectangle selection tool. Frame all points in front as shown in Figure 1.66.

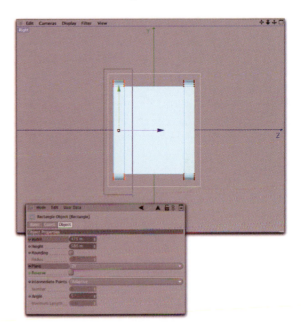

Figure 1.66: Setup of the spline object.

These points should be moved so that the foremost points are level with the spline. This sets the housing back to its original size.

For this purpose the snapping option of CINEMA 4D comes in handy. You can find it hidden in the ATTRIBUTE MANAGER in the column SNAP SETTINGS as soon as you select the move, rotate, or scale tool.

Because we want to move the points, select the MOVE tool and activate the section with the snap settings in the ATTRIBUTE MANAGER.

The option ENABLE SNAPPING activates the snapping of selected elements. How and where they should snap to will be determined in the settings underneath this option.

Snapping

Basically there are three snapping types that can be selected in the TYPE menu. The SNAP 2D

mode allows snapping only if the moved element and the target element are on the same plane. This is rather rare.

Snapping with SNAP 2.5D is less restrictive. It snaps the moving element when it is close to the target element. This only works though in the activated viewport.

If you want to use real 3D snapping, which means snapping in three-dimensional space, then you have to use SNAP 3D.

The various options determine which object will be snapped to. The RADIUS value sets the radius for the snapping.

Because we want to snap to the rectangle spline, only the option SPLINE has to be activated. Furthermore, the SNAP 2D mode should be selected. SNAP 3D would not make sense because the housing would actually snap onto the spline and be moved along the X axis.

Lock all directions except the Z axis and click one of the points on the front of the housing while holding down the mouse button. Move this point sideways toward the vertical spline line until it snaps. This step is shown in Figure 1.67 and is indicated by an arrow.

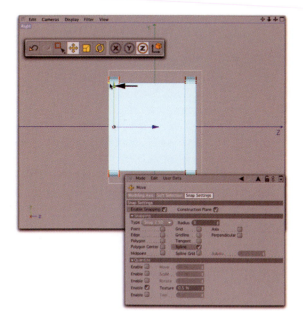

— Figure 1.67: Snapping points along the spline.

Repeat the selection of the points and the snapping at the spline on the back of the housing. Now our model has the right size.

The perspective viewport of the housing proves that the moved points snapped only in the side viewport and have not been shifted in depth (see Figure 1.68). The rectangle spline is still in the center of the housing.

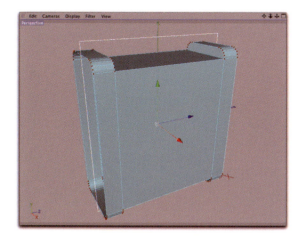

— Figure 1.68: The exactly scaled housing using snapping.

So far we have not made any improvements in the rounding of the cross section from the upper cover plate to the handles. The previously chosen radius for the rounding was too small and was reversed again.

Now we will try to improve that result by snapping.

Activate the ROUNDING option for the rectangle spline in the ATTRIBUTE MANAGER and change the size of the rectangle to 365 units in each direction. Set the radius to 30 units, which is the same size as the rounding of the cube in the beginning.

Now move the rounded spline along the Y axis until the position of the lower edge corresponds with the upper cover of our housing. Zoom closer to be able to work more precisely. The result is shown in Figure 1.69.

Select the LIVE SELECTION tool and make sure that the selection of hidden elements is allowed. Start by selecting the first point on

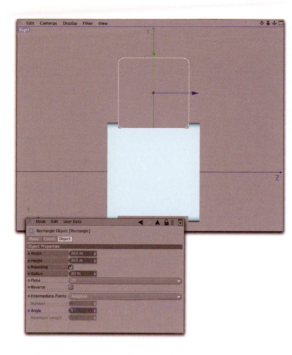

— Figure 1.69: Rounding and moving of the rectangle spline.

the inside of the handle, which has a visible gap to the rounded spline.

After this, change to the move tool and make sure that the 2.5D snapping is still active. Move the selected points until they snap to the spline. Repeat this step until all the points are moved and the result looks like Figure 1.70.

We also selected and snapped the points on the other end of the handle, as we enabled the selection of hidden elements. As shown earlier, the position of the points is still the same along the line of sight in the viewport.

The rounding on the handle already looks pretty good. There are not enough points only at the lower end, close to the top. The connection does not look as smooth as on top of the handle.

The Knife Tool

This shouldn't be such a big problem. We already learned with the EDGE CUT tool how easy it is to add subdivisions.

Figure 1.70: Moving the points.

We will use the STRUCTURE > KNIFE tool to introduce a new tool. It has more functions than the EDGE CUT tool, such as the individual cut line. Also, we didn't have to create a selection to use this tool.

The KNIFE tool has different options for setting up the kind of cut needed. We will use the MODE PLANE, which cuts, starting from the position of the mouse pointer, parallel to the current axis system. The advantage is that we can cut both handles at the same time.

The setting X_Z in the PLANE menu makes sure that the cut runs parallel to the floor.

The number of cuts is determined by the CUTS value set to 1. Deactivate the CREATE N-GONS option and place the mouse pointer next to the handle so that the cut will be displayed

Figure 1.71: Creating new edges with the Knife tool.

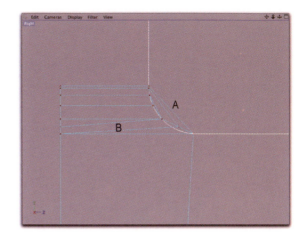

— Figure 1.72: Possible problems when using the Knife tool.

in color (see Figure 1.71). A mouse click executes the cut and seems a bit puzzling (see Figure 1.72).

The newly created edges do not follow the preview lines and create some unnecessary polygons in the lower part of the handle. These are marked with a B in Figure 1.72.

Also, the area created with the CLOSE POLYGON HOLE does not follow the curve of the handle anymore. You can see this marked by the letter A in Figure 1.72.

The latter happens because when the KNIFE tool cuts an N-Gon polygon, it is converted back into triangular and quadrangular polygons.

The converted N-Gon sorts the polygons and loses information about the rounding of the surface. New polygons appear that combine the upper edge of the handle with its base, resulting in rounding that does not show anymore. This is a common problem when using cutting tools on N-Gons.

Let's use the UNDO function and go back one step just before the KNIFE cut and create a RING SELECTION of the edges.

The tool for RING SELECTION can be found in the SELECTION menu of CINEMA 4D. This kind of selection works like the LOOP SELECTION but selects elements placed next to each other instead of on top.

Switch to the edge mode and move the mouse pointer over the edges of the base of the handle that need to be cut. Watch the colored preview of the selected edges and click when you have the desired selection.

Switch to the EDGE CUT tool to cut the selected edges once. The result is shown in Figure 1.73. The cut now looks much better.

The KNIFE tool is not a bad tool. It offers some good functions compared to the EDGE CUT tool. Just remember the disadvantages and switch to another tool if you run into problems.

The rounding now has sufficient details by selecting the new points and snapping them to the spline. Figure 1.74 shows the result from different directions.

— Figure 1.73: Result of a cut with the Edge Cut tool.

— Figure 1.74: Complete rounding.

We created the upper surface of the housing and the openings on the inside of the handles. There we used the BEVEL function at the edge of the bottom end of the handle. This was not very successful.

We have to delete these surfaces again. Use the LIVE SELECTION without the option of selecting hidden polygons.

The selected surfaces are visible in Figure 1.75. The lower part of Figure 1.75 shows the model after deletion of the unnecessary polygons.

Now we have to take care of the remaining handles and apply the rounding as well. We will start with the second handle on top of the housing.

In the side viewport select the points, one after the other, and let them snap to the spline. Here we should add some cuts on the lower part to create more details in the rounding. Use the RING SELECTION in the side viewport to select the edges and separate them afterward with the EDGE CUT tool.

After snapping the new point on the rounded side of the handle and on the spline you will get a little surprise (see Figure 1.76 on top).

The rear edge of the handle has not been subdivided. The reason is that we deleted the connecting surfaces on the inside of the handles. The RING SELECTION stops on the border of

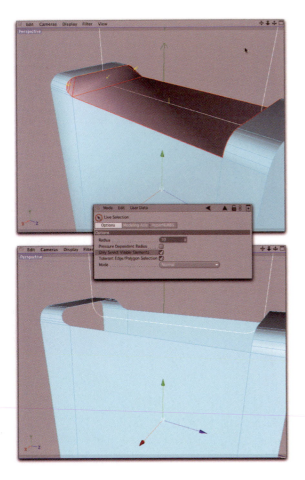

— Figure 1.75: Deleting closed polygons.

— Figure 1.76: Separate subdivision of the handle polygons.

the opening and the two selected edges that are in front of the side viewport.

Select the two edges that weren't cut yet in the perspective viewport and repeat all steps up to the snapping of the new point onto the spline.

The handles on the bottom of the housing will be adjusted using the same principle. Place a new rectangular spline under the housing. The fastest way is to duplicate the existing spline.

Click on the spline in the OBJECT MANAGER, hold down the CTRL key, and drag and drop the spline. After you release the mouse a copy of the spline will appear (see Figure 1.77).

Place a negative sign in front of the Y position of the new spline in the COORDINATE MAN-

AGER and confirm the entry by pressing the AP-PLY button. The spline then moves onto the appropriate position under the housing.

Here we should add additional points to the handles of the housing. We will give the KNIFE tool another chance. The mode should be set to PLANE X Z as in our first try and then deactivate the creation of N-Gons. The cut line is shown in Figure 1.78.

The KNIFE tool works as we expected and creates a clean cut without triangles. The advantage is that both handles on the front and back have been cut.

After the points in the side viewport have been snapped onto the new spline, deactivate

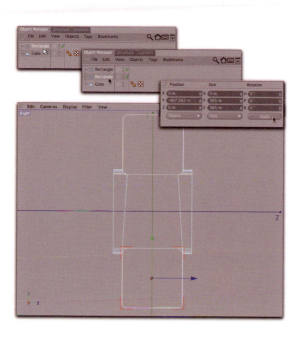

— Figure 1.77: Duplicating and moving the spline.

— Figure 1.78: Making a cut.

the snapping once again in the ATTRIBUTE MANAGER.

Extruding

We will use the EXTRUDE function in the STRUCTURE menu to thicken the housing (see Figure 1.79).

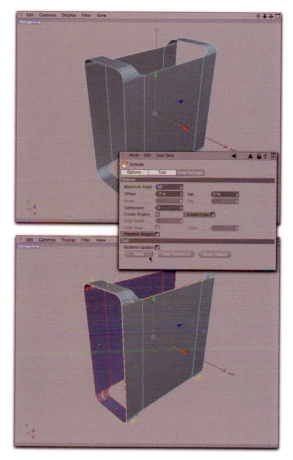

— Figure 1.79: Swelling of the housing.

The EXTRUDE function is one of the most used functions in polygon modeling. It shifts selected polygons along their normals and creates new surfaces at the outer edges. This way you can model bulges or branching.

When the option CREATE CAPS is activated, the original surfaces will be duplicated, and by extruding them we get a closed volume.

Turn off the option PRESERVE GROUPS if multiple surfaces need to be extruded at the same time. Otherwise, each surface will be ex-

truded by itself. This option works together with the MAXIMUM ANGLE value. This value determines that surfaces are extruded together when the tilt of the neighboring surface is smaller than the angle value.

The OFFSET value determines the distance of the surface movement. When the value is negative, the surface will be moved in the opposite direction of the normal.

Because we do not want to change the dimensions of the housing, we will use an OFFSET value of -3 and activate the CREATE CAPS and PRESERVE GROUPS option. Make sure that no polygons are selected and then press the APPLY button. The result is a housing with a wall thickness of 3, as shown in Figure 1.80.

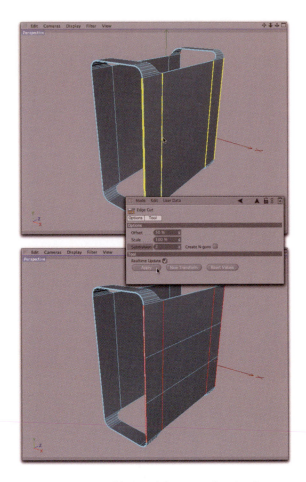

— Figure 1.81: Adding subdivisions for the door.

— Figure 1.80: The thickened housing in a close-up.

Separate Surfaces

On the side of the housing is a door that we will model.

Select the edges with the RING SELECTION tool on one side of the housing and then use the EDGE CUT function to create two subdivisions. Figure 1.81 shows the work steps and the result.

The door takes up most of the space on the side of the housing and already starts just below the handles. We have to move the new edges away from each other because they

need to restrict the door on top and on the bottom.

We will use the scale tool along the Y axis for this task.

Select the new edges in edge mode with the LOOP SELECTION tool and use the Shift key to add the second edge loop.

Lock all axes except the Y axis or click directly on the Y axis of the local coordinate system of the housing when scaling the edges.

These steps and the desired result are shown in Figure 1.82.

Change to the polygon mode and use RING SELECTION to select the new polygons between the new edge loops. These surfaces represent the new door and should be moved into a new object. After the selection of the faces, use the

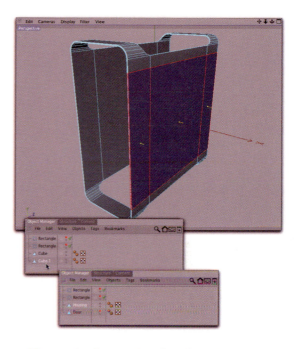

— Figure 1.82: Moving the new edges by scaling them.

command FUNCTIONS>SPLIT. This creates a new object in the OBJECT MANAGER that incorporates these new faces.

The separated faces also exist in the housing object and are not needed anymore. Delete these faces and give the new objects in the OBJECT MANAGER distinct names so you can tell them apart easily.

Figure 1.83 shows this step and has the door already set to invisible. This way we can see and edit the open edges more easily (see Figure 1.84).

Use the CLOSE POLYGON HOLE tool to close the open ends of the connection to the cur-

— Figure 1.83: Separating the selected polygons.

rently invisible door. In Figure 1.84 this example is shown by the lower section of the housing.

Change into the EDGE mode after that because we want to round the edges of the recently created faces. Select the edges at the closed ends of the housing with the LOOP SELECTION tool. You can see these selected edges in red in Figure 1.84.

Use the BEVEL command to create a convex rounding of these edges with two SUBDIVISIONS and a radius of 0.5 units. These settings and the result are displayed in Figure 1.85.

Now reverse the visibility of the housing and door so that you only see the door.

Work at the open areas on the top and bottom using the same principle.

First close the open areas with the CLOSE POLYGON HOLE function and afterward round the circular edges with the BEVEL tool. Use the same settings used for the housing.

When both parts are set to visible they will look like Figure 1.86.

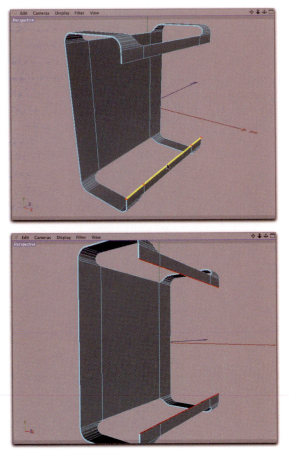

— Figure 1.84: Closing holes and selecting edges.

How to Give Phong Shading a Helping Hand

Maybe you already noticed the ugly lighting on the surfaces. The door and the housing seem to be lit from two different directions (see Figure 1.86).

This is a general problem when finely subdivided polygons border large polygons. It cannot always be solved by adjusting the angle of the Phong tag.

We can give the Phong shading a helping hand by subdividing the large areas in the border region. This can be done by making cuts with the KNIFE tool or by subdividing the edges. Instead we will work with the EXTRUDE INNER tool.

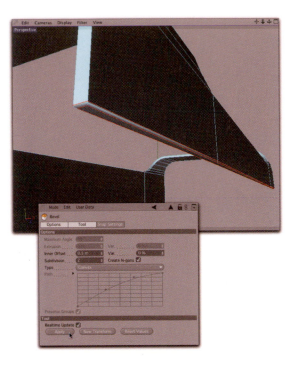

— Figure 1.85: Rounding the edges.

This tool works like the EXTRUDE tool but does not move the selected surfaces along their normals but scales them vertically to the normal direction. The surfaces will become bigger or smaller depending on the plus or minus sign used for the offset.

This is a good way to create subdivisions inside polygons. This command is used often in the modeling process.

The settings correspond mostly with those from the EXTRUDE command so there is nothing new to add here.

We start with the door object and use the LIVE SELECTION tool to select the three big polygons of the door in the side viewport.

Set the selection of hidden elements to active. You can see this selection in Figure 1.87.

Use the EXTRUDE INNER tool and put in an OFFSET value of 1. The new surfaces will, compared to the previous surfaces, be smaller by 1 unit. The room between the old edges and the new smaller one will be closed by quadrangle polygons.

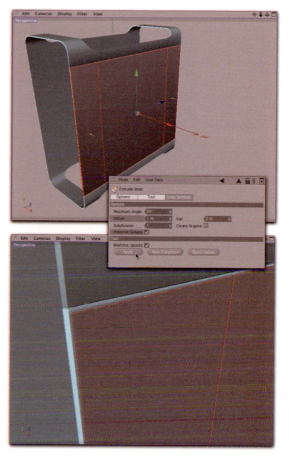

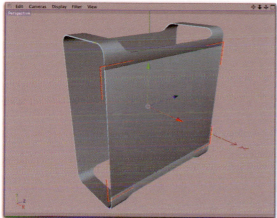

— Figure 1.86: Rounding the door.

— Figure 1.87: Inner extrude of the door polygons.

Because we are dealing with multiple polygons, you should activate the PRESERVE GROUPS option too.

The CREATE N-GONS should stay deactivated. After a click on the APPLY button you will get the desired effect. The result is shown in Figure 1.87.

The same procedure is used with the housing object. The selection of the polygons will be more difficult though.

We could work with the LIVE SELECTION tool but we need to practice using the other selection tools and the CTRL modifier.

Activate the housing object and make sure that you are working in the polygon mode. Use the SELECT ALL command from the SELEC-

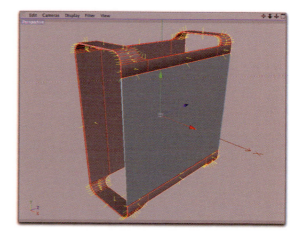

— Figure 1.88: Selected polygons of the housing.

TION menu. All polygons of the housing are now selected (see Figure 1.88).

Set the top of the housing to invisible so we are able to look in all parts of the housing. Use the LOOP SELECTION tool and move the mouse pointer to a polygon on the small front edge of the housing.

Hold the CTRL key while using the LOOP SE-LECTION tool to subtract the next selection from the existing one. You can see the result in Figure 1.89.

— Figure 1.89: Deselecting edge surfaces.

Move the mouse to the next polygon loop, which also needs to be subtracted from the selection. Figure 1.90 shows two examples. Deselect the circular loop between the handles

— Figure 1.90: Deselecting more polygon loops.

and the additional faces created by beveling the edges.

When that is done, select the EXTRUDE IN-NER command and use the settings set previously. This will add a new, completely circular polygon loop to the housing.

Save Selection

The setup of complex selection can become very complicated. It would make sense to save selections when they need to be used for separate work steps. The saved selection can be activated anytime by using a single mouse click.

You will test this function on the still selected polygons of the housing. Open SET SE-LECTION in the menu SET SELECTION.

A new tag appears behind the housing object in the OBJECT MANAGER. One click on this so-called SELECTION TAG shows the name and some buttons in the ATTRIBUTE MANAGER (see Figure 1.91).

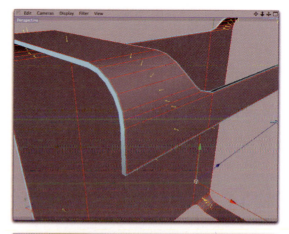

— Figure 1.91: Save selection.

When saving several selections like that, which also works with edge and point selections, definite names for the tags should be used.

The functions of the button are almost self-explanatory. The RESTORE SELECTION button deselects all active selections and restores the saved one. This refers only to the type of the saved selection. The edge and point selections will remain unaffected, as it is a polygon selection.

By using SELECT and DESELECT POLYGONS you can add or subtract the saved selection to existing selections.

Polygons can, like objects, be made invisible to work inside an object. You can control this by using the HIDE and UNHIDE button.

We will learn about another function of saved selections in connection with materials. The possibility exists of restricting a material to a saved selection stored in a SELEC-

TION TAG. Then material will only appear on the selected surfaces.

In order to do this, type the name of the SELECTION TAG in the material. This is another reason to apply memorable names to these tags.

The housing is now complete and is shown in Figure 1.92. In comparison with Figure 1.86 you can see the improvement of the shading on the surface through EXTRUDE INNER.

— Figure 1.92: The finished housing.

The door fits perfectly in the housing but is also easily recognizable as a separate object because of the rounded edges on top and bottom.

Modeling the Inner Housing

Now we get to the inner housing. As a starting point for our modeling we will use a basic cube object.

Create a new cube and resize it to 205, 450, and 470 for the X, Y, and Z directions. Also apply a rounding of 50 units with five subdivisions.

Because the cube is now too small you have to extend it in the X direction by adding twice the radius of the rounding (see Figure 1.93).

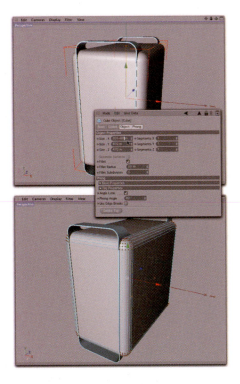

— Figure 1.93: The inside of the housing.

You could perform the calculations in your head and put the value 256 into the field SIZE.X. However, let's take the opportunity to test another useful feature of CINEMA 4D.

All numerical fields allow us to enter mathematical symbols. Put in simple equations and CINEMA 4D calculates the result automatically.

In our case, add a +60 in the SIZE.X field and CINEMA 4D calculates the value automatically after pressing the Return key.

We will delete the side parts as we are only interested in the rounding of the front and back. While in the front viewport, change into point mode and pull a selection frame around all points on one side of the cube.

Switch into polygon mode by holding the CTRL button and delete the polygons that are made out of the selected points. Change back into point mode and do the same on the other side of the cube (see Figure 1.94).

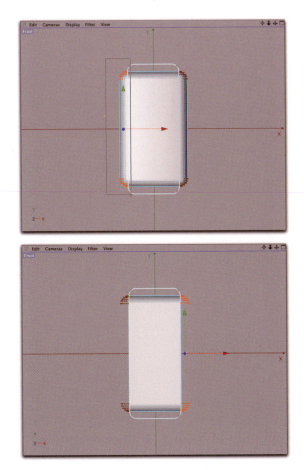

— Figure 1.94: Deletion of the side parts in the front viewport.

All points will remain after the deletion of the polygons as we discovered earlier. Delete these points by using optimize.

Make sure that all points are deselected and choose OPTIMIZE... in the FUNCTIONS menu.

Then switch into the model mode and scale the inner cube a little bit along the X axis (see Figure 1.95).

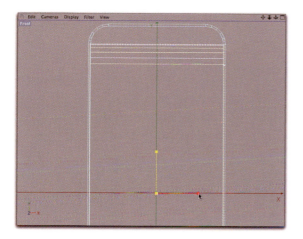

— Figure 1.95: Scaling the inner cube.

The Drive Bay

In the front we will build the drive bay in the upper part and the plugs and the buttons in the lower part.

For the bay in the upper part we will make two horizontal cuts with the KNIFE tool (see Figure 1.96). This time we will use the LOOP mode in the KNIFE dialog.

The options RESTRICT TO SELECTION and CREATE N-GONS should be deactivated.

Now we need two additional edges that form the right and left border. Therefore we will use RING SELECTION in the EDGE mode to select all horizontal lines of the inner housing. This selection is shown in yellow in Figure 1.97.

The lower part of Figure 1.97 shows the desired result after the edges were cut twice with the EDGE CUT tool.

When the option SELECT CUTS is activated in the dialog of EDGE CUT, the new edges will be

— Figure 1.96: Adding limited edges for the drive bay.

selected, and the SCALE tool can be used along the X axis to spread them apart until you reach the width of the drive bay.

Watch the COORDINATE MANAGER until it shows a width of about 160 units for SIZE X. For more precise results you can put the value 160 directly into the COORDINATE MANAGER.

The edges and the end result are shown in Figure 1.98.

Select the upper edge of the two newly created horizontal edges and change the Y position in the COORDINATE MANAGER to 410 units.

Taking the same steps, adjust the Y position of the edge loop beneath to 390 units. The drive bay is now 20 units high and is 40 units away from the upper edge of the housing.

— Figure 1.97: Adding vertical subdivisions.

— Figure 1.98: Scaling the new edges.

In POLYGON mode selects the surface that lies between the newly created edges and uses the EXTRUDE command to move this surface into the housing (see Figure 1.99).

Set the OFFSET value to –2 so that the surface will be moved toward the back and into the housing.

Be sure that the CREATE CAPS option is deactivated, as otherwise a volume would be created instead of a dent.

The Disconnect Command

There is a door behind the bay that swings open when the bay moves in and out. This part should be modeled separately because we might want to animate it later on or just leave

it as a separate surface from the rest of the object. We can always decide later if we want to turn it into a separate object.

Previously the SPLIT command was used to separate the doors on the side of the housing. This time though we will use the DISCONNECT command, which can be found in the FUNCTIONS menu.

Select the polygon that covers the drive bay and execute the DISCONNECT command by clicking on the OK button of the dialog.

The selected surface is now separated from the rest of the object and has its own points and edges without connections to the other object. In opposition to the result of the SPLIT command, here the face remains a part of the

— Figure 1.99: Extruding the bay.

— Figure 1.100: Rounding of the inner edges.

object. No new object is created in the OBJECT MANAGER.

Now add detail and round the inner edges of the bay with the BEVEL function (see Figure 1.100).

Use the RING SELECTION in EDGE mode to select the four inner edges of the bay and round them with the setting seen in Figure 1.100. A convex rounding of 1 with three subdivisions should be sufficient.

The activated CREATE N-GONS option helps display the model more clearly.

Stay in EDGE mode and use LOOP SELECTION to select the circular edge in front of the bay. We will round the edge with the BEVEL tool.

This time set a value of 0.25 for the INNER OFFSET. The rest of the settings stay the same (see Figure 1.101).

The modeling of the bay is finished. Now we turn our attention to the lower area in front of the housing where the switches and plugs are located.

Switches and Connecting Sockets

This area is even with the drive bay on the left side. We already have the necessary border. The only thing missing is the edge that borders the control panel on the right.

Create this edge with the KNIFE tool in the operating mode LOOP. Be sure that the KNIFE

— Figure 1.101: Beveling the front edge of the bay.

loop goes around the housing, as shown in Figure 1.102.

It is necessary to place the mouse pointer exactly on the edge that forms the border of the separated polygon at the end of the bay.

Adjusting the Phong Angle

After making the cut you may have noticed the change of lighting above the drive bay, as seen in Figure 1.103.

This is again a case where the PHONG ANGLE in the PHONG TAG has to be adjusted.

The reduction of this value by about 25% will get the desired result, as shown in the lower part of Figure 1.103. The errors in the

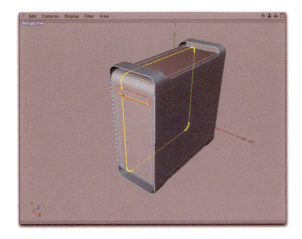

— Figure 1.102: Setting a loop cut with the Knife tool.

— Figure 1.103: Adjusting the Phong angle.

shading disappear without affecting the smoothness of the rest of the model.

The Modeling Axis

We can adjust the relationship of the two edges to each other by calculating the distance and putting the value of the right vertical edge loop into the Coordinate Manager.

An alternative method would be the lateral scaling of the two edges. The disadvantage here would be that both edges would draw near each other and the correctly positioned left edge would be moved too.

In this case we should use the Modeling Axis. It is found in the Attribute Manager when the move, scale, or rotate tool is active. With this function the otherwise always centered axis system can be moved anywhere (see Figure 1.104).

— Figure 1.104: Adjusting the distance of the edges.

In point mode and with the scale tool activated, select the two rows of points bordering the control panel laterally. Pull the controller for X in the Modeling Axis settings of the Attribute Manager to the left.

This pushes the local coordinate system of the object to the far left edge and will position

it directly over the selected points on the left. We do not want to change this position.

The points on the left will not move when scaling the point selection along the X axis.

The distance between the point rows can be seen in the Attribute Manager, as both rows of points are still activated. Scale them until you reach the value of 15 units for Size.X (see Figure 1.105).

— Figure 1.105: Scaling of point rows.

Entering the exact value would move both of the point rows.

Manipulating the Local Axes System

The functionality of the Modeling Axis is insufficient to move the axes system of an object permanently. It only moves the axes systems of selected points, edges, and polygons. This axes system works independently from the object system.

Now we will manipulate the real object system.

Turn on the object axes mode icon displayed in Figure 1.106. In this mode you can

Figure 1.106: Moving the local axes system.

still use the MOVE and ROTATE commands, but it will be restricted to the axes system of the object. The object itself will not move.

The only exceptions are the parametric objects. They are calculated using the position of the local axes system as reference for the center of the object. When you move the axes system of these objects, the whole object will be

moved as well. This does not matter to us though because we have already worked with converted basic objects.

Set the Y position of the axes system to –225 in the COORDINATE MANAGER. It is not necessary to make a selection for this. The axes system already exists and therefore is automatically active when the object axes mode is selected and the object itself is shown in the OBJECT MANAGER as being selected.

The axes system will be positioned exactly at the base of the housing. This enables values that are determined by the distance to the base to be entered directly into the COORDINATE MANAGER to place selected elements.

Change into the EDGE mode and activate the KNIFE tool in LOOP mode to test this theory. Make a horizontal cut at about the center of the front of the inner housing, as shown marked in yellow in Figure 1.107.

Select the new edges and take a look at the COORDINATE MANAGER. When the COORDINATE MANAGER is set to OBJECT mode, you will be able to see the distance of the selected cut from the base of the housing in the field for the Y position. Change the value to 140 units (see Figure 1.107).

This value represents the distance between the center of the control panel and the base of the housing.

The entire height of the control panel should be 90 units and should contain four separate faces for the diverse sockets and buttons.

We can create the necessary subdivisions in one step. Select the BEVEL tool and, in the INNER OFFSET, put in a value of 45. The actual distance will be 90, as, when beveling, the edge will be evenly extended on both sides. This results in 90 units, which is exactly what we need.

We will create the four subdivisions by entering 3 in the SUBDIVISIONS field. You can leave TYPE at the setting LINEAR. This setting has no influence on the result because the edge is at the same level as the surrounding faces (see Figure 1.108).

— Figure 1.107: The exact positioning of a horizontal cut.

— Figure 1.108: Adding parallel subdivisions.

Moving Edges

We want to place circular buttons and sockets in the upper two of the four polygons. It would be helpful if the faces, inside which we will build the circular structures, would be square. Select the two upper edge rings and select the EDGE CUT command (see Figure 1.109).

The selected subdivisions can now be moved up and down with the help of the OFF-SET value.

Set this value so that the two faces located directly under the new subdivision are square. It is sufficient to just estimate it (see Figure 1.109).

The final position of both edges is marked with arrows in Figure 1.109.

We will then start with work on the upper two square faces. Change to the polygon mode and select these faces.

First extrude this face two units toward the center and then two units toward the inside of the housing. You can see these steps in Figure 1.110.

Then delete the rear polygon of this inversion. The result is shown in Figure 1.111 (top).

Activate two SUBDIVISIONS and the option for HYPERNURBS SUBDIVIDE. The result is displayed in Figure 1.111 (bottom).

Dividing and Rounding Faces

The way the SUBDIVIDE function works is that the SUBDIVISION step subdivides every edge of the selected polygon. Subdividing a square would result in the creation of four faces. Because we put in a value of 2, each of these faces will be divided again into four faces.

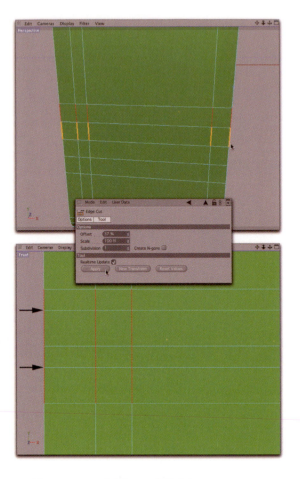

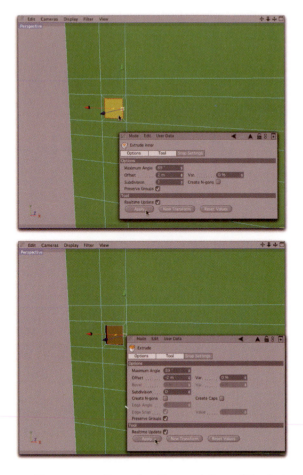

— Figure 1.109: Adding subdivisions.

— Figure 1.110: Preparing the modeling of the button.

As a result, every square polygon will turn into 16 new faces, which is why you should be careful when using the SUBDIVISION value. You can create a lot of polygons in a short period of time.

Without the option HYPERNURBS SUBDIVIDE activated, all the new faces would be created inside the already existing faces. The shape of the object would not be changed.

HyperNURBS smoothing uses the edges of the selected faces as a tangent for the rounding. The four edges that form a square would turn it into a circle, which is why you should adjust the shape of the faces before you use this option.

We will come across the term Hyper-NURBS when we talk about NURBS objects later.

The resulting circle is good enough for most of the applications but there are other techniques available when it comes to machine parts.

Saving Scenes and Objects

Let's save the model. Use the SAVE AS... command in the FILE menu of CINEMA 4D. Type in the file name and determine where to save it.

— Figure 1.111: Rounding by creating subdivisions.

Moving Points along Edges

You can use the command STRUCTURE>SLIDE to move points along edges when you have enough points to create a rounding (see Figure 1.112).

The advantage of this tool is the possibility of working in the perspective viewport. This works like an axis restriction, as it allows the points to be moved only to the neighboring edges.

If radii are to be exact, you can use a circular spline to snap to like we did previously with the handles. This would mean a lot of manual work, especially when there are many points.

Figure 1.112: Moving points along edges.

Let's look at a method of how to not only create a perfect rounding, but how to cut out any kind of polygon shape.

First select and delete all points that create the round opening in the housing. After that we have a square opening, which we will close with the CLOSE POLYGON HOLE tool. Figure 1.113 shows these steps in detail.

Figure 1.113: Deleting and closing the opening.

Next create a cylinder and set the option ORIENTATION +Z. This orients the cylinder vertically to the front of the housing cover.

Set the RADIUS to 5.24. The height is not so important. It is enough to set it to 10 units with one segment.

Activate the move tool and the 3D snapping with the option POLYGON CENTER (see Figure 1.114).

— Figure 1.114: Placing a cylinder in the center.

In the front viewport move the cylinder across the face that we closed previously until it snaps into position. Then deactivate the snapping function again.

Combining Objects with the Boole Object

Our goal is to combine the front of the housing with the cylinder by subtracting the shape of the cylinder from it. The result is a circular hole in front of the housing.

For this kind of task we will use the BOOLE object. You can find it in the ICON menu shown in Figure 1.115.

— Figure 1.115: The Boole object.

The BOOLE object has different operating modes that can be controlled with the ATTRIBUTE MANAGER. The most commonly used mode is A SUBTRACT B. The letters A and B represent the two objects where A is the first subordinate object and B is the object that follows right below.

Because we will need to use the cylinder again, make a copy in the OBJECT MANAGER and rename it *Button*, for example.

Subordinate the original cylinder and the model of the inner housing under the BOOLE object as shown in Figure 1.115.

The result is also displayed in Figure 1.115. The cylinder creates a circular opening in the

housing. Because the cylinder remains a separate object under the Boole object, you can still adjust its position and parameters or, after conversion to a polygon object, change its shape.

It just has to remain being a volumetric object. As soon as you delete the deck faces of the cylinder, calculation of the intersection of the Boole object will not work any longer.

The Boole object works like a parametric basic object and can be converted as shown in Figure 1.116. In this way we can continue to work on the edge of the opening.

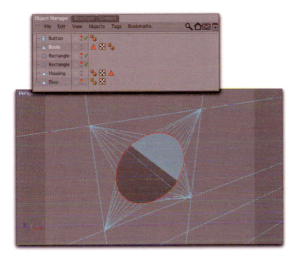

— Figure 1.116: Conversion of a Boole operation.

Extruding Edges

In order to create a better connection at the edge of the cut-out opening, change into the edge mode and select all edges with Loop Selection. Alternatively, you can activate the option Select Intersections in the Boole object dialog before converting it.

Then select the Extrude command. Extrude does not just work with polygons, but also with edges. You can set the direction of the extruded edges relative to the bordering polygons with the Edge Angle option. An Offset of 1 with an Edge Angle of −90 will move the new edges vertically into the area behind the hole (see Figure 1.117).

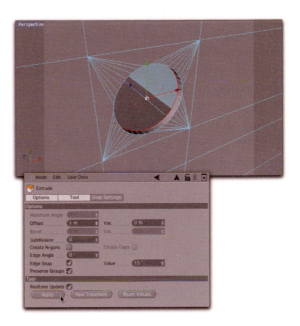

— Figure 1.117: Extruding edges.

With this step we will simulate a certain thickness of the wall of the housing and also get an edge that can be rounded with the Bevel command.

Select the edge loop around the opening in front of the inner housing and execute the Bevel command with a small radius (see Figure 1.118).

At first sight it seems to give us the desired result. However, because the edges around the opening do not have the same length, the rounding is not distributed evenly. You can see this especially well at the bottom of Figure 1.118, at the sides as well as on top and bottom of the opening.

Let's take this step back with the Undo function.

Rounding of Edges at the Opening

The Bevel tool will give you the best result when the edges that you want to round meet at a right angle at the edge where the rounding will be attached. This sounds more complicated than it actually is, as you will see in the next steps.

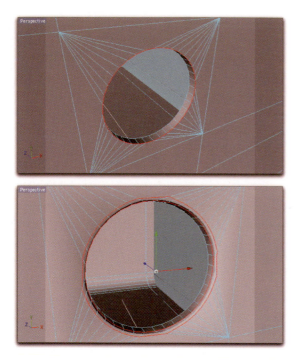

— Figure 1.118: The rounded opening at the front edge of the housing.

Start by selecting the edges at the inner wall with Ring Selection (see Figure 1.119).

Use the Edge Cut tool to divide the edges once in the middle.

Change to Loop Selection and select the forward edge of the hole. Then enlarge the circular edge selection with the scale tool. The scale should be large enough so that the planned rounding of the hole edge will have enough space. A possible result is shown in Figure 1.119 at the bottom.

Switch back to Loop Selection and select the edges that were created with the Edge Cut tool of Ring Selection.

Subtract the value 0.5 from the displayed Z position in the Coordinate Manager (see Figure 1.120).

The edge is now again in its original position at the forward rim of the opening. Even more important is that an additional parallel edge ring was created around the rim. The edges that move away from the rim of the hole are exactly vertical above the hole.

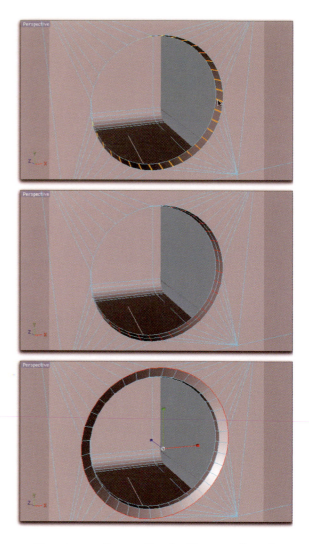

— Figure 1.119: Preparation for the rounding of the edge loop at the opening.

The resulting rounding of the edge loop at the rim of the opening should be perfect. Figure 1.21 shows the outcome and also displays additional possible settings for the Bevel tool.

The Control Lamp

We will model the little lamp over the switch recess with the same technique that we used before (see Figure 1.122).

Switch to the polygon mode and select the rectangular face over the circular recess. Use

— Figure 1.120: Moving the inner edge loop to the front.

— Figure 1.121: Better rounding of the hole edge.

— Figure 1.122: Modeling of the recess of the control lamp.

the EXTRUDE INNER command to shrink this face. The amount of this extrusion does not matter.

You have already learned that you can do more than just see the positions or measurements in the COORDINATE MANAGER. You can also put in the desired measurements for the polygons directly.

Enter the value 1.5 for SIZE X and SIZE Y in the COORDINATE MANAGER and apply this entry with the APPLY button or Return key. This will create a perfect square polygon in the center of the original face.

Create a new cylinder and enter in a height and a radius of 0.5 units. The segments for the height can be reduced to 1 and the circumference to a minimum of 24. Use the 3D snapping in the POLYGON CENTER to place the cylinder with the move tool exactly in the center of the small polygon. Then switch to the modeling mode again.

Group the cylinder with the inner housing object as subordinate objects of a BOOLE object like in Figure 1.123. The BOOLE object uses the subtraction mode again.

— Figure 1.123: Boole with a cylinder.

Be sure that the objects are correctly placed under the BOOLE object and correct them if necessary by pulling them with the mouse in the OBJECT MANAGER. The housing should be put in first under the BOOLE object and the cylinder should follow.

The reason why we previously shrank the polygon is because BOOLE can create many small polygons. Their placement and order can cause problems with the shading of the surface, which is why the influenced area should be kept as small as possible and shielded from surrounding faces.

One possibility is reducing the Booled area to one polygon as we have done here.

The faces created by using BOOLE will stay inside the small square polygon as seen in Figure 1.123. The surrounding faces that were created by EXTRUDE INNER are not affected at all.

Generating Objects out of Splines

Now we will build the sockets and plug-in positions in the front of the housing. We will mostly use splines and learn more about the possibilities of object modeling.

Working with Splines and NURBS Objects

You already learned about splines as possible helping objects during modeling. Splines can also be used to generate objects. For this purpose we use so-called NURBS objects in CINEMA 4D. We will use them in our example.

First we need to create one circular spline and two rectangular splines from the same menu as before.

We will look at different work techniques where some create better results than others.

Now might be a good time to save again.

Set the creation plane in the PLANE menu to XY. The circle defines the headphone jack and should be set to 2.5.

The first rectangular spline will be a USB port and gets a width of 7 and a height of 14, while the rounding is set to a radius of 0.5.

The second rectangle will be the plug for the fire wire connection and will have different dimensions at 8 units wide and 13 units high. We leave the rounding of the corners deactivated because we still have to change the shape of this spline.

Use the move tool in the model mode of CINEMA 4D plus the 3D snapping in the POLYGON CENTER in order to center the splines on the remaining three polygons of the control panel (see Figure 1.124).

— Figure 1.124: Three separate splines define the contour of the sockets.

Converting and Shaping Splines Individually

So far it has been sufficient to use the parametric spline basic objects. With the fire wire connection we have to modify it a bit. Use the C key or select MAKE EDITABLE in the FUNCTIONS menu.

The lowest rectangular spline will be modified so we can have access to the corner points of the rectangle while being in point mode.

There is a wedge-shaped indent at the lower end of the socket that we have to model by adding a point to the spline.

In the point mode we select ADD POINT in the STRUCTURE menu and click on the center of the lower edge of the rectangle, which creates a point in the spline.

Make sure that the OBJECT mode is activated in the COORDINATE MANAGER and set the value for the X position to 0. The newly placed and still selected point will be placed exactly in the middle of the edge.

Select the two lower corner points of the spline and move them upwards vertically by 2 units. Be sure that snapping is deactivated for the MOVE tool.

The distance for the move can be read in the editor. Figure 1.125 documents these steps.

— Figure 1.125: Adding and moving points.

The Chamfer Command

In order to flatten the currently pointed area on the spline we use the CHAMFER command in the menu STRUCTURE>EDIT SPLINE. This function can be compared with the BEVEL command for edges with the difference being that the spline points can be rounded.

Select the lowest point of the converted rectangular spline and activate the CHAMFER command. Activate the FLAT option inside its

dialog in the ATTRIBUTE MANAGER to create a linear bevel of the spline. A radius of 2.5 should be enough (see Figure 1.126).

— Figure 1.126: Bevel spline points.

After that use the LIVE SELECTION tool to select the original four corner points and use the CHAMFER command again.

This time we round the points without the FLAT option and with a RADIUS of 0.5. This step creates a rounding of the corners, which is fitting for the rectangular spline above.

The Extrude NURBS Object

If we want to create volumetric polygon objects out of preset splines, a variety of NURBS objects are available. One of them is the EXTRUDE NURBS.

The EXTRUDE NURBS object moves subordinate splines along a predetermined direction sequentially and covers these spline copies with a polygon skin. In this way you can very easily create, for example, 3D text.

The icon of the EXTRUDE NURBS object can be found in the ICON menu directly right next to the spline objects.

As with all NURBS objects, you have to subordinate one or more splines. Because we want to use the three splines that we created, we have to move the circle and the two rectangles under the EXTRUDE NURBS object in the OBJECT MANAGER. The order does not matter.

In the dialog of EXTRUDE NURBS of the OBJECT MANAGER, MOVEMENT controls the three values for the distance and direction for moving the splines.

When only one spline object is subordinated and the option HIERARCHICAL is deactivated, the location of the axes system of the EXTRUDE NURBS will be used to move it. However, when the option HIERARCHICAL is activated, the axes system of each spline will be used instead.

You will not have this choice when multiple splines are subordinated. The HIERARCHICAL option must be activated so that the EXTRUDE NURBS object recognizes and uses all the splines.

The SUBDIVISION value shows the number of spline copies that will be generated. When there is a value of 1, then only one additional copy will be generated. The distance of this copy from the original spline is represented by the values in the MOVEMENT fields.

The three MOVEMENT fields show, from left to right, the X, Y, and Z parts of the move. The setting 0, 0, 50 with the activated HIERARCHY option will move the spline by 50 units along the Z axis of each subordinated spline (see Figure 1.127).

Figure 1.127 shows the result of this action where I turned off the visibility for the moment to improve the view.

Figure 1.127: The Extrude NURBS.

Volumetric Boole

So far we have used the Boole object to combine an open object, the inner housing, with a closed object, the cylinder. The result is a simple opening in the housing.

We get a different result if we use closed or volumetric objects. We would get a duct instead of a hole.

Because we applied the Boole action in a relatively small area, we do not have to move the housing laterally. It is enough when the Booled faces are part of a closed body.

The Extrude function can help us here because with the Create Caps option we have the possibility to create double-walled objects. We already used this method to thicken the outer housing and the handles.

First select the three faces that are located directly under the three splines and execute the Structure > Extrude command.

Ten units should be enough for the depth of the sockets. Use the value −10 for the Offset so that the faces move inside the housing. Activate the Preserve Groups and the Create Caps options and click on the Apply button. On

the outside our model does not change, but behind the faces a cuboid was created.

Pull the splines with the profile of the sockets a little bit to the front of the housing as shown in Figure 1.128.

Figure 1.128: Creating a volume.

In order to subtract the Extrude NURBS shapes of the sockets from the front of the housing, we can use the already existing Boole object, which is currently responsible for the circular recess in the upper part of the control panel. Therefore, group the Extrude NURBS object with the cylinder inside the Boole object. The Extrude NURBS object will simply be used as an additional B object for the A Subtract B operation.

As you can see in Figure 1.129, this works without problems and creates not only holes but real ducts that are closed at the end.

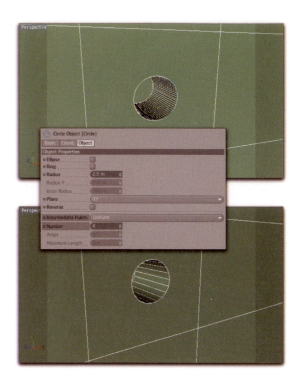

— Figure 1.129: Additionally pulled sockets.

— Figure 1.130: Optimizing the number of intermediate points.

If this is not the case then pull the splines in the EXTRUDE NURBS object a bit further in front of the housing or reduce the value of the Z part of the move.

The EXTRUDE NURBS sockets are not allowed to penetrate the faces behind the housing front, which were created by extruding with the CREATE CAPS option. Otherwise it is not possible to close the Booled ducts.

Intermediate Points

When we zoom closer to the newly created openings, you can see the very high subdivisions at the cylindrical duct and at the rounded corners of the sockets below. This can definitely be optimized.

The subdivisions used by the NURBS object are often based on the settings of the INTERMEDIATE POINTS in the dialog of the used SPLINE objects (see Figure 1.130).

These are the points that were placed between the already existing points to display the spline shape.

As we learned at the beginning of the chapter, CINEMA 4D can only use points and polygons and must therefore use straight faces and sections to construct curves and curved surfaces.

This also applies to spline curves. Their path needs to be separated into several sections to create faces through an EXTRUDE NURBS object.

The circular shape of the headphone jack shows clearly that a large number of intermediate points are needed to display a circle as exact as possible. This might make sense with large radii, but the smaller the circle gets, the more you can cut down on points without sacrificing quality.

It is generally recommended to use as few points and polygons as possible to save memory and render time later on. Also, the work

goes faster in the editor viewport and the additional rounding of edges will be easier when the objects have a low number of polygons.

The preset for the setting of INTERMEDIATE POINTS of every spline is ADAPTIVE, with an ANGLE value of 5°. This means that the bend of the spline curve will be evaluated and that an additional point will be added with every change of direction of at least 5°.

Because the circular spline we used has a continuous bend of 360°, this results in 360 divided by 5, which equals 72 points. Of these 72 points, 68 are INTERMEDIATE POINTS, as the circular shape is created with 4 points as seen when the circular spline is converted.

The value for the ANGLE can be raised step by step until a more accurate number of points is reached or another kind of interpolation can be chosen in the menu for INTERMEDIATE POINTS.

A good one for the circle would be the setting UNIFORM, which divides the space between the spline points evenly.

A NUMBER value of 4 creates a total of 20 points for the circle, which means 4 times the 90° curve segments, times the NUMBER value 4, plus the original 4 points. The result of this setting can be seen in Figure 1.130.

The outer shape of the socket looks the same even after the reduction of points and polygons.

Keep the setting for the INTERMEDIATE POINTS of the two other splines for the sockets beneath at ADAPTIVE. The ANGLE value can be raised to 11.25° or 22.5°. This reduces the additional faces, especially at the rounded corners. Their radius is so small that the reduction will not be noticeable.

Creating Double-Walled Splines

The sockets are done, but the insulation at the housing is still missing. We will create it with the same splines used in the EXTRUDE NURBS object.

Select the three splines in the OBJECT MANAGER and drag and drop them, while holding the CTRL key, to another place in the OBJECT

MANAGER. This duplicates the three splines. Alternatively, use COPY and PASTE in the EDIT menu of the OBJECT MANAGER.

Now convert the three spline copies, the circular spline, and the two rectangular splines into normal splines. The next command works only when they are converted.

Select all three converted spline copies and select STRUCTURE > EDIT SPLINE > CREATE OUTLINE.

When this function is active you can double the selected splines by holding down the mouse button, therefore creating parallel shapes (see Figure 1.131). Another option would be to enter the distance for the double-walled spline directly into the ATTRIBUTE MANAGER.

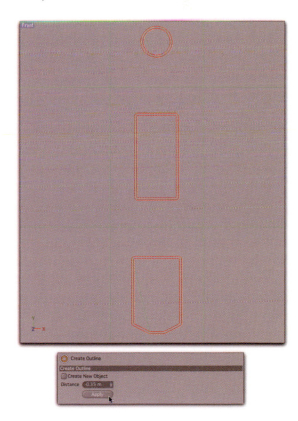

— Figure 1.131: Double-walled splines.

Unfortunately, this tool does not have a live mode. If the result is not right use the

UNDO command to go back one step and re-peat it.

Do not set the distance between the splines too high. It is especially noticeable at the rect-angular splines. It could cause problems and overlapping, particularly at the rounded edges. Let's try one's luck and start with a small negative setting as seen in Figure 1.131.

I will show you an alternate way that al-lows for a more flexible way of working.

It is important that the doubled splines are located inside the original curves. All splines should have enough space inside the sockets.

Create a new EXTRUDE NURBS object and subordinate the double-walled splines.

All NURBS objects that work with splines can also recognize double-walled splines. The completely enclosed shapes inside a spline will be interpreted as a hole. In this way you can avoid using the BOOLE object if the object can be generated with a NURBS object.

In our case the doubled splines inside the original splines are interpreted as openings.

Make sure that the EXTRUDE NURBS works with the HIERARCHICAL option and move the three double-walled splines so that their front deck faces rise a little bit above the front wall of the housing.

It is enough to set the depth of the extru-sion to 6 units in the Z direction. The insula-tion does not have to reach up to the rear wall of the socket.

On the CAPS dialog page of the EXTRUDE NURBS, the creation and look of the deck faces can be controlled. The deck face called START is positioned at the same location as the splines. The END deck face is located on the other end of the EXTRUDE NURBS object.

Rounding Caps

With these menus it is possible to control the creation of both deck faces separately. Set the END menu to NONE to deactivate the deck face in the rear of the socket. It is not visible any-way and can save us some polygons.

The START deck face, however, will get an additional rounding. Set the START menu to the setting FILLET CAP.

Choose the type of rounding in the FILLET TYPE menu. The simple CONVEX rounding is a good choice.

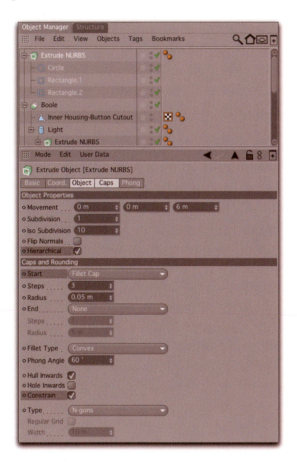

— Figure 1.132: Creating rounded deck faces.

The division of the rounding is set by the STEPS value. The RADIUS value determines the size of the rounding. Because of the small thick-ness of our spline, the margins are very small. I put in a radius of only 0.05 with three STEPS.

Upon taking a closer look, we see that the shape of the spline is larger after activation of the rounding on the deck faces. The reason is that the rounding is also applied to the shape of the spline. If the contour of the spline needs to be binding, activate the option CONSTRAIN.

Then the rounding of the deck faces will be applied to the inside of the spline curve.

Figure 1.132 shows the setting and the structure of the object in the OBJECT MANAGER.

Figure 1.133 shows the final result of this

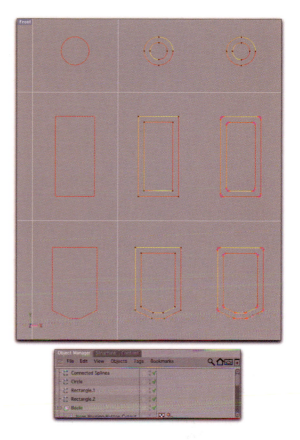

— Figure 1.134: Optimizing the spline wall thickness.

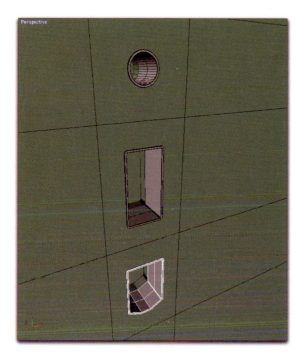

— Figure 1.133: Insulation for the sockets.

theme in the editor. The double-walled splines fit perfectly in the existing sockets. Unfortunately, we are a bit limited with the width of the insulation. This is due to the problems we had with the CREATE OUTLINE function and the rounded rectangles.

There is a better solution. Let's go back to a version of this scene where the three socket splines weren't converted or rounded yet. Use the file on the accompanying CD-ROM if you do not have the splines anymore or just build them again. They weren't very complex. The initial shapes are recognizable in Figure 1.134 on the far left.

The CREATE OUTLINE function apparently has problems with already rounded edges. For this reason we will skip the rounding and cre-

ate the desired wall thickness right away, as seen in the middle column of Figure 1.134.

Now we can use the CREATE OUTLINE for larger distances without a problem.

In point mode, select all the corners of the splines that need to be rounded and apply the command STRUCTURE > EDIT SPLINE > CHAMFER. A rounding radius of 0.5 should be sufficient.

Connecting Splines

In order to show this possibility, too, we will select all three splines and convert them. Select the command FUNCTIONS > CONNECT. All three splines are still connected, which results in a new spline that incorporates all the selected splines. This eases the handling of complex shapes made up of multiple splines. This

way it is possible to create splines with differently shaped holes.

First draw a closed spline. Then create a second spline that has to be located completely inside the first spline. Both splines have to be on one level. Therefore, work exclusively in the front viewport when creating the splines.

Select both splines and use the CONNECT command. The new spline can be used with the EXTRUDE NURBS object. Even the outer shape or the shape of the hole can be changed, as the points of the object stay editable in the connected object.

We can delete the originals in our scene after connecting the splines. We only need the connected spline.

When the connected spline has been subordinated to the EXTRUDE NURBS, test the settings again for INTERMEDIATE POINTS. As shown in Figure 1.135, I was able to raise the adaptive angle to 22.5° without seeing any significant difference in quality.

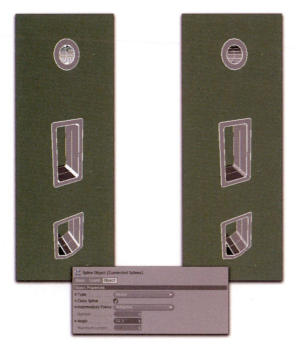

— Figure 1.135: Optimizing intermediate points.

For the following work steps we need additional subdivisions in the direction of movement of the insulation. Raise the value for SUBDIVISIONS in the EXTRUDE NURBS insulation object to 1. The added subdivision can already be seen in Figure 1.135.

In order to cover the insulations on the inside with a metal contact, we have to gain access to the polygons of the EXTRUDE NURBS object. Therefore, select the EXTRUDE NURBS object and use the C key or the command FUNCTIONS> MAKE EDITABLE.

We get a new hierarchy of polygon objects, which consist of separate objects for the body and caps and objects for the rounding of the caps.

Because we do not need separate objects for all the properties of the former EXTRUDE NURBS object, select all three objects. Then choose FUNCTIONS>CONNECT to combine them into a single object. Now delete the three original objects.

Now we have to optimize the new object because the edge rounding of the three original objects is still present in the new object and exists twice (see Figure 1.136).

Switch to the polygon mode and use RING SELECTION to select the rear polygon ring at all sockets. Then use the EXTRUDE command with an OFFSET of 0.25 to move these faces toward the inside. The option CREATE CAPS should be deactivated (see Figure 1.137).

The result is shown on the lowest socket top left in Figure 1.138.

Use the LOOP SELECTION on the foremost edge of the extruded polygons and move this selection along the Z axis until you are satisfied with the installation depth. These are supposed to be the metallic inner hulls of the sockets. They start a little bit behind the beginning of the insulation.

Activate the RING SELECTION and, while holding the Shift key, add the inner faces of the metal contacts to the existing POLYGON SELECTION.

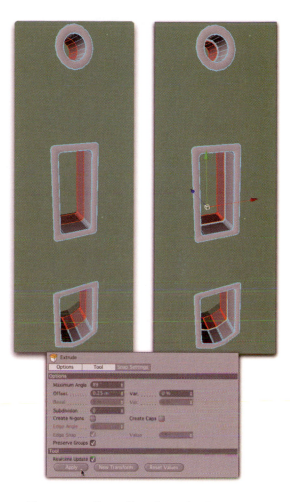

— Figure 1.136: Converting and optimizing the Extrude NURBS object.

These work steps are documented in Figure 1.138 and can be used for all three sockets simultaneously.

Because these polygons will get their own material, save the selection by using the command SELECTION>SET SELECTION. Name the new SELECTION TAG in the ATTRIBUTE MANAGER *metal*. This will make it easier to apply the surface attributes later on (Figure 1.139).

We could add more details but we will stop here with adding the inner contacts. This is seen in Figure 1.140.

These are simple basic cube objects with a small rounding of their edges.

The two cubes were snapped (with activated 3D SNAPPING TO POLYGON CENTER) onto the rear of the two lower sockets and then resized in the ATTRIBUTE MANAGER. I won't give you any values here because it is sufficient to just estimate the size.

Deactivate the snapping again to individually move the cube in a lateral direction. Fig-

— Figure 1.137: Extruding ring selection.

ure 1.140 shows the finished sockets from different perspectives.

This concludes our example of the use of POLYGON tools. You have already learned the majority of the more important functions, commands, and tools. You should be ready and able to tackle your own projects.

There is another important object group within the NURBS objects that can ease the work load when it comes to the modeling of objects with many curvatures or organic objects.

Before we begin the next subject consisting of materials, lighting, and rendering, we will take a look at the HYPERNURBS object and its advantages and disadvantages in modeling.

— Figure 1.138: Moving and saving of the inner polygons.

1.6 HyperNURBS Modeling

HYPERNURBS modeling is used when creating organic surfaces. This could be a human face or the flowing shape of a hood or a perfume bottle.

The actual form is roughly premodeled with polygons and then smoothed with the HYPERNURBS. The HYPERNURBS object subdivides and at the same time smooths the POLYGON object. The principle is identical to the function of the SUBDIVIDE command, which we already talked about.

In daily work you will use the HYPERNURBS object consistently. There is hardly a shape that can't be improved by adding additional subdivisions and round edges.

There are a few things to consider though because the HYPERNURBS object works con-

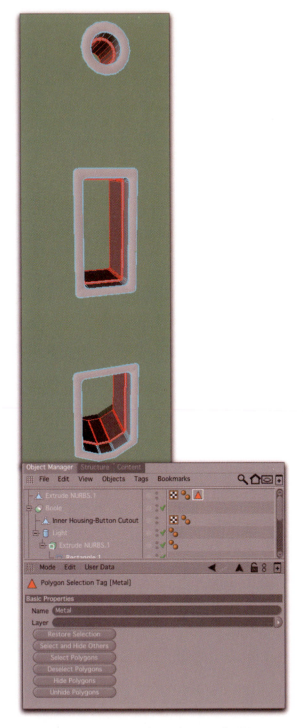

— Figure 1.139: Saving the Polygon Selection.

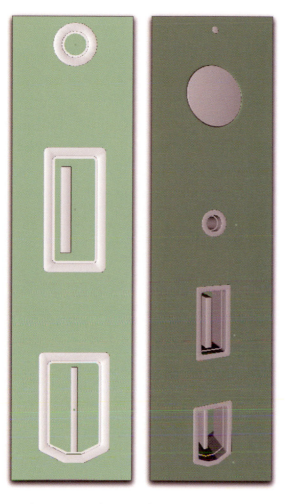

— Figure 1.140: Showing the inner contacts.

trary to pure polygon modeling. When we want to round an edge at a polygon object we have to add many new faces. At the HyperNURBS object it would cause a sharpening of the edges. The HyperNURBS will only be smooth in places where there are fewer subdivisions.

Modeling of HyperNURBS smoothing therefore looks very rough and bulky. This takes some getting used to.

We will model some simple shapes with the help of the HyperNURBS to better understand its function. Understanding its assets and drawbacks will be much quicker this way.

The HyperNURBS Display in the Editor

Open a basic cube object and a HyperNURBS object and subordinate the cube to the Hyper-NURBS object. You can find the HyperNURBS object in the same menu as the already used Extrude NURBS object. The corresponding icon and the group in the Object Manager can also be seen in Figure 1.141.

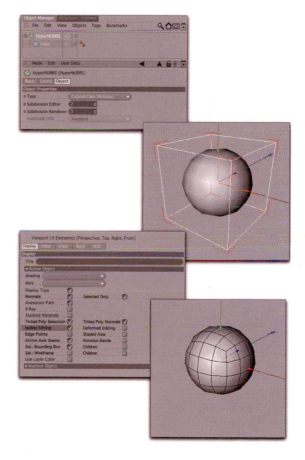

Figure 1.141: Different display types.

Notice that the cube turned into a sphere. That is because the HyperNURBS object automatically smoothed all the edges.

The existing edges of the subordinate object were used as tangents to calculate the smoothed shape.

The level of subdivisions can be determined in the settings of the HYPERNURBS object in the ATTRIBUTE MANAGER.

The value of the SUBDIVISION EDITOR controls the number of subdivisions for the display in the editor viewports. This value is usually smaller than the value for SUBDIVISION RENDERER. It controls the number of subdivisions when the picture is rendered.

As already explained in connection with the SUBDIVIDE function, SUBDIVISION values can create a large number of polygons in a short amount of time. Every square polygon turns into four polygons and a triangular polygon turns into three square ones when it is subdivided.

Try to work with small settings as much as possible. We will learn later about other possibilities of how to simulate high subdivisions without actually having to use them.

In the dialog of the HYPERNURBS there is a TYPE menu where a choice can be made from different calculation modes. The main reason for this feature is the compatibility with previous scenes that were created with version 7 or 8 of CINEMA 4D. In those versions we didn't have N-Gons and the HYPERNURBS worked differently. The differences are minimal, though, as seen in the editor when the TYPE modes are switched.

When modeling new objects in CINEMA 4D v10 none of these menu settings needs to be changed.

The menu of SUBDIVIDE UV plays a role in applying materials and fitting them as exactly as possible to the smoothed surface. We will talk about this later in connection with the material system in CINEMA 4D.

To give you an idea, when a material is assigned to the object which is smoothed by the HYPERNURBS object, then the material will be distorted by the rounding and smoothing of the surface as well. The settings BOUNDARY and EDGE counteract this effect.

It has to be tested which of these settings will produce better results for your object.

Before we work with the HYPERNURBS object, we should learn a bit more about the display in the editor.

The POLYGON object and the HYPERNURBS object can be displayed apart from each other. This is shown in the upper editor viewport in Figure 1.141.

Alternatively, points, edges, or polygons can be projected onto the surface of the HYPERNURBS object. The shape of the HYPERNURBS object can be manipulated directly by selecting and moving a point on its surface.

Which of the display types is used is controlled by the DISPLAY settings in the CONFIGURE menu in the editor viewports. The responsible option is called ISOLINE EDITING (see Figure 1.141).

I will leave this option deactivated for the next examples to let you see the original polygon shape and the smoothed result. For practical work, however, the ISOLINE EDITING option is very helpful and produces a display in the editor that is less confusing.

Using Weighting

HYPERNURBS objects have some additional functions that are somewhat hidden. The so-called HYPERNURBS weighting is activated by simultaneously holding down the Period key and the mouse button and pulling the mouse at the same time.

To test this, convert the subordinate cube under the HYPERNURBS object and, in the edge mode, select the four edges on top. This can be done very quickly with the LOOP SELECTION tool.

Hold the period key and the mouse button while moving the mouse pointer in the editor slowly to the left and right.

Notice how the shape of the HYPERNURBS changes, as if the edges are being pulled or pushed away.

Select a weighting that allows the upper edge to turn into a circle.

Then change into polygon mode and select the bottom polygon of the cube and repeat the weighting. This time, instead of turning into a circle the HYPERNURBS becomes a rectangle (see Figure 1.142).

— Figure 1.142: Weighting edges and polygons.

The reason is that the points are weighted at the same time as the edges. For maximum control, weight the edges and points separately from each other.

It is especially precise when LIVE SELECTION is used to weight selected elements. It has its own slide controller for HYPERNURBS WEIGHTS.

With the two INTERACTIVE values set it is possible to control the range of the STRENGTH controller or the range of the interactive weighting using the period key (see Figure 1.143).

— Figure 1.143: Numerical weighting entry.

First choose in the MODE menu how the STRENGTH value should be applied. SET overrides the existing weighting of the selected elements with the STRENGTH value. ADD and SUB do what their names imply: they add or subtract the set STRENGTH value.

Do not forget to click the SET button after the entry of the STRENGTH value. Then the HYPERNURBS will be actualized.

Figure 1.143 shows that values below 0 are also possible in order to push the HYPERNURBS away from points and edges.

Let's continue with our cube and select the upper and lower polygons. Use the EXTRUDE INNER to shrink both polygons.

The Bridge Tool

Activate the BRIDGE tool in the STRUCTURE menu. This tool is used to connect points, edges, and polygons to each other.

We want to connect the two smaller polygons to create a connecting tube. In order to use this effect, the option DELETE ORIGINAL POLYGONS has to be active in the ATTRIBUTE MANAGER.

Turn on the transparent display of the cube, the WIREFRAME mode, for example, in the viewports to be able to see both faces at the same time.

Click and hold the mouse button on one corner point of the upper selected face and move the mouse pointer down to the corresponding corner of the other polygon (see Figure 1.144).

Notice a line that shows the future course of the connection. Be sure that the connection

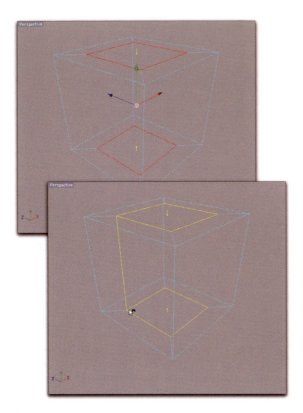

— Figure 1.144: Connecting polygons.

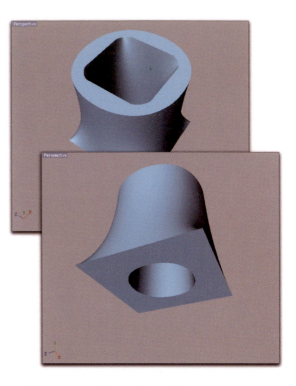

— Figure 1.145: The weighted object.

is as straight as possible so that edges do not get twisted.

When the mouse button is released, the new faces appear inside the cube and the previously selected faces will be deleted. As a result, the previous weighting has changed. Therefore, avoid adding new elements to already weighted objects, as this would cause errors in the existing weighting.

Fix the error by weighting the continuous edges on the top and bottom and the points on the bottom to 100%.

Do the opposite with the edges of the newly created tube. Weight the edges and points on top and only the edges on the bottom. The result is shown in Figure 1.145.

On the bottom the cube has a square base but shows a circle. On top the cube is cylindrical with an angled hole. The crossover be-

tween both ends is smoothed by the HYPER-NURBS.

This is an impressive result, especially when looking at the simple model that serves as the base.

However, it is evident that there are disadvantages to this technique. The subdivision setting of the HYPERNURBS has to be set pretty high in order to get a clean rounded result. The weighting only looks good in the maximum settings.

It is also difficult to create an individual rounding radius with this technique. The reason is that the weighting does not create additional subdivisions around the weighted area. The existing subdivisions are only moved in the direction of or pushed away from the weighted elements.

We have to raise the SUBDIVISION values for the HYPERNURBS object in order to display more details in the weighted areas. However, this would be a waste of polygons. As tempt-

ing as it is to use the weighting, it is seldom used in practice. There are more flexible possibilities that can be used to force the HYPER-NURBS into a desired shape.

HyperNURBS Work Examples

Let's look at some short examples that show the advantages of HYPERNURBS. We will first model a stylized heart. It is surprising how easy it is using a HYPERNURBS object.

We will start with a new scene. Just delete all your objects in your scene or use the NEW command in the FILE menu of CINEMA 4D to create a new scene.

It is also possible to have different projects open when you load different scenes with the OPEN command in the FILE menu. Just switch between the scenes by choosing the scene name on the very bottom of the WINDOW menu.

Create a cube and apply two segments in the Y direction. In model mode move the cube to the X position of 100. Just enter this value in the COORDINATE MANAGER and click on the AP-PLY button.

The standard cube has an edge length of 200 units and the left side is therefore located on the origin of the world system. This is helpful for the following task of mirroring of the cube.

Convert the cube with the C key and move its points are shown in the two steps in Figure 1.146. In the lower picture delete the selected red face, which is shown vertically in the front viewport.

This face would be on the inside of the cube and would exist twice when it is mirrored. Therefore, the face can stay in the upper part of the reshaped cube because it will not be in the mirrored area later on.

The Symmetry Object

This completes one side of the heart and we can recruit some help with the second half.

For these cases you would use the SYMME-TRY object, which is in the same menu as the

— Figure 1.146: A shaped cube.

BOOLE object. The icon shows a head with two different halves.

The SYMMETRY object creates a mirrored version of the subordinate object. In the dialog of the SYMMETRY object of the ATTRIBUTE MANAGER, you can determine which axis will be used to mirror the object.

In the MIRROR PLANE you can choose among three planes that will define the axes of the SYMMETRY object. In our case we will mirror on the ZY plane.

The additionally activated option WELD POINTS optimizes all points of the subordinate

object, which lie inside the TOLERANCE radius on the MIRROR PLANE.

In this way the lower parts of the heart shape get connected and form a single object while the two upper bulges stay separated. The left edge of the upper bulge protrudes too far over the MIRROR PLANE to fall under the TOLERANCE radius.

After the subordination of the modified cube under the SYMMETRY object, we will get a model like the one shown in Figure 1.147.

See how I reduced the depth of the cube along the Z axis in the lower part so that the heart tapers off. All changes of the object will automatically be applied to the SYMMETRY object on the other side.

We will smooth the heart by subordinating the SYMMETRY object to a HYPERNURBS object. Now we can work on the rounded heart on both sides at the same time.

Remember to watch that the points stay at the MIRROR PLANE where the original and the mirrored copies meet. It is possible to fix the position of accidentally moved points by setting the X position back to 0 in the COORDI-NATE MANAGER.

This kind of modeling with mirroring and smoothing is used often with symmetrical objects. This way you only have to model, for example, one-half of a car or a figure. Figure 1.148 shows the result.

Modeling a Cup

It is not always best to start modeling with a cube. If the object looks more like a cylinder, then we will use one to save us some work.

To model the cup in the following example, start with a basic cylinder object (see Figure 1.149).

We will later use a HYPERNURBS object to smooth the model. For now we can start out with fewer subdivisions on the cylinder. Use 12 segments for the circumference, 3 units for the height, and 1 unit for the caps, which should be detailed enough.

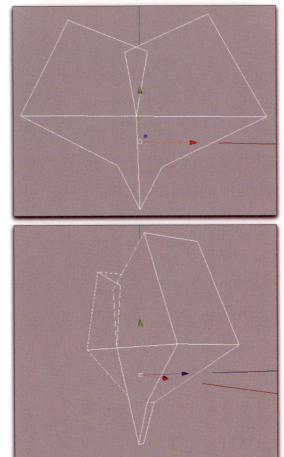

— Figure 1.147: Mirror objects with the symmetry object.

Convert this cylinder and select the faces of both caps.

Shrink the selection with the command EX-TRUDE INNER, and with the EXTRUDE function

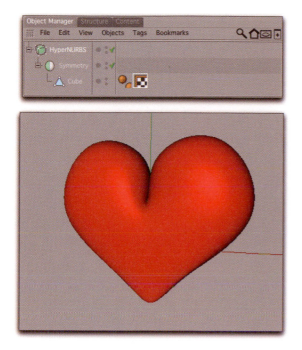

— Figure 1.148: The finished heart model.

— Figure 1.149: A cylinder as a basic object.

move the shrunken polygons of the upper caps down.

The distance between the bottom of the cylinder and the extruded faces defines the wall thickness of the cup on the bottom.

Let us continue on the side. Select two polygons in a column while skipping the one in the middle. Extrude these faces outward in two steps. The second OFFSET should be smaller than the first one. Figure 1.150 shows

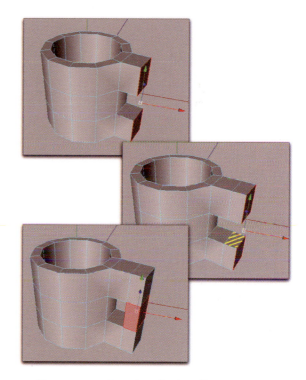

— Figure 1.150: Creating the handle.

you these work steps in the two upper images.

Notice a selected yellow face, which is one of the faces we will work on next. Select this marked face and the polygon that lies opposite this face on the upper protrusion.

Connect these two faces with the BRIDGE tool as shown in Figure 1.150. This completes the modeling of the handle.

Subordinate the object under a new HYPER-NURBS object and move the points of the handle so that the resulting shape looks right.

We will use the KNIFE tool in LOOP mode to add a continuous subdivision on top and bottom of the handle so that the connection between handle and cup will not be too sloped where it merges into the cup (see Figure 1.151).

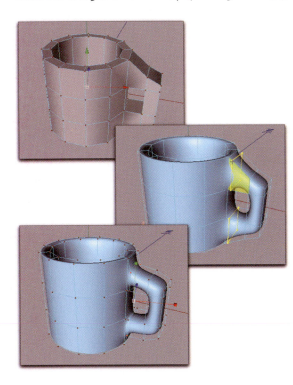

— Figure 1.151: The rounded cup.

Because of the added subdivisions, the HYPERNURBS does not have enough space to create a smooth connection. The smooth face has to be closer to the edges and faces of the polygon object.

Optimizing the Cylinder

When looking at the cup you will see a hard connection between the bottom and the side faces. This is unusual for a smooth object.

The reason is that the converted cylinder does not optimize its caps after the conversion to a polygon object. Therefore, the edges at the border of the caps exist twice. The HYPERNURBS object does not see one continuous

surface, but rather two separated objects and is incapable of smoothing beyond these edges.

We will fix this by using the OPTIMIZE function. The result is shown in Figure 1.152.

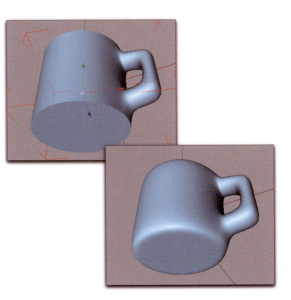

— Figure 1.152: Optimization of the cup.

The OPTIMIZE command can also be applied to selected faces only. When in polygon mode, make sure that all faces are deselected before executing the command so that it applies to the whole object.

Optimization of Smoothing

The view from the top looking inside the cup shows another problem (see Figure 1.153).

The object was smoothed there too but the surface appears to be wavy. The reason for this is the use of triangular polygons. The structure of the subdivision of the smoothed faces is different from the surrounding square faces.

There is always a problem when triangular faces are used at curved segments inside a HYPERNURBS object. Even though the cylinder is flat and even at this spot, the HYPERNURBS rounds this area and causes the problem.

When done right, the problems should disappear when we force the HYPERNURBS to a

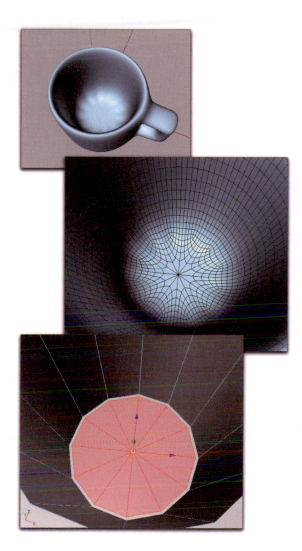

— Figure 1.153: Unfavorable smoothing at triangular polygons.

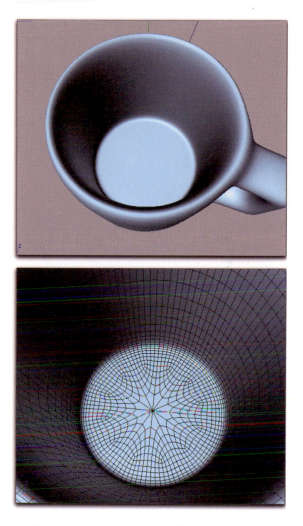

— Figure 1.154: Correct smoothing.

plane. We can accomplish this by shrinking the bottom of the cup with the EXTRUDE INNER command. Then the edges at the perimeter of the cup bottom come close together. This prevents the HYPERNURBS face from becoming overly round.

This step is shown on the very bottom of Figure 1.153. The result looks right (see Figure 1.154).

In the future, try to create objects only with quadranglular polygons when planning to use a HYPERNURBS.

If it is not possible to avoid using triangular polygons, try to restrict these polygons to segments where there is no rounding.

Additional NURBS Objects

To conclude the introduction to modeling, I want to talk about the other NURBS objects.

You already know the EXTRUDE NURBS object. It moves subordinate spline objects and can create simple volumes with these splines very easily. Because you know how to connect multiple splines, you can also create inclusions without having to use the BOOLE object.

We used it multiple times while creating the computer housing and do not need to repeat discussion of it here.

The Sweep NURBS Object

The next NURBS object is SWEEP NURBS. It needs two subordinate splines to work. The upper of the two splines defines a cross section and the lower one defines a path.

The cross section will be moved onto a path, creating a hose-like object. This NURBS is appropriate for the modeling of objects such as hoses and cables, as well as springs.

Here is a small example. We need a torus object, a cube object, and a linear spline with four points.

The splines are supposed to represent the course of a cable or a rope. The cube will be the anchor of one spline end on the wall, and the torus represents a simple pulley.

How these objects could be placed is shown in Figure 1.155.

The proportions of the objects are not important and are left to your discretion.

Select the spline by clicking on the icon in the spline menu and then click in the front viewport to create the desired spline. The number of points is not so important. Four points are already enough to draw the spline as shown in Figure 1.155.

We will round the corners of the spline later on.

Modeling the Pulley

First, concentrate on the pulley, which is still very rudimental. Convert the tube object and, when in POLYGON mode, select the middle polygon ring of the shell.

Use the scale function to widen the ring. The width should match the width of the cable or rope.

Create a HYPERNURBS object and subordinate the torus. Notice that the caps of the

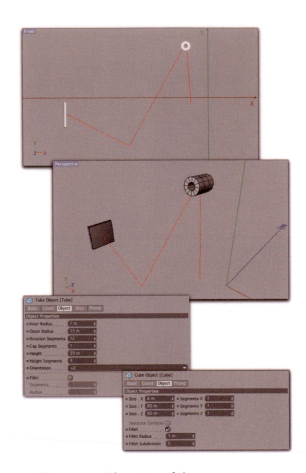

— Figure 1.155: The setup of the scene.

torus have been separated when it was converted to a POLYGON object.

Optimize the torus to eliminate the duplicated edges and points. Then select the narrowed polygon rings at the end of the shell and extrude those outward. The result is a depression with which the cable can be guided.

You can see all these steps in Figure 1.156.

Controlling the Spline Course

Now is the time to model and give more detail to the direction of the spline. Select the spline and switch its TYPE to BEZIER. The curves will be automatically rounded with tangents (see Figure 1.157).

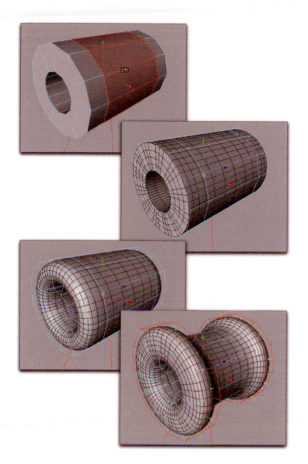

— Figure 1.156: The pulley.

Working with Tangents

Tangents only appear at selected points. At the end of the tangents, grab the control points, which, when moved, determine the tangent length and direction.

Adjust the tangents so that the curve sits vertically on top of the flat cube. Then drag it down to the lower part and place it over the pulley to follow its curvature.

Leave some space around the pulley, as the spline only represents the center of the rope, which we still need to model.

It is not applicable here, but you can break tangents at the center and move both tangents separately while holding the Shift key.

In the STRUCTURE menu at EDIT SPLINE > EQUAL TANGENT LENGTH and EDIT > EQUAL TANGENT DI-

— Figure 1.157: Rounding the spline.

RECTION, there are commands that let you reset the tangents to the same length and direction as before.

Optimizing the Subdivision

Create a circular spline, which must be on the XY plane, as otherwise the alignment to the path spline will not fit later on.

Subordinate this circular and path spline to a SWEEP NURBS object. The circle has to be the upper spline because it will determine the profile (see Figure 1.158).

Adjust the radius of the circular spline so that the thickness of the rope matches the scale of the scene and the pulley. Now check the settings for the INTERMEDIATE POINTS of both splines.

The circle can still use the adaptive mode, but we should raise the angle drastically to 22.5°. This should be enough to create a

smooth shape; however, the value can be split in half if extreme close-ups are required.

The settings of the path spline should be changed from ADAPTIVE to UNIFORM. This way we can add INTERMEDIATE POINTS to the spline evenly. This benefits all shapes that contain curves only. It also makes it possible to evenly twist the profile along the path spline, as we will see later.

Set the number of evenly distributed points high enough in order to get a sufficiently rounded shape.

Figure 1.158 shows the adaptive and even division in a comparison.

This finishes the modeling of our cable or hose. Let's make the scene a bit more complex and create another profile.

Creating a More Complex Profile

This time, the base will be the flower spline, which can be created by selecting it in the spline palette. This spline offers different settings to determine the number of flower pedals and to control the inner and outer radius. You can find my settings in Figure 1.159.

For us it is important only that the structure has a wavy course that should be as rounded as possible.

Convert this spline with the C key and select in point mode all points on the outside. Scale the points so that the profile looks like a thick rope containing several smaller, twisted ropes.

Use the INVERT command in the SELECTION menu to invert the point selection. Now all the points on the inner radius of the FLOWER spline are selected.

Right click in the active editor viewport; in the menu that appears, choose the command HARD INTERPOLATION. You can also find this in STRUCTURE > EDIT SPLINE.

This command shortens existing tangents of the selected points to 0 and creates a hard edge in the spline course, as shown in Figure 1.159.

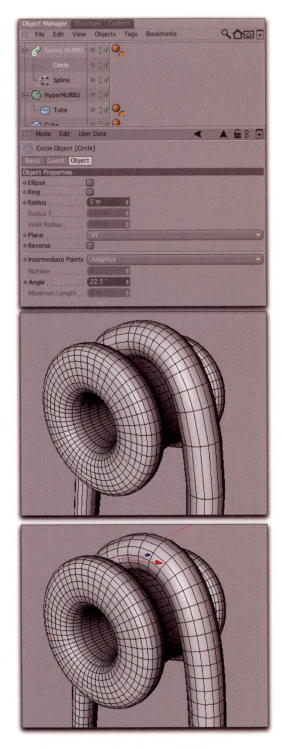

— Figure 1.158: Adjusting subdivisions.

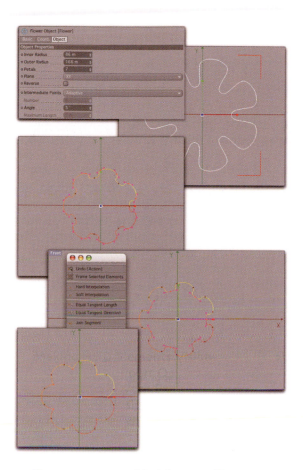

— Figure 1.159: A modified flower spline.

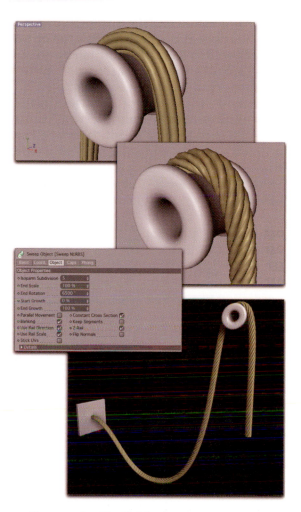

— Figure 1.160: The finished rope.

Pull the circular spline out of the group of SWEEP NURBS objects and replace it with our modified FLOWER spline.

Adjust the size of the FLOWER spline to the size of the pulley. See the result in Figure 1.160.

This is not exactly what we had in mind, as a rope contains several thinner ropes twisted together. This can be corrected easily in the SWEEP NURBS dialog where you will find the value for END SCALE and END ROTATION. These values let you rotate or scale the flower profile between the first and the last point of the path spline.

In our case, the rope should not change its profile so leave the value for END SCALE at 100%. Change the END ROTATION to an amount high enough that the twist of the rope looks realistic.

The evenly applied division of the spline path is a big help because the profile can only be twisted at the location of the INTERMEDIATE POINTS. Therefore, we get an even twist independent from the bend of the path.

Figure 1.160 shows the result in different perspectives.

I also want to mention the START GROWTH and END GROWTH values used in animations. With these percentage values it is possible to determine the section of the path spline that should be used by the SWEEP NURBS. When the END GROWTH value is set to 50%, the rope will be only half as long as the path.

When closed profile splines are used, the SWEEP NURBS object can then also create deck faces at both ends. These settings are found in the CAPS area of the dialog. The settings correspond with those of the EXTRUDE NURBS object and do not need to be repeated.

Additionally, the SWEEP NURBS object has rail options. These are extra splines that can be subordinated to the path spline. With these splines you can control the size and rotation of the profile individually along the path.

Alternatively, the same control can be achieved without the additional splines by instead using the built-in splines in the dialog (see Figure 1.161).

Here is a small example. We will need the STAR spline, a basic spline object that looks like a stylized star. Reduce its points to 5 and make sure that the star is placed on the XY plane.

Draw a simple Bezier spline, which should run straight from the bottom toward the top with a little bulge at the upper end. The upper display in Figure 1.161 shows this spline, together with the STAR spline.

Group them by subordinate both under a SWEEP NURBS object. Remember that the profile, in our case the star, has to be in the upper position right under the SWEEP NURBS object.

When the DETAILS area of the SWEEP NURBS dialog is unfolded, there will be two fields with curves (see Figure 1.161). These kinds of curves appear in different places throughout CINEMA 4D and make it possible to add points by clicking in the graph.

Existing points can be deleted by pulling them out of the graph on top or bottom. The points can simply be moved with the mouse. How the points are to be influenced is controlled with the TENSION value. This value appears after clicking on the small triangle in the left portion of the graph.

A right click on the graph opens a submenu, where standard curves can be chosen or, for example, mirroring a curve. The number of points in these standard curves depends on the DEFAULT POINTS value.

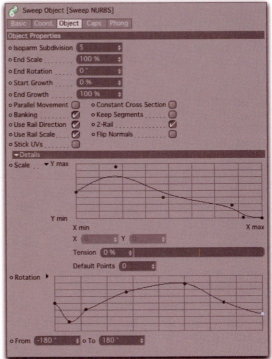

— Figure 1.161: Settings of the Sweep NURBS object.

The way the SCALE graph works is that the course of the curve, read from left to right, controls the size of the profile spline on the path. If the curve is along the upper edge of the graph, the profile will have a size of 100%. The lower edge of the graph reduces the size to 0.

The ROTATION graph works in the range of FROM /TO values. A curve that runs along the upper edge of the window will use the value for the rotation specified in the TO field. The lower edge of the graph uses the FROM value.

This way you can control the rotation and size of the profile at any place along the path spline.

This can look like the result in Figure 1.162. The same splines and curves were used as shown in Figure 1.161.

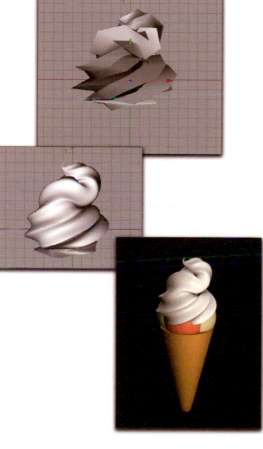

— Figure 1.162: The resulting Sweep NURBS object.

The shape is not very interesting yet. When it becomes smooth with a HYPERNURBS and is put on a few spheres and a flipped CONE object

that, however, will be a different story (see Figure 1.162).

Just make sure that the INTERMEDIATE POINTS of the spline path are set evenly so that the rotation will be calculated properly. The smoothing of the shape will be accomplished by subordinating a SWEEP NURBS object under a HYPERNURBS object. All parts will still be editable.

The Lathe NURBS Object

The LATHE NURBS object only needs one spline to generate the geometry. This NURBS works like a pottery wheel. It rotates the subordinate spline and creates a rotation-symmetrical object.

I will also show an example of how to use the LATHE NURBS and will take the opportunity to further work with splines.

Splines can also be connected with each other to create a complex path out of basic shapes.

We will use a circular spline and a rectangular spline, which can be selected in the spline palette. Reduce the height of the rectangle so that it becomes a small strip. Place the circle at the right end of the strip.

This order and the proportion of the splines are shown in Figure 1.163.

Convert both splines and change into point mode. In order to connect the rectangle and the circle we have to have additional points. We can create them with the ADD POINT function in the STRUCTURE menu or with the KNIFE tool.

Use the KNIFE tool because of its snapping option, which we will use in a moment.

Select both splines and activate the KNIFE tool in LINE mode. Make a vertical cut through the rectangle just where it meets the circle. The direction of the cut is shown in Figure 1.163.

In order to have an exact vertical cut you have to hold down the Shift key. This snaps the cut automatically in 45° steps. This stan-

— Figure 1.163: Circular and rectangular splines.

— Figure 1.164: Cutting with activated snapping.

dard setting can be changed by entering a different ANGLE value in the KNIFE dialog.

Activate the 3D snapping in the KNIFE tool. We are only interested in the snapping of the spline (see Figure 1.164).

Make two cuts along the horizontal edges of the rectangular spline through the left side of the circular spline. One of these two cuts is marked yellow and is emphasized by an arrow in Figure 1.164.

Because of the snapping, these cuts run parallel to the rectangular spline. Therefore the circular spline will get new points only where it crosses with the rectangle.

Changing the Order of Points in a Spline

We already talked about the color marking of converted splines and learned that the yellow (white in your layout) end of a spline represents its beginning. The red (blue) end is the end of the spline.

The gap between the beginning and the end of the spline can be opened and closed

with the CLOSE SPLINE option. This opening between the ends can also be used to connect another spline. We will do exactly that.

First, delete the points of the rectangle that lie within the circle. Now delete the point that lies between the two new points created by the cut. These selected points can be seen selected in Figure 1.165.

Select the lower of the two newly created circle points and right click in the viewport. Choose SET FIRST POINT from the context menu. Now the selected point will become the beginning of the spline.

Deactivate the CLOSE SPLINE option of the circle. The circle will be opened at the same place where it intersected with the rectangle.

Open the rectangle the same way in its dialog in the ATTRIBUTE MANAGER. The opening of the rectangle will automatically be at the right place without having to change the order of the points.

— Figure 1.165: Changing the order of the spline points.

These steps and the intermediate result of these actions are shown in Figure 1.165.

Connecting Segments

Next we will connect two separate points to one spline object. Select both splines while holding the CTRL key in the OBJECT MANAGER. Select the CONNECT command in the FUNCTIONS menu.

After that, delete both original splines. We will now work with the newly connected spline.

Select the upper two points of the new spline object where the circle and the rectangle are close to each other. This selection is shown at the top of Figure 1.166.

Right click in the editor and choose JOIN SEGMENTS in the appearing context menu. This

— Figure 1.166: Setting tangents numerically.

connects the two end points with a curve, and the whole spline changes its color.

This shows us that we now have a continuous spline and not two curved pieces as part of a single spline. We can also see that the curve between the circle and the spline is not optimal. The spline bends downward too much.

Controlling Tangents Numerically

We will therefore set the length of the tangent to 0 that causes this bow. As a result we have created a hard crossover. This only applies to the shorter tangent while the other one remains unchanged, as otherwise the shape of the circle would be changed.

For this kind of job we will use the STRUCTURE MANAGER. If necessary, switch into point

mode and consecutively click on the numbers that are in front of each row. This selects the corresponding point in the editor.

In this manner select the point in the circle that we want to work with. Then, scroll a bit to the right in the STRUCTURE MANAGER to see <−X, <−Y, and <−Z (these are the vector components for the left tangent) and X >, Y >, and Z > (the right tangent of the point).

The shorter of the two tangents is found quickly by the smaller values. Double click on these values and set them to 0. Repeat this with the short tangent on the other point.

When you have done everything right and have activated the CLOSE SPLINE object it should look like the top of Figure 1.167. The connection of the circular shape and the rectangle is at a hard angle.

— Figure 1.167: Opening the spline.

We are almost done; all we need to do is to rotate the spline around the world Y axis. Therefore, select the points to the left of the former rectangle and move them to the X position of 0. The simplest way to do this is to directly enter the value in the COORDINATE MANAGER.

Because the spline has to be open at this point (otherwise the rotation along this axis would create two edges), select the lower left corner point and choose SET FIRST POINT in the context menu. The point referred to is marked with an arrow in Figure 1.167.

Now deactivate the option CLOSE SPLINE to open the spline at that point. For the next step, we will need an additional division close to the world Y axis. Add it by using the KNIFE tool and subordinate the spline under the LATHE NURBS object (see Figure 1.168).

See immediately how the spline is rotated around the Y axis of the LATHE NURBS object.

The number of spline copies used can be controlled with the SUBDIVISION value. The ANGLE value provides the amount of rotation around the Y axis of the NURBS object. Therefore a complete circumference is 360°.

As with the examples given earlier, check the settings of the INTERMEDIATE POINTS on the spline and reduce them when necessary. I put in adaptive points with an angle of 22.7°.

My other settings for the LATHE NURBS and the result can be seen in Figure 1.168. We will make one more modification to make the model more interesting.

To accomplish this it is necessary to work on the LATHE NURBS in polygon mode. Select the NURBS object and convert it to a polygon object.

In the viewport shown at the top of Figure 1.168, select two polygons of the inner part of the disc. Skip the next polygon and select the following two. Continue this pattern all the way around. Use the LIVE SELECTION for this and activate the option to select hidden faces.

You can see this selection on the upper side of the model in the very top of Figure 1.168.

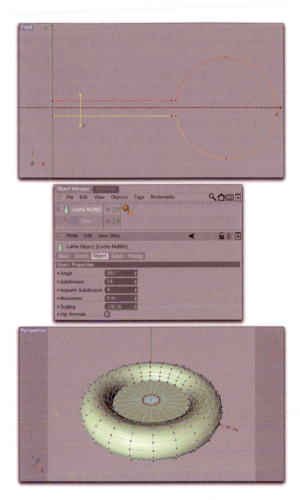

— Figure 1.168: The Lathe NURBS object.

Activate the wireframe display of the objects in the perspective viewport and use the BRIDGE tool to connect the selected faces on the top and bottom.

All polygon pairs need to be connected separately. The result is shown in the middle and lower parts of Figure 1.169. We have created a simple wheel with spokes.

Subordinate the wheel under a HYPERNURBS object and we have a pretty good object that could be improved further in order to get a more realistic looking rim, including wheel (Figure 1.170).

In this way we can create bottles, glasses, or vases quite quickly. As long as the start and end points are located on the rotation axis of

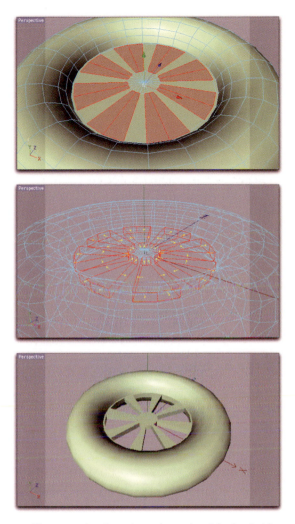

— Figure 1.169: Creating a breach with the Bridge tool.

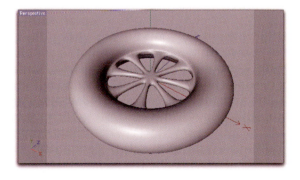

— Figure 1.170: The smoothed wheel.

the LATHE NURBS object, we will have closed objects.

We will stop this example and go back to the original spline. The LATHE NURBS object has other modes to create useful shapes. Notice in Figure 1.171 what happens when we move the spline laterally away from the rotation axis and, at the same time, put higher values into the MOVEMENT and ANGLE fields.

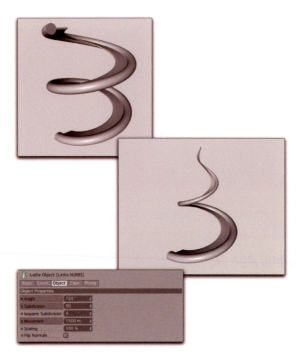

— Figure 1.171: Alternative modes of the Lathe NURBS object.

The MOVEMENT value allows the spline copy to move along the rotation axis while it is rotated. This is the way to create diverse screws or helix shapes.

By setting the ANGLE values above 360°, the windings can be repeated multiple times.

At the same time the SUBDIVISION value has to be raised so that the outer contour of the screw will be subdivided often enough to be rounded correctly.

If the spiral needs to be tapered, it is necessary to reduce the SCALING value. This technique can be used to create such things as corkscrews or a worm gear.

Also, the LATHE NURBS will close the caps when the spline is closed. This is deactivated by default when a 360° rotation is used without moving or scaling.

The Loft NURBS Object

The NURBS object that we talked about earlier was called LOFT NURBS and needed at least two splines to be able to create a solid object. The LOFT NURBS connects all subordinate splines consecutively. It connects the first point of one spline with the first point of another spline and so on.

It is therefore important to watch the order of the points in the used spline. The color of the spline helps and saves us from looking into the STRUCTURE MANAGER.

Different from the previous NURBS objects that worked with splines, the LOFT NURBS does not use the settings for the INTERMEDIATE POINTS to calculate the number of connected faces.

This wouldn't make sense anyway because every spline used can have separate settings and would therefore result in a chaos of connections.

The LOFT NURBS works with SUBDIVISION U and SUBDIVISION V values. The U value stands for the surrounding and the V value for connecting segments, which are subdivisions between the individual splines.

In order to check this we will create a number of simple splines in the front viewport. They could be wavy like as shown in Figure 1.172.

Move the splines so that they align like disks on the Z axis.

Create a LOFT NURBS object that can be found in the same palette as the other NURBS objects. Subordinate the splines under the LOFT NURBS object and make sure that the splines are sorted according to their order.

— Figure 1.172: Wavy splines inside a Loft NURBS object.

As shown in Figure 1.172 this technique can create hilly landscapes in a short amount of time.

Also, fabric with folds or a hood of a car would be two possible objects. The LOFT NURBS object is always the right choice when putting together an object based on different profiles.

The only disadvantage of LOFT NURBS object is that they can't be branched out. So, you can't start, for example, with a profile of a hand and then attach the five fingers at the

end. This can only be accomplished with polygon modeling and HYPERNURBS modeling.

A NURBS object also generates many polygons quickly when displaying angled profiles. The reason is that the circumferential subdivisions are applied evenly and not like the adaptive INTERMEDIATE POINTS where it concentrates on the areas with strong curvature or corners.

Another example will show how this looks.

We will use two circular and two rectangular splines that are placed parallel above each other. This arrangement and the result after we subordinate it under a LOFT NURBS object can be seen in Figure 1.174 in the two upper images.

First we see that the rectangular shapes look extremely rounded. The reason is the low number of circumferential segments. As Figure 1.173 shows, there is a preset value of 30 for MESH SUBDIVISION U.

— Figure 1.173: Subordinating the spline.

When this value is raised significantly, the result will look much better, as shown in Figure 1.174.

The value for MESH SUBDIVISION V can be reduced because our splines are close together and do not need to cover large distances.

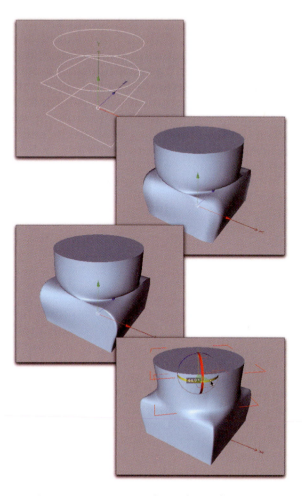

— Figure 1.174: Connected circular and rectangular splines.

The option SUBDIVISION PER SEGMENT determines whether the V subdivisions will be spread over the entire object or be placed between two neighboring splines.

The setting for the ISOPARM SUBDIVISION U has nothing to do with the shape. Instead, it determines the number of lines that will be displayed in the editor viewports when in ISOPARMS mode.

Look closely at the object and you will see a constriction in the area between the upper rectangle and the first circle. The reason is that the splines were connected to each other according to the order of their points. The first point of the circle seems to be placed in an awkward spot in relation to the first point of the rectangle.

The simplest solution would be to rotate both circles vertically as shown in Figure 1.174. The connections look much better now.

When using self-made splines, make sure that the positions of the first points correspond and that the direction of the point sequence is in order.

With the STRUCTURE > EDIT SPLINE menu, set a new start point for the splines anytime or invert the point sequence if necessary.

Splines with a different number of points can be used. Also, open splines can be mixed with closed splines. Just remember that only closed splines will generate caps.

The settings for the caps are the same as the ones in the NURBS objects that we already talked about.

Figure 1.175 also shows the difference between a calculation with and without a LINEAR INTERPOLATION option.

Notice in the upper part of the image that another, strongly rounded rectangular spline was placed close to the lowest circle. Both lower rectangular splines were also slightly rounded. This can be accomplished easily with the ATTRIBUTE MANAGER, as splines haven't been converted yet.

The two lower pictures in Figure 1.175 show the slightly different results when working with the LINEAR INTERPOLATION option.

When this option is active, the splines are connected in a straight line. The object does not expand past the dimension of the profiles.

This can be used for mechanical components. Without LINEAR INTERPOLATION we will get smoother transitions between differently shaped profiles that can be used for curved organic surfaces, such as the hood of a car.

The option ORGANIC FORM works in the same manner. When activated the surface is not as restricted by the spline points. The surface will not align stringently with the splines and can therefore adapt easily to extreme shape changes between splines.

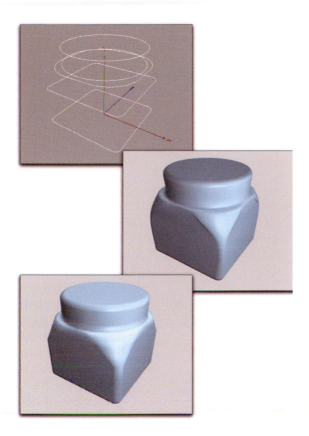

Figure 1.175: Building complex shapes out of a few profiles.

If you want to create ring- or hose-shaped objects, connect the first and last splines automatically with the LOOP option.

This concludes the explanation of all important object groups and tools. We cannot go into as much detail as in the handbook. To enable you to start working with the software, I have limited myself to the functions and commands that are commonly used in practice.

If you get into a situation where you have to know more about an option of an object or the function of a tool, you can use the online help of CINEMA 4D.

Working with Online Help

In order to use online help the files have to be installed in the help folder inside the CINEMA 4D directory. If these files are installed in a dif-

ferent place, then the path to the corresponding folder has to be correctly set in PREFERENCES in the EDIT menu of CINEMA 4D. In the column ONLINE HELP there is an input field with a file button where you can determine the folder with the ONLINE HELP.

When the path is correct, the ONLINE HELP window can be accessed immediately with a right click on the name of an input field or on an option in the ATTRIBUTE MANAGER. This opens the context menu where ONLINE HELP can be selected. Alternatively, the ONLINE

Figure 1.176: Online Help.

HELP can be opened in the HELP menu of CINEMA 4D (see Figure 1.176).

On the left side of the ONLINE HELP there are two categories: CONTENT and SEARCH RESULTS. The CONTENT window shows the complete index of the ONLINE HELP. There choose the desired column and display its content in the right side of the ONLINE HELP.

The ONLINE HELP works like an Internet browser. Click on the links in the text to get more information or to open subthemes.

By clicking on the house symbol in the upper left, you can always go back to the ONLINE HELP start page. The two arrows work like the forward and backward functions of a browser and let you switch between different help pages.

Use the search field in the upper right to look for a specific term. The results of the search are shown in the SEARCH RESULTS list and can be selected and displayed in the main window by clicking on them.

The search range of subcategories can be adjusted by the slide controller next to the search field. When the controller is all the way to the right, the entire ONLINE HELP database will be searched. When the controller is all the way to the left, only the main themes containing the search term will be displayed.

Continuative Information about the Managers

We worked with the OBJECT MANAGER and ATTRIBUTE MANAGER multiple times. However, both managers have somewhat hidden modes and additional options that we will talk about now. Let's start with the ATTRIBUTE MANAGER.

Display Modes of the Attribute Manager

You already experienced the versatility of the ATTRIBUTE MANAGER. We could adjust parameters of tags and objects, as well as making changes to tool settings. The reason is its preset for the display, which can be opened at MODE>CONFIGURE MODES... in the ATTRIBUTE MANAGER (see Figure 1.177).

The different parameters displayed in the ATTRIBUTE MANAGER can be activated separately. This makes sense, as multiple ATTRIBUTE MANAGERS can be open at the same time. Each manager can be configured differently too. For example, there could be one manager for tool settings and another one for object parameters. This will depend on the space available on your screen.

An additional ATTRIBUTE MANAGER can be created by pressing the key combination Shift + F5 or in the WINDOW menu of CINEMA 4D. We will learn about another display possibility next.

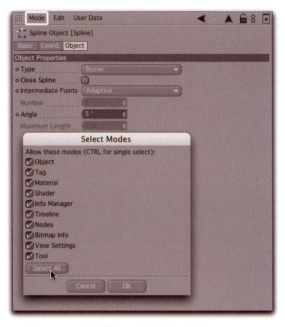

Figure 1.177: Different Attribute Manager modes.

History Functions

While working on the examples we noticed how inconvenient it can be when the ATTRIBUTE MANAGER switches to different parameters when a new tool is selected and data of a selected object disappear.

The object does not have to be selected in order to display the object data again. The arrows in the headline of the manager can be used too.

The left and right pointing arrows work like those found in a browser and make it possible to browse through already displayed parameters. All previous object or tool settings in a menu can be seen by right clicking on the arrows. You then are able to select it directly in this menu (see Figure 1.178).

The arrow pointing upward allows you to move up a step in the hierarchy of the selected element. As shown later, this is especially helpful when working with shaders and material.

— Figure 1.178: Navigation with the History function.

Locking the Display

The ATTRIBUTE MANAGER can be locked. This is especially helpful when copying parameters between different managers or simply not wanting the current display to change.

This function is turned on and off by clicking on the symbol of the first lock.

When it is activated, the display in the AT-TRIBUTE MANAGER will not change even if another tool or object is selected (see Figure 1.179).

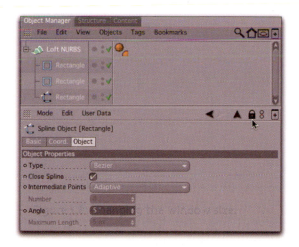

— Figure 1.179: Locking the display.

The symbol with the two chain links works in a similar manner (see Figure 1.180). With it the manager can be restricted to the currently selected mode.

— Figure 1.180: Locking of a mode.

For example, when an object is selected and its data is displayed in the ATTRIBUTE MANAGER, you can restrict the display to object parameters only by activating the chain link symbol.

The settings of a tool selected later would not be displayed. This allows quick changing between the different display modes in the manager, as you do not have to constantly change the settings in the MODE menu of the manager.

Selection Methods in the Manager

Parameters can be selected by their names in the ATTRIBUTE MANAGER. Click once on single values to select them. If selecting consecutive multiple values, select the top one, hold down the Shift key, and click on the last element. This automatically selects all parameters in between (see Figure 1.181).

If choosing inconsecutive values, hold down the CTRL key while selecting them.

Changing Different Parameters Simultaneously

The reason for this kind of selection is to change the parameters all at once.

When changing one of the values while holding the CTRL key, all other values will be set to the same number as the edited value.

This only works when all parameters have the same value range. For example, in Figure 1.182 the value for the RADIUS cannot be the

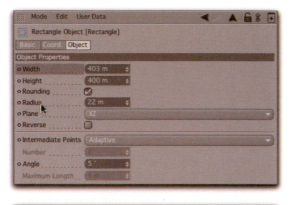

— Figure 1.181: Different selection methods.

same as the value for the width of the rectangular spline, even though the values were edited while holding the CTRL key.

Therefore, changing selected parameters by the same amount can be accomplished by holding the key combination Shift + CTRL. Then, when a value is increased by 10, all the other selected parameters will be increased by 10 as well.

Figure 1.182: Changing different parameters simultaneously.

Again, this only works if the value range of the parameters will not be exceeded.

Moving the Content

Figure 1.182 shows another feature in the shape of a hand cursor.

As soon as the content of the ATTRIBUTE MANAGER does not fit inside the window, scroll bars appear on the side or below that can be used to scroll inside the manager. Alternatively, click in an empty spot in the ATTRIBUTE MANAGER and move the display of the parameters by using the mouse.

Opening a New Manager

In addition to the previously discussed methods of opening multiple ATTRIBUTE MANAGERS, you can also click on the small window (see Figure 1.183).

A new manager opens that shows the same content of the old ATTRIBUTE MANAGER in locked mode.

Controlling Multiple Elements

The possibility of editing multiple selected elements at the same time is also very helpful. For example, select multiple spline objects in the OBJECT MANAGER and then change their settings in the ATTRIBUTE MANAGER simulta-

— Figure 1.183: Opening a new manager.

neously for the INTERMEDIATE POINTS or the CLOSE SPLINE option.

Figure 1.184 shows this in an example of two selected rectangular splines. The headline of the manager informs us that multiple elements are selected and that all of them are the same type.

— Figure 1.184: Working on multiple elements.

The colored fields show that the parameters of the selected objects are different from each other. A value that will be applied to all selected objects can be entered into these fields.

Fields with numerical values show that this value is the same as all selected elements.

Using the COPY and PASTE command, copy parameters between different objects

Both commands can be found in the context menu, which is opened by right clicking on the parameter name in the ATTRIBUTE MANAGER.

This can be helpful in copying vector values, colors, or whole splines as we have seen in the dialog of the SWEEP NURBS object.

Making a Selection in the Object Manager

In the OBJECT MANAGER, selections of multiple elements, such as objects and tags, can be created with different methods.

Elements that are one below the other can be selected with a rectangle selection. While opening a selection frame, click in the empty room to the left or right of the name or next to the symbol of the tag and hold down the mouse button.

The SHIFT click method delivers the same result. First, click on the name or tag of the first element that you want to select. Then hold the Shift key and click on the last element at the end of the desired selection. All elements in between will be selected as well.

When the elements are located in different places within the hierarchy, use the CTRL key while clicking on the elements. This way objects that have been previously selected by accident can be deselected.

Figure 1.185 shows these selection methods again.

The bottom of Figure 1.186 shows another useful command that can be executed in the EDIT menu of the OBJECT MANAGER. With SELECT CHILDREN, all subordinate objects can be selected automatically as long as the top object of a group is selected in the OBJECT MANAGER.

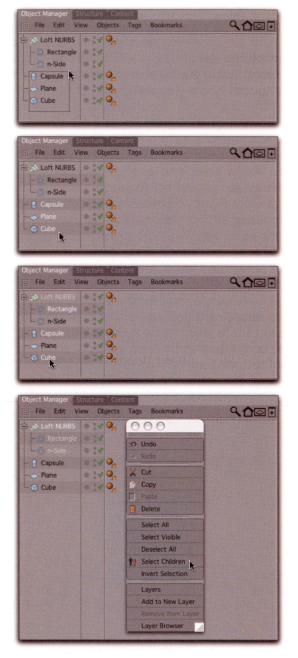

Figure 1.185: Different selection methods.

Using the Display Filter

Especially in complicated scenes, scrolling in the OBJECT MANAGER and working inside complex object hierarchies can become very con-

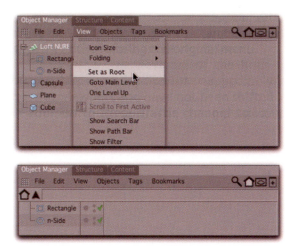

— Figure 1.186: Using the display filter in the Object Manager.

fusing. In this case, the selective display of diverse object groups can be helpful.

Select the upper element in an object group which is to be edited and right click on its name. In the context menu, select SET AS ROOT and all objects not part of this group will be hidden in the OBJECT MANAGER (see Figure 1.186).

With a click on the house symbol in the upper right of the OBJECT MANAGER, an additional navigation bar opens with two icons and a display field for the currently selected hierarchy level (see Figure 1.186).

Use the upward pointing arrow to move up a step in the hierarchy and to make more objects visible. To return to the default display in the OBJECT MANAGER, click on the house symbol next to the arrow. All objects will be visible again.

Individual Filter Settings

A click on the eye symbol in the upper right of the OBJECT MANAGER splits the manager. In the upper portion, all elements of a scene are sorted by objects, tags, and layers (see Figure 1.187). This kind of display also has a statistic value because it does not show all the elements in

— Figure 1.187: Activating filters.

the scene, only the sort of object and the quantity in parentheses behind it.

If there are three basic cube objects, there will only be one cube in the OBJECTS entry in the list. The number behind the cube shows the quantity of cubes.

Figure 1.187 gives an example of the list of PHONG tags showing that there are four tags in the example scene.

The eye symbol behind the listed elements controls their visibility in the OBJECT MANAGER. The objects remain visible in the editor even when they are hidden in the OBJECT MANAGER.

The magnifying glass symbol informs you if it is possible to find this element with the search function. We will see in a moment how this search for objects or other elements works.

Another click on the eye symbol in the upper right of the manager deactivates the split view.

Display of Tags

We are already familiar with different kinds of tags. There are, however, numerous other functions that can be controlled by tags too. Because the number of tags can grow rapidly, it is necessary to scroll sideways in the OBJECT MANAGER to see all of them.

In this case, displaying the tags vertically might be helpful. Activate this function in the VIEW menu in VERTICAL TAGS (see Figure 1.188).

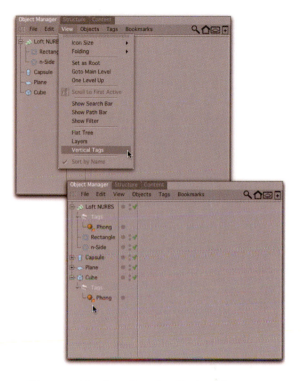

— Figure 1.188: Changing the display of tags.

The tags will then be sorted hierarchically under the object and are visible only after the hierarchy has been unfolded.

Searching for Objects

A click on the magnifying glass symbol in the upper right of the OBJECT MANAGER adds a search field to the upper portion of the manager. Type in the name of the object you are searching for. When an object with this name is found, it will be shown in the OBJECT MANAGER. All other objects will be hidden.

This also works when only a single letter or the beginning of the name is typed in. A list of all names with this series of letters will appear.

As Figure 1.189 shows, when the term *L* is entered, all names containing the letter *l* in the scene will be listed.

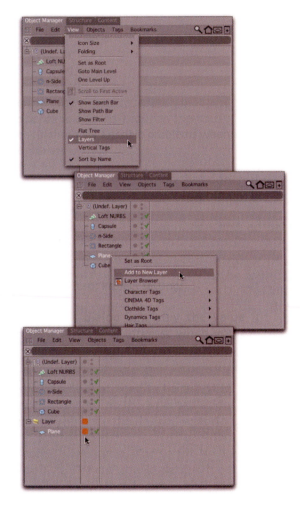

— Figure 1.189: Searching for names.

Only objects with the activated magnifying glass symbol in their filter settings will be included in the search.

A click on the X symbol in front of the search field deletes the list of search results and all objects appear again in the OBJECT MANAGER. Another click on the magnifying glass symbol in the headline of the OBJECT MANAGER deactivates the search field again.

Working in Layers

In the VIEW menu of the OBJECT MANAGER is the LAYER mode. This mode organizes the display of elements in your scene, depending on their affiliation to different layers.

Layers are groups of objects or tags. These groups can be put together differently from the hierarchies in the OBJECT MANAGER. The purpose of these groupings is to be able to sort elements that have the same function.

This is an important feature that makes the organization of complex projects clearer.

Elements that are sorted in layers can be hidden in the editor or be turned off for rendering.

As shown in Figure 1.190, all objects are already on one layer. This undefined layer will collect all elements that do not have their own layer.

Figure 1.190: Working with Layers.

To move an object to a new layer, right click on the name of the object or on a tag and then choose ADD TO NEW LAYER.

In addition to the undefined layer, a new layer with the selected element appears. This does not change anything in the order of the objects in the OBJECT MANAGER.

In the Layers display of the Object Manager, you drag and drop multiple objects from the undefined layer to the new layer. It is also possible to right click on the element and choose Add To Layer in the context menu. This selects the layer into which the elements will be moved.

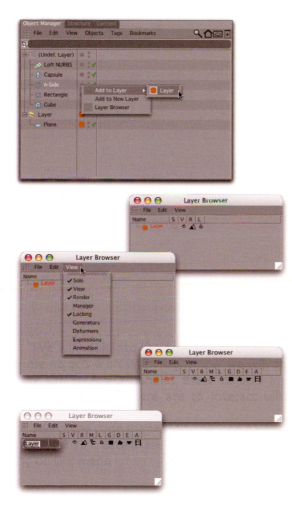

Figure 1.191: The Layer Browser.

A shortened menu can be opened by clicking on the light gray field to the left of the visibility points, which has only menu items related to layers. You can see this menu in Figure 1.191 at the top. A layer menu can also be found in the Basic settings of objects.

The names of the layers can be chosen by double clicking on the layer name. Every layer also has its own color, which shows its relationship to the layers in the Object Manager.

The Layer Browser

In order to define the attributes of each layer, use the Layer Browser. It can be opened by clicking on the already mentioned light gray field next to the objects or in the Edit menu in the Object Manager.

There is a list of all defined layers in the Layer Browser. Here the name of the layer can be edited by double clicking on it.

More interesting are the icons to the right of the layer name. Their state controls the visibility in the editor, the display of the elements of a group within the Object Manager, or if animations for the elements have to be evaluated.

The number of control elements used is up to the individual. The View menu in the Layer Browser shows all available options. This way, control possibilities can be customized. These will then be displayed as icons on the right side of the Layer Browser and can be activated or deactivated by clicking on them.

Figure 1.191 shows this View menu and how the number of icons can be influenced.

Through the View and Render options, control of the visibility of all elements in the layers of the editor and at the rendering is possible. The Manager option allows the display in the Object Manager to be turned off and Locking locks the elements so they can't be moved or selected by accident.

The Solo option turns all objects invisible which are not part of the layer. This affects all the managers, the display in the editor viewports, and the rendering.

The remaining icons control the calculation of generators, XPresso expressions, deformers or animations.

To separate already existing scenes into layers, select all objects that will be organized into one layer and then choose Add Objects To Layer in the Edit menu of the Layer Browser.

Here, there is the possibility to use SELECT FROM LAYER to select all elements of a chosen layer or to merge layers with MERGE LAYERS (see Figure 1.192).

Figure 1.192: Other Layer functions.

Working with Presets

The use of certain settings for objects and tags can become a habit over time. It could be that triple subdivision of the caps of basic cylinder objects is never used and the height segments are always set to 1 in order to save polygons.

For these situations, CINEMA 4D lets you save presets for tags or objects that can be reloaded anytime. This saves time by avoiding having to change the basic settings every time an object is created.

In order to do this, create the object, change it to your liking, and then select the option SAVE OBJECT PRESET in the FILE menu of the OBJECT MANAGER.

From now on the saved object can be loaded with the entry LOAD OBJECT PRESET. This way you can create multiple presets for all objects (see Figure 1.193).

Not only the geometry but also the existing tags and their settings will be saved.

Figure 1.193: Using Presets.

Using the same method, save and load presets of tags separately. For this purpose, the commands SAVE TAG PRESET and LOAD TAG PRESET are available.

Working with Bookmarks

When the settings in the OBJECT MANAGER are switched often, it may be helpful to create bookmarks for those settings that are used more frequently (see Figure 1.194).

Figure 1.194 shows an OBJECT MANAGER containing a larger icon and a search field and shows how to save this layout in the BOOKMARK menu. These saved bookmarks can be re-

Figure 1.194: Using bookmarks.

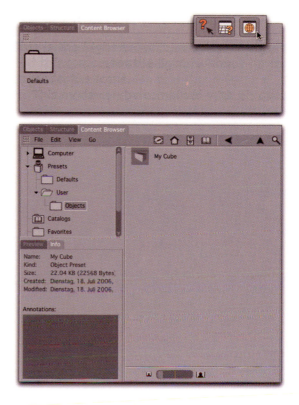

Figure 1.195: The Content Browser.

named in the BOOKMARK MANAGER or can be removed again with the DELETE button.

Saved bookmarks can be selected in the lower part of the BOOKMARK MANAGER in order to switch to the desired OBJECT MANAGER layout.

The Content Browser

After working with CINEMA 4D for a while, you will have saved a number of scenes and accessed external files, such as pictures, movies, or 3D files of other programs. To keep an overview of all these items, take a look at the CONTENT BROWSER (see Figure 1.195).

Its window can be opened by using the CONTENT BROWSER icon in the upper icon palette (see Figure 1.195) and is connected to the OBJECT MANAGER and the STRUCTURE MANAGER

by default. Access to this manager is also possible using the WINDOW menu of CINEMA 4D.

The CONTENT MANAGER can work in different modes. The so-called SIMPLE BROWSER shows the file structure of your hard drive and the dates of the presets, catalogs, and search results.

With a right click in the browser, the option SIMPLIFIED BROWSER (located in the context menu) is deactivated. This results in a triple splitting of the browser, which, in my opinion, is easier to work with.

On the upper left is a list of different folders, which, in addition to the hard drive, shows the various folders CINEMA 4D uses to save its presets.

When a folder is selected, all the readable files appear as icons in the right part of the browser. When the folder PRESETS/USER/OBJECTS has been opened, you can see the ob-

jects that have been saved with the SAVE PRE-SET function.

These objects can be opened by double clicking or by pulling them via drag and drop directly into the editor.

In the same manner browse the hard drive for useful files and add them to a scene. The CONTENT BROWSER works in this case like a file browser.

To show the content of different directories, use the icons in the upper right. The first icon on the left stands for the desktop of the computer. The house icon sets the file display to your personal user directory. The switch symbol lets you go to the saved presets of CINEMA 4D, and the open book icon stands for the catalog directory in which personal links to files can be put together.

This is very handy because it becomes unnecessary to copy files between different directories. The catalog only saves the links to the file locations on your hard drive and does not move or copy them into a new directory.

A new catalog can be created at FILE > NEW CATALOG... in the layout of the complete CONTENT BROWSER.

In the dialog enter the name for the catalog and leave all other fields empty. The other entries are only relevant when the catalog is copied onto a CD-ROM and given to a colleague.

Catalog data is saved in the CINEMA 4D directory LIBRARY/BROWSER as a *.cat4d* file and should be added to the content of the CD-ROM. The recipient can then copy these files into his or her LIBRARY directory and gain access to the catalogs with the CONTENT BROWSER. You can find more information about this in the ONLINE HELP.

Because more than one CONTENT BROWSER can be opened at one time, assembling personalized catalogs is easy. Just drag the desired files from one browser window and drop them onto the catalog name in the other.

Another way to organize files and to search is the search function of the CONTENT BROWSER, which can be started with the magnifying glass icon in the upper right.

Figure 1.196: Display options in the Content Browser.

First choose the directory or folder that needs to be searched. Then click on the magnifying glass. Several menus and a search field appear. In the menus, choose the way the search term should be analyzed. If, for example, everything should be searched that con-

tains a part of the search term, then choose the combination NAME CONTAINS.

The search will be started with the SEARCH button. The search results will appear below and are also saved in the folder SEARCH RESULTS under the current date. This item can be opened anytime without having to start a search again. The PREVIEW window shows an enlarged view of the currently selected file. The accompanying INFO window informs as to the file size or the resolution of the picture.

To control which files should be shown, use the VIEW menu of the CONTENT BROWSER (see Figure 1.196). There, movies or unreadable files can be excluded from the display.

The symbol with the arrow pointing upward in the headline of the browser allows you to change the level inside a folder hierarchy.

The two arrows next to it work like those in a file browser and show the content of previously viewed folders.

With the controller on the lower edge of the browser, determine the size of the icons with the preview pictures. In the maximum setting the icons can reach the size of the PREVIEW window. This, however, can slow down working in the browser, especially when many preview images for a series of scenes have to be calculated.

We now conclude this chapter and will finally start something new, which is the exciting subject of materials, lighting, and rendering.

Surfaces, Light, and Rendering

After the objects are constructed they are usually textured, which means applying surface properties to the objects.

Because this subject is very complex, we will work again only with the most important tools and settings. This includes materials, textures, shaders, and material application.

Just as complex is the subject of lighting the objects. We will take a look at traditional lighting and also talk about the radiosity calculation of light distribution. I will use examples to show the advantages and disadvantages of these techniques.

Finally we will go through the available options for rendering your work so you can create, for example, an animation, a pre-press-ready image, or a preliminary stage for postproduction.

Some of these options are available only when the ADVANCED RENDERER is installed, a separate module which expands the range of render settings.

You will discover though that impressive results can be achieved without this module.

2.1 Creating Materials

The way CINEMA 4D works is that materials are generated and edited separately from the objects. Objects and materials are then connected by tags, which are created in the OBJECT MANAGER.

Materials and their structuring are produced inside another manager, which is highlighted in the lower part of the layout in Figure 2.1.

This MATERIAL MANAGER has, like the OBJECT MANAGER, different display modes. For now, we will not make any mode changes. Go to the FILE menu and select NEW MATERIAL.

In the same menu there is the command LOAD MATERIALS, which loads materials from an already saved scene. With this useful feature materials can be used repeatedly in multiple projects.

2.2 Edit Materials

A gray sphere appears inside the MATERIAL MANAGER. This sphere presents a preview of our new material, as materials cannot be shown in a three-dimensional space without being applied to an object.

In order to change the name of the material, either double click on the name under the preview or use the BASIC settings in the ATTRIBUTE MANAGER that is displayed when the material is selected.

In the ATTRIBUTE MANAGER you can gain access to some properties of the new material. They are separated into channels, such as a channel for the color, one for specularity, and yet another one for the roughness of the surface.

There will hardly be a case when all the channels will be used. Therefore, channels can be activated separately in the BASIC page of the ATTRIBUTE MANAGER. Only active channels will be included in the final calculation and can be edited in the ATTRIBUTE MANAGER. The center of Figure 2.2 shows some example settings for the color channel shown.

— Figure 2.1: The position of the Material Manager in the standard layout.

The Material Editor

Because of the multiple channels and some-times very complex settings, working in the AT-TRIBUTE MANAGER can become very crowded.

The solution is to edit materials in the MA-TERIAL EDITOR. Because the MATERIAL EDITOR can be opened in a separate window, it can be scaled and placed without changing the rest of the layout of CINEMA 4D. The settings are identical to those in the ATTRIBUTE MANAGER.

Figure 2.2 shows the MATERIAL EDITOR in the bottom of the image. It can be opened with a double click on the preview of the MA-TERIAL MANAGER.

Basic Channel Settings

Most of the channels of a material are struc-tured similarly. Many parameters, such as

color, the possibility of loading images or shaders, or the mixing of colors and pictures, are identical.

For this reason we will go over these repet-itive elements once, such as the COLOR chan-nel, and skip them when looking at the other channels.

On the left side of the MATERIAL EDITOR, un-der the preview, is the list of all the channels of the material.

After clicking on the name, the properties of the selected channel are shown on the right side of the MATERIAL EDITOR.

Select the COLOR channel on the left and take a look at its parameters. The purpose of the COLOR channel is to color the surface of an object. All chosen settings will also be influ-enced by the virtual light sources, which we will talk about later.

This is why the color can appear on the ob-ject much duller or be completely overpow-

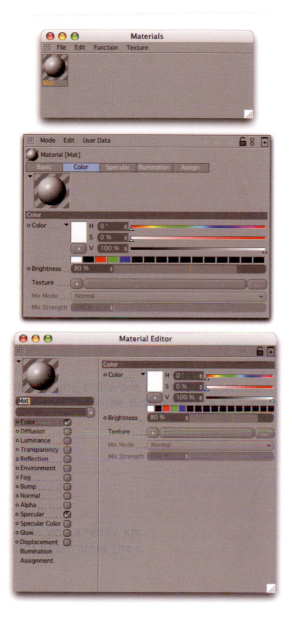

ues directly into the field, it is possible to enter values over 100%.

Under these sliders are the Texture parameters through which shaders or pictures can be loaded. Since we will talk about the shaders later, we will first try to load images (see Figure 2.3).

— Figure 2.3: Working with images in the material.

— Figure 2.2: The Material Manager and different editing possibilities.

ered by the light source when the color selector, located in the upper right corner of the Material Editor, is set to a bright red.

Depending on which color presets were selected for the color selector in CINEMA 4D, the RGB or HSV slider will be shown. The Brightness slider can be used to additionally brighten or darken the color. By entering val-

Use the button with three dots, identified with an arrow in Figure 2.3. A system dialog will open where the image or even a movie can be selected. You can use, for example, the YingYang image from the DVD accompanying this book. Then you will be surprised by the dialog shown in Figure 2.3.

CINEMA 4D expects to find external data, which are used with materials, in certain places on the hard drive.

One of these places is the start directory of CINEMA 4D. This should not be used for storing images, as it would get cluttered very quickly. It makes more sense to save the neces-

sary images together with their scene file in a folder. This would be the second place where CINEMA 4D will look for images.

Additionally, a TEXTURE PATH list can be found in PREFERENCES. There, a path to an image folder can be specified by clicking on the button at the end of each input field (see Figure 2.4).

— Figure 2.4: Texture paths in the Preferences of CINEMA 4D.

In our case it is enough to close this dialog by clicking on the NO button. The loaded picture then stays in its directory and will not be copied into the CINEMA 4D directory.

Now there should be a little preview of the loaded image under the TEXTURE list of the COLOR channel along with some data about the resolution and color depth (see Figure 2.3).

At the same time the material preview changed and now has the image projected onto its surface. This gives a hint as to how the image will be distorted on a rounded surface, such as the preview sphere.

Maybe you have noticed that the color chooser apparently lost its abilities. That is because the COLOR and TEXTURE parts of the channel are used like two layers. The TEXTURE represents the top layer and covers the color settings (see Figure 2.5).

The reason for this is the standard setting NORMAL for the MIX MODE. This can be changed to another mode, such as MULTIPLY or

— Figure 2.5: Mixing of image and color.

ADD, to let the image and color interact with each other.

With the MIX STRENGTH slider the opacity of the TEXTURE layer can be changed, just like the same option in Photoshop.

Figure 2.6 shows an example using the MIX MODES. In MULTIPLY mode the color values of the image are multiplied with the color value of the color chooser. That way, simple color adjustments can be applied directly in CINEMA 4D without having to change the original image.

Let us take another look at the preview in the upper right of the MATERIAL EDITOR. The size of the preview image and the shape of the displayed object can be controlled over a context menu that can be opened by right clicking on the preview.

The context menu offers several standard sizes between SMALL and HUGE, as shown in Figure 2.6.

For even more control select OPEN WINDOW..., which opens a scalable preview window. Depending on the complexity of the material it might take a long time to calculate larger previews. In this case, the AUTO option in the separate preview window can be deacti-

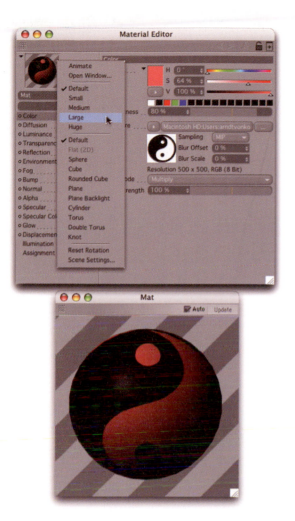

— Figure 2.6: Adjusting the Material Preview.

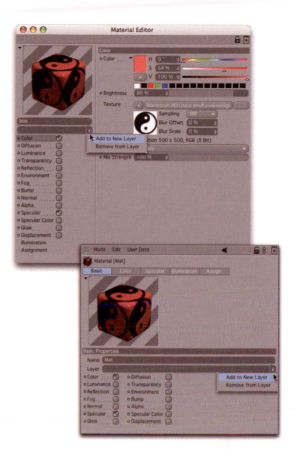

— Figure 2.7: Organizing materials in layers.

Hidden Functions

One of the hidden functions is the small menu under the color field (see Figure 2.8). A click on this button opens a list of possible color systems and values. The color system can always be changed and is independent from the standard settings of the program.

Click on the color field above the menu when the color chooser of the operating system is preferred.

Copy Parameters

When complex data, such as colors or even whole materials, need to be copied between channels, the easiest way to accomplish this

vated and refreshed manually by clicking on the UPDATE button.

Under the name field of the material, there is a layer menu for sorting the material (Figure 2.7). Figure 2.7 also shows that I set the preview size to HUGE and the shape of the shown object to ROUNDED CUBE. This makes it easier to preview the image.

The rounded edges of the cube also give a better impression of the shininess of the material.

— Figure 2.8: Changing the color systems.

is to use the COPY and PASTE command for parameters.

This and other commands can be found in the context menu, which is opened by right clicking on the parameter name. Figure 2.9 demonstrates this with the COLOR parameter.

— Figure 2.9: The Context menu for parameters.

This explains the most important structures of a material channel. The difficulty in creating believable materials is not the ability to use the MATERIAL EDITOR, but rather in selecting the right combination of different channels and properties.

Therefore, we need to know which property of the surface will be influenced by what channel. Let us take a look at the details of all channels.

The Diffuse Channel

The job of the DIFFUSE channel is to weaken the properties of a material. The affected properties are determined by the options AFFECT LUMINANCE, AFFECT SPECULAR, and AFFECT REFLECTION. The COLOR channel will also be affected, even if it does not appear as a separate option (see Figure 2.10).

— Figure 2.10: The Diffuse channel.

With the BRIGHTNESS slider the intensity of the channels selected in the options can be reduced. The same effect may also be accomplished by changing the intensity directly in the channel. This only makes sense when, for

example, pictures are loaded into the TEXTURE part of the DIFFUSION channel to restrict this effect to certain areas of the material.

This is used for simulating a dirty surface or to additionally darken ridges or grooves. In this case only the light parts of a loaded image or shader will be evaluated.

The color properties of the material also do not change and will only be darkened.

The MIX MODE settings are the same as the settings in the COLOR channel. They enable us to multiply loaded images or shaders with the value of the BRIGHTNESS slider.

The Luminance Channel

Deactivate the DIFFUSION channel again and select the LUMINANCE channel. Notice how the surface of the preview cube turns white (see Figure 2.11). This is because the color value set in the LUMINANCE channel is added to the whole material.

It does not matter if any part of the material is in a shady spot or brightly lit. The shading of the object loses its three-dimensional appearance because of it. In extreme cases the object loses its perspective, and only the contour is visible.

Therefore, it is important to keep the intensity of the LUMINANCE channel low. It should also only be used in selected parts of the material. Later we will learn about different shaders that restrict this channel to certain areas of the applied object.

The LUMINANCE channel gains another purpose when the radiosity calculation in the advanced render module is used later on. The intensity of the channel will be used to generate light in the scene.

Objects that use the LUMINANCE channel can be used like light sources and illuminate other objects.

The LUMINANCE channel can also be used for simulating very hot, self-illuminating, or translucent materials.

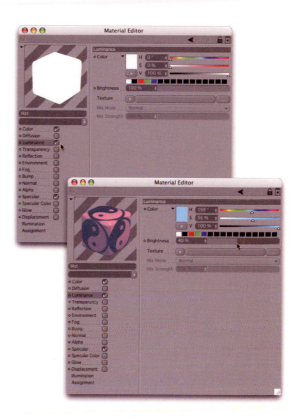

— Figure 2.11: The Luminance channel.

Just remember that the intensity of this channel can destroy much of the shading capabilities of the surface of an object. The object will then look, in extreme cases, two dimensional.

The lower part of Figure 2.11 demonstrates how intensities can be used to simulate diffuse illumination of objects. It appears that the object is lit from all sides. This would make sense, for example, when simulating the diffuse light of the sky.

The Transparency Channel

Deactivate the LUMINANCE channel and select the TRANSPARENCY channel of our material. The preview cube will then become almost invisible (see Figure 2.12).

This channel simulates the transparency of materials and uses some physical properties to accomplish this. When the material needs to be accurate, then the value of the REFRACTION (the strength of the refractive light property) can be taken directly out of a physics book. For example, water has a REFRACTION value of 1.333. Normal glass has a value between 1.5 and 1.6.

The air that surrounds us has a REFRACTION value of 1. When the air is hot, this value will increase. An example of this can be seen in the desert or over hot asphalt when the air appears to shimmer.

Try it yourself and put in a value of 1.5 for the REFRACTION of the material. After a short calculation the shape of the rounded cube in the preview can be seen much clearer. In addition, the gray stripe in the background shows how the material distorts its surroundings.

The Fresnel Effect

In this context, there is an optical unit that is used for all transparent and reflective objects. The effect actually changes in relation to the viewing angle.

This can be tested when standing in front of a store window. When looking straight through the window, this effect is hardly noticeable. Everything behind the glass is clearly visible.

However, if you get closer to the window and look parallel along the glass, you cannot see anything behind it. Instead, the reflection in the glass can be seen.

The transparency will be reduced depending on the angle between the viewer and the surface. This property can be activated with the FRESNEL option in the TRANSPARENCY channel.

When this option is activated the cube loses its transparency on the surfaces that are angled further away from the viewer. These surfaces now show more of the settings of the COLOR channel.

The influence of the COLOR channel can be increased by activating the ADDITIVE option.

— Figure 2.12: The Transparency channel.

When we look closer we can still see the highlights on the rounded preview cube.

However, this often results in an extreme brightness of the surface, as the brightness of the COLOR channel and the TRANSPARENCY channel are combined.

The degree of transparency can be controlled by the brightness of the color value or the brightness of the loaded shader or image. In this manner the color values are evaluated again.

That way, for example, colored glass can be created where the degree of transparency is controlled by the brightness of the color.

Figure 2.12 shows all these settings again in a series of images.

The TRANSPARENCY channel can also work with images or shaders, so let us try it out.

When an image was used in another channel and should also be used in this channel, it does not have to be loaded again by clicking on the three-point button.

Use the three-point button in the TEXTURE area of the channel instead (see Figure 2.13).

In this menu there are the commands for loading and deleting an image, and it has also a BITMAPS entry. Under this entry all the previously loaded images and movies are listed, which can be selected by clicking on them. Load the YingYang symbol we used previously in the COLOR channel.

On the preview cube, notice how the TRANSPARENCY channel applies images. The darker an area is in the image, the less transparent the material will be on this spot. Completely white areas will be 100% transparent (see Figure 2.13).

The colors of the image are evaluated too and the transparency is colored accordingly.

Gradients can also be used to gradually raise the transparency.

COLOR and TEXTURE settings, as we already know, can be combined with the MIX parameter, for example, if we only use a black and white image to control the intensity of the transparency and additionally want to color the object with the COLOR value.

The settings for DISPERSION are new. This means the spreading of light rays in a transpar-

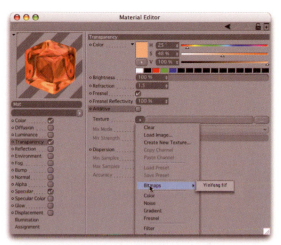

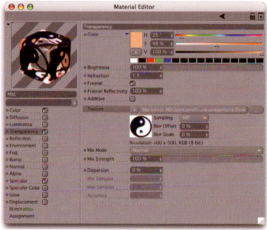

— Figure 2.13: Loading images or shaders.

ent material, which can be compared to a rough surface or frozen water. The irregularities of the surface will further distort elements that are located behind the transparent objects.

The transparency might be completely gone when extreme settings are used.

The Dispersion Effect

The strength of this effect is controlled by the DISPERSION setting. A value of 0% will deactivate this calculation completely. In this case, the parameter beneath will therefore be grayed out.

The higher the DISPERSION value is set, the more intense the disturbance is inside the transparency. Values between 5 and 30% should be sufficient when simulating realistic materials.

The following parameters control the precision of the calculation of this effect while having a direct influence on the quality of the display and the time it takes to calculate the material.

Because additional calculation rays have to be sent through the material, their quantity will be restricted by the values in MIN and MAX SAMPLES (see Figure 2.14).

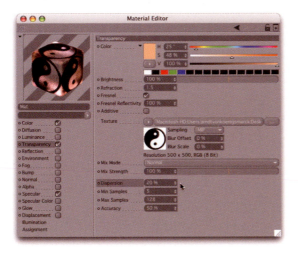

— Figure 2.14: The Dispersion effect.

CINEMA 4D checks in advance the shape of the surface of the object and selects the appropriate number of sample steps. When the surface is a plane, the MIN value will be used. Curved or angled surfaces need more calculation steps and use the MAX SAMPLES setting.

The value for ACCURACY works like a multiplier for the SAMPLES settings. When a balanced setting of the SAMPLES values is found, then the quality of the calculation can be controlled with the ACCURACY value.

Because of the extended time it takes to calculate each additional SAMPLE, it does not make sense to set all of the values to a high

number and hope for a perfect result. Instead, the values should always be optimized.

We will come across this way of working throughout CINEMA 4D, for example, when we use the radiosity calculation.

The Reflection Channel

Let us move to the next channel after deactivating the TRANSPARENCY channel in the list of those available.

The REFLECTION channel works almost like the TRANSPARENCY channel. Here too the intensity of the coloring of reflections on the surface can be controlled by the color value or a loaded image.

As shown in Figure 2.15, the loaded YingYang image causes no reflection in dark places and maximum reflection in light ones.

— Figure 2.15: The Reflection channel.

Here too the DISPERSION settings are available, which work after the same principle found in the TRANSPARENCY channel. This time though the reflection will be calculated to be blurrier (see Figure 2.16).

— Figure 2.16: Dispersion.

There is a connection between the Trans-parency and the Reflection channels by the Fresnel Reflectivity value on the Transparency page of the material.

We learned earlier about the example of the shop window that loses transparency depending on the viewing angle and in return gains reflective properties.

When both channels are activated, the strength of the reflection can be controlled with the Fresnel Reflectivity value. It determines how strong the reflection will be at parts that are angled away from the viewer and lets us control individually the blending between transparency and reflection.

This effect is already calculated when only the Transparency channel is activated without the Reflection channel. This makes sense because there is no transparent material without reflective properties.

The Environment Channel

The Environment channel offers an alternative to the real reflections of the Reflection channel.

A loaded image will be wrapped around the object like a shell. That way, for example, a landscape image can be loaded and a simulated reflection of this landscape will appear on the object, which means that reflections of objects can be generated that are not in the scene.

How many times the loaded image will be put around the object is determined by the Tiles value for both the X and the Y directions. This makes sense when abstract images are used and the tiling will be less obvious.

The Exclusive option should be left activated when the Environment effect needs to be mixed with real reflections. Then the Environment reflection will be deactivated where real objects are reflected in the material. Otherwise both reflections would be calculated on top of each other and would not create a realistic result.

The Fog Channel

This channel has the ability to calculate objects as if they are filled with fog. Other properties of the object get lost or severely reduced when this effect is used, which is why this channel is often used by itself.

The advantage is that the fog stays within the boundaries of the object. This feature can be used, for instance, when portraying fog in a depression in the landscape or cirrus clouds.

The density of the fog can be set with the Distance value. This parameter determines the distance at which the fog becomes so dense that objects behind cannot be seen anymore.

This presumes that the object that the material will be applied to has the appropriate size.

Fog with a Distance value of 1000 will not be shown to advantage in a cube with an edge length of 10. The Distance value strongly depends on the dimensions of the object.

The fog can also be colored with the Color and Brightness settings. It is even possible to generate black fog by setting the Brightness slider to 0%.

The Bump Channel

We already discovered in the first chapter how time-consuming it is to model something. Imagine having to build an extreme close-up or a large printout of a surface. Would you want to model all the grain of a wooden board, all pores of a face, or all grooves of a CD-ROM?

This would not only slow down even the most powerful computer and make editing impossible, but the small details would be disproportional to the size of the whole object.

— Figure 2.17: The Environment channel.

Therefore, there are multiple methods available for creating fine details in the material. One possibility is to use the BUMP channel.

This channel evaluates the lightness of a loaded shader or image and changes the normals, which are responsible for the shading of the surface, based on this information. We already talked about this in the first chapter.

When one pixel is darker by comparison than the surrounding pixels in the loaded image, it will appear to be lower than they are. However, if the pixel is comparatively lighter, it will appear higher than its neighboring pixels.

This effect takes advantage of brightness transitions. Black and white images next to each other therefore will not have a strong ef-

— Figure 2.18: The Fog channel.

fect on the surface since there is hardly a transition between the two.

This is also the reason why I increased the strength of the effect in our YingYang image by using the STRENGTH slider in the BUMP channel (see Figure 2.19). Just like many sliders, a value above 100% can be entered.

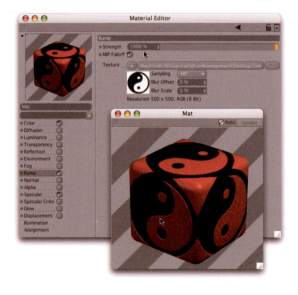

— Figure 2.19: The Bump effect.

As we can see in the enlarged preview, the darker parts look depressed.

The default highlight in the material amplifies this effect and shows additional bumps on the edge of the dark areas.

Be aware that this effect only influences the direction of the normals and therefore changes the properties of light on the surface. The shape of the surface itself does not change.

The effect should therefore not be used with extremely high values. The viewer of the object may expect big bumps on the surface while the contour of the object remains unchanged.

The BUMP effect should be used for the finest structures in which size and shape do not have any effect on the contour of the object.

The result of the loaded picture can be inverted using the STRENGTH slider. Move the slider to the left into the negative part. Light areas in the picture will then be lowered and dark areas will apparently bulge outward.

Almost all objects will benefit from the BUMP effect, as in reality there are almost no perfectly smooth surfaces.

The Normal Channel

The NORMAL channel (Figure 2.20) has the same job as the BUMP channel, but with the ability to display surface details even more realistically. The reason for this is that the NORMAL channel works with specially colored images with which the new direction of all three axes of the normals can be controlled.

By comparison, the BUMP channel only works with brightness and must calculate the direction of the normals based on the brightness of the surrounding pixels. The individual freedom of movement of the normals is therefore very restricted.

The method of operation of the NORMAL channel is, at the same time, its biggest disadvantage, as the necessary images, also called NORMAL maps, have to be created and calculated in advance. The BUMP channel can use

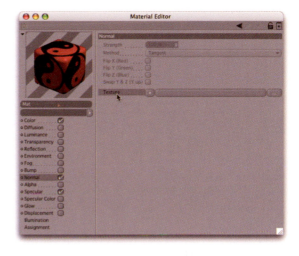

— Figure 2.20: The Normal channel.

any grayscale image, even one custom painted by the user.

We will come back to the NORMAL channel later.

The Alpha Channel

There are several situations where the material should not cover the whole object. As a result, parts of the material need to be removed. For this purpose the ALPHA channel will be of use.

With its help, loaded images can be used like alpha maps. The functionality is the same as the alpha channels in Photoshop.

The usage of an image in the ALPHA channel is inverted compared to the TRANSPARENCY channel. White areas remain visible, whereas black areas will cause the material to be invisible (see Figure 2.21).

Gray scales are also allowed and create transitions in the visibility of a material.

With the INVERT option the brightness of a loaded image can be inverted and therefore the visibility of the material will be reversed.

In some cases there is no alpha image available and we have to extract the information out of a normal color image. In this case we de-

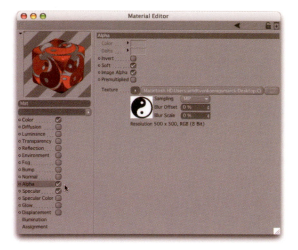

— Figure 2.21: The Alpha channel.

activate the SOFT option. This gives us access to the two color fields for COLOR and DELTA.

With the COLOR value, the color will be defined that should be extracted for the alpha part. Because colors rarely exist without variations, the DELTA value can be used to define the maximum deviation from the COLOR value.

The presets of 100% of white for COLOR and 25% for the RGB value in the DELTA field determine that pixels with RGB values between 100 and 75% will be recognized as an alpha mask. In order to control it more exactly we should use separate alpha images.

When an image is loaded that already contains an alpha channel it can be activated with the IMAGE ALPHA option.

The PRELMULTIPLIED option additionally multiplies the loaded alpha mask with the colors of the surface. These alpha maps would have to be created especially for this purpose in order to get the desired result. Generally this option will not be needed.

The Specular Channel

Because the SPECULAR channel is activated by default together with the COLOR channel, we could enjoy its effect from the beginning.

The SPECULARITY adds highlights to the surface. The location of these highlights depends on the angle between the surface normal and the incoming light beam.

Because the surface normal is also influenced by the BUMP and NORMAL channels, these channels also change the position and size of the highlights.

The four sliders in the SPECULAR channel determine what the highlight will look like.

The WIDTH value controls the range of possible angles between surface and light, which result in a highlight. Wide highlights make the surface look dull or rough, whereas small highlights simulate a polished surface.

The HEIGHT value determines the intensity of the highlight. Values above 100% can artificially improve the effects of weak lighting. Lower values reduce the intensity of the highlight and allow it to look weaker.

The FALLOFF parameter influences the transition between the center of the highlight and the outer edge of the highlight. Small values create a needle-shaped gradation, which reduces the intensity of the highlight quickly. Values over 0% keep the brightness constant up to the edge of the highlight.

The INNER WIDTH scales the area in the center of the highlight where the intensity stays the same.

The visual display of the resulting highlight is very helpful, as these parameters are very theoretical. The curve above the slider represents the intensity of the highlight. The center of the lower edge stands for the location where the light hits the surface vertically.

The height of the curve above this location shows the intensity of the highlight. At the bottom, the more the curve moves away from the center, the wider the highlight will be.

Finally there are three modes available that can be selected in the MODE menu of the SPECULAR channel (see Figure 2.22).

There is a preset PLASTIC mode that can, despite its cheap sounding name, be used for almost all surfaces. It creates a highlight that can be controlled independently from the pa-

object. The highlight is therefore better integrated and blends in more.

Figure 2.22 shows these three modes together with the same settings for the highlight.

There are also other possibilities for coloring in highlights individually.

The Specular Color Channel

To add color in highlights, the SPECULAR COLOR channel can be used. The highlight can be colored with either a color value or a texture.

Dark areas in the texture can cause weak highlights, or black parts can make the highlight totally invisible. This channel is perfect for creating different kinds of shininess on one material.

Figure 2.23 shows on the example of the YingYang sign that there are no highlights in the dark areas of the surface.

— Figure 2.22: Specularity.

rameters of the other channels. The highlight intensity will be added to the already existing brightness of the surface.

The METAL mode is a different story. This mode darkens the whole object and creates a weak highlight. Often, values way above 100% have to be chosen to show some shininess.

The reason is that metals mainly function through their reflective property. The surface color is therefore darkened. I recommend the use of the PLASTIC mode when metal should be created. That way, the coloring and brightness of the surface stay predictable.

In COLORED mode the color of the highlight is adjusted to the color of the surface of the

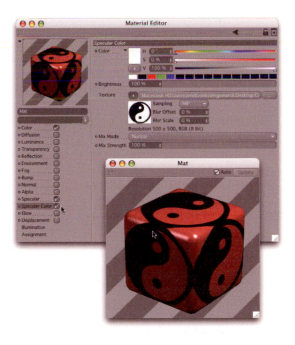

— Figure 2.23: Specular color channel.

The Glow Channel

There are situations where an illuminated or hot surface has to be simulated. For these cases the material system of CINEMA 4D offers the GLOW channel, which can generate a glow around the object (see Figure 2.24).

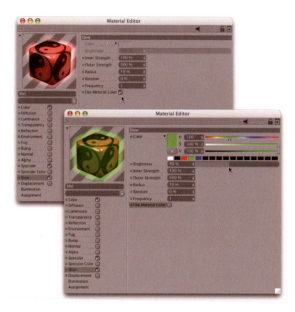

— Figure 2.24: The Glow effect.

This glow is part of the so-called post effects, which means that it is not calculated at the same time as the rest of the material properties. The advantage is that post effects can be calculated very fast.

The disadvantage is that post effects can no longer interact with other channels of the material. This means that the glow effect cannot, for example, be reflected on other objects or be visible behind transparent objects.

The color of the glow can be set with the color chooser or be taken from the surface color when USE MATERIAL COLOR is active.

The latter has the advantage that the coloring of the object is not influenced by the color of the GLOW effect. The upper part of Figure 2.24 shows this. The lower part of Figure 2.24 shows how the color of the object is changed by the color of the GLOW.

The three-dimensional expansion of this effect can be set with the RADIUS value. It defines the maximum expansion of the glow starting from the surface of the object.

The intensity of the effect can be set separately for the surface and the outer area. The intensity on the surface will be set in the INNER STRENGTH parameter and is usually lower than the outer radius. That way, the color of the surface is not influenced as much.

The intensity of the glow can be varied by the number set in the random value when an animation is planned that should use this effect. The speed of the variations is controlled by the frequency value.

As is common in physics, the frequency describes the number of oscillations per second. The value of 1 generates a rather sedate speed of one change of GLOW intensity per second.

When a movie runs with a frame rate of 24 images per second, for example, a value of 24 would result in a jitter because the GLOW would have to be calculated for every single image.

The Displacement Channel

At first it looks like DISPLACEMENT works like the BUMP or NORMAL mapping. The big difference though is that the surface can actually be deformed by the luminescence of a loaded picture or shader.

In normal mode the points of the object, which has the material applied, will be moved. The amount of movement is the result of multiplying the STRENGTH slider with the HEIGHT value.

When the HEIGHT and STRENGTH settings are positive, the light places in the loaded picture cause the points to be moved outward along the surface normals. Dark areas will be lowered and moved inward (see Figure 2.25).

The TYPE menu controls how the original position of a point will be kept.

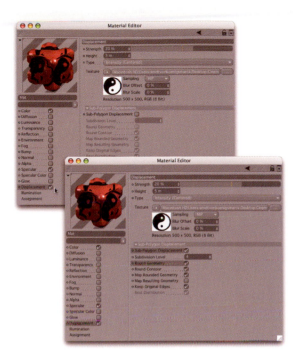

— Figure 2.25: The Displacement channel.

In INTENSITY mode a black textured point will not be moved at all while a white one moves to the maximum height. INTENSITY (CENTERED) bases its calculation on a brightness of 50%. Dark points move below and light points above this center line.

The following modes are more abstract. These will not be used very often, as it is difficult to predict their outcome.

The RED/GREEN mode only affects the red and green parts of an image. The more red there is in a pixel, the deeper it gets pushed into the object. With more green, the pixel will be moved outward along the normals.

The modes RGB (XZY LOCAL) and (XYZ WORLD) work similarly, but are based on two different reference systems.

All three color components will be evaluated. The red part moves the pixel in the X direction, the green part in the Y direction, and the blue part in the Z direction. The direction of the normals does not matter in this case.

The modes determine the use of the local coordinate system or the world system on the object with the applied material.

All modes have in common that the DISPLACEMENT effect can only be shown where there are points on the object. The more subdivided the object is, the finer the details shown with this technique. With the BUMP and NORMAL effect this did not matter.

Sub-Polygon Displacement

We are in a bit of a dilemma. It would be nice to replace BUMP mapping with the higher quality DISPLACEMENT mapping, but then the object's subdivision would be so high that editing it would be difficult.

There is a solution if the Advanced Render module is installed. It is called SUB-POLYGON DISPLACEMENT.

When this option is active in the DISPLACEMENT channel, the number of additional subdivisions of the object can be set with the SUBDIVISION LEVEL value. This value works like the SUBDIVISION parameter of a HYPERNURBS object.

We could even replace existing HYPERNURBS objects completely with the SUB-DIVISION DISPLACEMENT, as the option ROUND GEOMETRY activates the rounding of the geometry, including the newly created faces.

Because this is a material property the effect will only be visible when the object is rendered.

The upper portion of Figure 2.26 shows a loaded structure, while the middle part displays a cube smoothed and deformed by the SUB-DIVISION DISPLACEMENT option. The same setup applied to our YingYang symbol in the DISPLACEMENT channel is shown in the lower part of Figure 2.26.

Be aware that subdivisions of the HYPERNURBS objects can be added to the materials with SUB-POLYGON DISPLACEMENT. Objects with this kind of texture should therefore not be used as a subordinate of HYPERNURBS objects.

The number of subdivisions could quickly rise to enormous amounts.

— Figure 2.26: Sub-Polygon Displacement.

When ROUND GEOMETRY is active, the ROUND CONTOUR option can determine if the rounding will also be applied to open edges, such as the edge of a plane or the edge of an opening of an object.

This option does not make a difference when applied to a closed object, such as a sphere or cube.

The option MAP ROUNDED GEOMETRY makes sure that the remaining channels will be applied to the material after the SUB-POLYGON has been calculated. This should always be active to prevent distortion of the texture on the surface.

However, the object does not need to be rounded. The subdivisions created by SUB-POLYGON DISPLACEMENTS might be enough to use for the display of the loaded image.

Figures 2.27 and 2.28 show the effect and demonstrate the BEST DISTRIBUTION option at the same time. This option is only available when ROUND GEOMETRY is deactivated.

Small bevels will appear between the cube sides when BEST DISTRIBUTION is deactivated (see Figure 2.27). This is because no normals, smoothed by the PHONG angle, were used for the DISPLACEMENT.

Figure 2.28 shows the same scene, but this time the BEST DISTRIBUTION option is activated. The DISPLACEMENT follows the smoothed normals and does not generate a visible transition at the cube edge anymore.

It can also be seen that the YingYang sign is sloped outward and enlarged.

The option MAP RESULTING GEOMETRY determines at what time the remaining channels are applied to the object. When this option is deactivated, the material is calculated before the points are moved. It could happen that the colors and shapes of the loaded image are smudgy and be distorted by the DISPLACEMENT map.

When this option is activated, the material properties will be applied after deformation of the surface. The result mainly depends on the projection method of the texture. Materials applied with UV mapping are not affected by this option, as every point of the

— Figure 2.27: Sub-Polygon Displacement without rounding.

— Figure 2.28: With best distribution.

Texture Settings

Maybe you have already noticed the BLUR and SAMPLING settings displayed next to the Preview window of a loaded image (see Figure 2.29).

These settings are the same for every channel that works with textures. Because the original size of an image is changed when being applied to an object, it is determined here what methods are used for scaling and interpolation.

Figure 2.29 already shows a comprehensive list of all properties of a loaded image. These parameters can be seen by clicking on the preview image.

The parameters are split into three groups. In the basic group there are two sliders for BLUR OFFSET and BLUR SCALE, in addition to the NAME and LAYER menu.

The BLUR OFFSET can be used to blur the image. The BLUR SCALE value controls how precisely the image will be calculated. It also influ-

object "knows" which part of the texture is meant for it.

We will learn more about the different projection methods and their usage later.

The option KEEP ORIGINAL EDGES keeps hard edges where the PHONG shading was turned off at the original object.

With our cube the PHONG tag is set to an angle of 80°. Therefore, the cube has hard edges.

When the KEEP ORIGINAL EDGES option is activated, these edges will remain hard even though this effect is somewhat reduced by the rounding of the geometry.

— Figure 2.29: Settings for loaded images and sha-
ders.

— Figure 2.30: Shader settings.

ences interpolation of the image in the MIP
and SAT Sampling mode.

Negative Blur Scale values result in a
sharper image. Values above 0% will blur the
image. Blur Scale with a Blur Offset value of
0% can therefore be used to blur an image.

The Sampling menu, mentioned earlier, can
be found in the Shader settings group (see
Figure 2.30).

Only the MIP and SAT modes allow the use
of Blur values. Of these two modes, SAT sam-
pling delivers better quality but also needs
multiple times the memory.

It makes sense to soften images with the
blur settings to avoid the flicker or vibration
that occurs when using fine structures in ani-
mations.

The remaining Sampling modes do not of-
fer Blur settings and are used to sharpen the
image. The difference between modes is often
marginal and only visible when extremely en-

larged. Check the Online Help if you are inter-
ested in finding out about the fine differences
of these modes.

The setting None deactivates every addi-
tional interpolation of image pixels. This mode
should be used when the image already has a
high resolution.

With the Layerset menu, a special window
can be opened where alpha channels or layers
of a loaded BodyPaint or Photoshop file can be
activated or deactivated. This eliminates the
additional step of switching between different
programs (see Figure 2.31).

In Layers/Layerset mode all layers of a
loaded image can be seen. When the Show
Layer Content option is also activated not
only will the names of the layers be displayed,
but also their content and icons.

The layers that need to be used in the ma-
terial can be marked by clicking on the name
of the layer. Selecting multiple layers can be
done by holding the Ctrl key.

The option Layer Alpha turns selected lay-
ers into alpha masks where transparent areas
will be filled with black. All other parts will be
filled with white.

The Layer Mask shows, when available, the
mask of a selected layer.

Alpha Channels show alpha maps saved as
separate channels. They could have been cre-
ated, for example, in Photoshop by saving a se-
lection.

— Figure 2.31: A Layerset.

The GENERATE ALPHA option only makes sense when used with a LAYER shader. This option turns a loaded image into an alpha mask for other images or shaders within the LAYER shader. We will talk about this shader together with all other shaders later.

After selecting the right mode and the desired layers, we can return to the parameters of the shader group by clicking on the OK button.

The brightness and contrast of the loaded image can also be adjusted directly in CINEMA 4D without having to alter the original.

The brightness of the image can be changed by using the EXPOSURE value, and the gamma value can be adjusted with the HDR gamma value.

The standard preset for Macintosh systems is 2.2, whereas for Windows systems it is 1.8. This is close to the calibration settings used for attached monitors of both systems.

The values for BLACK POINT and WHITE POINT define the bandwidth of brightness in the loaded image. Ideally the values are set in a way that a black point, representing the

brightness value in the image, is entered in the field for BLACK POINT.

The same is done with a white point in the field for WHITE POINT. CINEMA 4D will spread the existing brightness in the image to maximize the range of value.

Of course it is more comfortable to do this in image-editing software, but then the image would have to be changed, saved in the new version, and loaded again in CINEMA 4D.

The values can be adjusted without changing the original image. The RESET button returns to the standard settings and therefore back to the original image.

Animation

Settings in the ANIMATION group are used when the loaded file is an animation in QuickTime or avi format. This setting only makes sense when an animation is calculated in CINEMA 4D.

In the MODE menu it will be determined how often the movie is to be played. SIMPLE plays the animation once, LOOP plays it repeatedly, and PING-PONG plays it forward and backward continuously.

The TIMING menu sets the speed of the movie. EXACT SECOND adjusts the frame rate of the animation so that 1 second in the animation equals 1 second of the animation in CINEMA 4D.

This makes sure that the movie does not play slower or faster even though the frame rates of the movie and CINEMA 4D do not correspond.

When the frame rates are considerably different it may cause skipping or dropped frames in the loaded movie.

When the frame rates of CINEMA 4D and the loaded movie are identical, EXACT FRAMES can be used. This means the next frame of the movie will be loaded when CINEMA 4D moves ahead one frame in the calculation of the animation.

The setting RANGE determines when and how fast the movie should be played within CINEMA 4D. RANGE START sets the time of

when to start and RANGE END the time to stop the movie.

When a movie is 50 frames long and plays in the RANGE of 0 to 25, it will run twice the speed. With the LOOP value the number of loops can be set.

CINEMA 4D uses the number of frames and the frame rate of the loaded movie as a basis for the calculation. In most cases these data will automatically be entered into the fields MOVIE START FRAME, MOVIE END FRAME, and MOVIE FRAME RATE. These values can be manipulated and, for example, as a result one frame of the movie can be used as an image.

In order to accomplish this set MOVIE START FRAME and MOVIE END FRAME to the same frame numbers.

After we have learned everything important about the material channels and the loading of images and movies, we will take a look at the remaining settings in the MATERIAL EDITOR.

Illumination Settings

When the desired material has been determined by adjusting the channels, the basic settings can be set in the ILLUMINATION page of the MATERIAL EDITOR (see Figure 2.32).

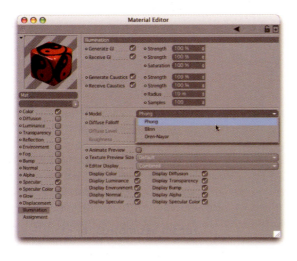

— Figure 2.32: Selection of the shading system.

In the upper part, options can be found that define the behavior of the material when the radiosity calculation is used. There it can be determined how much light will be generated and received. The saturation of the incoming light can be controlled in these options too.

In the lower section are the settings for caustic effects. This is the visible refraction and bundling of light in transparent and on reflective surfaces.

Radiosity and caustics are only available when the Advanced Renderer is installed.

The shading of the material created by normal CINEMA 4D lights is not influenced by these settings. This can be changed by the settings in the model menu. Here there are three systems that define the behavior of light on the surface. The PHONG setting is the most used of the three. It creates a balanced relationship among light, shadow, and highlights.

The BLINN system shades the surface like the Phong model but shows a bigger and stronger highlight.

The OREN-NAYAR model is suited for dull or rough surfaces. The shading and highlight have less contrast. This can be set even more precisely with the DIFFUSE LEVEL and ROUGHNESS parameters. The DIFFUSE LEVEL value controls the brightness of the whole shading. The ROUGHNESS parameter adjusts the simulated roughness of the surface. Larger values increase the spreading of light on the surface and let the object appear even duller.

In all three modes, on surfaces bent away from the light source, the reduction of shadow brightness can be increased with the diffuse FALLOFF value.

When the material channels contain movies, the option ANIMATE PREVIEW can be activated to see the animated material in the editor. The animation has to be played in CINEMA 4D in order to see it. All necessary information about the subject animation will be discussed in a later chapter.

The TEXTURE PREVIEW SIZE determines the resolution of the material preview in the edi-

tor. This setting can become very important when, for example, images are used as templates for models.

The menu offers a variety of common resolutions and informs about the required memory. This setting does not influence the quality of the material in the rendered image. It is only meant for the display in the editor.

The setting in the EDITOR DISPLAY menu sets the visibility of the material channels. Again, this has nothing to do with the final calculation of the surface and only benefits the display in the editor.

For example, when the COLOR channel is selected, all other channels are invisible. This could be helpful when determining the effects of light on just this channel.

The setting COMBINED calculates all active channels and shows all material properties.

The options underneath this setting allow us to activate certain channels or to make them invisible in the editor. That way, various material properties can be combined that should be shown in the editor.

2.3 Applying Materials

Materials cannot be used by themselves in a three-dimensional space. They have to be applied to objects first in order to be visible.

The most comfortable way to apply materials can be done with all basic objects and NURBS objects that work with splines. Simply pull the material from the MATERIAL MANAGER onto the object in the OBJECT MANAGER (see Figure 2.33).

What Are UV Coordinates?

Spline NURBS and basic objects automatically contain the so-called UV coordinates. They determine which part of the texture should be visible at each point of the object.

— Figure 2.33: Applying materials.

These coordinates have the advantage of allowing the texture to follow the deformation of the object. The material applied to the face of a figure would move also when the mouth is opened or the head turns.

The disadvantage of these UV coordinates is the time it takes to assign and adjust them to the shape of the object.

This also affects the basic objects and NURBS objects when they are changed. It includes every step that deletes or adds points, edges, or polygons.

These objects only have usable UV coordinates in their original shape and, after finishing the modeling, need to have new UV coordinates assigned to them.

Do not be confused by the tags with the checkerboard pattern behind the converted object in the OBJECT MANAGER. This only shows the existence of UV coordinates for the object. It does not tell us if these coordinates are still up-to-date. Data in the UVW tags is not automatically updated after the use of Polygon tools.

In addition to UV, there is also the term UVW in CINEMA 4D. These are the normal UV coordinates of the surface of the object with the additional W component. This additional component describes the distance of a UV coordinate from the surface of the object.

The W part of a UVW tag can be edited with the STRUCTURE MANAGER, but is of no use

for the majority of materials. This value is only used by certain shaders that change depending on how deeply they are penetrating the object.

For example, there is a shader that simulates wood grain or the marbling of stone. In these cases the W component is used for the calculation.

We will mainly talk about the two-dimensional UV coordinates that can, for example, be edited in BodyPaint 3D.

The Quality of Textured Objects in Editor Viewports

We already talked about the advantages of OpenGL acceleration of the viewport display.

The ENHANCED OPENGL option, which can be activated in PREFERENCES of CINEMA 4D or the DISPLAY menus of viewports, goes one step further. It enables the display of many material properties directly in the editor without having to render the image.

Even shadows and transparencies can be displayed, depending on the activated option.

Additionally, a portion of the quality of the display can be individually set for each material in the ILLUMINATION page of the material dialog (see Figure 2.34).

The menu EDITOR DISPLAY provides all important material channels and allows a selection of just one channel in the viewports. This is helpful when the settings of one channel need to be checked.

All of this influences only the display in the editor. All material properties will be shown when the image is rendered.

Not all material properties can be simulated and displayed perfectly by OPENGL. Therefore, it is necessary to test render the image to fine-tune the material and light settings.

Overview of Textured Objects

In a complex scene it is not always possible to see where a certain material was used. In this

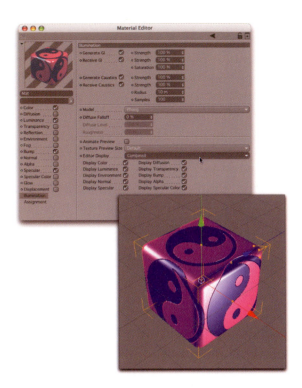

— Figure 2.34: The display of textured objects in the editor.

case the ASSIGNMENT page in the material editor can help (see Figure 2.35).

— Figure 2.35: The assignment page of the material.

On this page is a list of all objects that have a particular material assigned to them. When a group has the material applied to it, only the top object will be shown in the list, even though all the subordinated objects take on the material as well.

Multiple functions are shown with a right click on an object in the list. One such function is the selection of an object in order to find it easier in the OBJECT MANAGER or in the viewports.

To get a better overview of the materials used, choose REMOVE UNUSED MATERIALS or REMOVE DUPLICATE MATERIALS in the FUNCTION menu of the MATERIAL MANAGER. This makes sure that there are no duplicated or unassigned materials.

Finally we will take a look at the material editor and its options for displaying materials.

2.4 Organizing and Editing Textures

The MATERIAL MANAGER has other functions in addition to listing existing materials. For example, the display of the material can be optimized in the EDIT menu, depending on the usage (see Figure 2.36).

The mode MATERIAL previews all materials next to each other. MATERIAL LIST turns it into a list with columns. In addition, the size of the material icon can be set in the lower part of the EDIT menu.

To get a better overview of the loaded images in the materials, use one of the following modes.

LAYER MANAGER (COMPACT) shows the materials underneath each other but also has other functions. Next to the material preview image there is an X symbol. A list of all bitmap files loaded in the material will be shown next to it when it is clicked. In our case, only the YingYang symbol is loaded in the COLOR and BUMP channel.

— Figure 2.36: Modes of the material manager.

In order to find out in which channel the image was loaded, we just have to look at the headline where the names of the channels are displayed. They are the COLOR and BUMP channel, as can be seen in Figure 2.37.

— Figure 2.37: Working with layers.

In this mode the MATERIAL MANAGER works almost like a drawing program. You can draw directly in the loaded images using the draw

functions of BodyPaint 3D or new layers can be created, as shown in the lower part of Figure 2.37.

New layers can be created in the TEXTURE menu of the MATERIAL MANAGER.

A display that is even more oriented toward the layer system can be activated at LAYER MANAGER (EXPANDED). The mode (EXPANDED/COMPACT) shows both kinds of displays (see Figure 2.38).

— Figure 2.38: Layer Manager (expanded/compact).

In order to tell CINEMA 4D which material channel and image / layer will be painted, click on the preview of the image or layer. It will then be shown with a yellow frame.

It can only be painted in one image at a time. However, there are situations where it makes sense to paint in multiple layers. For example, a color can be changed in the COLOR channel, and at the same time the paint strokes create a bump map in the BUMP channel. This is an advantage because the color and bump will match 100%.

In order to activate this mode, click on the icon in the upper left corner of the MATERIAL MANAGER (see Figure 2.38). The icon will then be highlighted. From now on, several pen icons next to the row names can be selected.

The color fields under the names of the rows represent the foreground and background colors, which can be used to paint within these rows. With a click on these color fields, a color chooser can be accessed, as shown in Figure 2.39.

— Figure 2.39: Settings for painting.

In addition to a color, a structure may also be loaded by clicking on the arrow button in the WALLPAPER part of the dialog. With the sliders, the color can then be overlaid and mixed with this structure just like in a material channel.

The switch between foreground and background color is achieved by clicking on the icons in the CHANNEL column of the dialog.

These are pretty much all of the settings of the paint functions in the standard layout of CINEMA 4D. Let us take a look at Body-Paint 3D.

Painting with BodyPaint 3D

BodyPaint 3D is an integrated module in CINEMA 4D that lets us paint objects and edit textures. The advantage here is that the objects can be directly painted on and the results are immediately displayed.

Furthermore, BodyPaint 3D offers a series of tools that can edit the UV coordinates and edit the position of the texture on the object. We will talk about this in detail later.

First we will take a look at the paint tools. Luckily for beginners, most of the paint tools in BodyPaint 3D work just like similar functions in other paint programs. For example, a brush can be used to paint or a smudge tool to smear colors.

Working with bitmap textures also follows these standards as we have already seen in the MATERIAL MANAGER. Therefore, we will start right away and modify our YingYang material so that the YingYang symbol will be in the COLOR channel without the multiplied color value.

In the next couple of steps we will paint directly on the object. In order to get an unaltered result, we should turn off the glow.

First we have to switch the layout, as the standard layout of CINEMA 4D does not include elements of BodyPaint 3D. There are two layouts available. We will use the BP3D PAINT layout, which includes all managers, menus, and icons for the painting and texturing of objects.

Figure 2.40 shows the slightly modified material, which is still assigned to the rounded cube and the menu to change the layout.

Make sure that there is an additional layer above the YingYang image. We will use this layer to paint in. We could paint in the YingYang image directly, but that would alter it permanently and certain options would become unavailable, such as changing the opacity of the painted layer.

New layers may be created in the TEXTURE menu of the MATERIAL MANAGER. In order to do this the material has to be active. In case it is not active, click on the X symbol to the right of the preview image of the material in the LAYER MANAGER view of the MATERIAL MANAGER. Choose the channel below where the new layer is to be created.

In our case it does not matter if the BUMP or COLOR channel is selected because both

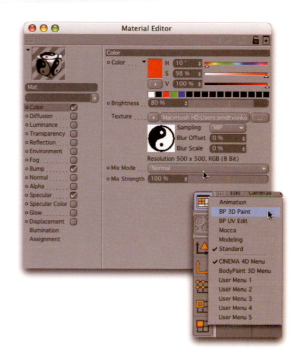

— Figure 2.40: Adjusting the material and change of layout.

have the same bitmap. Painting in the COLOR channel will automatically change the BUMP channel as well.

The BodyPaint 3D Layout for Painting

In order to ease the introduction into the BP3D paint layout I will go over the most important command groups and manager (see Figure 2.41).

Icons marked with the letter A in the image are already partly known. There is the layout menu as well as the UNDO and REDO functions. These are supplemented by an extra UNDO function used only for the DRAW functions of BodyPaint 3D.

The PAINT SETUP WIZARD can be found here as well, which guides you through different settings.

New materials can be created and prepared for painting in your objects instantly.

Icons with the letter B work like the operating mode. The brush icon activates the PAINT

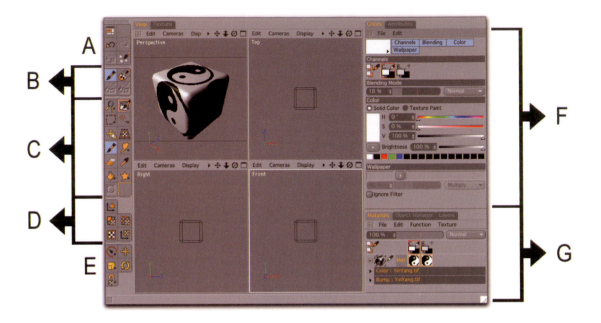

— Figure 2.41: BodyPaint 3D layout.

mode, and the icon next to it activates the PRO-JECTION mode. The latter allows the projection of brush stokes and images onto the objects. BodyPaint 3D ensures that the projection will be adjusted to the shape of the object.

The two icons in the second row of this group confirm or delete this projection. That way, several projected brush strokes and images can be layered on top of each other.

Tools can be found at the letter C. Many should be familiar from other graphics programs. For example, a selection tool, a brush, an eyedropper, and tools for filling faces or for creating common shapes can be found here.

Icons in group D will be relevant when we work with UV coordinates and texture projections. With these icons it can be decided whether the UV coordinates of a whole polygon or point should be edited.

Icons in group E look like the already familiar selection and manipulation tools. Here, the MOVE and ROTATE tools can be activated to influence UV coordinates.

The shape of the object will not be changed because the UV coordinates are independent from the point coordinates of the object.

At the letter F we find the familiar color chooser, which can also load complex structures to be used as brushes. Connected to this window is the ATTRIBUTE MANAGER, which lets us edit the parameters of the selected tools.

In the window group of letter G the MATE-RIAL MANAGER, OBJECT MANAGER, and LAYER MANAGER can be found.

The LAYER MANAGER only shows the bitmaps and layers selected in the MATERIAL MANAGER.

Between these icons and managers, the familiar editor viewports can be found. Connected to them is the TEXTURE view. This view displays the currently selected bitmap with all existing layers. The bitmap can be painted directly on the object inside this window or in the viewport.

It is necessary to activate the PAINT mode in the group with the letter B and the BRUSH tool at letter C in order to start painting. Both icons show the same stylized brush.

In the ATTRIBUTE MANAGER the direction, size, and shape of the brush can be set.

 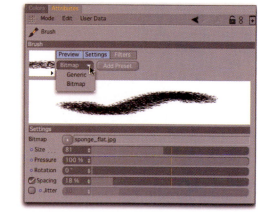

— Figure 2.42: Configuring the Brush.

We have two modes available, GENERIC for simple, round, or square brushes and BITMAP for various structured brushes (see Figure 2.42).

In BITMAP mode a list of the installed bitmaps is displayed and a shape can be selected by clicking on the small arrow at the BITMAP parameter in SETTINGS.

Brush Presets

If you do not want to take the time to adjust these settings, there is a selection of generated and bitmap brushes. This list can be opened by clicking on the brush preview (see Figure 2.43).

These presets are already partly colored or combined with filters.

These brushes then work like an exposure tool or a colored smudge tool. As we can see, they are also useful for other things besides painting.

Another preview of installed brushes is accessible at BRUSH PRESETS in the WINDOW menu of BodyPaint 3D (see Figure 2.44).

This kind of list offers a more organized structure, as all brush shapes are sorted in folders. A double click on the preview images opens the preset in the ATTRIBUTE MANAGER.

Brush Settings

Brushes may also be scaled, rotated, and their opacity changed.

The SIZE parameter is self-explanatory. There is a preview of the brush itself and also the resulting brush stroke.

What all these parameters do is shown in detail in Figure 2.45. Every row displays the minimum and maximum parameter setting.

The PRESSURE setting defines the intensity of the brush, whereas HARDNESS controls the density between the center and the edge of the brush stroke.

Every brush stroke contains a row of single brush tips. The distance between these brush tips is determined by the SPACING value.

The JITTER value allows variations of the brush tip and creates differently scaled copies of the brush tip.

The SQUEEZE parameter squeezes the brush laterally. In order to see the effect of this parameter, I raised the SPACING value in Figure 2.45.

It makes sense to use the ROTATION value, which rotates the brush, in combination with this parameter. In practice though, it will be difficult to adjust the angle to the movement of the brush in order to get the desired result.

— Figure 2.43: Brush presets.

We will learn about other possibilities of controlling the rotation of a brush with, for example, a graphics tablet.

— Figure 2.44: Brush presets.

Individual Brush Profile Settings

In addition to these values, the density inside the brush tip can be set. Use the PROFILE menu in the SETTINGS of the brush.

Along with the common gradients, an editor for BRUSH PROFILE can be opened. Click on the blue dot in front of the word *Profile* in the USER-DEFINED setting (see Figure 2.46).

A custom profile for a brush can be designed with this curve.

The EFFECTOR SETTING dialog works in a similar manner and opens by clicking on the name of the parameter (see Figure 2.47).

When the use of a graphics tablet has been activated in the presets of CINEMA 4D, the tilt and pressure of the pen on the tablet can be

— Figure 2.45: Effects of the Brush parameter.

— Figure 2.46: Individual Brush profile.

— Figure 2.47: Effector settings for painting.

used to control the brush tip. These settings may also be useful without the tablet.

The curves can be set for each parameter separately. The blue dot in front of the parameter name determines where additional effector curves were created.

The activated DRAW DIRECTION curve at the ROTATION parameter allows the brush tip to orient itself on the shape of the brush stroke. Combined with a larger SPACING value and a square brush tip, it becomes possible to paint zippers or seams.

With the DISTANCE curve the brush strokes can fade over distance. This simulates natural brushes. For example, Figure 2.47 shows how to influence the look of brush strokes. With the LOOP value the brush stroke can be repeated multiple times when the PIXEL LENGTH is shorter than the overall length of the painted brush stroke.

Here I would like to recommend the online help in order to learn more about all of the settings for the brushes. It would take too long to list here all of the options and functions.

Instead, I would rather practice. Choose a random foreground color in the COLOR channel for the brush and select any brush tip shape.

Painting the Object with the Brush

In the editor view the mouse pointer changes to the shape of a brush when it is over the object with the active material (see Figure 2.48).

— Figure 2.48: Painting on the object.

By holding the left mouse button, the preset color can be painted onto the object with the preset brush. In addition, there is a stylized preview of the brush size projected onto the object. That way, it can be seen exactly where the color will be applied before the mouse button is pressed.

You may wonder why multiple spots are painted at the same time and not just the area at the mouse pointer.

The reason is that the material currently uses the UV coordinates of the cube. The standard UV coordinates determine that every side gets a copy of the material. This is the reason why the YingYang symbol appeared automatically on all sides of the cube.

Let us leave it like that until we work with projections and UV coordinates.

As discussed earlier, we are painting in the COLOR and BUMP channel at the same time, as both have the same image. Therefore, the new layer was created and painted in both channels.

This means that a brush stroke not only colors the surface but also raises and lowers it op-

tically with the BUMP effect. This depends on the color setting for the foreground color of the BUMP channel in the LAYER MANAGER.

In order to paint in another channel, the image needs to be present. For this reason there is the CREATE NEW TEXTURE entry in the TEXTURE field of the materials (see Figure 2.49).

— Figure 2.49: Creating a new texture.

Let us test this on an example of the highlight channel of our material.

Activate the SPECULAR COLOR channel in the MATERIAL EDITOR and choose CREATE NEW TEXTURE in the TEXTURE menu of the highlight color.

Now you are asked for the desired size of the texture and the background color. This color should be chosen with care, depending on which material channel the texture will be applied to.

In the BUMP channel, a 50% gray would make sense, as this marks the midpoint between white and dark faces. As we know, light color values are interpreted as elevation and dark color values as impression.

When we want to define areas for high-lights by painting them, we should use black as the background color. The object would then not have any highlights and would react well to our painted color values.

After this dialog is set and applied with the OK button, the new texture will appear in the MATERIAL MANAGER. It can then be activated by clicking on it (see Figure 2.49).

Select a random brush and activate a reddish foreground color. Paint the edges of the cube as shown in Figure 2.50.

— Figure 2.50: Painting highlights.

When the standard light is at the correct angle, the highlights can be seen in the painted areas. The highlights also take on the painted color.

If necessary, move the position of the DE-FAULT LIGHT in the DISPLAY menu of the editor viewports until a good lighting situation is achieved.

Now we know how materials are applied and textures are painted. Let us explore how to use UV coordinates and projections.

The Projection of Materials

So far we have not had to think about the projection of the material. The material was sim-ply pulled onto the object and adjusted itself automatically. This is the advantage of existing UV coordinates of basic objects and NURBS objects, which work with splines.

However, when the material is not placed on the object the way we envisioned it or when we work with edited basic or NURBS objects, we need to use the projection.

There are different ways to project the material in a spherical, cylindrical, or planar way. This works much like a slide projector that projects the material onto the object.

The disadvantage of these projections is the distortion of the material at places where the surface of the object is not perpendicular to the direction of the projection. On complex surfaces where it is important to have an exact fit of the material, these projections are only used to generate UV coordinates, which can then be further adjusted.

The advantage of these projections is the easy adjustment of position and size. This is helpful, for example, when stickers or logos are to be placed precisely onto an object.

Let us take a quick look at the different kinds of projections and how to handle them.

The Texture Tag

After applying the material, a new tag appears that shows a small preview of the material behind the object in the OBJECT MANAGER. This so-called TEXTURE tag controls the projection of the material (see Figure 2.51).

Under the MATERIAL field of the TEXTURE tag in the ATTRIBUTE MANAGER, where the applied material is shown, is the SELECTION entry.

Here, a POLYGON SELECTION tag can be dragged and dropped from the OBJECT MANAGER. Now the material is shown only on surfaces that are saved in the selection.

Below is the PROJECTION menu where the different directions for the projection can be chosen. The setting in the SIDE menu determines if the material is to be shown only on the front or back or on both sides of the polygon.

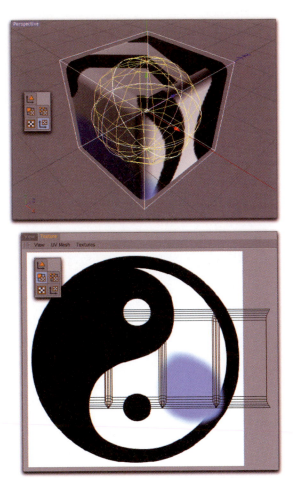

— Figure 2.51: The Texture tag.

Different Kinds of Projections

One basic rule is that when no UVW coordinates can or should be used, the projection should be adjusted to the shape of the object. A surface could have a cylindrical or spherical projection applied, a computer housing or refrigerator a cubical one, and a poster would have a planar projection.

Let us start by setting the projection in the TEXTURE tag to spherical. Activate the TEXTURE AXIS mode in order to see the position of this projection in three-dimensional space. The icon can be seen in the upper part of Figure 2.52.

The yellow sphere represents the surface from where the material is applied to the cube.

The shape of the sphere already indicates that this kind of projection will cause problems on the poles of the sphere. The material would be condensed at these places and be extremely deformed.

Switch to the TEXTURE view of BodyPaint 3D to get an idea as to which part of the texture is applied to what part of the object. This view is combined with the editor viewports and can be brought to the foreground by clicking on the tab.

— Figure 2.52: The spherical projection.

The TEXTURE view shows an enlarged preview of the activated bitmap or layer. To see an additional display of the superimposed surfaces of the cube, activate the UV POLYGON or UV POINT mode. The icon of the activated UV POLYGON mode can be seen in the lower part of Figure 2.52.

In the overlay the four large sides of the cube can be seen clearly, including the rounding in between. However, the upper and lower surfaces cannot be seen as well. The reason is the tapered shape of the sphere at the poles, which explains why the YingYang symbol is extremely deformed on these two sides.

The spherical projection is meant mainly for materials that have no visible structure. When images are to be used, they should be adjusted to this kind of projection and have the right pole coordinates.

This category includes, for example, 360° panoramic images of landscapes and rooms. However, we do not have to leave the projection the way it is. It can be moved, rotated, and scaled.

Switch back to the TEXTURE AXIS mode and select the move, rotate, or scale icon.

The yellow projection sphere can be moved freely (like a normal object) and be independent of the object.

I rotated the projection sphere a bit, as shown in Figure 2.53. The material on the cube follows the rotation automatically. This can be seen very well in UV POLYGON mode in the TEXTURE window as shown in the lower image of Figure 2.53.

The Flat Projection

Let us try the FLAT PROJECTION next (see Figure 2.54). It works much like a slide projector. Therefore the direction of the projection is even more important than the other projection modes.

The advantage is that with this kind of projection, materials can be applied precisely to flat surfaces.

Because a material does not have to cover the whole object, it is possible to apply the texture to curved surfaces to simulate, for example, a sticker.

In addition to manual work with the texture projection, there are some additional functions in the TAGS menu of the OBJECT MANAGER. These functions allow the axis system of the projection to snap to the axis system of the object.

Another command scales the projection so that the whole object will be covered.

The FIT TO REGION command in the TAGS menu is very interesting, especially when used

— Figure 2.53: Manipulating the projection.

— Figure 2.54: Switching to the flat projection.

in connection with the FLAT PROJECTION. When this command is active, it is possible to draw with the mouse a frame in the perspective viewport. The material will then be fitted to the frame size and aligned parallel to the camera.

A possible result is shown in Figure 2.55. This saves us the steps involved to manually move, scale, and rotate the flat projection.

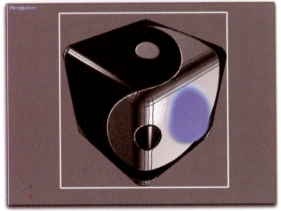

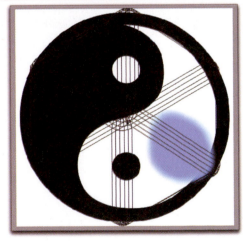

— Figure 2.55: Aligning the projection.

The camera is moved to the desired spot and a frame is drawn around the area where the material is to be seen.

The overlay of the cube faces in the Tex-ture window proves that the marked area fits exactly into the YingYang sign.

In Flat Projection we need to pay close attention to the extreme deformation of material that occurs on surfaces perpendicular to the projection plane. The material only looks perfect in the camera view. This can be seen when we move around the cube in the perspective viewport.

Working with Material Tiling

In some cases this effect can be softened by tiling the material, which means continuous repetition of the material. It is like putting multiple tiles next to each other in all directions.

This Tile function in the Texture tag is activated by default and ensures that the object is covered with the material even if the projection is not applied to the whole object.

We can test this function ourselves by scaling the flat projection in Texture Axis mode (see Figure 2.56).

New copies appear on the object, as can be seen in Figure 2.56. This is helpful when certain patterns have to be created, such as a perforated metal plate.

The picture does not have to contain all the holes. We just need a square image with one hole. This image would then be tiled.

There are additional parameters for tiling in the Texture tag. The Seamless option activates alternate mirroring of the material tiles. This is helpful when images and structures are used that were not adjusted to the tiling. In these images the tiling is obvious, as the left and right edges do not fit to each other and the edge of every tile is very prominent. The Seamless option mirrors every second tile and puts the same edges next to each other.

The number of tiles can be set separately for both directions with the Tiles X and Tiles Y values. The Offset value moves the original start tile.

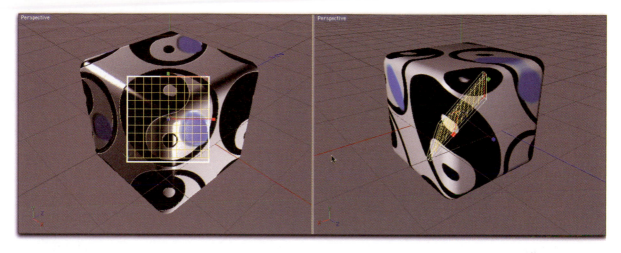

— Figure 2.56: Tiling the material.

Tiling does not always make sense. A logo should, in most cases, only appear once on a certain spot on the object.

In this case the tiling can be turned off completely in the TILE option. Then the material can be seen only in the area where the projection is placed (see Figure 2.57).

Now we get to cylindrical projection. As the name implies, the material is wrapped cylindrically around the object. This is great for the texturing of cans, bottles, or even a limb.

Use the ADAPT TO OBJECT AXIS in the TAGS menu of the OBJECT MANAGER to snap the cylindrical projection to the axis of the cube.

The only problematic region is the top and bottom caps of the cylinder. The texture tapers extremely on this spot. We already know a less extreme version of this effect from the spherical projection. Therefore, I adjusted the tiling again, as shown in Figure 2.58.

We have to pay attention to the fact that, like with all circular or ring-shaped projections, only whole-numbered values are used for TILES, as otherwise there would be a partially visible tile where the beginning and end of the unfolded projection meet.

The Cubical Projection

With a cubical projection, one tile of the material will be projected onto the object from all six directions. This is exactly what the cube shows with an active UVW projection in Figure 2.59.

All sides of the cube show the same material, which is why there is only one side of the rounded cube shown in the TEXTURE window. All other sides are placed above this location.

The Frontal Projection

The frontal projection looks at first like the FLAT PROJECTION. The main difference is that there is no connection between material and object. The material depends only on the view in the camera of the object (see Figure 2.60).

The current camera becomes, therefore, the projector of the material.

The CAMERA MAPPING mode is very similar to frontal projection. The difference is that at CAMERA MAPPING, a camera can be assigned to project the texture onto the object. This means that several cameras can project textures whereas others are used to render the image.

The advantage is that the camera, which is designated to render the image, can be moved freely without it shifting the texture.

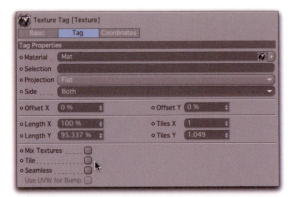

— Figure 2.58: Cylindrical projection.

— Figure 2.57: Deactivating tiling.

Shrink Wrapping

Finally we will take a look at the projection in SHRINK WRAPPING mode (see Figure 2.61).

This mode pulls the material over the object like a rubber glove. It can cause extreme distortions and produces unpredictable results. In practice this method is rarely used, as the goal is mostly to avoid distorting the material when it is projected.

In the next section we will go over the possibilities of individual assignment of materials. This includes the handling of UV coordinates and the use of POLYGON SELECTION tags.

Editing UV Coordinates

As mentioned previously, all basic objects and NURBS objects have the UVW coordinates already included, even if these are not visible as a UVW tag in the OBJECT MANAGER.

The advantage is that applied materials adjust immediately to the surface. In many cases it is necessary to adjust the projection to the shape of the object.

Therefore, we need to switch to standard projections, such as spherical, cubical, or planar mapping. We have already talked about these projections.

Another way to individualize application of the material is by adjusting the existing UV coordinates. In order to do this, the NURBS or basic object has to be converted first. Standard UV coordinates are constantly generated as long as the parametric properties are active, which prevents us from manipulating them.

— Figure 2.59: The cubical projection.

— Figure 2.60: The frontal projection.

Therefore, convert the rounded cube to a POLYGON object and switch the layout of CINEMA 4D to BP UV EDIT. This gives us a work environment adjusted for working with UV tools.

Activate the UV POLYGON mode in order to show the overlaid UV coordinates of the cube in the TEXTURE window.

As we have already seen at the cubic projection, all six sides get the same material applied to them. We will now interfere and apply the material once to the top and bottom sides of the cube as well as to the surrounding rounded edges.

The remaining sides also get one tile each of the material, but the round edges are not included. Another material will be applied to them. This simple example will show the basics of working with UV coordinates.

We begin with starting the OPTIMAL (CUBIC) function in the UV MAPPING>MAPPING window (see Figure 2.62). This will map our cube and give us all six sides as separate UV coordinate groups.

Also try the OPTICAL (ANGLE) mode. It analyzes the normals of neighboring polygons and generates connecting groups of UV polygons as long as the angles do not differ too much, although this does not make much of a difference with our cubic shape. Only the order of the UV polygons on the image in the TEXTURE window is different.

Regardless of the mode used we have the advantage of being able to see all UV polygons separately and that no UV faces are on top of each other.

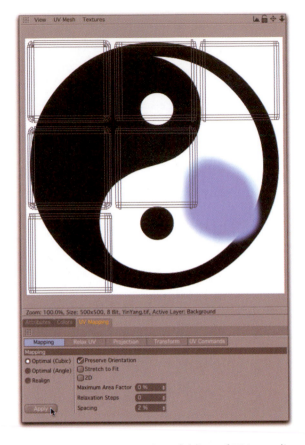

— Figure 2.61: Shrink wrapping.

— Figure 2.62: Automatic unfolding of UV coordinates.

Any selection method can be used to select the UV polygons in the TEXTURE window. Move, turn, and scale them so that the UV polygons are positioned exactly over the desired part of the background image.

We should not do so much by hand but rather let BodyPaint 3D do some of the work. First we have to tell BodyPaint 3D which UV coordinates should be edited. The fastest way to accomplish this is with a selection directly on the object in the viewports (see Figure 2.63).

Activate, if necessary, the UV POLYGON mode and the rectangle selection. Both icons can be seen in Figure 2.63.

Look at the options for selection in the ATTRIBUTE MANAGER. The TOLERANT option should be deactivated. That way, only the UV poly-

gons that are completely within the rectangle selection are selected.

Frame the UV polygons in the upper part of the cube with the selection tool. Hold the Shift key while selecting the UV polygons in the lower part of the cube.

Remember that we are working with UV polygons and not with normal polygons that form the surface of the object.

In the next step we align the UV polygons so they fit exactly the background image in the TEXTURE window. These surfaces are supposed to get a tile of the material applied to them.

A look at the TEXTURE window is a bit sobering. All UV faces are recognizable, but the faces we need are spread over the whole material tile and are not connected (see Figure 2.64).

— Figure 2.63: Selecting UV polygons.

A way of fixing this problem is to apply a different kind of projection to the selected faces.

Interactive Mapping

Luckily, standard projections can be converted into UV coordinates. In this manner we can project one part cylindrical and another part flat.

This function is started with the START INTERACTIVE MAPPING button in the UV MAPPING>UV COMMANDS window (see Figure 2.65).

In the opening standard dialog of the TEXTURE tag we can select the desired projection. We will choose the FLAT mode, as the YingYang symbol can be easily adjusted to the top of the cube.

— Figure 2.64: Selected UV polygons in the texture window.

This projection will also be assigned to the bottom of the cube because it is exactly parallel to the top.

In order to align the FLAT projection to the selected UV polygons, activate the TEXTURE AXIS mode. This will show the familiar yellow preview of the projection plane in the viewports (see Figure 2.66).

Use the rotate tool to rotate this plane around its X axis so that it is positioned parallel to the top and bottom of the cube.

A look at the TEXTURE window confirms that the selected polygons are covered exactly by one material tile.

We can see in the editor that the top and bottom of the cube are covered with the YingYang symbol.

— Figure 2.65: Interactive mapping.

— Figure 2.66: Adjusting the flat projection.

This completes this part of the job, and now we have to end the INTERACTIVE MAPPING mode again. Because the ATTRIBUTE MANAGER does not show the dialogs of the TEXTURE tags, after activating the ROTATE tool we need to reactivate their display again.

Use the left arrow in the headline of the ATTRIBUTE MANAGER. This lets us switch to past dialogs, allowing us to go back to the settings of the TEXTURE tag (see Figure 2.67).

Again we can use the STOP INTERACTIVE MAPPING button in the TEXTURE tag to leave this projection mode.

We achieved a perfect result for the large sides on top and bottom of the cube. The flat projection, though, could not follow the curve of the rounding of the edges well enough. This results in some distortions of the material in these areas. This is a problem typical of the planar projection that we now have to fix.

The Relax UV Function

To unfold UV polygons and force them onto the projection plane, BodyPaint 3D offers the RELAX UV function in the UV MAPPING window (see Figure 2.68).

— Figure 2.67: Ending the interactive mapping.

— Figure 2.68: Relaxing the UV polygons.

Imagine little springs along the edge of the selected UV polygons. Every spring length represents the real edge of the POLYGON object.

When the elastic force of the springs is applied, the deformed UV polygons will be strained so much that they unfold automatically.

It makes sense to anchor certain points and edges so that the springs have a starting point to work from to deform the UV mesh.

Therefore, select the FIX BORDER POINTS option. This option will hold the outer points of the selected UV polygons. All other selected UV faces then have to sort themselves so that the spring forces will balance themselves.

The proportions of the UV polygon sizes will ideally be the same as the proportions of the real polygons of the object. The result can be seen in Figure 2.68.

In the next step we will work on the UV polygons of the side faces. They should show

one tile of the material while the rounding is excluded.

Here the INTERACTIVE MAPPING will again help us. First though let us get a better overview in the TEXTURE window and in the editor.

Working with UV Polygon Selections

The line between real and UV polygons becomes blurry when working with selections. The SELECT POLYGON menu in BodyPaint 3D can be used, for example, to invert selections of UV polygons and to save real polygon selections in a tag.

For that reason click on the command HIDE SELECTED in the SELECT POLYGON menu while the faces on top and bottom of the cube are still selected.

The selected polygons then disappear in the TEXTURE window as well as in the editor and give us a better overview (see Figure 2.69).

Invert the section with the INVERT command in the same menu and select CUBIC in the UV MAPPING > PROJECTIONS window.

All of the familiar buttons for standard projections can be found here. They can be assigned directly to selected faces.

It is almost the same principle as INTERACTIVE MAPPING, but it does not provide as much control over direction, position, and size of the projection. It only offers the choice between the world system and the object system as reference systems for the projection and the analysis of the normals on the faces.

In our case this is not an advantage, as the sides of the cube sit perpendicular to the object and world axes. This gives us the desired result of one tile on each of the side faces of the cube (see the lower image in Figure 2.69).

Unfortunately, this also includes the rounded edges of the cube, which results in a slight deformation of the image in the material.

In order to fix this problem, we need to adjust the size of the side faces to the material tile. Their position in the TEXTURE window is not so important to us, as the rounding is supposed to get another material anyway.

It is best to activate the Only Visible Elements option in the setting of Live Selection in the Attribute Manager to avoid this error.

Click on the Max UV button in the UV Commands of the UV Mapping window. This function automatically scales all selected UV polygons so that they fit exactly on the material tile (see Figure 2.70).

— Figure 2.69: Working with selections.

Use the Live Selection and click on the four large side faces of the cube. Be sure not to select any of the faces of the rounding.

— Figure 2.70: Adjusting the side faces.

The last step would be to take care of the rounded edges. Invert the current selection again in the Select Polygon menu. This selec-

tion should now only include the rounding at the cube corners.

In the same menu use the SET SELECTION function in order to save the current selection in a POLYGON SELECTION tag (see Figure 2.71).

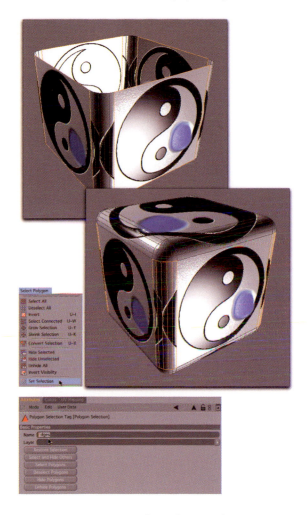

— Figure 2.71: Saving the Polygon Selection.

We can give the selection a meaningful name in the ATTRIBUTE MANAGER by clicking on the tag in the OBJECT MANAGER.

I called the selection *Edges* and made all polygons visible by using the UNHIDE ALL command in the SELECT POLYGONS menu.

Now we have to create and apply a new material to this new polygon selection.

Use the NEW MATERIAL command in the FILE menu of the MATERIAL MANAGER. Apply random attributes to the material. I just happened to use a striking color.

When the material is done, pull it onto the cube in the OBJECT MANAGER. To the left of the original TEXTURE tag a new TEXTURE tag appears with settings for our new material. Especially interesting is the SELECTION field (see Figure 2.72).

— Figure 2.72: Restricting a material to a selection.

Pull the POLYGON SELECTION tag from the OBJECT MANAGER into this field or enter the name of the selection directly into it.

Now the material is only visible on the faces that are saved in the POLYGON SELECTION tag.

The order of the TEXTURE tags behind the object also plays an important role. Next to the object, the further left a TEXTURE tag is placed, the higher it will be on the surface. A TEXTURE tag placed farthest to the left would cover all the material to its right.

An exception is, like in our case, the restriction to a POLYGON SELECTION or when the material uses an alpha channel. In these cases areas appear where materials underneath are visible.

The order of the tags behind the object in the OBJECT MANAGER can be modified by drag and drop.

Now we can see in the editor how the material is placed and how it appears on the rounded edges (see Figure 2.73, top).

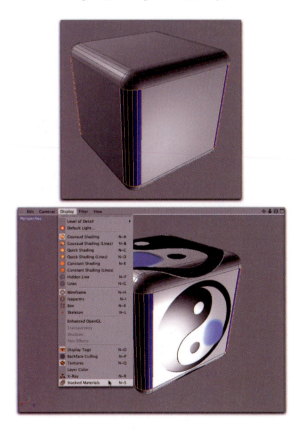

— Figure 2.73: Adjusting the editor Display.

If necessary, we can adjust the UV coordinates of the rounded edges to the new material. This is helpful when images are to be loaded and we want to avoid distortions. The position of the UV faces does not matter when just a color is being applied, nor does it matter for the use of reflective or transparent properties.

Because multiple materials have been applied to the object, we need to tell this to the editor by way of using the DISPLAY menu, as otherwise only the currently selected TEXTURE tag will be shown.

After STACKED MATERIALS has been activated, the cube should be displayed in all its glory (see Figure 2.73, bottom).

For the time being we are finished with the subjects of UV coordinates, texture layers, and painting of surfaces. Now let us take a look at the most important shader in CINEMA 4D.

2.5 Defining Surfaces with Shaders

We briefly talked about what a shader is. They are integrated programs in CINEMA 4D that can portray multiple aspects of a surface.

There are different pattern generators, along with more complex shaders that can simulate translucent materials or the refraction on smooth surfaces.

Due to the large number of shaders and, in some cases, their abundance of properties and options, we will restrict our focus to, in my opinion, the most important shader.

We will need to reconstruct a few materials in order to learn their use with practical examples and to get to know their combination possibilities.

Let us start with an empty scene. Save and close the open scenes and switch back to the standard or start layout of CINEMA 4D.

Texturing of a CD

As our first example we will apply a material to a music CD, DVD, or CD-ROM.

The first step would be the creation of the object. In this case it can be done quickly because the disc basic object already contains all properties of the desired shape (see Figure 2.74). Make sure that the disc is placed on the XZ plane.

— Figure 2.74: The disc basic object.

In order to work to scale, use the original measurement of a CD. We will need an OUTER RADIUS value of 60 units and an INNER RADIUS value of 7.5˚.

Set the ROTATION SEGMENT value to 144 so that the disc can also be used for close-up views. For the application of different materials later on, we need four DISC SEGMENTS.

Modeling of the CD

We have already learned that materials can be applied easily to saved polygon selections. This will be helpful with the CD, as multiple materials will be used.

The inner ring looks transparent. Then a small ring follows that has perfect reflective properties. The next segment contains data and has a different surface property. Depending on the amount of data, there are fine lines on the surface of the CD resulting in brightness differences.

The outer edge of the CD is also reflective. In order to separate the sections from each other, the EDGE LOOP needs to be scaled.

We now have to part from the basic object and convert it to a POLYGON object.

In order to select the edges and move them to the right place, we will use the LOOP SELECTION in EDGE mode.

Start with the second edge loop when counting in from the outside. It is marked in white in the upper part of Figure 2.75. In the COORDINATE MANAGER, enter in the value of 117 for the X and Z sizes of this EDGE LOOP and apply the entry with the APPLY button. The edges now run exactly 1.5 units parallel to the outer edge of the disc.

Execute the same steps for the two following EDGE LOOPS (see Figure 2.76).

Enter the sizes of 42 and 39 for X and Z for these edge loops. After that, start saving the selections for future texturing. Change into POLYGON mode and make a RING SELECTION of the outermost polygon ring of the disc.

Use the SET SELECTION command in the SELECTION menu to save this selection in a POLYGON SELECTION tag. Give the tag a meaningful name such as *Outer Ring*. These steps are also shown in Figure 2.76. Then use SET SELECTION again to select the small polygon ring closest to the center of the disc (see Figure 2.77).

This time the selection cannot be saved instantly because most likely the first POLYGON SELECTION tag is still active. This is evident by the frame around the icon in the OBJECT MANAGER. By saving the selection again the SET SELECTION function would overwrite the content of the first tag with the actual polygon selection.

In order to avoid this, click on any other tag, such as the UVW or PHONG tag behind the

— Figure 2.75: Moving of Edge Loops.

— Figure 2.76: Scaling the Edge Loops and saving the Polygon Selections.

disc object, and use the SET SELECTION command. A new POLYGON SELECTION tag will be created that can be renamed to *Inner Ring* (see Figure 2.77).

Do the same steps for the innermost ring of the disc and save these polygons in a new selection tag (see Figure 2.78). My name for this selection is *Transparent*.

Unfortunately, the disc is not completely flat in real life. The thickness is almost exactly 1 millimeter (0.04 inches) and needs to be applied to the model.

This can be done very quickly with the EXTRUDE function. Make sure that you are in POLYGON mode and that no faces are selected. With the LIVE SELECTION tool, click once next to the disc in the editor or choose the DESELECT ALL command to be sure. That way, all polygons will be considered for extruding.

Select the EXTRUDE command and activate the CREATE CAPS option. This will take care of the double-walled extrusion. Finally, set the

OFFSET value to 1 and click on the APPLY button to extrude our disc to the desired thickness (see Figure 2.79).

The POLYGON SELECTION in the image only clarifies the thickening effect.

The Centering Ring

Basically the modeling of the CD is complete. A closer look at the CD will show that there is a centering ring near the center on the bottom of the disc. The task of creating this can be done quickly (see Figure 2.80).

While in EDGE mode, make an EDGE LOOP selection in the middle of the bottom of the disc. Then use the EDGE CUT tool.

Select and enlarge the created edge loop in the COORDINATE MANAGER to 35 units for both X and Z. The result can be seen in the bottom of Figure 2.80.

— Figure 2.79: Thickening the disc.

— Figure 2.77: Saving the second selection.

— Figure 2.78: Saving the Inner Ring.

The width of the centering ring is 1 millimeter (0.04 inches). This means that we need to only split the new EDGE LOOP with the BEVEL tool (see Figure 2.81).

Be sure that the SUBDIVISION value is set to 0 and that the option to create N-GONS is deactivated. The value of the INNER OFFSET results from the preset width of the centering ring, as both edges will move away from the original edge by the value specified in the INNER OFFSET.

Change into POLYGON mode and select the polygons created by the EDGE LOOPS with the RING SELECTION tool.

Here we will also use the BEVEL command to round the ring. I used an EXTRUSION of 0.2 with an INNER OFFSET value of 0.3. Raising the SUBDIVISION value to 1 will help us control the PHONG shading between the disc and the ring. These settings and the result can be seen in Figure 2.81.

Now the model is completely done. The rest has to be done with materials. Therefore, we should update the saved selections. By

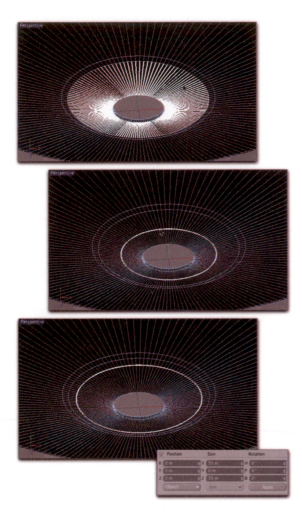

— Figure 2.80: Modeling the centering ring.

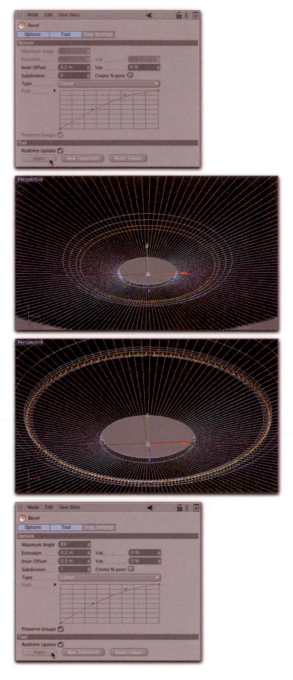

— Figure 2.81: Shaping the centering ring.

thickening the disc, new polygons were created that are not yet part of a selection.

Because the selection of the polygon loops, which are very close together, is difficult to accomplish, we will simply expand the currently chosen POLYGON SELECTION of the centering ring multiple times.

Use the GROW SELECTION command repeatedly in the SELECTION menu until it looks like the one in Figure 2.82. The selection includes the thickening polygons at the inner hole of the disc, but does not contain any of the faces on the upper side of the CD.

Expand the selection while holding the Shift key until the whole bottom side of the CD and the thickening at the outer edge is included.

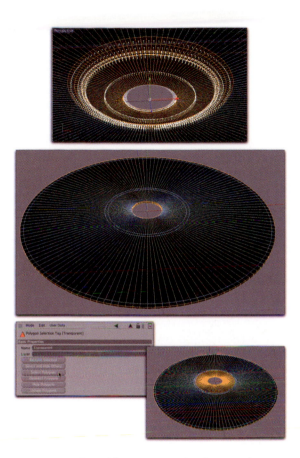

— Figure 2.82: Adding to a saved Polygon Selection.

These selected faces are meant to be transparent. Therefore, it would make sense to add this selection to the already saved selection of the inner ring of the disc.

Click on the POLYGON SELECTION tag of the transparent faces and use the SELECT POLYGONS button in the ATTRIBUTE MANAGER. These faces are now selected without influencing the previous selection.

Using SET SELECTION in the SELECTION menu, save the new selection in the already existing tag to update it.

Adjusting the Phong Angle

A closer examination of the bottom of the disc shows us that the transition between the centering ring and the disc is still too smooth (see

Figure 2.83). Therefore, reduce the angle in the PHONG tag until the centering ring is well defined. I have it set to 33°.

— Figure 2.83: Adjusting the Phong angle.

The Most Important Settings for Light Sources

Because the surface of our CD will react strongly to light, let us use this opportunity to take our first look at the light sources in CINEMA 4D.

The basic settings can be explained quickly. Basically, only the intensity, color, and direction of the light have to be set. Later it can be decided what kind of light source will be used and what kind of shadow is to be calculated.

A variety of light sources can be found. For example, in the first row of the icons is an omni light, a spotlight, an infinite light, an area light, and a spotlight with a target. All of these lights can be switched to another kind later on.

An omni light radiates light evenly in all directions and can be compared to a light bulb or a flame.

The spotlight shines its light along its local Z axis only. The angle of the cone can be individually set. It can be used for a specific illumination when the light should shine only on certain objects or parts of the surface.

The infinite light simulates light, such as that from the sun. The light rays are parallel to each other and generate a kind of lighting different from an omni light, where the angles between the light rays are all different.

The area light simulates light sources that have an aerial expansion, such as a neon light or the sky.

Area lights deliver a very natural light but also need more calculation time than the other light sources.

Light sources equipped with a target work like other light sources but can be directed more easily.

An additional NULL OBJECT is created where the light source is automatically directed along its Z axis. This NULL OBJECT can be placed where the light is needed. Then only the position of the light source has to be set and it will always shine in the desired direction. This works best with spotlights.

In order to test this automatic alignment, select the spotlight icon with the target object. The icon is shown in Figure 2.84 with a white border.

A glance at the OBJECT MANAGER shows that, in addition to the light source, a NULL OBJECT and a previously unknown tag behind the light source have been created.

A click on that tag opens the settings in the ATTRIBUTE MANAGER, which mainly deal with the alignment of the tagged object. In our case, the NULL OBJECT is entered into the TARGET OBJECT field.

This tag can also be created manually. Delete the TARGET tag and right click on the light source. In the context menu select CINEMA 4D TAGS>TARGET.

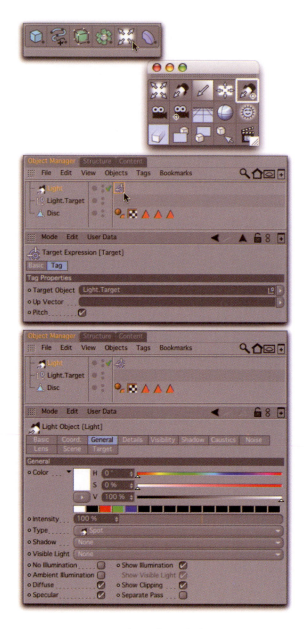

— Figure 2.84: An aligned spotlight.

A NULL OBJECT can again be pulled from the OBJECT MANAGER into the TARGET OBJECT field. No matter what you decide to do, the assigned object will always be targeted by the spotlight.

Select a light source in the OBJECT MAN-AGER so that we can look at the most important settings.

The dialog of the light source is very extensive, but the most important functions are quickly explained. On the GENERAL page there are basic settings for the color of the light and underneath there is a slider for the intensity. It is possible to enter values above 100%.

The TYPE menu lets us change the type of light. This can be done later without losing the rest of the settings.

We can also decide if or what kind of shadow should be shown. The SHADOW menu of the dialog shows the available shadow types. The quality of the shadow can be fine tuned on the SHADOW page as well.

When a light is supposed to create an optical effect without being used to light objects, activate the NO ILLUMINATION option.

The options DIFFUSE and SPECULAR control separately if this light will create highlights or will influence the brightness of the surface. This can be helpful when an additional highlight is needed and the brightness of the object is enough.

Available Shadow Types

We have already seen that there are different kinds of shadows. Depending on the chosen shadow, additional settings can be found on the SHADOW page of the light source dialog (see Figure 2.85).

The SHADOW MAP shadow is used most frequently because it offers a good balance between quality and calculation time.

The shadow works in a way that in the worst circumstance images for all six directions will be calculated.

The resolution of these images is controlled by the SHADOW MAP menu. It is there that we have the choice between several standard sizes. However, custom resolutions can also be entered in the RESOLUTION X and RESOLUTION Y fields.

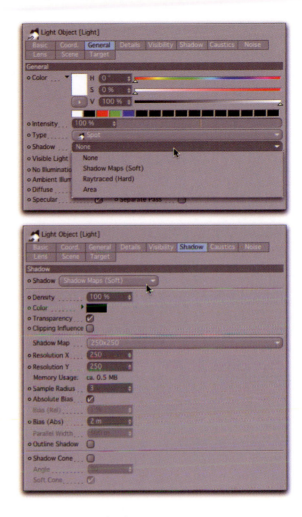

— Figure 2.85: Shadow settings.

Because these images represent the shadows of the light source, it is clear that higher resolutions will result in a more defined shadow. To clarify this we will calculate our scene with different shadow settings. To do this, create an additional object that will cast a shadow. I used a cube, scaled it a little, and placed it on the CD, as shown in Figure 2.86.

In order to see the shadow in its highest quality, we need to use the RENDER function that calculates the content of the active editor viewport. A click on the icon shown in Figure 2.86 will start the calculation process.

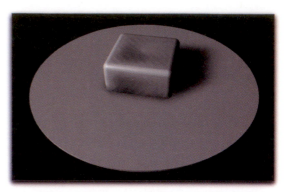

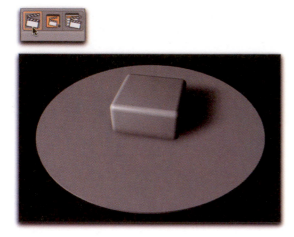

— Figure 2.86: The calculated Shadow.

Depending on where the light source is positioned in the three-dimensional space, the shadow of the cube should be visible on the CD after the calculation.

The soft shadow that we chose looks just like its name indicates. The edges are very soft and do not look especially realistic at the moment. This is because of the small SHADOW MAP preset. We will correct that in a moment, but before we do, let us talk about another possible source of the error in calculating soft shadows.

A correction value is included in the calculation of the SHADOW MAPS and determines at which point a changed surface will cast a shadow. When this value is set too small, even the smallest changes will cast shadows. This also includes points and edges of a curved surface.

The effect can be seen in the example of the cube in Figure 2.87 and shows that unwanted shadings and spots were created.

This effect is controlled by the BIAS value on the SHADOW page of the light source dialog. Raise this value until the error disappears.

In the upper part of the dialog page there are settings that are the same with all types of shadows. One is the DENSITY value, which controls the density of the shadow, and another is

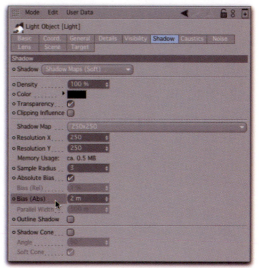

— Figure 2.87: Possible errors because of a small bias value.

the COLOR parameter, which colors the shadow individually.

Remember, colored shadows only appear when light shines through transparent objects. When the TRANSPARENCY option is activated, the shadow will be colored automatically. Use of the COLOR value only makes sense for special effects.

Let us see what kind of influence the size of the SHADOW MAP has on the look of the shadow.

Increase the size of the SHADOW MAP to 1000 × 1000 pixels and calculate the viewport again. The shadow is now much less soft and is more exact at the corner of the cube. The di-

DIUS value. Higher values will calculate the shadow more exactly without enlarging the map, but more time is needed to calculate it.

There is another helpful option when soft shadows are used with an omni light. With a spotlight the soft shadow is automatically calculated only in the Z direction of the light. The SHADOW CONE option activates the same calculation with omni lights (see Figure 2.89).

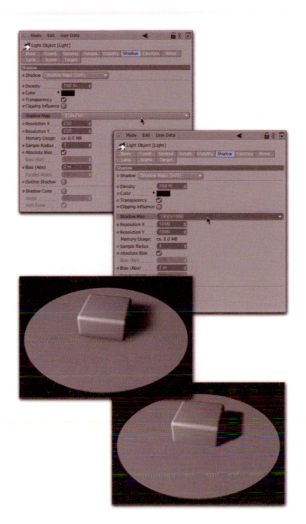

— Figure 2.88: Different Shadow Map sizes.

— Figure 2.89: Using the Shadow cone.

rect comparison in Figure 2.88 shows this even more clearly.

The only disadvantage to increasing the SHADOW MAP size is the simultaneous increase of memory. A SHADOW MAP is an image that has to be calculated first and then stored in memory for rendering the image.

For our enlarged SHADOW MAP, 8 MB has been used. This value can be read directly under the resolution parameters. This alone is not that bad, but if there are a few dozen light sources in the scene, it will be noticeable.

There are a few alternatives to enlarging the SHADOW MAP. One is to increase the SAMPLE RA-

Be sure that the Z axis of the light source is aligned to the objects that will generate the shadows. The ANGLE value of the SHADOW CONE might need to be adjusted so that all targeted objects will be included. This can reduce the memory used for the shadow calculation to one-sixth of what we used before. As a result, a larger shadow map can be used.

Switch to RAYTRACE shadows in the SHADOW menu. The majority of the parameters disappears because this type of shadow offers almost no adjustment settings.

This is a shadow with a very sharp edge, as can be seen when the image is calculated. This kind of shadow only exists under extreme lighting situations. This might be, for

example, intense sunlight without any other diffused light.

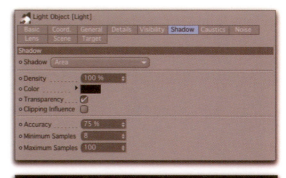

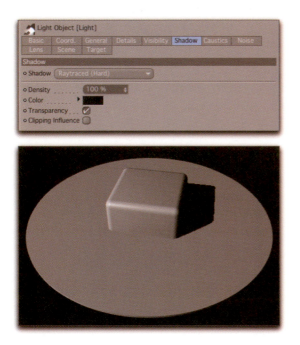

— Figure 2.90: The Hard shadow.

— Figure 2.91: The Area shadow.

Maybe you have noticed the steps at the edge of the shadow. The reason for this is the preset quality of the image rendering. We will learn later how to improve this. Right now, this quality is good enough for evaluating materials and shadows.

We will conclude the examination of shadows with the highest quality one, the AREA shadow (see Figure 2.91). This shadow is put together by a series of samples. Their quantity is determined by the SAMPLES value, which works using the same principle as the scattering of transparencies and reflections in the material.

Values too small cause the AREA shadow to look noisy, whereas high settings increase the calculation time unnecessarily.

One way of finding the right setting is to set the MINIMUM and MAXIMUM SAMPLING values to the same value and increase both numbers until the calculated result looks good.

Because the MINIMUM value is used only for less problematic spots in the scene, then the MINIMUM SAMPLING value can be reduced to one-quarter or one-fifth of the MAXIMUM value.

Now that we have found a useful balance of these values, we can use the ACCURACY value to raise or reduce the quality.

The two set values are a solid base for many scenes and only have to be adjusted when the quality is not good enough or when the calculation takes too long.

Now we know about the most important parameters of the light sources. Next we will go over additional settings and options using examples.

Let us now continue with the texturing of our CD and take a look at the shaders. The cube can be deleted. It only served as an example of the source for displaying the available shadows.

Switch the light source back to soft shadows with a SHADOW MAP of 500 × 500 pixels. The SHADOW CONE option can stay deactivated because we used a spotlight.

Simulate Spectral Refraction and Scattering

Good image reference should be available, whenever possible, before 3D objects are textured.

With an object as common as a CD we can take advantage of looking at the real thing. You could also take a look at the DVD of this book.

When we look at the surface of the CD or DVD we realize that it is a highly reflective material covered by fine lines in the data area of the disc. This causes the highlights to be stretched and spectrally broken, which is why the CD shimmers in all colors of the rainbow.

The silvery data coating is applied only to one side of the flat CD disc. The rest of the CD material consists of transparent plastic, which is especially visible in the center of the CD.

The data portion is not spread over the whole CD. The outer edge of the CD and the space between the area containing the data and the transparent part in the center cannot hold data. Therefore, only the reflective material is shown in this area without the burned lines.

Upon closer examination we can also see that the outer edge of the CD goes from silver to the transparent material.

We now have a whole series of materials that we will create and apply, one after the other.

The Color Channel

We will start with material of the data containing portion of the CD by creating a new material in the MATERIAL MANAGER.

Let's split the desired material over several channels and start with the COLOR channel.

For the moment leave all other channels deactivated to see the isolated result of the shader.

As we already know, the COLOR channel reacts to light sources and takes care of the shading of the surface. Traditionally it is a fact that reflective surfaces have a very dark color. When creating chrome or a mirror, we can leave the COLOR channel untouched. In this case though, we have to use it because we need its light properties to create the circular grooves, elongated highlights, and spectral coloring.

The spectral light strips can be created with the SPECTRAL shader. For the circular scratches and the distortion of highlights, our choice will be the LUMAS shader. This shader can also work very well when used for brushed metal.

In order to connect both effects, use the LAYER shader. In the COLOR channel, click on the button with the little triangle in the TEXTURE area and choose the LAYER shader in the list of installed shaders.

As this name implies, images and shaders can be loaded, mixed with each other, and stacked on top of each other.

Use the SHADER button in the LAYER shader and select the LUMAS and SPECTRAL shaders. Both can be found in the EFFECTS list.

The order of the shaders can be changed inside the listing of the LAYER shader by pulling them with the mouse. Make sure that the SPECTRAL shader is on top of the list (see Figure 2.92).

By clicking on the small preview image behind the names of the shaders their dialogs can be opened. With the arrow pointing upward in the headline we can always go back to the LAYER shader and, with an additional click on this arrow, back to the COLOR channel.

We will start with the settings of the LUMAS shader. On the SHADER page of the dialog general settings for the color of the surface and its shading mode are offered. I decided on a very dark and desaturated blue and the OREN-NAYAR model with 0% ROUGHNESS. As explained previously, reflective surfaces are, for the most part, a dark color. This is reflected in these settings.

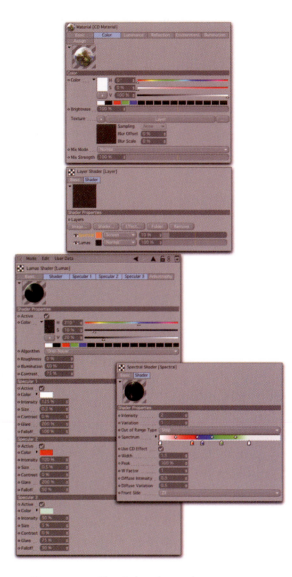

— Figure 2.92: The Color channel.

I chose a white color for the smallest and most intense highlight, red for the medium highlight, and a soft green for the weakest highlight (see Figure 2.92).

These colors are supposed to represent the color changes of the surface as a result of incoming light. You can use different colors if desired.

Anisotropy—Distortion of Highlights

These settings are an advantage only when the ACTIVE option is selected on the ANISOTROPY page of the LUMAS dialog.

This effect distorts highlights in different directions and simulates fine scratches without having to use the BUMP channel.

Select the RADIAL PLANAR PROJECTION since the CD has circular grooves. With the ROUGHNESS values the highlights can be distorted in both X and Y directions (see Figure 2.93).

— Figure 2.93: Anisotropy.

The OREN-NAYAR model creates aerial shading with little change in brightness.

The following three setting windows define three independent highlights. The coloring, brightness, and size of the highlight are the most important parts. Generally the procedure is that the intensity of the highlights is gradually reduced in the three setting windows while the size of the highlights is increased. That way, we get a natural looking highlight with soft edges.

The lower part of the dialog page deals with scratches and grooves. The AMPLITUDE determines their depth, the SCALE value the distance between the grooves, and the LENGTH

parameter to what distance the grooves will be visible around the area of the highlights.

This effect depends on the angle in which the light hits the surface. There will not be any grooves without highlights.

The display of grooves and the distortion of highlights can be limited to single highlights. Use the SPECTRAL 1 to SPECTRAL 3 options.

As we can see in my settings in Figure 2.93, in the standard values I reduced the amplitude to 10%. This way the grooves are shallower than the grooves in an album.

This completes the simulation of the highlight properties and grooves. Now we can add the splitting of the color highlights with the SPECTRAL shader.

Use the arrow in the headline of the MATERIAL EDITOR or ATTRIBUTE MANAGER to go back to the list of the LAYER shader and open the SPECTRAL shader.

Here we have to pay special attention to the right settings of the FRONT SIDE. Our CDs need to be entered here, as the disc lies in the ZX plane. Conveniently, the SPECTRAL shader offers a USE CD EFFECT option. The typical color stripes between the center and the edge of the CD will be created when this option is active. The color used is specified in the color gradient of the shader (see Figure 2.92).

New color stops can be created anytime by clicking under the gradient. Existing color stops are deleted by pulling them upward or downward.

Editing of the color values is done by double clicking on the color stop or with a single click on the color stop, which opens the color selector with the arrow next to the gradient.

There are also different kinds of interpolations with which we can control the calculation of the gradients between the different color stops.

In the dialog itself the WIDTH value controls the width of the color stripe on the CD surface. The PEAK parameter determines which colors will be displayed and their intensity. When the light is actually not intense enough,

values above 100% show more colors of the gradient.

The W FACTOR determines the starting point of the color stripes. The value of 1 should be kept so that these stripes start in the center of the CD.

Finally, the DIFFUSE INTENSITY value determines the brightness of the color stripes. Do not set this value so high that fading or overexposure will occur.

More information about the parameter can be found by right clicking on a parameter name. In the context menu choose ONLINE HELP.

I will limit myself to the most important parameter.

Now both shaders are set and only need to be put in a useful relation in the LAYER shader. Currently the SPECTRAL shader covers up the LUMAS shader.

It would not be fair of me to claim that my way of mixing the shader is the only way. Actually, it makes more sense to just play around with different modes and use the best-looking result.

I decided to use the SCREEN mode with an opacity of 10% for the SPECTRAL shader, as shown in Figure 2.92.

Applying the Material

We always have to examine these settings under the existing light while being applied to the surface. Now it is time to apply the material to the disc.

Because we activated the RADIAL PLANAR PROJECTION option in the LUMAS shader, the material needs to be applied as a plane parallel to the surface that is supposed to show the grooves. In the OBJECT MANAGER pull the material onto the disc and activate FLAT PROJECTION in the TEXTURE tag.

Switch to the TEXTURE mode and rotate the front of the material projection so that it lies parallel to the disc, as seen in Figure 2.94.

— Figure 2.94: Projection of the material.

Adding an Environment to the CD

Before we test the material and make test renderings, I would like to add a simple scene. This alone makes sense due to the fact that our spotlight casts a shadow but does not have an object to cast it on. Additionally, the standard black background of the scene gets boring after a while.

I have decided to create a large cube and to place it so that our CD and the spot fit inside. We can also use the bottom side of the cube as our floor.

Basically we could have used a simple polygon or the plane basic object as a floor. Because the CD is placed inside the cube we get a reflection of the inner sides of the cube on our CD. This will help us later when simulating a simple environment for the CD.

The cube is 1000 units in edge length and I have moved it 499 units along the Y axis. There will be a small gap between the CD and the floor, which will enhance the look of the spotlight shadow.

In order to light the sides and top of the inner cube, I will add an omni light without shadows and a brightness of 30% (see Figure 2.95). I have placed this light exactly in the middle of the cube above the CD.

By using the SCENE page of this new light source, I can pull our CD from the OBJECT MANAGER into the OBJECTS field in order to exclude the CD from this light.

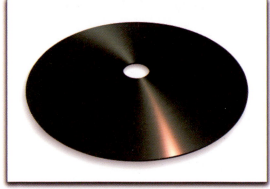

— Figure 2.95: An environment for the CD.

When the MODE menu above this list is set to EXCLUDE, then all objects in this list will not be lit by this light source.

The opposite will be the case when using the INCLUDE mode. Then, only the objects in the list will be lit by the light. This is a practical possibility for controlling the effects of light within a scene. This is a feature that many photographers would envy us for.

Even this effect can be controlled more precisely with the small objects next to the objects in the list. From left to right they represent highlights, the normal shading of the surface, shadows, and the extension of the INCLUDE/EXCLUDE effect to subordinate objects.

When an object is left out of being lit by the light with EXCLUDE, it is still possible to force the display of a highlight by deactivating the HIGHLIGHT icon.

Let us render the perspective viewport. The result might look like Figure 2.95. The reflection of the CD cannot be seen, as we have not activated the highlights yet. However, the grooves, distorted highlights, and the discreet spectral coloring are already clearly visible.

Change the position of the spotlight, if necessary, to create a good looking shadow and to change the position and intensity of the highlights.

The Luminance Channel

In order to amplify the spectral stripes we will need to activate the LUMINANCE channel in the material and load the SPECTRAL channel. The colored stripes can be shown more intensely than in the COLOR channel, as the LUMINANCE channel is independent from the lighting (see Figure 2.96). It would not make sense to use the same settings of the SPECTRAL shader for the COLOR channel. New lines should be created rather than old ones becoming intensified.

I have decided on another direction of the color beam calculation by using the XY setting of the FRONT SIDE. This results in slim stripes, but they clearly have a position different from the existing ones. Nevertheless, they react to a change in light source position, which could be important, for example, in an animation.

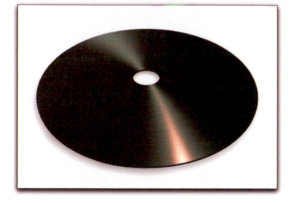

— Figure 2.96: The Luminance channel.

The Reflection Channel

Let us take a look at the reflective properties of the CD in the REFLECTION channel of the ma-

terial. It is difficult to determine its strength; however, the intensity should not be as high as with a perfect mirror.

I decided on a perfect white and a BRIGHTNESS of 70% (see Figure 2.97).

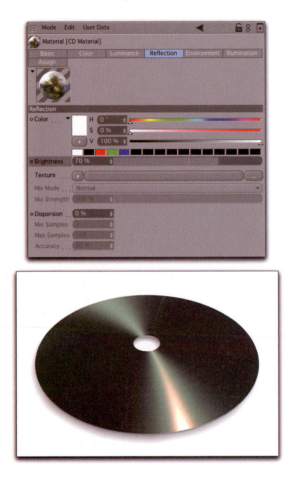

— Figure 2.97: Activating the reflection.

Because of the reflection of the cube, the CD is brightened a bit. This also helps the spectral stripes, which are more visible. However, the color changes of the surface are still not prominent enough. The problem could be solved by adding additional light sources that will only complement the highlights.

At the same time, though, the elongated highlights in the LUMAS shader would be generated.

I take advantage of a trick and add these colored stripes through the ENVIRONMENT channel. This channel does not react to the position of the light sources, but that does not matter anyway when rendering the single image of the CD.

The Environment Channel

We will use, as it seems, a complex arrangement of shaders, where one shader takes on a small role, but when combined with others can create the desired result.

Theoretically, we can use the WATER shader in the SURFACE entry of the shader list to create the irregular stripes. However, because these stripes need to radiate from the center of the CD to the outside, the projection of these stripes has to be changed in the material itself. The PROJECTOR shader will accomplish this and can be found among the EFFECTS shaders.

The result of this shader still needs to be colored so that the desired spectral colors are generated. We will use the COLORIZER shader, which can be found in the uppermost area of the hierarchy of the shader list.

The nesting of the shader can be seen in Figure 2.98. The procedure should be to first open the COLORIZER in the ENVIRONMENT channel and then open its dialog. Next, open the PROJECTOR shader in the TEXTURE area and load the WATER shader in its dialog.

Set the PROJECTOR shader to SPHERICAL. We have already learned how the texture tapers at the poles of a spherical projection. This will then generate the desired stripes, radiating from the center of the disc. The remaining settings in this shader do not interest us.

In the COLORIZER, colors of an applied shader can be changed and manipulated at will.

We can use the gradient to add color to the gray steps of the WATER shader, which in this case are green and red. The left edge of the gradient represents the dark areas in the applied shader, and the right side represents the light areas. That way, images and shaders can

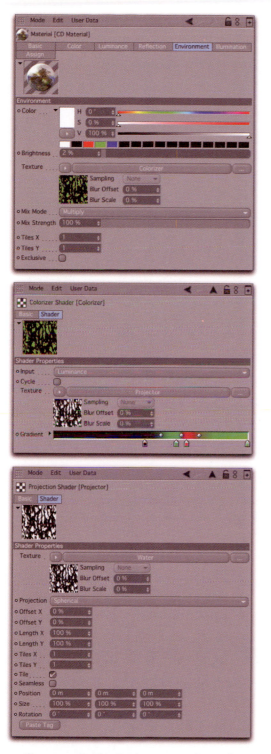

— Figure 2.98: The Environment channel.

be colorized later. Of course you can use other colors different from the ones I used.

Be sure that the left edge will fade to black. This way the stripes of the WATER shader will still be defined and the dark areas between will not be filled in with another color.

In the WATER shader, the width and length of the waves that will become our stripes can be set through the U and V FREQUENCY values.

The gradient can also be used to amplify the color contrast.

The parameter WIND and T FREQUENCY are not of interest here, as they only control the movement and shape change of the waves in an animation.

I deactivated the EXCLUSIVE option in the ENVIRONMENT channel, as can be seen in Figure 2.98. The stripes should also be visible where portions of the cube are reflected in the disc.

The strength of the stripe can be set by multiplying them in MIX MODE with the BRIGHT-NESS of the ENVIRONMENT color value. I chose a very discrete setting of only 2%. This completes the material for the data section of the CD and can be checked by rendering it in the editor (see the lower image in Figure 2.99).

The brightness of the CD is controlled by the strength of reflection, intensity of highlights, and grooves of the LUMAS shader in the COLOR CHANNEL. The other colored stripes are set primarily with the LUMINANCE and ENVIRONMENT channels.

The missing materials will require less work. For the small rings inside and outside the data area, we can even work with copies of the recently created material.

The Reflective Part of the CD

Create an identical copy of the material by using COPY and PASTE in the EDIT menu of the MATERIAL MANAGER and rename it to *Mirror* so that the materials are distinguishable from each other.

The small ring of space between the data-containing area and the transparent inner part of the CD differs from the data area. It does

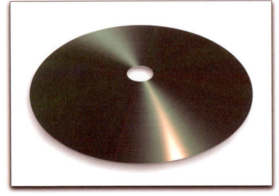

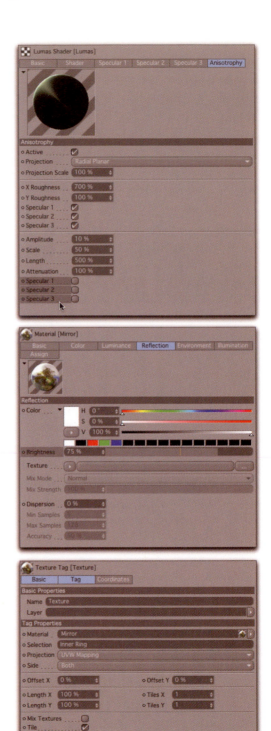

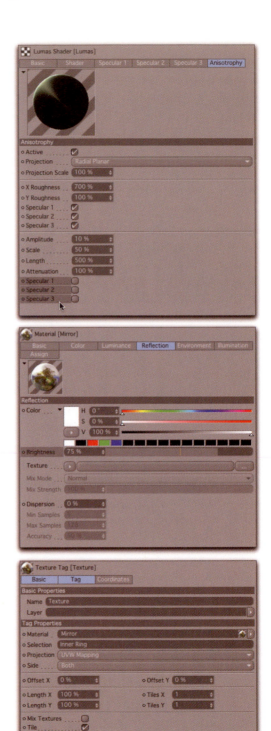

— Figure 2.99: The Water shader and the finished material.

not have grooves, but does have stronger reflections.

Go to the LUMAS shader dialog in the COLOR channel of the *Mirror* material and deactivate the three SPECULAR options (as shown in Figure 2.100). The grooves will then be deactivated. Increase the reflection of the new material to a BRIGHTNESS value of 75%.

Pull the new material onto the CD model and enter the name of the POLYGON SELECTION of this inner ring in the SELECTION field of the new TEXTURE tag.

The MIRROR material should be positioned to the right of the first material in the OBJECT MANAGER. This means that it is placed one hierarchy level higher and should be able to partly cover the data sector material.

Render the perspective viewport again to evaluate the new material.

— Figure 2.100: The material of the inner ring.

Figure 2.101 shows my rendered result. Be aware that the colors in the book could appear a bit darker and duller than is really the case.

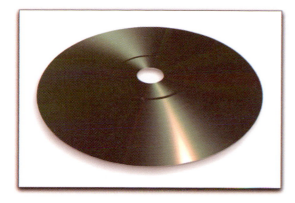

— Figure 2.101: The transition to the center of the CD.

Because all the used scenes are also saved on the DVD of this book, it is worthwhile to take a look at the real scene on your own monitor.

The Transparent Inner Ring and the Bottom of the CD

Let's get to the transparent parts of the CD. They are especially visible at the inner part of the CD. Note that the bottom of the CD is completely transparent. Only one side of the CD is covered with the reflective surface. On top of that is a layer of the basic transparent material and several protective coats, which prevent scratches and associated errors when reading the CD.

The material is not especially complex. My settings can be seen in Figure 2.102.

As we can see, the surface has a brightness of 40% and a transparency of 80% with a RE-FRACTION of 1.5.

An intense highlight will complete the material.

Do not forget the FRESNEL option in the transparency, which simulates the natural relationship between reflection and transparence.

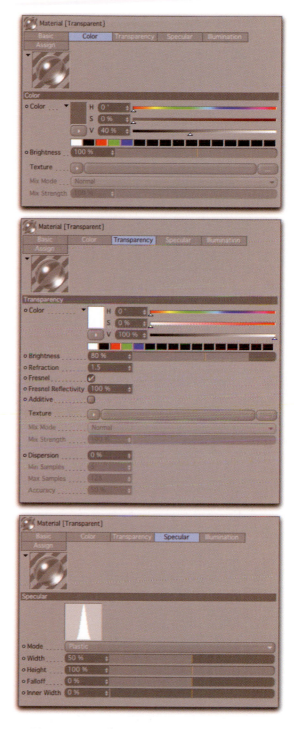

— Figure 2.102: The transparent material.

Pull this material onto the CD object in the OBJECT MANAGER and restrict it to the selection of the transparent surfaces.

The object already looks very good, as shown in Figure 2.103. The centering ring on the bottom helps a good deal.

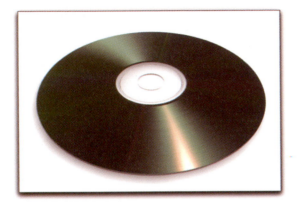

— Figure 2.103: The transparent material.

All that is left is the slim ring on the outer edge of the CD. Unfortunately, it is not as easy to apply here the *Mirror* material, as this material has to show a transition to the transparent material.

The VERTEX MAP shader is suited for this job because it allows us to use structures inside materials, which are painted directly onto the object.

The Vertex Map Shader

Because the basic material is identical to the *Mirror* material, we will use a copy of the material as a base.

I call the copy of the *Mirror* material *Falloff Mirror* and have activated the TRANSPARENCY channel too.

We can adjust the settings to those of the transparent material in the inner part of the CD. We will also set the BRIGHTNESS to 80%, the FRESNEL option, and a REFRACTION value of 1.5.

Because not all of the material should be transparent, we have to restrict the area that will be.

As already mentioned, we will use a VERTEX MAP. This represents a value between 0 and 100% that can be directly painted onto the points of the object with the LIVE SELECTION tool.

Because so many points will get a percentage value assigned to them, we can use another selection method and assign the values to the points later.

Activate the LOOP SELECTION and select the second point circle on the upper side of the CD, counting in from the outside.

Select SET VERTEX VALUE in the SELECTION menu of CINEMA 4D. There, a percentage value needs to be entered that is assigned to the points. Put in a VALUE of 100% and click on the OK button.

Behind the CD object a new tag appears that saves all the percentage values of the model. Additionally, there will be a colored display of these values on the model when the VERTEX MAP tag is active and the object is in POINT mode.

The VERTEX MAP works almost like the POLYGON SELECTION tag. This tag can be used with a material after being renamed in the ATTRIBUTE MANAGER (see Figure 2.104).

A special tag is necessary for the material, which can be found in the shader list of the EFFECTS subfolder. This VERTEX MAP shader reads the percentage values in the applied VERTEX MAP and converts them into different brightness values. Because this VERTEX MAP tag always applies to all points of the object, all points not set by these values get a 0% value.

The VERTEX MAP shader will turn this value into black. Points with a value of 100% will be shown as white. Values in between will be shown in gray tones.

Because there are only two point rings in the relevant edge area, we cannot apply a gradation of values. The value gradation is therefore linear between the points.

In order to change this, we first load the familiar COLORIZER shader in the TRANSPARENCY channel. Then the VERTEX MAP shader will be loaded in the COLORIZER.

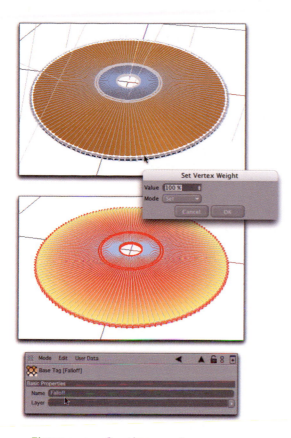

— Figure 2.104: Creating a vertex map.

The color gradient of the COLORIZER allows us to control the contrast and brightness of the VERTEX MAP shader exactly.

Open the VERTEX MAP shader and pull the VERTEX MAP tag from the OBJECT MANAGER into its VERTEX MAP field. In this case we also have to activate the INVERT option, as the TRANSPARENCY channel evaluates bright areas as being transparent and dark areas as having mass.

The percentage values need to be inverted, as the transparency is located at the outer edge of the disc.

When this is done, with the arrow in the headline of the MATERIAL MANAGER or ATTRIBUTE MANAGER, move up one level in the hierarchy. Change the grayscale gradient in the COLORIZER so that the black/white gradient goes from left to right. The black color stop should be in the center of the gradient.

The result is that the VERTEX MAP values up to 50% will be interpreted as black and therefore stay visible. As a result, we move the transition from reflective to transparent material further outside and also create a harder transition.

The complete setup for this material and the new shader can be seen in Figure 2.105.

The lower part of Figure 2.105 shows the finished model of the CD with applied materials. Note that this material is also placed all of the way to the left of the object and is restricted to the POLYGON SELECTION of the outer polygon ring.

Now that our object is complete we can build a simple scene. I simply created a copy of the CD and moved it slightly to the side (see Figure 2.106).

Note that both CDs were rotated so that the bottom is facing upward. We are looking at the transparent bottom of the CD and see the back of the data area. As a result, the highlights are different and the objects look even more realistic.

When the arrangement and the lighting of the objects are to our liking, we can then think about the rendering of the image. So far we have only created test renderings in the editor that have not been saved.

2.6 Rendering and Saving Images

All important settings for determining the image size, the quality, and the path to save the image are in the RENDER SETTINGS (see Figure 2.107). This setting window can be opened with the icon shown in Figure 2.107 or in the RENDER menu of CINEMA 4D.

The RENDER SETTINGS contain a flood of setting possibilities and options, but the most important settings can be explained quickly. The majority of the options that control the qual-

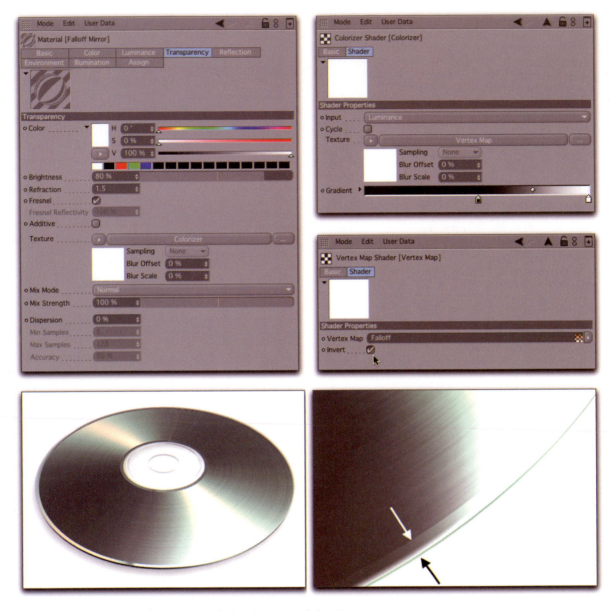

— Figure 2.105: Setup of the materials for the edge of the CD.

ity of the rendering can be found on the GEN-ERAL page of the dialog.

We already went over the step structure at the edge of the shadows when looking at hard shadows. They are the result of a small ANTI-ALIASING setting in the RENDER SETTINGS.

Basically there are only two settings beside the deactivation of this effect: GEOMETRY and BEST.

In the GEOMETRY setting, all edges are smoothed. The outer contours of objects appear very precise and sharp. No material properties will be used in this setting.

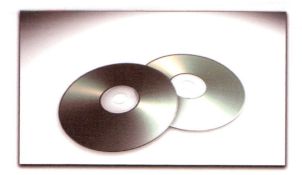

— Figure 2.106: Completing the scene.

— Figure 2.107: Render settings.

This includes, for example, reflections, transparencies, or shaders and images. Shaders and images can be smoothed with the already discussed SAMPLING and BLUR settings directly in the TEXTURE area of every material channel, but the quality is often not good enough.

The ANTIALIASING should include the whole material with all its properties and not just one channel in the material. For this reason there is the BEST setting for the ANTIALIASING. It already contains the geometry smoothing and complements it with an additional interpolation for materials. Basically, the BEST setting is used for the calculation of the best possible quality.

This interpolation can be supported by the FILTER menu. The setting STILL IMAGE creates a very sharp rendering of the image when used for print or generally for the display of a still image.

Sharp details can cause flickering or movements that look like stop motion when animations are calculated. For this reason there is an ANIMATION setting that calculates a slightly blurred image.

The BLEND filter can seamlessly mix these two filters. The mix ratio can be adjusted on the ANTIALIASING page of the RENDER SETTINGS. We will talk more about this later. The remaining filters can be used alternatively depending on the occasion.

The advantages and disadvantages of these filters can be researched in the ONLINE HELP. For example, the SINC filter can calculate an even better ANTIALIASING for still images, but needs more time to do so than the STILL IMAGE filter.

The following three menus on the GENERAL page of the RENDER SETTINGS activate the different render qualities for transparencies, reflections, and shadows (see Figure 2.107).

All settings for the final rendering will be left at their maximum. We will want to see all properties of our materials and lights in our image.

For test renderings it makes sense to deactivate some settings in order to save time.

The RENDER AS EDITOR setting works similarly. It calculates the image in the desired resolution, looking exactly like the editor viewport. That way, for example, a wireframe or a scene displayed in quick shading mode can be calculated. The three modes available in the RENDER SETTINGS represent the settings in the editor viewports or the presets of CINEMA 4D.

This kind of rendering is used mainly for test rendering of animations, as the focus is on timing and movement of objects and high-quality surfaces are not needed. That way, an animation containing several hundred images can be rendered much more quickly than it would take to calculate each image in high quality.

Let us summarize. Mainly the type of antialiasing and filters can be selected on this page of the RENDER SETTINGS. The remaining settings can be left at their standard settings or best-quality settings.

Output Settings

Now take a look at the output settings for the rendering. The desired resolution for the final image or animation can be set here (see Figure 2.108).

— Figure 2.108: Output settings.

An extended list of standard settings, for example, for video or monitors, can be accessed in the RENDERING menu. It is also possible to enter resolutions independent from the standard in the two fields responsible for the number of pixels in X and Y directions behind the menu. The RESOLUTION menu then automatically switches to MANUAL mode.

The FILM FORMAT menu works in a similar manner. Standard settings can also be chosen or entered here. This menu is not needed when the desired resolution is already known.

When the width-to-height ratio is known, 4:3 for example, then the FILM FORMAT can be set to MANUAL and the values of 4 and 3 can be entered into the fields behind.

When a pixel value is entered into one of the two RESOLUTION fields, the second field is automatically entered and adjusted so that the ratio stays at 4:3.

Some video formats work with distorted pixels. The shape of the rendered pixel is therefore no longer a square. Different ratios can be entered into the fields at the PIXEL entry. The still image ratio can, in any case, remain at 1:1.

The following settings only relate to the rendering of an animation. In the FRAME menu the range of the animation that should be rendered is specified.

The FRAME STEP value determines if frames should be skipped during the render process, which can help save time while rendering a test. Otherwise, this value remains at 1 so that every image is rendered.

The FIELD RENDERING activates the line by line rendering of the animation. This setting will become important when the plan is to show the animation on television. Because televisions only work within the frequency of the local power supply, the image is split into two half images. This pretends to be a more fluid movement to the eye and is important with fast-moving objects.

Starting with an even or uneven row depends on the kind of postproduction of the film material. This should be discussed with the person who will do the postproduction.

Finally, the FRAME RATE has to be set in which the animation should be rendered. Be sure that the FRAME RATE in EDIT> PROJECT SETTINGS and the settings in the RENDER SETTINGS are coordinated or else the animation will be played at a speed other than previously determined in CINEMA 4D.

Save Settings

On this page of the RENDER SETTINGS dialog, the format and the path used to save the rendered image or animation are set (see Figure 2.109).

— Figure 2.109: Save settings.

The SAVE IMAGE option can be deactivated when the image is not to be saved in the dialog page. An alternative way to render is the MULTI-PASS rendering, which we will learn about later.

With the PATH button the desired name and path to save the data are determined. The format by which the data is saved can be changed in the FORMAT setting. Many formats can be found here, for example, Photoshop, TIFF, or JPG, or film formats such as AVI or QuickTime.

Note that animations can also be saved as single images. This makes sense because the entire scene does not have to be rendered again when there is an error.

When the animation is saved as a TIFF sequence, the render process can be interrupted at any time and continued later with the next image.

The image sequence also has the advantage that all single images can be saved with a custom compression setting. This provides maximum control over the quality of the images.

At the end of the render process the single images just have to be put together to form an animation. This is done by external programs, such as video-editing programs or players such as QuickTime Pro.

The DEPTH setting determines the color depth of the rendered image. For color-editing purposes it should be set to a high color depth. Not all graphics program tools and filters can handle extreme color depths, but 16 bits per channel should not be a problem for most of the external programs.

The NAME menu is only interesting for the output of animations as single images. With this menu the numbering sequence can be determined for saving the images. This should be set based on the naming habits of your video-editing software.

The DPI value determines the point depth of the saved image. The preset 72 dpi represents the standard resolution of monitors.

The required resolution can also be determined by setting up a new image with the desired measurements and resolution in, for example, Photoshop and by using the resulting pixel resolution of the image in CINEMA 4D.

These values can then be entered into the RESOLUTION setting of the RENDER SETTINGS. Recalculation to the desired dpi can then be done in postproduction.

The lower part of the dialog shows several options where additional information can be saved. The activated ALPHA CHANNEL option calculates and saves an alpha channel of the image or animation. Depending on the format, this mask can be saved separately or as part of the image.

The JPG format, for example, does not allow the integration of masks. In these cases additional images are saved for the ALPHA CHANNEL.

We will learn about a better option for saving these masks when we talk about the MULTI-PASS settings.

When the ALPHA CHANNEL is active the calculation can be changed with the STRAIGHT ALPHA option. In this mode there will be no antialiasing or mixing of alpha masks with the rendered image. When your compositing program supports these alpha maps, they can be used to select parts of the image, even problematic objects such as fog or transparent objects.

The image will be changed as well and can only be reconstructed in connection with the STRAIGHT ALPHA. I would like to show this with a small example.

The Straight Alpha

I will start with a new scene and create a spotlight. At the GENERAL page of the light source dialog, I switch the VISIBLE LIGHT menu to VISIBLE. This creates a kind of fog around the light source.

The rest of the modes create a similar effect, the only difference being that the fog will be volumetric, meaning that objects within the light cone can cast shadows into the fog.

In the DETAILS page of the dialog we set two opening angle values for the spot light in the INNER and OUTER ANGLE. The brightness of the spotlight is constant within the INNER ANGLE light cone and will be reduced toward the outer light cone down to o. These settings can be seen in Figure 2.110.

— Figure 2.110: Settings of the light source.

The light intensity can also be restricted along the direction of the shining light. For this there are several reduction functions and radii that we do not need for this example.

Instead we will work on the visible part of the light on the VISIBILITY page of the dialog (see Figure 2.111). Interesting to see here are the settings for INNER and OUTER DISTANCE, which determine two radii around the light source.

Within the INNER DISTANCE radius the light remains a constant brightness. Then the brightness reduces up to the OUTER DISTANCE radius.

When the USE GRADIENT option is activated the visible light cone can be colored individually. This is not important though for our test.

— Figure 2.111: Visibility settings of the light.

In order to give this rather boring looking visible light more structure, activate the VISIBILITY setting in the NOISE menu on the NOISE page (see Figure 2.112).

— Figure 2.112: Noise settings.

The pattern chosen in the TYPE menu will be multiplied with the visible light. This is a simple way to create, for example, fog banks or clouds.

The noise pattern can be scaled independently by the visibility scale values in X, Y, and Z directions. The octaves parameter determines the accuracy of the pattern calculation.

Brightness and contrast of the pattern can be controlled with the BRIGHTNESS, CONTRAST, and ILLUMINATION SCALE settings.

With the VELOCITY and WIND settings, even fog bank animations can be created.

Depending on the settings in the NOISE menu, this pattern can be used for lighting and not just for creating a more interesting light cone.

This should do it, and we just have to rotate the spotlight into a favorable direction for rendering.

Activate the straight alpha in the RENDER SETTINGS for calculating the straight alpha and render the image. The result does not look very good, as shown in Figure 2.113. The image lets us only guess the light cone. Only the alpha channel matches our expectations.

The actual advantage of this rendering will be apparent in postproduction. I opened the image in Photoshop and used the STRAIGHT ALPHA as a mask. The background is replaced by a gradient to see the quality of the extraction.

As shown in Figure 2.114 there are no remains of the original black background. The edges of the light cone and the segments affected by the noise look very natural in front of the new background. This is a helpful option when working with transparent objects.

This concludes our small tour of the subject of extraction. We will continue with the settings of additional project data on the SAVE page of the RENDER SETTINGS. They are only important for further work on animations in Motion, Final Cut Pro, Shake, After Effects, or Combustion.

Saved project data of the single images can be opened directly in the programs mentioned earlier, but make sure that all layers are loaded

— Figure 2.113: The result of the rendering with a Straight Alpha channel.

in the proper rows. However, this only works when the MULTI-PASS part of the RENDER SETTINGS is activated and the desired channels are activated for rendering.

The position of cameras and light sources can be saved, too, enabling the creation of elaborate effects. Therefore, apply a special tag in TAGS > CINEMA 4D TAGS > EXTERNAL COMPOSITING in the OBJECT MANAGER. In addition to the COMPOSING PROJECT FILE option, activate the 3D DATA option in RENDER SETTINGS > SAVE and render the animation.

When the 3D data is not needed, it is enough to just click on the SAVE button. This saves a project file with all included file paths of the raw materials for the selected program. These file paths should already be set correctly in the MULTI-PASS page, as the project file can

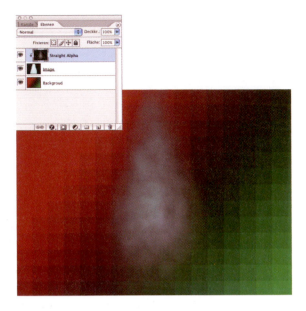

— Figure 2.114: Exchanging the background.

be accessed afterward, even if the option to save the project file was not activated when the animation was rendered.

Antialiasing Settings

We already know the basic settings for the type of edge smoothing and the calculation of filters from the GENERAL page of the RENDER SETTINGS. These parameters appear again in the ANTIALIASING page and can be adjusted further (see Figure 2.115).

— Figure 2.115: Antialiasing settings.

The SOFTNESS value controls the mix between the sharp STILL IMAGE and the softer ANIMATION filter in BLEND mode. A value of 0% equals the effect of the STILL IMAGE filter. With some other filters this value determines the strength of the antialiasing.

The THRESHOLD value sets the maximum allowable color difference between neighboring pixels. When the BEST ANTIALIASING option is active and when the measured color value exceeds the THRESHOLD, the color difference will be blurred between pixels.

The standard value of 10% is enough for most situations and should only be reduced when the quality of the result is not good enough.

The actual strength of BEST ANTIALIASING is controlled with the MIN and MAX LEVEL values.

The setting for MIN LEVEL equals the quality level of each pixel. The MAX LEVEL represents the highest quality.

Depending on the complexity of the calculated surface, CINEMA 4D itself chooses a quality setting from these presets.

If there is a situation where even the standard settings of BEST ANTIALIASING do not provide a satisfying result, then these values need to be raised. There are several steps available.

In order to not raise the values too high and to extend the render time it should be determined where the higher quality is needed.

When there are errors at shadows, inside materials, or behind transparencies, then the MAX value should be raised. Errors of simple geometries and object edges can be fixed with the MIN value.

If the render error is isolated to only one object or group of objects, the quality of the ANTIALIASING can be raised especially for these objects. Therefore, assign a COMPOSITING tag to these objects. These tags can be found in the TAGS > CINEMA 4D TAGS > COMPOSITING menu of the OBJECT MANAGER.

Within these tags there is, for example, the FORCE ANTIALIASING option, which makes it possible to assign individual MIN and MAX LEVEL values. They can be entered directly into

the MIN and MAX fields in the tag. Even the THRESHOLD can be adjusted this way.

The USE OBJECT PROPERTIES option in the ANTIALIASING page of the RENDER SETTINGS needs to be active so that the settings in the COMPOSITING tag can be used. This tag has a series of other useful options. Let's take a look at some of them (see Figure 2.116).

— Figure 2.116: Settings of the Compositing tag.

In the tag area of the dialog are some options that control if the object is visible for the camera, should receive or cast shadows, or be reflected in other objects. This makes it easy to use help objects that, for example, only cause a reflection on a surface without being visible in the image.

With the settings in the EXCLUSION page of the dialog, properties can be limited to certain objects (see Figure 2.117).

— Figure 2.117: The Exclusion list.

Imagine that object A will not be reflected in object B but in object C. By the deactivation of the SEEN BY REFLECTION option, object A would not be reflected in any of the reflecting objects.

Thanks to the EXCLUSION list this problem can be solved quickly. Just pull object B into the list and select the property icons that should not be active.

Their meaning is, from left to right, visibility behind transparent objects, visibility in refractions, visibility in reflections, and the inclusion of all subordinate objects.

The function of these icons will change depending on whether the EXCLUDE list is operated in INCLUDE or EXCLUDE mode.

When the list is operated in EXCLUDE mode the active icons represent properties of the object in the list that are not calculated. In INCLUDE mode the active icons represent visible properties.

Also very interesting is the OBJECT BUFFER page of the COMPOSITING tag. Here one or more buffer numbers can be assigned to the object that has a COMPOSITING tag (see Figure 2.116).

With the MULTI-PASS settings, separate alpha channels can be calculated for these buffers. This is a helpful option for instantly extracting objects in the scene later on.

Options Settings

This area of the RENDER SETTINGS has basic settings that need only be changed for rendering on rare occasions (see Figure 2.118).

— Figure 2.118: Options settings.

In the left column are options through which the calculation of the BLURRY EFFECTS, meaning the matte reflections and transparencies of materials, can be turned on and off.

The AUTO LIGHT option activates the DEFAULT LIGHT in scenes where no other light source is placed. I only mention this option because there are situations where this additional AUTO LIGHT interferes when radiosity is used to light the scene.

The CACHE SHADOW MAPS option is interesting. This is when camera flights are animated without any other objects in the scene. Then the soft shadows only have to be calculated for the first frame of the animation. These shadows will be saved to the hard drive, when the option is activated, and loaded again for the following calculation.

Depending on the size, number, and complexity of the shadows the render speed can be accelerated tremendously. The presumption is though that the shadow will stay the same or else CINEMA 4D has to calculate the shadows again and the advantage is gone.

In the right column of the dialog window are some number values. With these we can influence the number of samples in scenes with many transparent or reflective objects.

RAY DEPTH determines the maximum number of surface permeations that will be allowed for the rendering of an image pixel. Imagine a long row of glasses or several windows that are stacked behind each other.

Always, when a transparent or polygon masked by the ALPHA channel of a material is rendered, a new ray needs to be sent that determines what can be seen behind the polygon.

In order to cut down on extreme render times, the RAY DEPTH value controls the maximum number of these additional rays.

When the exact calculation of several transparent surfaces cannot be avoided and when there are errors in the test renderings, this value has to be raised.

The REFLECTION DEPTH parameter works after the same principle, but refers to reflections. A typical example is two reflective surfaces that are placed across from each other.

The worst-case scenario would be when the ray is caught between the surfaces and reflected indefinitely. The REFLECTION DEPTH automatically stops this reflection after a certain number.

The SHADOW DEPTH parameter works along the same principle and determines the maximum number of rays that are used to see if a pixel lies in the shadow of another object.

The THRESHOLD value works like a filter for the ray tracer. Only color, transparency, and reflections that have a value exceeding the THRESHOLD will be rendered.

Raising the THRESHOLD suppresses the display of small pixel properties and accelerates the render time. Imagine, for example, a surface with 10% transparency. With a THRESHOLD of 11% this transparency would not be displayed and the render time would be faster. However, because this setting is unpredictable and goes along with quality reduction, it is better to leave it at 0% to get the maximum quality.

GLOBAL BRIGHTNESS and RENDER GAMMA deal with the display and brightness of the rendered image on the monitor.

With GENERAL BRIGHTNESS the brightness of the rendered pixel can be generally raised or lowered. RENDER GAMMA should be set as determined by the operating systems calibration of attached monitors.

— Figure 2.119: Multi-Pass settings.

On Windows PC's the value is 2.2, whereas Mac OS PC's have a value of 1.8. The value that fits will automatically be entered by CINEMA 4D.

Multi-Pass Settings

The settings on the MULTI-PASS page of the REN-DER SETTINGS can be used in addition to the SAVE settings or as an alternative (see Figure 2.119).

Just like in the SAVE settings, a file format and a path for saving the render results can be set.

The big advantage here, when compared to the function on the SAVE page, is that not only is the complete image saved, but also that the physical properties are saved in separate layers.

Therefore, for example, the shadow, reflection, or the material colors can be rendered as separate layers. These can be activated by clicking on the arrow in the upper right side of the page. This opens a list of possible passes.

The OBJECT BUFFER channel can be found there too. It can be used to separate objects marked by the COMPOSITING tag into ALPHA channels.

A balanced list of multi-passes can be found in the selection of ADD IMAGE LAYERS in the MULTI-PASS list. This activates the most common channels and shows them in the list.

Unnecessary channels can be deactivated by removing the checkmark in front of the channel. Missing channels can always be loaded from the MULTI-PASS list.

The light effect and shadows can even be rendered separately for each light source when the SEPARATE LIGHTS menu is used.

Which light sources are used can be determined in the SELECTED setting. In the dialog of each light source there is the option SEPARATE PASS in the GENERAL page. Otherwise, all the lights will be saved when ALL is set in the SEPA-RATE LIGHTS setting.

The MODE menu in the MULTI-PASS settings determines which properties of light sources or lighting will be saved as separate layers.

How all these RENDER SETTINGS and MULTI-PASS settings will lead to the desired image can be seen in our little example with the two CDs.

Preparing the Scene

We will start with checking on the GENERAL page of the RENDER SETTINGS to see if the settings for TRANSPARENCY, REFLECTION, and SHADOW are set to their highest quality. RENDER AS EDITOR has to be turned off as well.

At the OUTPUT page, set the desired resolution of the image. Be sure that, for the still image, the FRAME menu is set to CURRENT FRAME. The PIXEL ratio should be 1:1.

Because we want to try out the MULTI-PASS channels to make it easier to edit the image later, deactivate SAVE IMAGE on the SAVE page of the RENDER SETTINGS. The ALPHA CHANNEL option on the SAVE page can be left active when a STRAIGHT ALPHA is needed.

Choose BEST and STILL IMAGE as FILTER in the ANTIALIASING settings. The rest of the standard settings for MIN/MAX LEVEL and THRESHOLD can be used without a change.

In the MULTI-PASS page choose ADD IMAGE LAYERS in the MULTI-PASS list and deactivate the channels for AMBIENT, GLOBAL ILLUMINATION, CAUSTICS, ATMOSPHERE, ATMOSPHERE (MULTI-PLY), and POST EFFECTS. These properties will not be used in our scene and would therefore only deliver empty layers.

Also add an OBJECT BUFFER channel with the number 1 and put the desired path for saving the file over the PATH button.

The options ENABLE MULTI-PASS RENDERING, SAVE MULTI-PASS IMAGE, and MULTI-LAYER FILE must be active so that a file with layers can be saved.

Be sure to use a file format, such as Photoshop or BodyPaint 3D, that is able to manage layers.

The RENDER SETTINGS can be closed again. Before the scene is rendered we have to mark the objects that are supposed to be saved in the active OBJECT BUFFER 1.

These will be the CDs. Apply a COMPOSITION tag to both objects and activate OBJECT BUFFER 1 in both tags. Then check one more time the part of the image in the perspective viewport. It could have been moved by the change of the RESOLUTION value in the RENDER SETTINGS.

If necessary, correct the position of the virtual camera. Be sure that the USE AS RENDER VIEW option in the EDIT menu is active in the perspective viewport. By switching this option every viewport could be used to render an image (see Figure 2.120). That way, undistorted renderings of the front and side viewports can be created.

— Figure 2.120: Use as Render View.

Starting the Render Process

The rendering or calculation of an image or animation can be started by clicking on the displayed icon shown in Figure 2.121.

This RENDER TO PICTURE VIEWER function opens the so-called PICTURE VIEWER and shows the progress of the calculation. The image displayed there is not always shown in the right size or quality, as the size of the PICTURE VIEWER can be changed.

While the calculation is running, we can take a look at the activated multi-pass layers in the CHANNEL menu of the PICTURE VIEWER. Therefore, just deactivate the MULTI-LAYER DISPLAY option in the CHANNEL menu and click on the desired channel in the same menu. That

— Figure 2.121: The Picture Viewer.

The saved file can now be opened, for instance, in Photoshop. This is provided you have followed the example. Figure 2.122 shows the saved layers and the entire image resulting from all the combined layers.

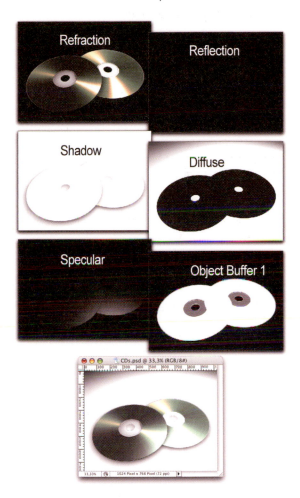

— Figure 2.122: The Multi-Pass file.

way, errors can be detected early and the render process can be stopped.

When everything is okay, wait for the end of the render process and close the PICTURE VIEWER. The end of the render process can be determined in the status bar of the PICTURE VIEWER. The progress bar disappears, and only the time needed to render the image is shown.

Note that the image is only saved when the path where it should be saved was specified in the MULTI-PASS page or SAVE page in the RENDER SETTINGS. An alternative is to save the image directly in the PICTURE VIEWER. The command can be found in the FILE menu of the PICTURE VIEWER.

The advantage of multi-pass is obvious. The intensity of shadows or highlights could be changed afterward without having to change the scene or to render it again.

Now you have gone through a complete work cycle of modeling, texturing, lighting, and rendering.

2.7 The Virtual Photo Studio

I would like to get deeper into working with light in this section. For this reason we will create a virtual photo studio where, for example, we can create product shots for catalogs.

We start with a new scene and create a kind of stage for the objects. Therefore we will use a backdrop, which is also used in traditional photography.

It is often made of fabric or paper that covers the wall behind the scene and, with a slight bend, goes down to the floor and under the object to be photographed. Floor and background appear to be merged into one unit.

Define the shape of the backdrop in the side viewport with a spline. Use the Bezier spline, which can be adjusted exactly with its tangents.

Be sure that the spline part, which represents the floor, is flat. Set this point to the world coordinate of 0. This makes it easier to place objects on the floor later on.

A possible shape of this spline is shown in the upper part of Figure 2.123. Group the splines under an EXTRUDE NURBS and set the MOVEMENT values so that a wide backdrop is created. The lower part of Figure 2.123 shows a possible result in a view from above.

The backdrop can already be used but I also want to create a slight curve. This will benefit the lighting later on. The EXTRUDE NURBS does not offer the possibility of a curvature.

Deformers

We will use a DEFORMER object. This object type can be found in the icon menu shown in Figure 2.124. These are HELP objects that can be activated by subordinating them.

The most common DEFORMER objects are in the first row. What kind of deformation will be achieved can be seen by looking at the icon.

— Figure 2.123: Extruded spline.

— Figure 2.124: Deformation objects.

We are interested in the BEND deformer. Open it by clicking on the icon and group it under a newly created basic cube object.

In order to bend the cube, the number of its segments should be raised in the direction of the bend. My settings can be seen in Figure 2.125.

Activate the move tool in model mode and use the handle of the BEND object. It can be seen how moving the handler can control the intensity and direction of the bend in the cube.

— Figure 2.125: The Bend deformer.

A possible result is shown in the lower part of Figure 2.125.

The values of the deformer objects can be set in the ATTRIBUTE MANAGER when an exact angle or direction has to be used.

There are different modes at our disposal. The standard mode is MODE LIMITED. This means that the deformation is only calculated between the bottom and the top faces with the handler of the BEND cube. The parts that extend the BEND cube on top and bottom will not be affected.

The place of deformation can be chosen freely, as the BEND cube is moveable in all directions. The length of the bendable segment is defined by the Y size.

The KEEP Y-AXIS LENGTH option can be activated if the original length of the object should be kept.

In addition to the standard mode, there are the modes WITHIN BOX and UNLIMITED. Both are shown in Figure 2.126.

In the WITHIN BOX mode, only the part of the object that lies within the deform object is deformed. This mode is hardly used.

The UNLIMITED mode works like the LIMITED mode, but extends the deformation past the lower part of the deformed cube. This makes it easier to create symmetrical bends.

A big advantage of the deformer is that they can be combined with each other and applied to an object (see Figure 2.127). Test it yourself by opening a TWIST deformer and subordinate it under the cube.

The order of the deformers under the object plays an important role because the deformers are applied from the top to the bottom.

When the cube is bent first and then twisted, it would result in a confusing object. It makes more sense to twist the cube first and then bend it. A possible result is also shown in Figure 2.127.

Now the basics of the use of deformer objects are known and we can go back to the backdrop.

Delete the cube and the deformer again. They were used only to show the effects we went over. Create a new BEND object in UN-LIMITED mode and subordinate it under the EXTRUDE NURBS. Then correct the order of the objects under the EXTRUDE NURBS again so that the spline is on top. Adjust the Y axis of the BEND object so that it lies on the X world axis.

Use the handler of the BEND object in the top viewport until a good looking curvature of the backdrop is achieved (see Figure 2.128). If necessary, adjust the size of the BEND object to the size of the backdrop.

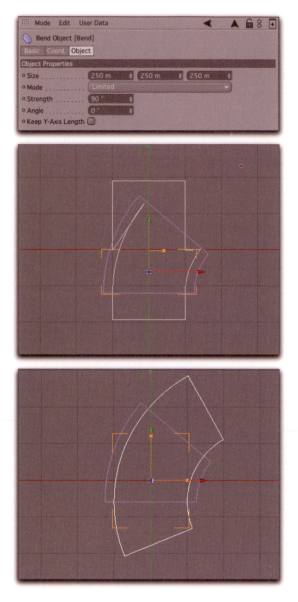

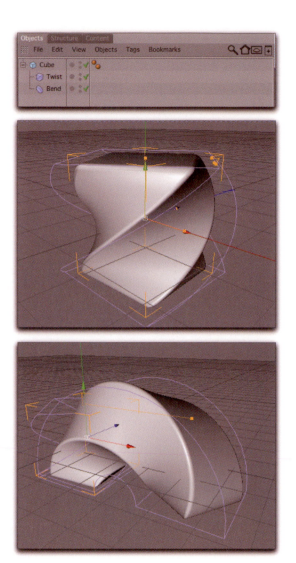

— Figure 2.127: Combining deformations.

— Figure 2.126: Different mode settings of the Bend object.

Choose a camera perspective in the perspective viewport. Note the slightly darker areas. Only the section between these areas will be shown in the image. The border of this section was additionally marked with black lines in Figure 2.129.

Using a Camera

This perspective will now be transferred to an extra camera object. Select the camera symbol in the icon menu of the light sources (see Figure 2.130).

The viewing direction and perspective of the viewport chosen for rendering (remember the USE AS RENDER VIEW setting) will be transferred to the camera object.

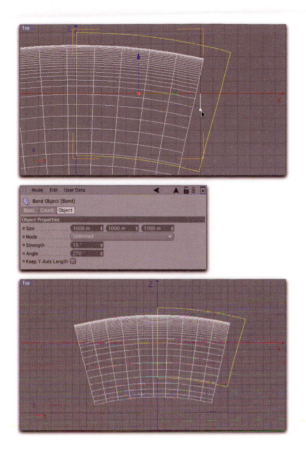

— Figure 2.129: Choosing a camera perspective.

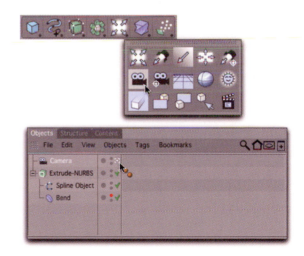

— Figure 2.128: Bending the backdrop.

In order to use the camera later for rendering, the small symbol behind it in the OBJECT MANAGER needs to be clicked (see Figure 2.130).

The camera is displayed in the editor viewports just like all the other objects, as shown in Figure 2.131. That way, we know where the camera is located and where it points, even if we are using the front or the side viewports. The viewing volume of the camera also helps.

Besides that, there are additional settings for the FOCAL LENGTH of the camera in the AT-TRIBUTE MANAGER.

With the FILM OFFSET value of the camera, the display window can be moved laterally and vertically without moving the camera or changing the perspective. This is helpful, for

— Figure 2.130: Creating a camera.

example, when showing very high objects or the interior of rooms and so-called falling lines need to be prevented. Vertical edges can be displayed vertically, even when a wide angle lens is used.

— Figure 2.131: Parameter of the camera.

— Figure 2.132: Avoiding falling lines.

This effect can be seen in Figure 2.132 where we want to render a part of a high-rise building, which is represented by a simple cube.

When the camera is placed at the base of the building and we look up, then the vertical lines are tapered toward the upper edge of the viewport. This effect can be seen in the left rendering in Figure 2.132.

When the camera is placed parallel to the floor instead and not angled as steep as before, then the vertical edges are almost parallel, which would not be of much use though because the parts of the building further up need to be shown as well.

The FILM OFFSET value can help us with that, as the display window can be moved again in such a way that the initial part of the building is shown. The necessary settings and the rendered image can also be seen in Figure 2.132.

The side viewport in Figure 2.132 also shows the different positions and orientations of the camera. The yellow camera is the one that uses FILM OFFSET to move the display window.

When this trick does not help to create the desired perspective, then CLIPPING might help. It defines a distance to the camera that will remain invisible to the camera. This allows us to place the camera outside the building and to use CLIPPING to make the front walls invisi-

— Figure 2.133: The Clipping effect.

ble. Figure 2.133 demonstrates this again with an example.

A cube was placed directly in front of the camera, as shown in Figure 2.133. Let us imagine that this is a complete room that we want to show in the image.

Because of the restricted space in the room we would need a wide angle lens to get the desired viewing angle. However, it would distort the image.

The camera could be moved further away from the room, and objects between the camera and the room could be made invisible by increasing the CLIPPING value. The bottom image in Figure 2.133 shows the result. The camera can have an unobstructed look into the room.

Working with Area Lights

Let us get back to our project, the photo studio.

In the following step we will create ambient lighting, which is caused by scattering light in the room. It will be created with an area light and an individually shaped geometry (see Figure 2.134).

— Figure 2.134: Using geometry as a light source.

Create a basic sphere object and scale it so that part of the backdrop, which will be shown in the image later, can fit inside.

Convert the sphere into a polygon object and delete all faces below the bottom of the

backdrop. Open the remaining half sphere in back of the backdrop by deleting more faces.

The former sphere now looks more like a concert shell, as shown in Figure 2.134.

Execute the OPTIMIZE command so that all points left behind by the sphere are deleted. This shape should now glow; by illuminating the shell we simulate incoming light from all directions.

Because the geometry itself should be invisible (we only need the light), assign a COMPOSITION tag to the former sphere in the OBJECT MANAGER.

Deactivate all options in the TAG page of the dialog. The sphere will now be invisible for the camera and will not show up in reflections or behind transparencies and also cannot cast a shadow.

Now create an AREA light and activate the calculation of an area shadow. Set the brightness to 70%. This value needs to be checked later with test renderings.

Generally the rule is that the size of the area light can have an influence on the brightness of the radiated light. This means that a small light with 100% brightness can be very bright, whereas a large area light with the same setting can appear dark.

Deactivate the SPECULAR option in the GENERAL page of the light source. The creation of highlights for ambient light would have a deceptive effect.

Let us continue with the parameter in the DETAILS page of the dialog (see Figure 2.135).

The OBJECT/SPLINE mode in the AREA SHAPE menu has to be selected in order to get the area light to use our faces as a base. Then the former sphere needs to be pulled from the OBJECT MANAGER to the OBJECT field in the DETAILS page of the light source.

In the FALLOFF menu of the same settings page, we will choose the INV. SQUARE LIMITED mode to limit the width of the light radiation. The intensity will be reduced inversely proportional to the square of the distance, which about equals natural light.

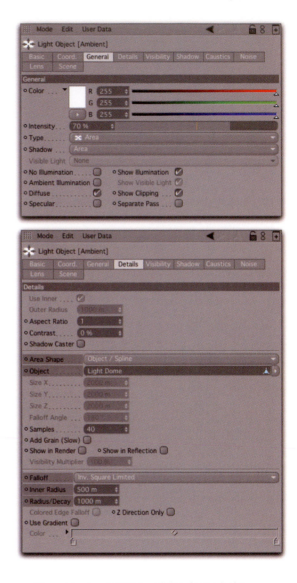

— Figure 2.135: Settings of the dome light.

The advantage of the FALLOFF mode is that we can specify two radii to control this reduction visually.

The value for INNER RADIUS defines the distance from the light-radiating area where the intensity of the light stays the same.

Until it reaches the value set in RADIUS/DECAY, the light will reduce the brightness according to the value specified in the FALLOFF function.

With these settings we can prevent, for example, that too much light will be radiated from the left surface to the side facing it. These settings can also only be guessed at. They need to be checked with test renderings.

Because both radii can be set by using handlers in the viewports, I can give an indication as to where to put the light source.

Place it on the former upper pole of the sphere. The light does not change because it will only radiate from the specified surfaces. Then the INNER RADIUS value has to be set so that the circle in the editor reaches the floor of the backdrop.

The outer radius is simply twice the INNER RADIUS value.

Figure 2.136 shows how this would look. In the front viewport, the light source can be seen placed over the former sphere and with both radii for the light reduction.

— Figure 2.136: Amounts of the light reduction function.

— Figure 2.137: The ambient light.

Figure 2.137 shows how the rendered image looks.

In order to better judge the effect of the light and the shadow, I put a slightly rounded cube on the floor of the backdrop. The cube represents the objects that will be placed on this spot later on.

Everything still appears a bit dark, but this is just all about the ambient light that will be replaced by main light sources in the next step.

The Main Light

The counterpart to ambient lighting, which affects the scene from all directions at the same time, is direct light. It shines directly from the light source to the object that is supposed to be lit (see Figure 2.138).

These light sources are used to define the main light source. In the real world, this could be the sun or the ceiling light in a room.

The number of lights and the direction from which they affect the objects depend on the mood that is to be created.

Because this is a simulation of a clean studio atmosphere, there is an even illumination of the object. We will increase the light from the right and create more variations in the surface shading to prevent the object from appearing flat. This main light will again be an area light because they generate a very soft and natural light.

Set the brightness of this new light to 90% and deactivate the shadow. We have to be careful with the creation of additional shadows, as multiple lights interact with each other in our small space.

Too many active shadows would create multiple shadows on the floor, which would look like floodlights in a soccer stadium.

Product photographers especially try to avoid intense shadows on the floor or on the object. We will do the same.

In the DETAILS page we will set the shape of the light to RECTANGULAR.

The FALLOFF ANGLE parameter defines the angle range from which the light is emitted

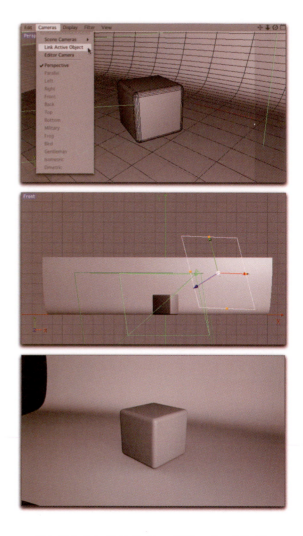

— Figure 2.138: The main light.

— Figure 2.139: Orientation of the direct light.

from the surface. A value of 180° would mean that, even in extreme cases, the light would be emitted parallel to the surface. Therefore, we will restrict the emitting direction a bit and enter a value of 90°.

To be sure that this new light source is oriented the right way, we will use a little trick. Make sure that the new area light is selected and choose the entry LINK ACTIVE OBJECT in the CAMERAS menu in any of the viewports. This will switch this viewport and will now use the light source like a camera (see Figure 2.139).

With normal navigation icons, the view of the light source can be controlled and exactly target the area that is supposed to be lit.

Choose the position shown in Figure 2.139. The lower part of Figure 2.139 shows a test rendering of the actual scene.

There is still some light missing from the left side and from the top. The sides of the cube still appear a bit dark too. Therefore, create another area light and set it to 20% brightness (see Figure 2.140).

This light source also does not have a shadow. Place this brightener light to the left

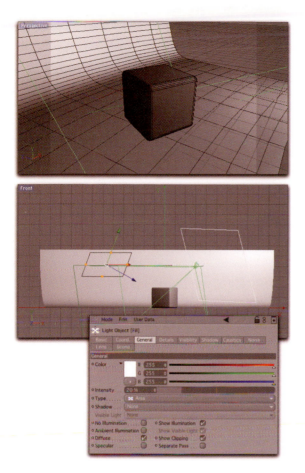

— Figure 2.140: A brightener light.

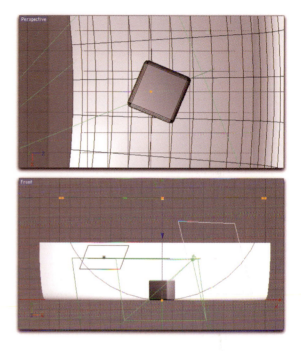

— Figure 2.141: Another light illuminates from above.

Finally, we will add one more area light, which will take care of additional lighting from above.

We will again use an area light without shadows and place it exactly above the lit cube (see Figure 2.141).

side of the cube and orientate it to the cube using the LINK ACTIVE OBJECT function in a viewport. Then leave the editor view again with CAMERAS> EDITOR CAMERA. A possible position of the light source can also be seen in Figure 2.140.

The size of the area lights can be controlled directly in the viewports by moving the handles. Imagine that these area lights are light boxes or reflectors like those used by photographers.

The size of the area lights should be in the right proportion to the size of the backdrop and the lit objects. Ultimately this can only be tested by test rendering the scene.

In order to avoid an overexposure of the now heavily lit floor, we will use a FALLOFF INVERSE SQUARE and set the radius so that it is located just above the floor (see Figure 2.142). That way, the parts of the lit objects placed higher will get more light than the floor.

The objects are now lit evenly but not flat, like the test rendering shown in Figure 2.143 demonstrates.

What are still bothersome are weak shadows or the lack thereof. Because of this, the cube seems to hover over the floor.

We could go the easy way and apply a shadow to one of the area lights, but this would change the appearance of the scene completely. Depending on the light source,

— Figure 2.142: The upper area light.

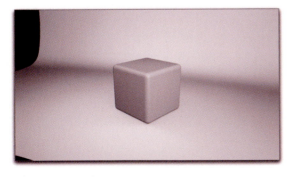

— Figure 2.143: The final lighting of the scene.

this would result in a long shadow that would look artificial.

Ambient Occlusion

In these cases the AMBIENT OCCLUSION calculation is used and can calculate a shadow independent from the position of the light sources.

The covering of every spot of an object will be checked and converted into brightness values.

Creases and faces, which sit in an angle on top of each other, are darkened and look like there is a shadow.

There are two possibilities to create this effect. There is the AMBIENT OCCLUSION shader, which can be found among the EFFECTS shaders loaded in the DIFFUSION channel of a material. This results in the automated darkening of surfaces in areas where the view of the surface at its surrounding is obstructed. This way has the advantage that we can decide for ourselves where and how strong the effect should be used in the scene.

Alternatively, the setting AMBIENT OCCLUSION can also be found in the RENDER SETTINGS of CINEMA 4D (see Figure 2.144). The effect is calculated automatically for all objects when the APPLY TO SCENE option is active. The only exceptions are objects that are excluded from the AMBIENT OCCLUSION calculation with a COMPOSITION tag. Otherwise, the parameters of this effect are the same in the shader and in the RENDER SETTINGS.

The most important settings concern the length of the rays, which are adjusted with the MINIMUM and MAXIMUM RAY LENGTH values.

From every point on the surface, rays are sent that check for other faces in the vicinity. This ray is stopped after it reaches the MAXIMUM RAY LENGTH distance, unless it hits another surface first.

The greater the MAXIMUM RAY LENGTH is set, the more faces will be discovered, and the greater the darkening is calculated.

— Figure 2.144: Render settings.

The MINIMUM RAY LENGTH value defines the start point of the ray over the surface. Therefore, nothing has to be changed at the basic setting of 0.

The DISPERSION parameter controls the angle in which the rays depart the surface. At 100% DISPERSION, angles are possible that run almost parallel to the surface.

The smaller the value is set, the closer the departing angle is to the angle of the surface normals. This effect can be seen in the upper two images in Figure 2.145. The uppermost image shows a DISPERSION of 50%, and the image below shows a DISPERSION of 100% while all other settings remain the same.

The darkening will appear softer with larger values. In extreme cases this can be compared with hard and soft shadows. Additionally, we can use the color gradient in the AMBIENT OCCLUSION settings to control the brightness and its course. The lowest image in Figure 2.145 shows this.

There the standard black color stop of the gradient was set about 25% brighter. The shaded areas will then be brightened by this amount.

The settings for MINIMUM SAMPLES, MAXIMUM SAMPLES, and ACCURACY are already known from the materials and shadows. They work using the same principle.

The MINIMUM value determines the lowest value for the number of rays per point. This value is used with simple geometry.

— Figure 2.145: Ambient Occlusion.

The MAXIMUM SAMPLE value controls the upper limit of rays and is responsible for angular and problematic areas.

The ACCURACY parameter acts like a multiplier for SAMPLE settings and also determines the quality.

In the lower part, options can be set as to how an existing sky object should be checked. This causes a coloring of the dark areas by the colors of the sky.

EVALUATE TRANSPARENCY calculates the transparencies in a scene. Transparent surfaces will then only partially take part in the darkening, depending on their visibility.

SELF SHADOWING ONLY evaluates the rays only when they hit faces that are part of the same object as the one the rays originated from.

In the series of images in Figure 2.145 it can be seen that the AMBIENT OCCLUSION really improves the quality and creates the deep shadow that was missing.

Unfortunately, the AMBIENT OCCLUSION is only available to users who own the ADVANCED RENDERER module. Traditional shadows have to be used when this module is not installed.

It might help to know that light sources can also be used as a producer of shadows. The broadening of the shadow can be controlled pretty well when the light source is used as infinitely distant light. Figure 2.146 demonstrates this in our scene.

I doubled the light placed above the cube and switched the copy to TYPE INFINITE. This light source works like the light coming from a very distant point. The advantage is that the light beams are running almost parallel.

The shadow will therefore not be much bigger than the contour of the object which casts it.

Because we only need the shadow and not the additional light source, activate the SHADOW CASTER option on the DETAILS page of the light source. I chose a soft shadow in the GENERAL page for the shadow type.

The shadow quality is not quite the same as the AMBIENT OCCLUSION shadow shown in Figure 2.146, but at least we have an alternative.

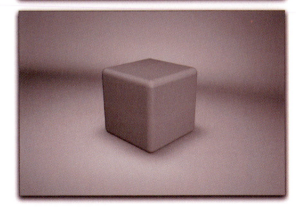

— Figure 2.146: Shadow Caster.

Applying the Material

The surface properties can also add to the general look of our studio. So far we have not applied any materials.

The preview sphere already gives us a pretty good idea as to how the material will work. There is still a brightness decline between areas directly lit and those that are only touched by the light, but this transition is very soft. The effect on our backdrop is shown in Figure 2.148.

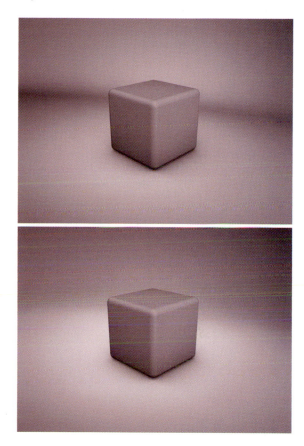

— Figure 2.147: Material settings for the backdrop.

— Figure 2.148: Before and after the material application.

Create a new material and apply it to the EXTRUDE NURBS of the backdrop (see Figure 2.147).

Leave the color at white with a brightness of 80%. On the ILLUMINATION page of the material it gets interesting. There the OREN-NAYAR model makes sure that the shadow will be even and that there is no large contrast. We will amplify this effect by raising the ROUGHNESS to 100%.

When the DIFFUSE FALLOFF and DIFFUSE LEVEL are raised to 100%, the shading is brightened right up to the TERMINATOR. This is the space where directly lit areas and shadows meet.

By direct comparison, it can be seen that the material has a big influence on the shading of the backdrop.

The upper image in Figure 2.148 shows the scene before applying the material. Even though the transition runs in a soft curve, the transition between the back wall and the floor is still visible.

It is different after the material is applied, as seen in the lower image in Figure 2.148. Back wall and floor now merge fluently into each other and do not distract anymore from the object.

Calculating the Computer

Because the cube is boring to look at after a while, we will now load the computer from our modeling workshop into the scene.

Use the MERGE command in the FILE menu of CINEMA 4D or, directly, the MERGE OBJECTS command in the FILE menu of the OBJECT MANAGER.

Now it depends on the size of the photo studio if the computer has enough space. In my scene the computer was too big and needed to be scaled down. Therefore all elements of the computer should be combined into a group, which is easy to do. Just click on the first object of the computer in the OBJECT MANAGER. While holding the Shift key, click on the last object of the computer. All objects in between will then be selected automatically.

In the OBJECTS menu of the OBJECT MANAGER, GROUP OBJECTS can be selected. The selected objects will be sorted under a NULL object.

Rename the NULL object to *Computer*. From now on, the whole computer model can be moved and scaled with this NULL object.

A possible result is shown in Figure 2.149. The cube is already deleted there. The lighting and the AMBIENT OCCLUSION seem to work instantly with more complex models.

Only the materials of the computer are missing. However, we can optimize the computer and combine objects (see Figure 2.150).

We do not need, for example, the BOOLE calculation of the front of the computer any more. The shape will not be edited any further. Therefore, select the BOOLE object in the *Computer* group and use the C key to convert the object to a group of POLYGON objects.

As we know, all geometric objects that have a green check in the OBJECT MANAGER can be converted this way. These are not only

— Figure 2.149: The computer in the photo studio.

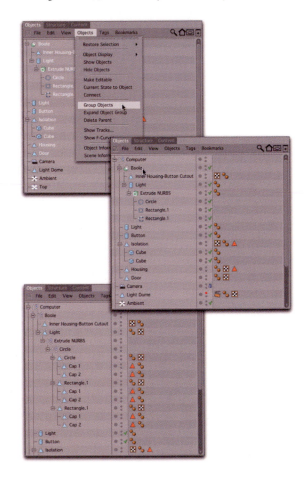

— Figure 2.150: Grouping and converting objects.

parametric basic objects, but are also NURBS or even BOOLE objects.

The conversion creates a large number of new objects, which, for example, include the caps of the EXTRUDE NURBS used in BOOLE (see Figure 2.150).

These objects should also be combined. With a CTRL click select all objects in the OBJECT MANAGER containing polygons of the previous BOOLE object (see Figure 2.151).

— Figure 2.151: Selecting Polygon objects.

Choose CONNECT in the FUNCTIONS menu for the selected group and then use the OPTIMIZE command in the same menu to remove duplicate edges and points.

Because the computer is covered with some sort of perforated plate up to the front handles, the UV coordinates should be checked for usability.

Later the material has to be bent around the curvature on the top and bottom of the housing without distorting the structure of the holes. This cannot be accomplished with the standard projections such as plane or cubic mapping.

Create a new material and load the CHECKERBOARD shader in the COLOR channel. It can be found in the shader category SURFACES.

Increase the density of the check pattern in the shader by raising both FREQUENCY values and apply the material to the front of the computer (see Figure 2.152).

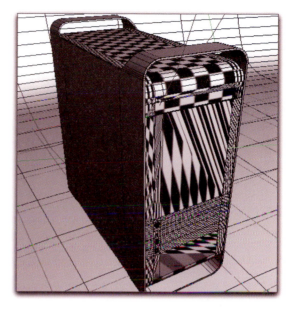

— Figure 2.152: Destroyed UV coordinates.

These UV coordinates cannot be used anymore, as shown in Figure 2.152. The BOOLE function and added steps distorted it completely. Therefore, we will use a trick. Delete the UVW tag behind the object and create a copy of the object that should be placed outside the *Computer* group in the OBJECT MANAGER (see Figure 2.153).

Make the *Computer* group temporarily invisible in the editor viewports so that we can work on the front of the computer at the duplicated object.

Change into EDGE mode and activate the LOOP SELECTION. We will bend the front of the computer apart, including the rounding, so the material can be applied later as a plane.

Activate the STOP AT BOUNDARY EDGES option in the LOOP SELECTION so that only one horizontal EDGE LOOP is selected at one time.

Then select all horizontal edges of the rounding above the drive bay, plus the edges

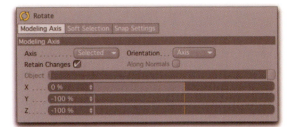

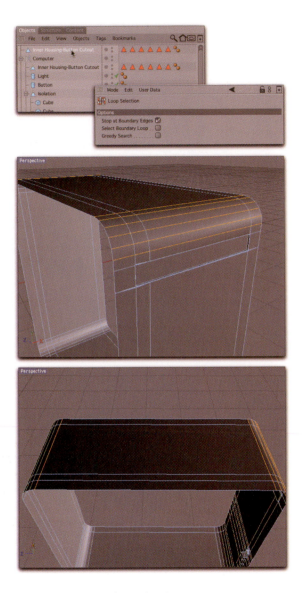

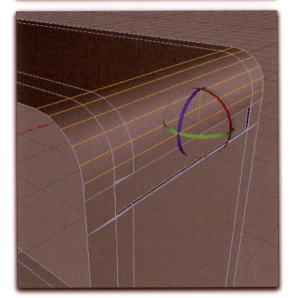

— Figure 2.153: Edge Selection.

that border the upper surface of the computer. Figure 2.153 shows this EDGE SELECTION from different viewports.

Activate the rotate tool and change to the display of the MODELING AXIS in the ATTRIBUTE MANAGER (see Figure 2.154). Set the AXIS to SELECTED and use the XYZ slider so that the MODELING AXIS is placed exactly on the lowest selected edge.

— Figure 2.154: Rotating with help of the modeling axis.

By rotating around the X axis, the face positioned above the edge can be aligned vertically. This can be estimated.

Use the LOOP SELECTION again, but this time deselect the lowest edges. The deselected edges are shown in Figure 2.155 and are indicated by an arrow.

With the ROTATE tool, bring the face bordering the lowest selected edge into a vertical position.

The goal is to align all faces of the rounding and the upper face of the housing parallel to the XY plane. This plane is indicated by a dotted line in the upper portion of Figure 2.155.

After rotating all of the faces, the shape should look like the one in Figure 2.156.

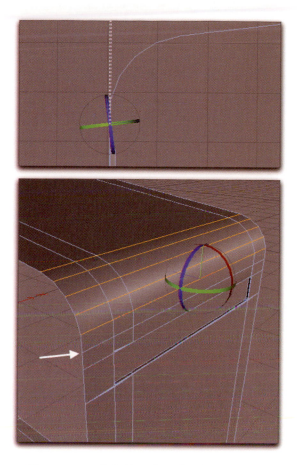

— Figure 2.156: The unfolded upper half of the housing.

— Figure 2.155: Rotating the selection.

Use the same principle for the lower half of the housing (see Figure 2.157).

In the image, the necessary adjustment for placing the MODELING AXIS can be seen as well.

Creating New UV Coordinates

The advantage of this time-consuming but easy unfolding of the object is that all edges keep their original length. This could not be guaranteed when working in BodyPaint 3D. This is very important for us though because every small distortion of the circular structures in the front would be obvious.

Apply the material with the checkerboard pattern to the unfolded object and choose FLAT as PROJECTION (see Figure 2.158).

Be sure to place the preview of the projection in TEXTURE AXIS mode centered in front and parallel to the front of the computer.

When this is done, choose GENERATE UVW COORDINATES in the TAGS menu of the OBJECT MANAGER (see Figure 2.159). A new UVW tag will be created behind the object that now contains the flat projection of our material, converted into UVW coordinates.

We can now pull the new UVW tag and our checkerboard material behind the original model of the computer because we did not change the number of points on the object (see Figure 2.159).

The point numbers and the order of points in the STRUCTURE MANAGER of both objects are identical; therefore, the new UVW tag works with the original object without any problems.

Every point knows which part of the material it has to show, and the checkerboard pattern wraps itself perfectly around the curvature of our computer (see Figure 2.160).

The unfolded model has done its job and can now be deleted. Make the *Computer* group visible again for the editor to see the result.

— Figure 2.158: Applying the material.

— Figure 2.157: Unfolding the lower part.

The Material of the Perforated Plate

The structure of the perforated plate could be loaded as bitmap, but then why do we have shaders?

Therefore, exchange the CHECKERBOARD material with the TILES shader, which can also be found in the SURFACES column in the shader list.

The TILES shader offers a series of often used patterns, for example, for tiles, wood floors, or our perforated plate.

Activate the PATTERN setting CIRCLES 2 in the shader and set COLORS 1 and 2 to white (see Figure 2.161).

The size of the holes is defined by the GROUT WIDTH value.

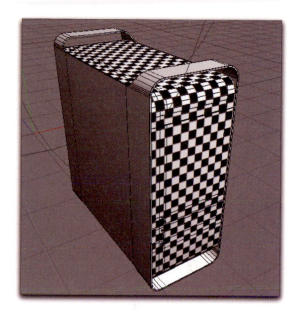

— Figure 2.160: Adjusted projection.

— Figure 2.159: Creating new UVW coordinates.

Interactive Render Region

Unfortunately, the material preview in the editor is often not precise enough to see if the size of the holes in our shader is set correctly. In such situations the interactive renderer of CINEMA 4D is a big help.

First, choose a viewport by clicking on its headline and then select INTERACTIVE RENDER REGION in the RENDER menu of CINEMA 4D (see Figure 2.162).

In the selected viewport a frame with a handler will appear with which the position and size of the rendered area can be controlled.

The render result is not as exact as the "true" renderer, but it is much faster.

The quality of the display can be adjusted with the arrow symbol on the right side of the render frame. This slider can be moved up and

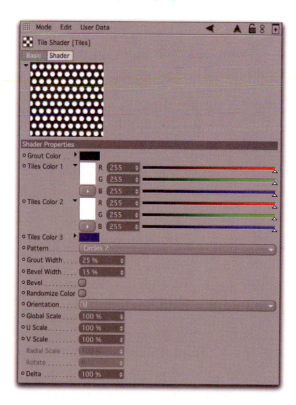

— Figure 2.161: The pattern of the perforated plate.

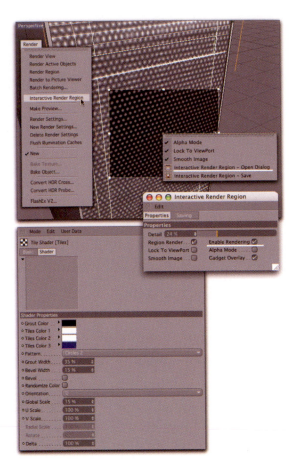

— Figure 2.162: The Interactive renderer.

down with the mouse. Moving it downward results in a faster display and, at the same time, reduces quality.

A right click on this slider opens a small context menu with additional options. There the render process is activated in INTERACTIVE RENDER REGION>OPEN DIALOG. When ALPHA MODE is active, then only polygon objects will be calculated. The background of the scene would be skipped in this mode.

LOCK TO VIEWPORT makes sure that the frame remains in the initial viewport, even if another viewport is activated, as otherwise the frame jumps to the currently activated window.

The SMOOTH IMAGE option smoothes the rendered image inside the frame and can imitate a better quality.

Generally, the ANTIALIASING in the RENDER SETTINGS should be deactivated when the interactive renderer is used. Otherwise it will be used, slowing down the renderer unnecessarily.

The goal is not the best possible quality but the test of material and light settings.

Based on this test I set the GROUT WIDTH to 35% at a GLOBAL SCALE of 15% in the TILES shader. In BEVEL WIDTH the rounding of the circles will be set to 15%. These values depend on the size of your computer model and could be slightly different.

When the interactive renderer is not needed anymore it can be closed by selecting RENDER>INTERACTIVE RENDER REGION again.

Defining and Applying Materials

Because the perforated plate does not cover the whole body, we have to restrict it to a polygon selection.

With RING SELECTION, select the outer edges of the inner housing, as shown in Figure 2.163, and split it in the middle with the EDGE CUT tool.

Then select all faces on the front that are supposed to have the perforated plate (see the lower image in Figure 2.163).

Invert and save the selection as a SELECTION TAG (see Figure 2.164).

Because we do not want to look through the holes directly into the inside of the computer, we will close the opening at the left and right of the inner housing with the STRUCTURE>CLOSE POLYGON HOLE command. This step is shown in the lower image of Figure 2.164.

To avoid having these two new faces placed inside the housing, use FUNCTIONS>DISCONNECT to separate these faces from the surrounding polygons.

The scale tool can be used to move the two faces toward each other so that they are inside the housing. Later we will be able to see them when looking through the holes.

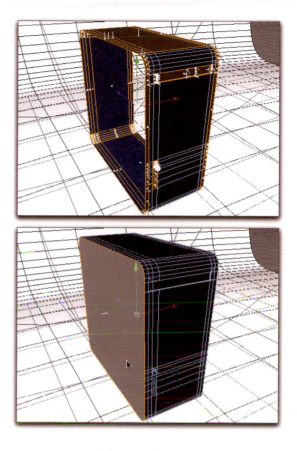

— Figure 2.164: Closing sides.

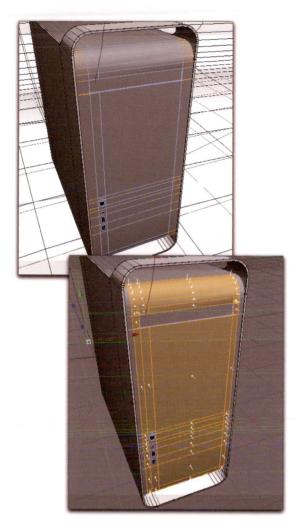

— Figure 2.163: Saving selections.

In a moment we will color these faces completely black on the reverse side. Be sure that the normals both point toward the outside.

The Material of the Perforated Plate

The main part of the material for the perforated plate is already defined by the TILES shader. This shader does not work in the COLOR channel of the material. Therefore, use the COPY CHANNEL and PASTE CHANNEL commands in the shader list to copy the TILES shader from the COLOR into the ALPHA channel of the material.

In the COLOR channel load the LUMAS shader, as this shader has the settings for metallic surfaces.

Apply a white color to its three highlights and to the COLOR setting on the SHADER page of the dialog.

Set the ILLUMINATION of the shader to 100% and use anisotropy highlight distortion with SHRINK WRAP PROJECTION. Deactivate the three highlights for the calculation of grooves on the surface (see Figure 2.165).

Activate the REFLECTION channel of the material and set the BRIGHTNESS to 30% with a DISPERSION of 15%. This should help simulate the rough-looking surface of the original housing.

— Figure 2.165: Material settings of the perforated plate.

Activate the BUMP channel in the material and load the TILES shader with the PASTE CHANNEL command. This helps make the holes look a bit beveled.

Because the circles in the shader are white, yet the bevel at the holes needs to go toward the inside, we have to use a negative STRENGTH value. Let us try a value of –10.

We already loaded the TILES shader into the ALPHA channel. Because of the color choice in the shader we have to activate the INVERT option so that the holes will be invisible and not the black faces in between.

Finally, on the ILLUMINATION page of the material, we will use the OREN-NAYAR model because we are dealing with a rough surface.

The DIFFUSE FALLOFF is raised to 50% to apply more brightness to the material. This material is now finished.

All settings are shown again in Figures 2.165 and 2.166.

Let us go to the metallic material of the rest of the housing. It differs only at a few places from the material of the perforated plate. Therefore, make a copy of the perforated plate material to save some time.

Material Settings for the Housing

In the COLOR channel of the new material, change the LUMAS shader so that it receives only 90% ILLUMINATION and only calculates an anisotropic distortion for SPECULAR 3.

The highlight properties would otherwise be too high for the large faces at the housing.

For now we will use the PLANAR PROJECTION for the anisotropy. This can be changed later if you prefer another look.

The REFLECTION settings stay identical to the ones of the perforated plate (see Figure 2.167). The same applies to the ILLUMINATION settings.

In this material the channels for ALPHA and BUMP are not needed and are deactivated, as shown in the headline of Figure 2.168.

This material can now be applied to the inner housing. Do not forget to enter the previously saved selection of the faces without the perforated plate into the SELECTION field of the TEXTURE tag.

— Figure 2.166: Material settings of the perforated plate.

— Figure 2.167: The material for the housing.

Create a third material and deactivate all channels so that it is completely black.

Pull the material onto the object and choose the setting BACK in the SIDE menu of the TEXTURE tag (see Figure 2.169).

This colors all the rear sides of the housing polygons black. The view through the perfo-

— Figure 2.168: Illumination for the housing.

rated plate will therefore always appear and simulate the dark inside of a computer.

Afterward, pull the metallic material of the outer housing onto the separated door object at the side, the handles object, and the on/off switch at the front of the housing.

A simple material with a white coloring can be used for insulation of the socket in front, and a glowing white material should be applied to the thin cylinder, which represents the control light.

The complete object hierarchy and all applied materials can be seen in Figure 2.170.

Creating Metallic Shininess

Test renderings show that the front still appears to be a bit dark and does not show the typical metallic shininess. We will correct this with an additional light source.

Duplicate the left brightener light and place it steeper in front of the computer hous-

— Figure 2.169: Material applications.

ing. The upper image in Figure 2.171 shows the view from the light source at the housing.

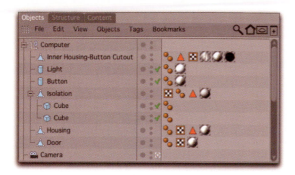

— Figure 2.170: The complete material application.

We will set the INTENSITY to 40% as we can see in the same image. The desired metallic shininess will be achieved with an additional feature of the AREA light source.

Activate the SHOW IN REFLECTION option in the DETAILS page of the dialog. This will make it possible to show this light source as a glowing object within reflections.

The value for VISIBILITY MULTIPLIER defines the intensity of the reflection. This makes sense because that way the display of the light source in reflections can be controlled independently from the brightness of the emitted light of the same light source.

Because we want to brighten the front of the housing, we need to activate the INCLUDE mode on the SCENE page of the light source. Pull the inner housing object from the OBJECT MANAGER in this list.

Figure 2.172 shows the difference of the additional light source and its reflection in the perforated plate. In the upper image there is the scene without the new light source. Underneath is the same scene with the same settings, but with the new area light.

I did not apply the black material to the back of the polygons at this time, as you can see in the images in Figure 2.172. This shows how distracting the view in the inside of the housing would be without the material.

Figure 2.173 shows the rendered scene with all applied materials.

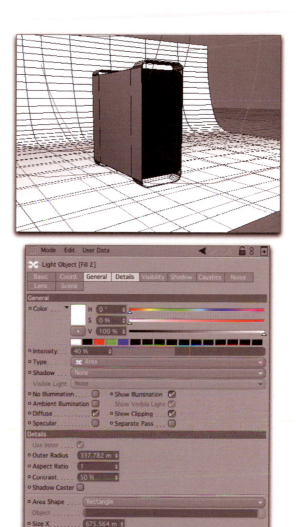

— Figure 2.171: Placing an additional help light.

Now we will leave the technical objects behind us and concentrate more on organic objects and materials.

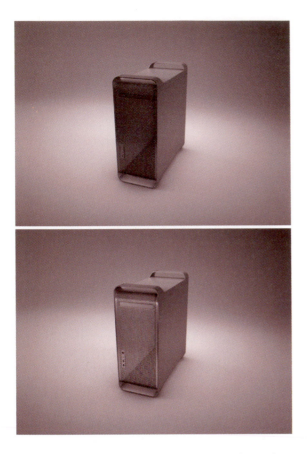

— Figure 2.172: The display with and without the additional light source.

In the following section we will model and texture a few simple plants. We will learn about shaders that we have not used yet and intensify our basic knowledge of modeling. This will be done with the help of the HAIR module.

2.8 Modeling and Texturing a Palm Tree

The next chapter talks about an example where elements will be integrated into a photo. Because it will be an outside scene in a tropical environment, we will need to have the

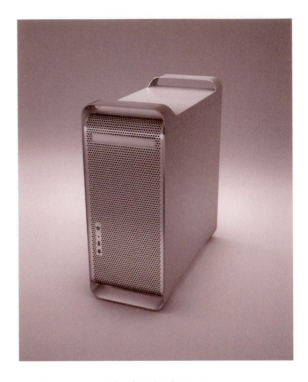

— Figure 2.173: The finished image.

typical plants found in these regions to populate our scene.

Therefore, at the end of this chapter, I would like to model a small palm tree and apply appropriate materials.

The difference from before is that we can now work more freely and do not have to familiarize ourselves with exact measurements anymore.

Creating Symmetrical Splines

We will start at the base of the palm tree by modeling the stump, which would be left if we were to cut off the palm fronds.

Draw two separate splines, each of which represents half the profile of the stump and the palm branch (see Figure 2.174).

Be sure that the points at the symmetry axis are located exactly on the world Y axis. This allows us to mirror this spline and therefore only have to create half the object.

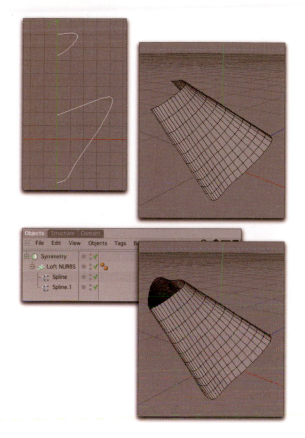

— Figure 2.174: Creating symmetrical splines.

Subordinate both half splines under a LOFT NURBS and move the splines along the world Y and X axes so that a slanted stump is created.

The missing second half of the object can be added with a SYMMETRY object that has the LOFT NURBS object subordinated to it. This way the splines can be edited more easily, as we have now the complete shape in front of us.

The only disadvantage of this technique is that the splines are not optimized by the SYMMETRY object. This means that no closed splines are created by creating the reflection. The caps of the LOFT NURBS object therefore cannot be generated and the stump remains open at both ends (see Figure 2.174).

When we are happy with the shape and position of the splines, we can remove the LOFT NURBS object from the grouping with the SYMMETRY object and then delete the SYMMETRY object.

Select one of the splines and change into point mode. Be sure that either all or none of the spline points are selected and choose the MIRROR command in the STRUCTURE menu of CINEMA 4D (see Figure 2.175).

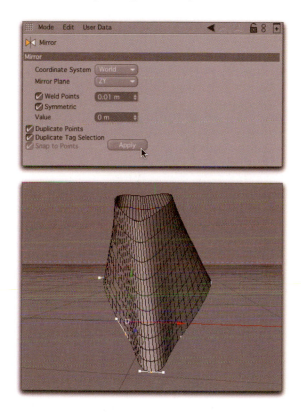

— Figure 2.175: Mirroring splines.

In its dialog, set MIRROR PLANE to WORLD ZY and apply the tool by clicking on the APPLY button. We can now see that the spline received its missing half.

No points are optimized, even though the WELD POINTS option in the MIRROR tool is activated. This function is not available when splines are mirrored. This can be tested by selecting and moving spline points (see the arrows in Figure 2.176).

Therefore, we have to optimize the points ourselves and create a continuous spline.

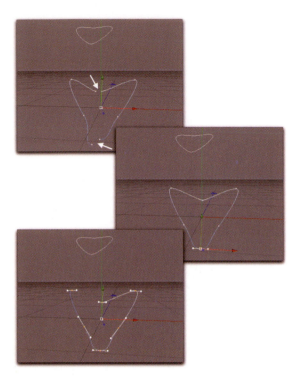

— Figure 2.176: Connecting spline segments.

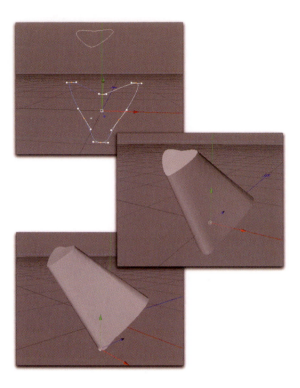

— Figure 2.177: Adjusting the Loft NURBS object.

Activate the Live Selection and allow the selection of hidden elements in its settings. Select one of the two spline points on the symmetry plane and select Structure>Edit Spline>Join Segment (see Figure 2.176).

The two separated spline halves will be combined into one spline and can now be closed with the Close Spline option in the Attribute Manager.

When the second spline pair is connected as well, the two caps of the Loft NURBS will appear.

We will now create several copies of this Loft NURBS stump and align them in a spiral manner. Therefore, it makes sense to move the axes system of the Loft NURBS object to the base of the stump.

Activate the object axis mode and move the axes system of the Loft NURBS object with the move tool to the lowest spot on the stump (see the lowest image in Figure 2.177).

Duplicating along a Spline

In order to align the copies of the stump automatically around the trunk, which we still need to model, we will use a helix spline from the basic objects (see Figure 2.178).

Create a helix in the XZ plane and make sure that in the settings of the helix spline, the radius on top is smaller than the radius on the bottom.

The height inside the helix, where the radius reduction will be started, can be controlled with the Radius Bias value.

Smaller bias values will make sure that the bias radius stays constant longer and that a stylized dome is created (see Figure 2.179).

Adjust the End Angle value so that a tight wrapping of the spline is created. I put in an angle of 200° with a wrapping length of 350, a base radius of 200, and an end radius of only 25 units. I set the Radial Bias to 7%.

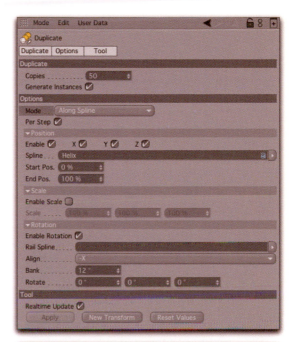

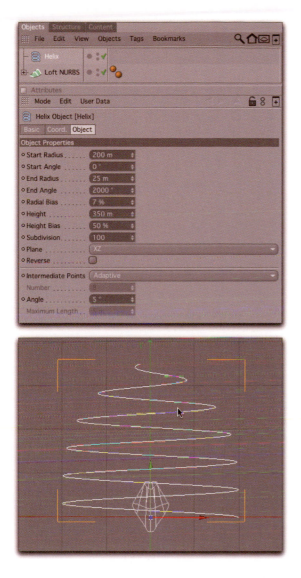

— Figure 2.178: A helix spline.

— Figure 2.179: The duplicate function.

When you are happy with the shape and size of the helix, select the LOFT NURBS object and open the DUPLICATE tool dialog in the FUNCTIONS menu (see Figure 2.179).

In the DUPLICATE part of the dialog, enter the desired number of copies and their type. We will try 50 instance copies, as we do not want to work on the individual stumps.

In OPTIONS choose MODE ALONG SPLINE and pull the helix spline from the OBJECT MANAGER into the SPLINE field of the DUPLICATE tool in the POSITION column. The tool knows that it is supposed to spread the instance along this spline.

The orientation of these copies is set in the ROTATION column. There, activate ENABLE ROTATION and ALIGN –X. The negative X axis of the duplicates will orient itself to the course of the spline curve.

The BANK value can be used, if necessary, to individually adjust the slant of the copies.

A possible result of this calculation is shown in Figure 2.179.

You can work with more or less copies, whatever you prefer.

When the number and orientation of the copies are determined, we should loosen the even alignment and orientation again. For this job we will use the RANDOMIZE function.

With this function the selected objects can be randomly moved, rotated, and scaled (see Figure 2.180).

Activate a generous rounding at the upper end of the cone.

We will create a BULGE deformer and subordinate it to the cone to adjust the cone better to the stump. It can be used to bulge the cone laterally and to adjust it better to the original helix shape (see Figure 1.182).

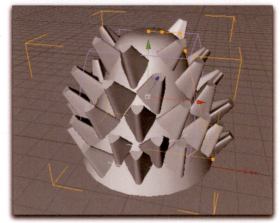

— Figure 2.180: Adding random changes.

In order to select all instance objects, select the null object, which contains all the copies, and right click on it.

In the context menu that has appeared, choose SELECT CHILDREN, hold the CTRL key, and click on the NULL object. It will then be deselected again and we are left with the selected LOFT NURBS instances.

Select FUNCTIONS>RANDOMIZE and enter 10 units for the MOVE vector and 5° for the ROTATE vector. Apply the variations to the selected objects by clicking on the APPLY button.

Finishing the Trunk

The trunk is still missing and will now be added by creating a basic CONE object.

Adjust the two radii and the height of the object so that it fills the gap between the stumps (see Figure 2.181). This can only work

up to a certain point because of the round shape of the helix spline. We will deal with this in a moment.

— Figure 2.181: The trunk of the palm tree.

The BULGE deformer works the same way as the already used BEND deformer. Simply use the upper handler, after which the size of the BULGE object is adjusted to the cone. A possible result is also shown in Figure 1.182.

— Figure 2.183: The stem of the palm frond.

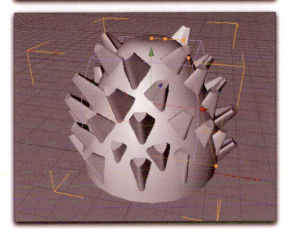

— Figure 2.182: Inflating the cone.

The Palm Branch

This completes the base of the palm tree, and now we concentrate on the modeling of the palm frond.

It will be made out of two objects. We will start with the branch from where the palm leaves will later originate.

As a summary, we will use the same spline that we already used for the end of the stumps. Enlarge this spline with the scale tool so that it has about the same size as the base of the stumps (see Figure 2.183).

Create a new linear spline with only two points, which should be placed vertically above each other. Because this spline will represent the length of the branch, the distance between the points should be chosen so that the length of the branch fits the proportion of the palm base.

Then subordinate both splines under a new Sweep NURBS object.

As we already know, the profile has to come first and the path for the movement below the profile.

Use the Scale curve of the Sweep NURBS object to start the branch wide and then quickly make it slimmer.

Note that the interpolation of the linear two-point spline has to be set to Uniform so that enough Intermediate Points are created to scale the profile properly.

A possible shape is shown in Figure 2.184.

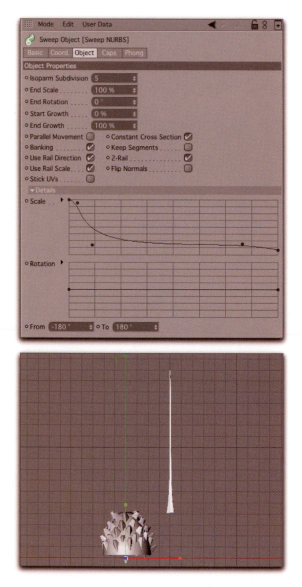

— Figure 2.184: The finished branch.

The Palm Frond

The actual palm frond contains a large number of similar objects that are sorted next to each other along the branch. We could solve this problem by modeling one single leaf and multiplying it along the branch spline of the palm branch with the Duplicate function.

This would work the same way as the multiplication of the stumps at the base of the palm tree, only this time a less complicated spline would be used and more copies would be needed.

When you own the Hair module of Cinema 4D there is an alternative. If you do not own the module, then use the Duplicate function as described earlier.

Working with Hair

Create a copy of the linear path spline from the Sweep NURBS object. We will let hair grow at its side and use it as a base for the following modeling of the palm frond.

Open the Feathers object in the Hair menu of CINEMA 4D. As already mentioned, this separate module from Maxon needs to be installed in order to use this feature.

Subordinate the copied path spline under the Feathers object. There should be splines visible instantly that stand laterally on the path spline.

Adjust the Barb Length in the dialog of the Feather object to determine the length of the palm leaves (see Figure 2.185).

Raise the Start value in the Spacing settings of the Feathers object so that the base of the branch remains free of leaves.

The length of the palm leaves can be controlled with the two Shape curves. Set up the curves in such a way that the length of the leaves is slightly reduced at the base and end of the branch.

Activate the Splines setting in the Generate menu in the Generation column, which is in the dialog. This allows us to use the created hairs, for example, within a Sweep NURBS.

Finally the order of the hairs can be loosened and randomized with the Barb Spacing and Variation setting in the Spacing column.

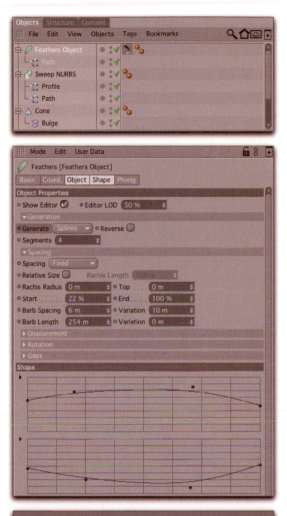

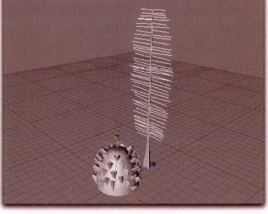

— Figure 2.185: The FEATHERS object.

A possible result is shown in the lower part of Figure 2.185.

Because we will not need the settings of the FEATHERS object for the next couple of steps, convert it to a simple spline object. The C key can be used for that.

Bending the Palm Leaves

Create a new RECTANGULAR spline and subordinate it along with the converted hair spline under a new SWEEP NURBS. Adjust the edge length of the rectangular splines so that flat palm leaves are created.

Because it would be unrealistic to attach the palm leaves in a right angle to the branch, we use two BEND objects to correct this.

The best way is to place them in the upper left and right sides of the palm frond in the editor viewport and subordinate the two deformers under the spline that was created by converting the FEATHERS object.

Use the two handlers of the deformers to bend the palm leaves in the desired direction. Reduce the Y-SIZE of the BEND objects so that the bend will happen relatively close to the branch (see Figure 2.186).

Instead of using two BEND objects, we could reduce it to one and use the UNLIMITED mode. However, two BEND objects have the advantage that the bend can be controlled at both branches separately.

Regardless of the method used, KEEP Y-AXIS LENGTH should be activated in all deformers so that the length of the leaves is not changed when they are bent.

Bending the Palm Frond

Not only the palm leaves, but the whole palm frond should be bent.

Because two objects, the SWEEP NURBS of the branch and the SWEEP NURBS of the leaves, need to be deformed, both need to be grouped under a new null object.

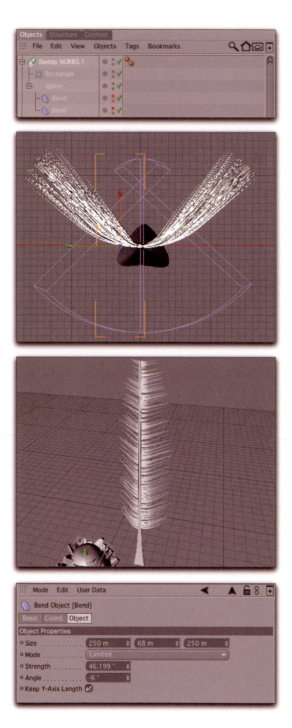

The fastest way is to select both SWEEP NURBS objects and then open OBJECT MANAGERS GROUP OBJECTS in the OBJECTS menu.

OBJECT AXIS mode moves the null object to the lower end of the palm frond and creates a new BEND object, which will be subordinated to the null object (see Figure 2.187).

— Figure 2.187: Bending the complete palm frond.

The new BEND object now affects the null object and automatically all objects inside this one.

Enlarge the BEND object along the Y direction and move it so that the whole palm

— Figure 2.186: Bending the palm frond.

frond fits inside. Now the palm frond can be bent. Here too the KEEP Y-AXIS LENGTH should be activated.

Rotate and place the new null object with the whole palm frond so that it looks like the branch grows out of the modeled trunk. You will find enough spaces between the stumps at the trunk.

Normally, we would create and assign the materials so that it could be used by all the following copies of the palm frond. However, I like to model the palm tree first and then apply the materials at the end.

You can create the materials now and come back to this point if you would like to finish the modeling later.

Create copies of the palm frond and place them around the trunk. Take your time to adjust the bend of the palm fronds or their individual rotation so that the fronds are all slightly different from each other.

Figure 2.188 shows some of the steps. You can see there too that I changed the tips of some of the leaves individually.

Because we only have splines and their points to work with, we can use the MAGNET tool in the STRUCTURE menu to deform or move separate areas of the leaves. Figure 2.189 shows this with an example of a palm frond.

Select the spline with the paths of the leaves and activate the magnet tool in point mode.

Deactivate the SURFACE option and adjust the RADIUS value to restrict the magnet to single areas of the whole object. Then all points of the selected object that fall in the range of influence can be interactively moved with the mouse directly in the editor. We can use the decline function, which can be controlled in the MODE menu of the magnet tool. This means that points further away from the cursor will be less affected by the magnet.

Work this way especially at the end of the palm fronds so that the leaves stick out more naturally.

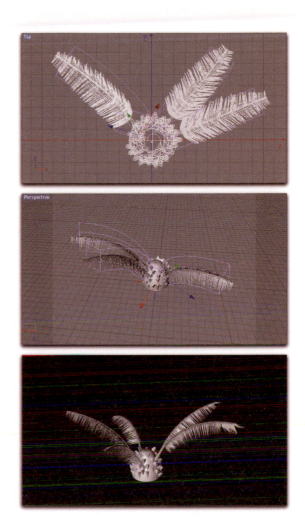

— Figure 2.188: Creating copies of the palm frond.

Follow this system and add more copies of the palm fronds until we have a realistic palm tree. Then we can start working with materials.

Materials of the Palm Tree

We do not have to worry about the application of materials, as all objects are created with NURBS objects or BASIC objects. Therefore, we will immediately start with the material that should be assigned to the deformed cone at the base of the palm tree.

We will create a dark material with a slightly rough structure. Much of this surface will not be seen later anyway because we will let some hairs grow there to simulate dry and dead fibers.

Create the new material and assign a dark brown color in the COLOR channel.

— Figure 2.189: Moving spline points with the Magnet.

Activate the DIFFUSION channel in the material and load the NOISE shader. Choose the cellular VORONAI 3 structure.

Invert the percentage values for LOW CLIP and HIGH CLIP in the NOISE shader so that we get an inverted NOISE brightness.

I raised the GLOBAL SCALE to 400% so that the NOISE size of the cone is approximately as large as the stumps. This has to be checked with test renderings.

In the active BUMP channel of the material, load the NOISE shader again, but this time with the FBM structure. Otherwise the settings remain the same.

The strength of the BUMP effect is set to 20%.

Finally, use the OREN-NAYAR model in the ILLUMINATION settings of the material with 100% ROUGHNESS.

The SPECULAR channel remains deactivated, as this rough surface is not supposed to show highlights. This material can then be applied to the cone. All settings are shown again in Figure 2.190.

The Stump Material

The stump material is structured even simpler. We only need the COLOR and DIFFUSION channels.

Load the GRADIENT shader with TYPE 2D – V in the COLOR channel and create with it a gradient going from a dark brown tone to a light green one.

The gradient running from brown to green or opposite depends on the order of your splines in the LOFT NURBS object. When the larger spline was put in first, then the gradient has to start with brown.

Load the WATER shader in EFFECTS in the DIFFUSION channel. Nothing needs to be changed at its settings. Only reduce the MIX STRENGTH in the DIFFUSION channel to 30%.

Finally, activate the OREN-NAYAR model in the ILLUMINATION setting of the material.

I set the DIFFUSION FALLOFF to –50%. This reduces the area of the surface, which is brightened by light and therefore gives the impression of a smooth surface.

By raising the ROUGHNESS value to 100%, we further spread the incoming light more evenly.

All these settings can be found in Figure 2.191.

The Branch Material

The branches of the palm tree differ from the stump only by their green part and less weathering.

We therefore only need the COLOR channel in the new material and again load the GRADIENT shader.

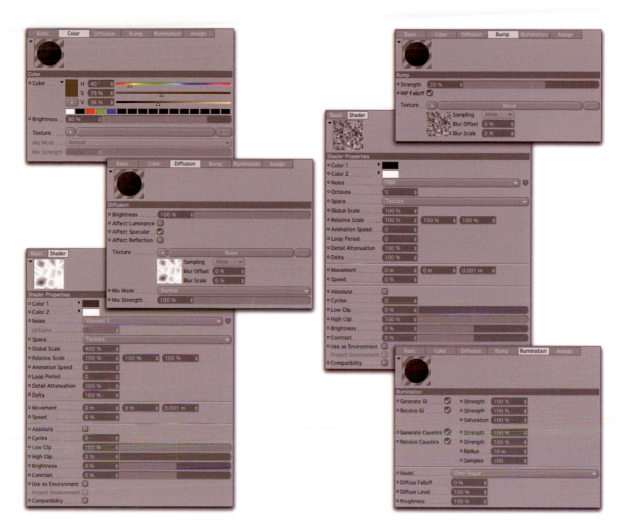

— Figure 2.190: Material settings for the base of the palm tree.

The gradient TYPE is again vertical, 2D – V, and spreads from a dark brown tone to a healthy green up to a desaturated yellow.

This time the direction of the gradient depends on the order of both points of the linear path spline of the palm branch.

The branch needs to be brown at the base and yellowish-green at the tip.

The mixing of the color can be set more chaotic by increasing the TURBULENCE value in the GRADIENT shader.

In the ILLUMINATION settings of the material, I reduce the DIFFUSE FALLOFF value again to –50% while using the OREN-NAYAR model.

All of these settings are shown combined in Figure 2.192.

The Material of Palm Leaves

Also in the material for the palm leaves we use the GRADIENT shader in the COLOR channel. Also here switch the gradient to 2D – V mode and create a gradient between dark and light green.

Use the MIX MODE MULTIPLY to control the brightness of the color more easily in the BRIGHTNESS value directly on the COLOR page of

— Figure 2.191: The stump material.

— Figure 2.192: The branch material.

the material. I used a BRIGHTNESS of 40% for the gradient.

In the REFLECTION channel I set a small reflection of 10%. The wax-like coat of the leaves should have a slight reflection. Therefore we will also add a small highlight.

OREN-NAYAR will again be used in the ILLUMINATION settings. This time we reduce the DIFFUSE FALLOFF to –100% to support the smooth material.

The difference between this material and the others lies in the settings of the LUMINANCE channel.

Plants and especially leaves transfer light very well and often appear translucent. This means that a certain percentage of light goes through the leaf and illuminates it, even when the light source is on the other side. This effect is subtle, but nevertheless distinctive.

In order to simulate the transfer of light in an object, we have several shaders at our disposal. These are the BACKLIGHT, SUB-SURFACE SCATTERING, and also the CHANLUM shader. All of these can be found in effects.

The way of working with these shaders is completely different from each other. The SUB-SURFACE SCATTERING shader, often just called SSS, offers the most exact calculation, but also needs a lot of calculation time.

The CHANLUM shader offers a less exact but faster alternative. The principle of its calculation is as easy as it is effective. It simply searches light in a certain distance around a

point. This calculation does not take the thickness of the object into account. However, this effect is good enough for us, as we only want to add a supporting effect.

Load the CHANLUM shader in the LUMINANCE channel of the leaf material and activate in the channel the multiplication with a light green tone. The CHANLUM shader itself creates only grayscale and has to be colored by us.

The SAMPLES value in the dialog of the shader determines the precision of the calculation. The eight standard samples are enough.

The INITIAL OFFSET determines the distance to the surface where the light search is started. SAMPLE RADIUS is the maximum searched radius around the point on the surface.

The larger the value, the greater will be the chance that one of the samples will find light.

The setting for SAMPLE TYPE defines which method is used to look for the position of the samples. AREA looks around the surface point and ALONG NORMAL only checks for light along the surface normals.

We will decide upon the settings of 1 unit for INITIAL OFFSET and 30 units for SAMPLE RADIUS. The settings can be found again in Figure 2.193.

Ultimately, all these settings depend on two factors: the actual lighting of the object and the size of the object. The rule is that this effect works best with light sources that generate shadows.

When light sources without shadows are used, then they should be excluded from the CHANLUM calculation. Therefore, there is an INCLUDE/EXCLUDE list directly in the shader.

Creating Fibers on the Trunk

In order to have a not so smooth and perfect trunk, we will again use the HAIR module.

Because we do not need its hairs all over the cone, we can select the cone and execute a CURRENT STATE TO OBJECT in the FUNCTIONS menu. It creates a copy of the cone in deformed condition (see Figure 2.194).

Now we can create a selection of faces in POLYGON mode where hairs should be generated. Select all faces except the rounding on top and the lower bottom of the cone, and save this selection in a POLYGON SELECTION tag.

The original cone should be deleted or turned invisible in the editor and renderer.

When the cone and its lateral faces are selected, choose ADD HAIR in the HAIR menu of CINEMA 4D. The module will then create hairs only at the selected faces.

As already explained at the FEATHERS object, I would like to note that the HAIR module is not part of the standard setup of CINEMA 4D and needs to be purchased separately from Maxon.

In my opinion, this is a worthwhile addition because it can be used, in addition to creating all kinds of hair and fur, to create objects such as grass or plant parts.

The ADD HAIR command has created so-called GUIDES on the selected polygons. These lines can be shaped individually and will be used later for the hair display.

First we use the LENGTH parameter in the GUIDES column of the HAIR dialog to give the guides an appropriate length. The object size used by me is enough for a guide length of 50 units.

On the HAIRS page of the dialog the number of hairs can be set. A COUNT value of 2000 should be enough. This can be changed again later if, for example, a close-up is needed.

The SEGMENTS setting for the guides defines the stiffness of the lines and their movability when influenced by wind or gravity. All properties can also be animated.

The SEGMENTS in the HAIRS page work like the INTERMEDIATE POINTS of spline objects. They change the density of details that a single hair can show.

We are done with all the settings and can concentrate on the styling of the guides. The guides serve as a general indication of the growth direction of the hair, as hairs can also be formed by a material.

— Figure 2.193: The leaf material.

To avoid having hair that stands up artificially, my suggestion is to bend the guides up and to push them more toward the surface.

The BRUSH tool in the HAIR>TOOLS menu can be used for that (see Figure 2.195). As the name suggests, this tool works like a comb or a brush and pulls the guides when moving over them with the mouse.

Brush with the tool from the bottom up over the guides in the front and side viewports. They will then be closer to the surface of the cone (see Figure 2.195).

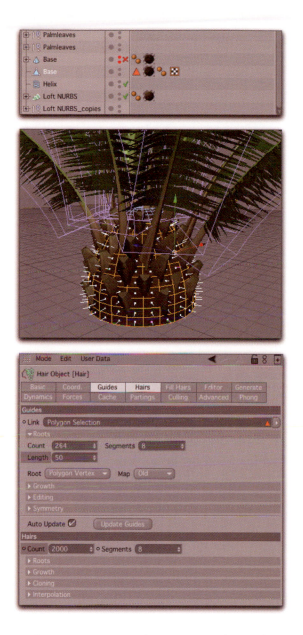

— Figure 2.195: Adjusting guides.

Generally it works like a normal material for determining the surface properties of objects, but there are different channels and properties available.

The function of the single channels of this type of material can be explored very simply. In many cases, by activating the channel, the preview of the hair in the material changes instantly.

We will take a look at only some of the available channels.

The COLOR channel defines the color of the hair. The course of the color is applied along its length, which means that the root can be colored differently from the tip.

Additional color variations can be entered over the variation values of H, S, and V underneath the gradient. It varies the color, saturation, and brightness of every hair.

If, like in our case, the hairs should have the color of the surface they grow on, then the SURFACE option in the section with the same name in the COLOR channel should be activated.

In the THICKNESS channel of the material, the diameter for the root and the tip of the hair is entered separately. If necessary, by using a curve, even the diameter of every part of the hair can be set individually. This works like the SWEEP NURBS object.

— Figure 2.194: Letting hair grow on the trunk.

The Hair Material

Together with the HAIR object, which includes the guides and determines the number and behavior of the hair, a new HAIR material was created.

Adjusted to the dimensions of my model I chose a diameter of 5 units for ROOT and 1 unit for TIP.

In the LENGTH page of the dialog the length of the hair can be varied. Do not confuse this setting with the SCALE channel of the material. It scales the hair in one piece, including all diameter and shape changes. The LENGTH channel only changes the length of the hair like it would be cut off at the tip.

I used a basic length of 100% with a generous variation of 50%. The AMOUNT value determines what percentage will be affected by this setting. All settings can be found again in Figure 2.196.

— Figure 2.196: Settings of the hair material.

The FRIZZ channel varies the directions the hair grows in. The hairs then grow, with in-creased intensity of the setting, not in the direction of the guides anymore.

I entered a value of 50% for FRIZZ with a variation of 10%. The material preview gives us a good idea of the intensity and impact of this effect.

The KINK channel works similarly, but folds the hairs within itself without affecting the growth direction as much as the FRIZZ effect. A value of 20% kink with 10% variation should be enough.

We will also use the CLUMP channel to glue neighboring hairs together when they are close enough.

The COUNT value defines the percentage of all hairs and is the initiator for the creation of clusters.

The CLUMP value controls the attraction that these clusters have to surrounding hair.

The RADIUS value determines the maximum space around the cluster, where hairs are still being gravitated.

As shown in Figure 2.197, I tried it with the settings of 10% for COUNT and CLUMP and a RADIUS of 40 units.

As we can see, the HAIR material offers an abundance of setup possibilities, from which we mentioned only a few. Luckily, most options and channels are self-explanatory and invite experimentation. Because of the almost simultaneous feedback of the material preview, the effect on the hair can be reviewed immediately.

When the DISPLAY HAIR LINES menu in the EDITOR column in the dialog of the HAIR object is activated, then the change can be viewed directly on the object.

Use the DETAIL slider to reduce the number of hairs in the editor in case many hairs are created on the object. This accelerates the work in the editor and the display of changes, for example, by the HAIR material.

Figure 2.198 shows a test rendering of the trunk of the palm tree. The fiber hairs add tremendously to the overall look and make the model look even more realistic.

— Figure 2.197: Settings of the hair material.

— Figure 2.198: The trunk of the palm tree.

Before we render the whole palm tree, the PHONG angle of the leaves should be adjusted.

As you may remember, we defined their profile with a rectangular spline. Because the preset PHONG angle in the SWEEP NURBS is

smaller than 90°, the corners of the rectangle remain visible as sharp edges.

This is not as visible from a distance, but should be corrected in case we zoom in closer to the object.

With the CTRL key, select all SWEEP NURBS in the OBJECT MANAGER needed for the creation of the palm leaves. Select the entry CREATE SELECTION OBJECT by clicking on the icon with the question mark and the mouse pointer. This icon is also shown in Figure 2.199.

— Figure 2.199: Creating a Selection object.

The reason for this action was to have all selected objects now listed in the newly created SELECTION OBJECT. To some degree this can be compared to saving a point or polygon selection in a SELECTION tag.

With the RESTORE SELECTION button in the SELECTION OBJECTS dialog, the saved objects can be selected again anytime to make changes. This makes it unnecessary when having complex selections with many objects to repeatedly select all the objects.

Another advantage of the SELECTION OBJECT is that key frames can be created for the saved objects. We will hear more about this subject when we talk about the animation of objects.

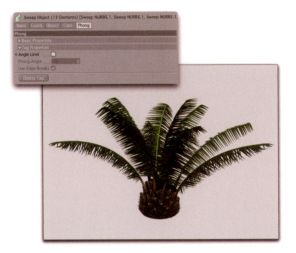

— Figure 2.200: Changing the phong angle.

Therefore, use the RESTORE SELECTION button of the SELECTION OBJECTS to select all SWEEP NURBS objects of the leaves. Deactivate the ANGLE LIMIT option of the selected NURBS objects in the ATTRIBUTE MANAGER (see Figure 2.200).

The shading of the leaves will now be wrapped around the 90° corners of the rectangular spline and will make the profile of the leaves look smoother.

Figure 2.200 finally shows how the final palm tree looks.

In the next chapter we will mainly work with modeling and more complex objects, and we will talk about working with templates.

Working with Image Templates

Now that we have worked with all the important tools and managers, we can go on to more complex objects.

So as not to waste space with already explained techniques, I will assume that the tools and functions discussed previously are by now familiar.

As subjects for our next modeling examples, I have chosen a sports car and a character/figure. The techniques to be shown are transferable to other objects as well.

You will see that the majority of the work can be done with a few functions.

Ultimately, the important part is the most efficient way of placing points. Generally it should be a light mesh, which means a model with the least possible number of polygons and points.

In order to keep in sight the shape that is supposed to be modeled, templates are used during the modeling process. These are mostly photos or sketches that can be shown in the viewports. We will use this technique when we model the figure.

We will use yet another way of showing image templates when complex models are to be built. With this method, images or sketches are used to create spline curves at the most important contours. This might sound a bit complicated because of the time it takes to create these splines.

Especially for organic objects with complex curvature this method has the advantage of providing a three-dimensional frame of the shape that will be modeled. The frame of the object is then created and only needs to be filled with polygons.

We can start with loading the image templates in the BACK side of the EDIT>CONFIGURE dialog of the editor viewports (see Figure 3.1).

Ideally we have a front, side, and top view image. These will then be loaded into the appropriate editor viewports.

In order to be able to work with these images in the editor, they need to have the same scale and to be adjusted according to size in the viewports.

My images have different sizes, as shown in Figure 3.1.

The scaling, though, will be quite simple because the images are reduced to the area between roof and wheels. Therefore, only the SIZE Y value has to be transferred to the CONFIGURE settings of the other images.

The X value of the size will be adjusted automatically, as the KEEP ASPECT RATIO is activated by default.

This procedure can be seen in the upper image of Figure 3.2. There, the Y SIZE value was copied from the front viewport to the side viewport. The proportion of the two images is now correct.

We can also use the OFFSET values in the CONFIGURE menu to move the image templates to any place in the viewports. This is especially important when an additional top view image is loaded.

These images have to fit to each other so that a point placed at the headlight in the side view will also be placed at the headlight in the other two viewports.

After the images are loaded, resized, and placed correctly, it is time to create several splines to trace the contours of the car. Interesting here is the area where component groups meet and also distinctive creases and edges.

The best way of creating the spline is to finish it in one viewport and then adjust and correct it in the other. An example is shown in Figure 3.2.

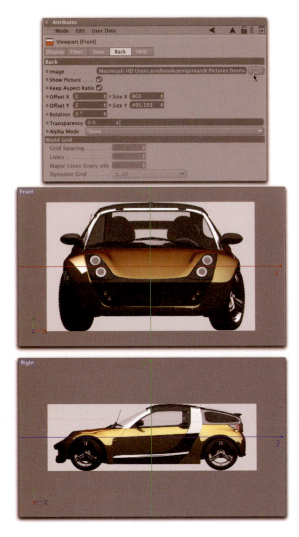

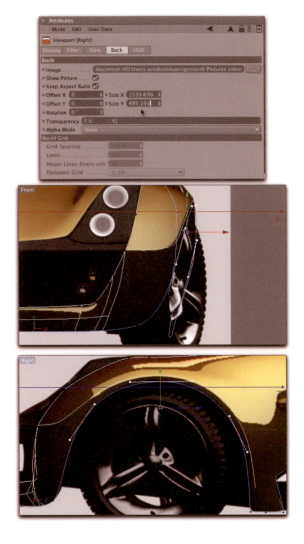

— Figure 3.1: Loading image templates.

— Figure 3.2: Tracing contours with splines.

The more carefully the splines are placed, the easier and more exact the following modeling will be.

Because this is more of a chore than a challenging technical exercise, I have already created the splines for you and placed them in a scene on the DVD of this book (see Figure 3.3). There you will find several intermediate states of the modeling process so that you can start this workshop at any point.

I myself used blueprints and photos for the creation of the splines. These I cannot give to you because of copyright reasons.

It is easy enough though to find these kinds of images and drawings on the Internet. For example, at www.suurland.com there is an abundance of up-to-date blueprints of cars, boats, and even airplanes.

The vehicle that I chose for the modeling is a Smart Roadster, which I could not find as a 3D model on the Internet yet. Therefore, the effort is worthwhile.

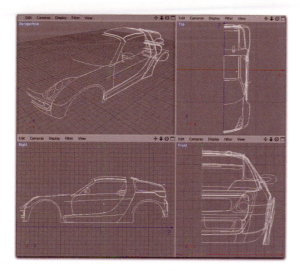

— Figure 3.3: Spline contours of the car.

3.1 Modeling the Fender

We start our modeling with the fender of the car. It is necessary to model only one-half of the car, as all parts will be mirrored later on.

Start with a new scene and load the splines from the DVD. Then create a POLYGON object in the OBJECTS menu (see Figure 3.4). It will serve as a container for the points and faces.

Switch to POINT mode and select STRUCTURE>CREATE POLYGON. Click on the four corner points of the first polygon that we want to create in the front viewport. Double click on the last point to create the polygon. In this manner, create several polygons, then switch to the MOVE tool.

In the MOVE tool setting, activate the 3D snapping to splines and snap all edge points to the splines. Points that do not have another point near by have to be moved by hand to the appropriate position.

Continue this technique until the upper edge of the fender is evenly covered with polygons (see Figure 3.5).

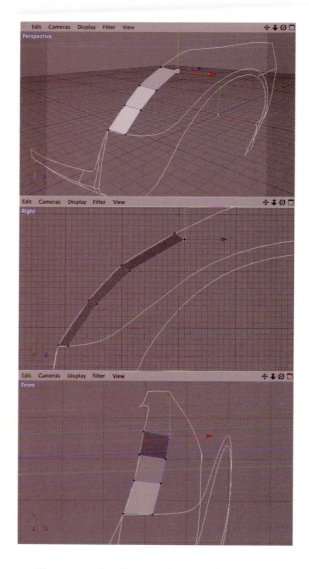

— Figure 3.4: Creating a polygon strip.

Do not create too many polygons and points at once or you may lose the overview. Try to use as few polygons as possible.

Keep in mind that we have to round and smooth the model later with the help of a HYPERNURBS object.

In this way, create polygon strip after polygon strip along the fender and finally down behind the wheelhouse, as shown in Figures 3.6 and 3.7.

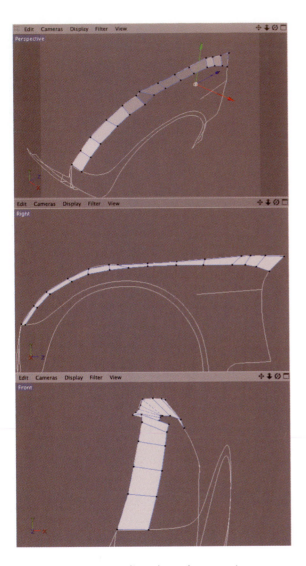

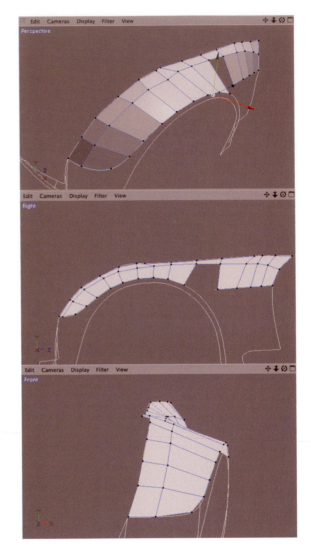

— Figure 3.5: Extending the polygon strip.

— Figure 3.6: Widening the polygon strip.

Try to bridge the gaps with polygons as large as possible. This will make you feel more secure in the beginning process of modeling the shape.

The faces between the splines can be subdivided with cuts later.

When, like in this case (see Figure 3.8), cuts have to continue around a corner, we use STRUCTURE > ADD POINT and create new points directly on the existing edges or even in the middle of faces.

The reason for the sort of cut shown in Figure 3.8 is to (1) gain more control over the curvature of the front part of the fender and (2) raise the point density in the front of the fender where the headlights will start.

After the points have been created, convert the newly created N-GON faces into rectangular polygons. This will give us more control over the path of the edges and the result of the rounding with HYPERNURBS objects.

— Figure 3.7: Defining the wheelhouse.

— Figure 3.8: Adding subdivisions.

Use the FUNCTIONS>REMOVE N-GONS to convert the N-GON faces. The result can be seen in Figure 3.9.

As we can see at the path of the new edges, some new triangles were created that we will have to remove manually. Therefore, delete these polygons and create new faces between the existing corner points with the BRIDGE or CREATE POLYGON tool. The result can be seen in Figure 3.10.

At the right edge of the fender starts a slightly tilted hard edge that will continue up to the end of the door. This edge would need to be created by a few parallel edges. They should be close enough to each other so that the HYPERNURBS smoothing will work later on.

Therefore, I moved a row of points closer to the crease, as shown in the lower images of Figure 3.10.

The effect can be seen instantly when the POLYGON object is grouped for a moment under the HYPERNURBS object (see Figure 3.11).

I have already added an additional cut above the edge, as you can see in Figure 3.11 and even more clearly in Figure 3.12.

The KNIFE tool can be used here, as this cut follows the polygon loop.

Remember to move instantly newly created points to their right position or else areas will be created where all the points are positioned in a two-dimensional plane. This would result in a suboptimal result at the HYPERNURBS smoothing.

We already talked about the shape change of the upper part of the fender, where the headlight will be attached.

We will add a vertical cut like the one shown in Figure 3.13 in order to have an exact enough shape change after applying the HYPERNURBS.

This section can be seen very well in the view from above where the fender recedes laterally.

Make sure to snap new points, which were created by the subdivision, to the splines

— Figure 3.9: Converting N-Gons.

whenever possible. This does not happen automatically, so these points need to be moved by hand. This is another reason why you should work in small steps and create faces only where they are really needed.

However, cutting back on faces should not go so far as to result in cuts that are restricted to single polygons. Basically, it is always better to create an evenly subdivided mesh that contains as many rectangular polygons as possible for the smoothing later on.

We also use the additional points to further fine-tune the crease at the right edge of the fender, as shown in Figure 3.14.

Surely you have noticed the extremely rounded corners at the edge of the object when the model was smoothed by the HYPER-NURBS object.

Generally the extreme rounding is a desired effect, but we need exact fitting edges in the upper area and to the right where the door component and front part of the trunk meet.

— Figure 3.10: Developing the crease.

We need to support the edge area with additional cuts so that the HYPERNURBS does not have enough space to round the edges. Therefore, use the KNIFE tool in LOOP mode without creating N-GONS. Both cuts are highlighted in Figure 3.15.

Make the cuts as close as possible to the outer edge of the shape. This will strengthen the corners in the HYPERNURBS. These areas are marked by red arrows in Figure 3.15.

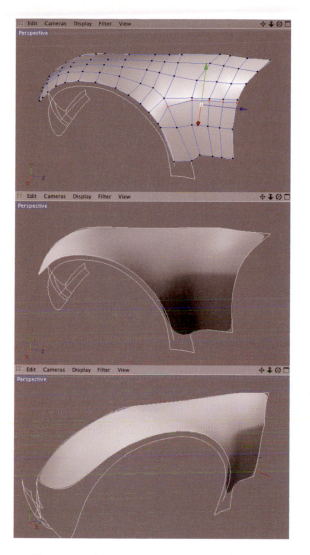

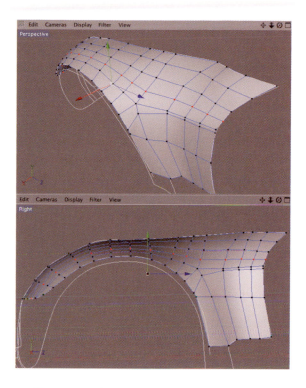

— Figure 3.12: A new cut.

Just select all edges in the area and use the EX-TRUDE command for duplicating and moving the edges. However, the next step of snapping the new points to the spline has to be done manually (see Figure 3.17).

Figure 3.17 shows how the faces on the right of the wheelhouse can be extended downward to complete the right part of the fender.

The contour of the wheelhouse is one of the distinctive parts of the model that needs to be shown as a visible edge. Therefore, we will add a new edge loop with a KNIFE cut in LOOP mode. This is shown in Figure 3.18.

The Front of the Fender

The fender turns into a slim strip in the front. In order to model a clean transition, we have to make sure that there is the appropriate order of faces.

— Figure 3.11: The HyperNURBS smoothing.

We will rearrange the two faces marked in Figure 3.16 so that the already modeled crease in the fender does not run toward the wheelhouse.

Delete the faces and create two new polygons as shown in the center of Figure 3.16. As a result, the crease deviates in an arc to the upper area and ends in the smoothed version in a soft line parallel to the wheelhouse.

The distance to the edge of the wheelhouse needs to be bridged with a polygon strip, but the points do not need to be created by hand.

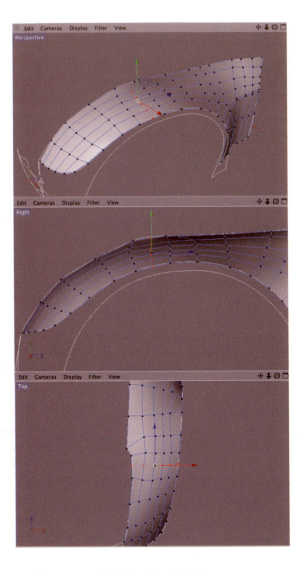

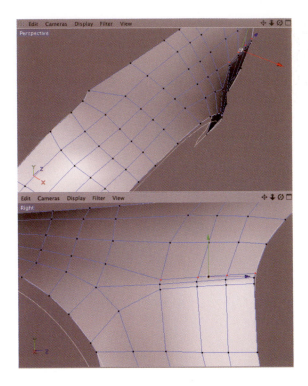

— Figure 3.14: Finishing the crease.

— Figure 3.13: Additional subdivisions.

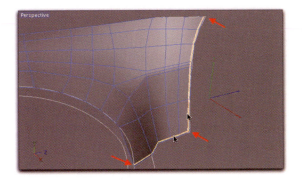

— Figure 3.15: Creating additional cuts.

Use the ADD POINT function in the STRUC-TURE menu again and place new points on the vertical edge in front. Figure 3.19 shows these points in red.

After the conversion of the created N-GONS with the REMOVE N-GONS function, arrange the faces as shown in the bottom of Figure 3.19.

Remember to use all new points to shape the model and to snap the points to the splines. A possible result can be seen in Figure 3.20. The model slowly takes shape.

If your model does not look so smooth, it could be that a POLYGON object was not auto-matically created with the PHONG tag. Just add this tag with the TAGS > CINEMA 4D TAGS > PHONG menu in the OBJECT MANAGER.

A narrowing of the polygon strip needs to be done at the same time, as there is a sharp tapering of the front shape of the fender.

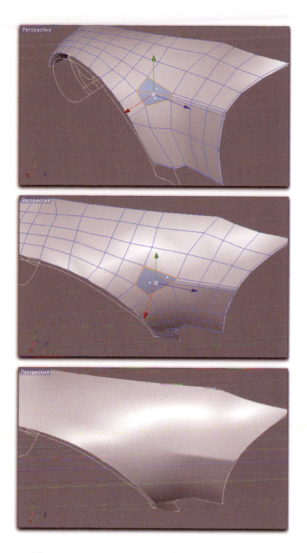

— Figure 3.16: Reorganizing faces.

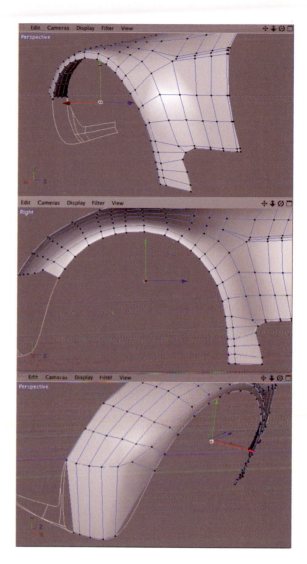

— Figure 3.17: Extending the shape.

Add a few new horizontal loop cuts to the front part of the fender to aid the transition to a small area.

Then use the EXTRUDE function at the left front edges (see Figure 3.21).

A triangular face should have been created after the new points were snapped to or placed along the splines (see arrows in Figure 3.22).

Make a KNIFE loop cut downward, starting from the lower edge of this triangular face.

The triangular face now has an additional point and can be closed with a rectangular

polygon. The result can be seen in the lower part of Figure 3.22.

Extrude the edges in the lower area of the front the same way to transform the shape in one step to the profile of the front bar (see Figure 3.23).

Additional vertical cuts will allow us to adjust the edge areas at the splines.

When creating new cuts, be sure that as many areas as possible are closed by rectangular polygons between the old and new

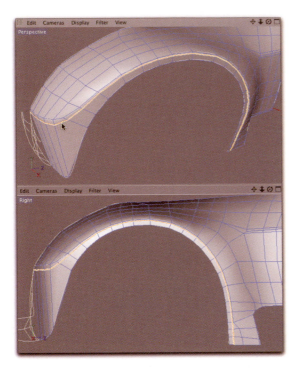

— Figure 3.18: Strengthening the edge of the wheelhouse.

faces. The finished transition could look like Figure 3.24.

Also note here how the edges are pulled together in order to create a hard edge in the middle of the front bar.

This part is almost done because the profile will not change anymore. Therefore, the outer edges can be extruded to the middle of the car in one step. The result can be seen in the top image of Figure 3.25.

If we want to be precise, then the gap between the fender and the front bar has to be created too. It looks as if the two components were put together at that spot. This kind of gap can be added easily.

Select the vertical edges at the place where the gap should be produced. The corner points are marked in red in Figure 3.25.

Use the BEVEL command to duplicate the selected edges and to move them away from each other in a parallel manner.

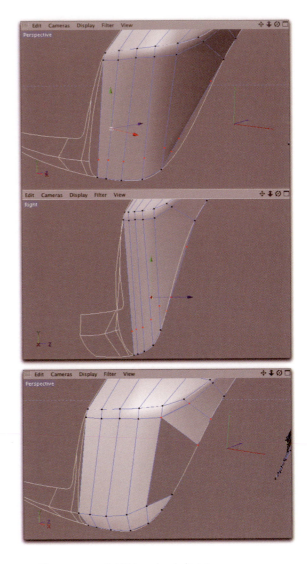

— Figure 3.19: Additional subdivisions.

Select the polygons located between the two new edges and use the EXTRUDE tool to recess them into the model. The result is shown in the lower image in Figure 3.25.

Create a SYMMETRY object and subordinate the model to it. Set the symmetry plane to YZ and activate the merging of points at the symmetry plane.

Check if the points of the front bar are exactly in the middle on the symmetry plane and

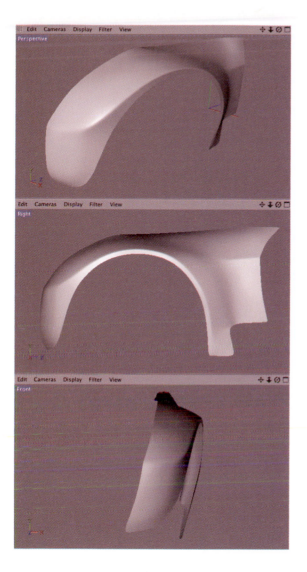

— Figure 3.20: Views of the model.

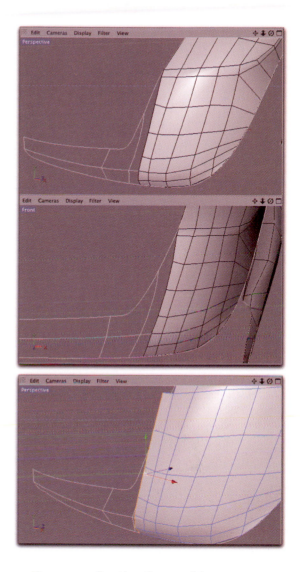

— Figure 3.21: Creating the transition.

then subordinate the Symmetry object under the HyperNURBS object.

Figure 3.26 shows the mirrored object prior to smoothing and the same scene with the active HyperNURBS object.

Note that by melting the front bar points in the middle, a nice curvature is created in the bar. We therefore do not need to add additional subdivisions.

Next, we will create the illusion of wall thickness. Make a loop selection of the continuous edges. Use the Extrude function to double these edges and move them simultaneously to the edge faces (see Figure 3.27).

The direction of the move can be controlled exactly by the angle value in the Extrude dialog. This component is now completely done and we can go on to the next one.

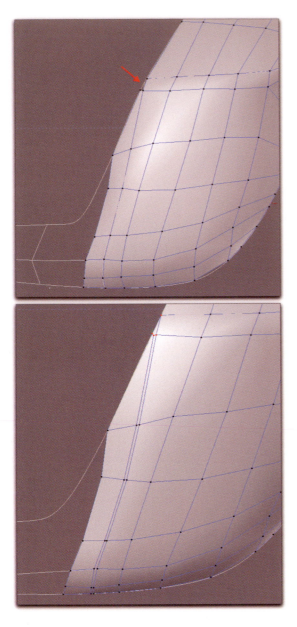

— Figure 3.22: Fine-tuning the edge.

3.2 Headlights and Bumper

We will continue with the front headlights and front bumper. These parts are made with

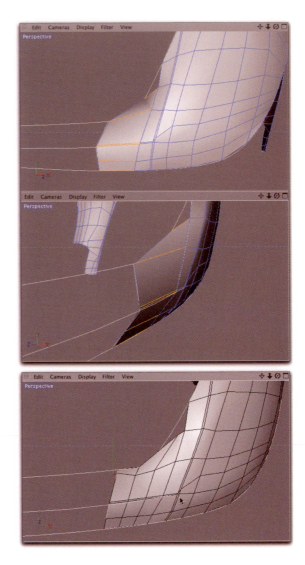

— Figure 3.23: Extruding edges.

the same material, which creates the illusion that they are one unit. Therefore, we will build this component group as one model.

It is always difficult to integrate exact openings into an object afterward. For this reason, we will start with the shaft of the headlight and continue from there with the rest of the component group.

Let us close both splines, which represent the front edges of the headlights, with an Ex-TRUDE NURBS object (see Figure 3.28).

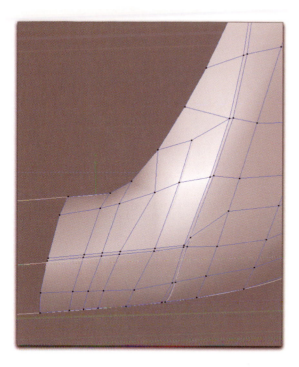

— Figure 3.24: The finished transition.

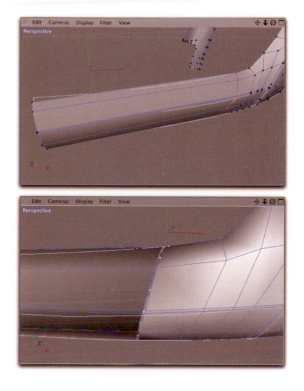

— Figure 3.25: Creating a gap.

All MOVEMENT values of the NURBS object should be set to a value of 0, as we do not need movement of the splines. Furthermore, we need only one cap. Deactivate the end function for caps and be sure that the cap is closed by rectangular splines.

The HIERARCHICAL option needs to be active when both splines are subordinated under the EXTRUDE NURBS object. All necessary options are shown again in Figure 3.28.

Now convert the EXTRUDE NURBS object and change into point mode since we will continue with polygons.

Use the CREATE POLYGON tool to close the gap between the filled-in ellipses with polygons.

Then change into edge mode and select the continuous edges of the upper ellipse face that do not yet have a connection to the lower ellipse. Extrude these edges a little bit outward. Figure 3.29 shows this step in the second image from the top.

Back in point mode, move the newly created points farther outward and snap these to the spline with 3D snapping. Repeat these steps with the edge of the lower ellipse, as is also shown in Figure 3.29.

Finally, create the transition faces so that a closed area is created around the headlight. The result is shown in the uppermost image of Figure 3.30.

Figure 3.30 also shows how the original faces of the headlight shafts are selected again and extruded inward a little bit. A small polygon circle has been created around the shafts of the headlights.

Extrude these polygons forward a bit. This will create a small beaded rim around the headlight shafts, as seen on the bottom of Figure 3.30.

Now the actual shafts can be created by extruding the faces inside the beaded rims (see Figure 3.31).

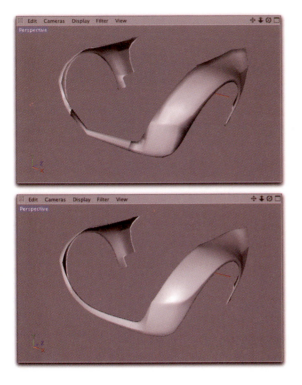

— Figure 3.26: The mirrored and smoothed model.

— Figure 3.27: Extruding continuous edges.

Do this in two steps. First, extrude the faces only a little bit and then extrude them to the desired depth. This additionally sharpens the shape at the front edge of the shafts when the HYPERNURBS smoothing is calculated.

The length of the shafts is not important, as they will be closed in by the headlight glass in the front part.

A continuous cut has to be added as shown in the bottom image of Figure 3.31 because the transition between the headlight shafts and the outer edge of the component group will be shaped as a gentle curve.

The best way to do this is to select the necessary edges and then use the EDGE CUT tool.

After that, use the newly created points for continuous molding of the headlights. The arrow in Figure 3.32 points to the desired bend of the shape. Figure 3.32 also shows how to continue with the lower edge of the model.

The Bumper

Select the continuous edges in the lower area of the object and extrude them a short distance. Then, in another step, bring them up to the middle of the upper bumper.

Now the upper bumper can be created quickly by a few new extrusions. The result can be seen in the upper image of Figure 3.33. All points can be comfortably snapped to the splines.

Create a one-polygon-wide strip going downward at the right edge of the bumper. This will be its lower border and is also documented in Figure 3.33.

The basic form is now completed and now we can extrude the continuous edges vertically to give the object more volume (see Figure 3.34).

— Figure 3.28: The headlights.

Finally, delete the faces that create the back walls of the headlights so that open-ended pipes are created. This saves us a few polygons.

The polygons in the "mouth" of the bumper will also be extruded a bit.

Be sure to have a large border angle so that a coherent extrusion is formed. This creates a new parallel edge loop around the mouth opening, which lets the edge look sharper in the HYPERNURBS smoothing.

— Figure 3.29: Extending the object.

After subordinating this new object under the HYPERNURBS and the SYMMETRY objects, it might look like Figure 3.35.

Then check if all the points along the left edge of the object are placed exactly on the plane of the symmetry object and if both ob-

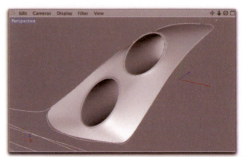

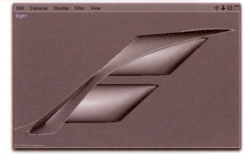

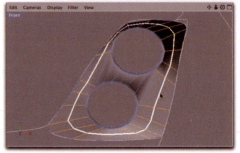

— Figure 3.30: The frame for the headlights.

— Figure 3.31: Extruding the shafts.

jects (fender and headlights) lie snug against each other.

Turn Signal and Fog Light

On the outside of the opening in the bumper, there is a combined unit with integrated turn signal and fog light. We will model their housing next.

We can save a lot of work by separating a few faces directly from the inner area of the mouth opening, as this housing will be placed exactly at the shape of the bumper.

Therefore, switch to POLYGON mode and select the inner faces on the right side of the mouth opening. Use the FUNCTIONS > SPLIT to double these faces and to copy them into a new object. These faces are recognizable in the upper image of Figure 3.36.

In this image, a red arrow already points to the next step, as the left side of the separated faces will be closed by a single polygon. You can use the CREATE POLYGON tool for this step.

Add two horizontal cuts to the manually created polygon so that the edges will be preserved when the component is sorted under the HYPERNURBS object. These cuts are highlighted in Figure 3.36.

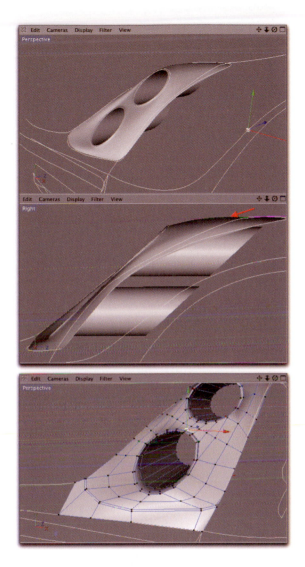

— Figure 3.33: Modeling the bumper.

— Figure 3.32: Molding the headlights.

Finally, use the CLOSE POLYGON HOLE command in the STRUCTURE menu to close the front face of the object.

Use EXTRUDE INNER with this new face to create a small polygon ring around it. This will keep the front of the object smooth, even with activated HyperNURBS smoothing, as shown in the lower image in Figure 3.36.

The Grille

The gap between the just created turn signal lights will be closed by a stylized grille. We will now build the frame of this grille. We can start with existing faces here.

Use the SPLIT command for the inner faces on top and bottom of the opening, as well as for the faces that form the left border of the turn signal housing (see Figure 3.37).

With FUNCTIONS>CONNECT, connect the new objects to each other to form one object. The original objects with the separated faces can then be deleted.

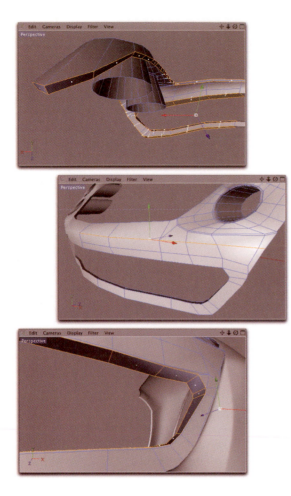

— Figure 3.34: Extruding the edges.

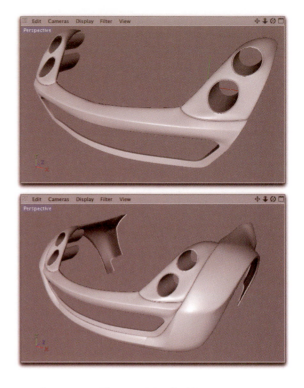

— Figure 3.35: The combined objects.

Add a few KNIFE cuts to subordinate the corners, as the faces on the right side do not blend seamlessly into each other.

The upper right corner is highlighted in red as an example for the newly created points in Figure 3.37.

The overlapping faces can now be deleted. Create new connection faces so that a continuous frame is built. The new faces are shown with arrows in Figure 3.38.

Now select all faces of the object and extrude them (with the activated CREATE CAPS option) further into the opening. Make sure that the MAXIMUM ANGLE value is adjusted so that all faces will be extruded together. The desired result is shown in Figure 3.38.

Then select the front faces as shown in Figure 3.39 and extrude them inward a short distance. The finished smoothed image is also shown in Figure 3.39.

3.3 The Front Trunk Lid

The motor is in the back, as is common with sports cars. Therefore, under the trunk lid, which we will now model, there is only a small storage compartment.

A simple plane is already very close to the shape of the trunk lid. Create a PLANE object and set it to 10 segments in the X direction. It should be aligned parallel to the floor.

Convert the plane to a POLYGON object and let the points of the plane snap with 3D snapping onto the splines. The end result is shown in Figure 3.40.

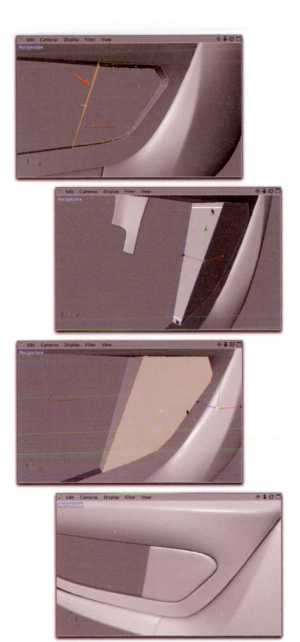

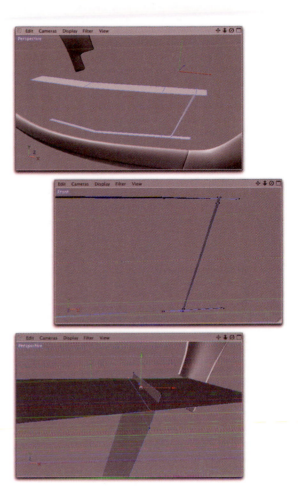

— Figure 3.37: The frame of the front grille.

Thicken the continuous edges by extruding them, like we did before, after the shape of the trunk lid is adjusted by moving the points. As a result, the trunk lid looks like it has volume.

Check if all points are lying in the middle at the symmetry axis. The finished lid is also shown in Figure 3.41.

— Figure 3.36: The housing for the turn signal and the fog light.

Three cuts have to be added, as the trunk lid has a curvature at the outside and is not straight. This can be done very well with the KNIFE tool in LOOP mode. These three cuts, marked with arrows, can be seen in Figure 3.41.

3.4 A Pillar and Roll Bar

Let us get to the bar that frames the windshield. The basic form can already be framed by two spline curves.

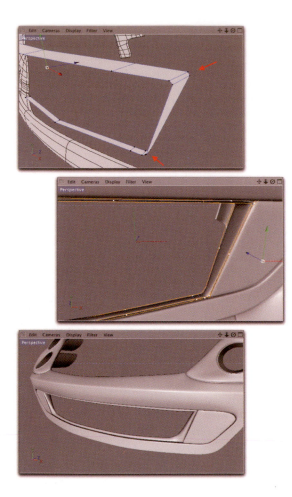

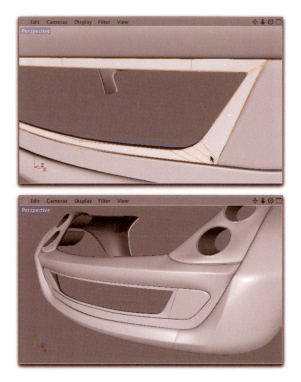

— Figure 3.39: The finished frame.

— Figure 3.38: Giving the frame a volume.

You can take either the premade splines or create your own.

A polygon skin is formed when the splines are subordinated under a LOFT NURBS object (see Figure 3.42).

Make sure that the LOFT NURBS object has a sufficient number of subdivisions. The bar will be smoothed and subdivided later by the HYPERNURBS object and should not be divided too much.

I think a MESH SUBDIVISION U of 20 is sufficient for the LOFT NURBS object.

The object just needs some volume and then we will already be done with this part.

Convert the LOFT NURBS to a POLYGON object and use the EXTRUDE function with the activated CREATE CAPS function to create the thickness of the bar. Thicken the bar toward the inside of the car. The outer measurement is determined by the splines and should not be changed.

Remove faces located in the symmetry plane and set all point coordinates there to the X position of 0, as this shape will be mirrored with the SYMMETRY object and thus be merged at the symmetry plane.

The position of the face, which needs to be deleted at the thickened bar, is marked by the mouse pointer in Figure 3.43. Figure 3.43 also shows an image of the finished bar as it will look when the SYMMETRY object is smoothed by the HYPERNURBS object.

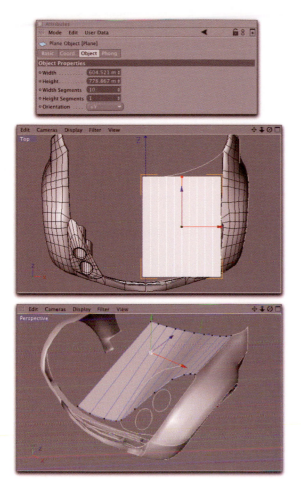

— Figure 3.40: The trunk lid.

3.5 The Door

The short crease in the rear part of the fender also continues over the entire length of the door. Therefore, the easiest way to start the door is to use the profile of the fender.

Select the polygons at the side of the rear fender. These faces are marked in red in Figure 3.44.

Separate these faces with the SPLIT command in the FUNCTIONS menu in order to get a new object.

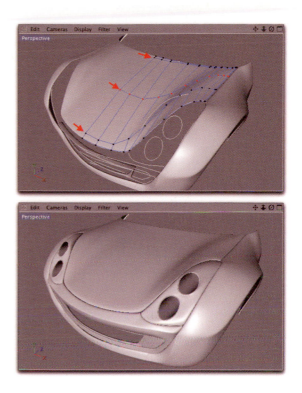

— Figure 3.41: Adding subdivisions.

Extrude the front edges of these separated faces and then pull them in the direction of the spline that borders the right side of the door. The end result can be seen in Figure 3.44.

We will leave a little gap between the moved points and the spline as Figure 3.44 shows.

Add a cut at the lower part of the door, as the amount of points is not enough to form the curvature of the door. The course of the cut is shown in Figure 3.44 by the red line.

The previously mentioned gap up to the right spline will now be bridged by another edge extrusion. Only the edges marked in green in Figure 3.44 will be extruded together.

By closing the resulting gap on the bottom right with a polygon, the door is framed on the bottom and right with a polygon strip. This will improve the edge sharpness tremendously after the HYPERNURBS smoothing. The result is shown in the two upper images of Figure 3.45.

— Figure 3.43: The complete bar.

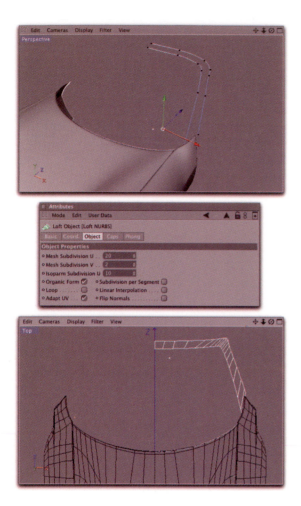

— Figure 3.42: The roll bar.

Now we will give the door some volume as we have done before with other parts. Therefore, extrude the edges on top, bottom, and to the right. Spare the upper right edge of the door because here is where a door handle will be later on.

Due to the left side of the door having been thickened, we will get double points.

The procedure in these cases is demonstrated in the series of images in Figure 3.46 with a simple example object.

Optimizing Edges and Points Manually

For a simple demonstration I rebuilt the door in a stylized shape (see Figure 3.46).

In the uppermost image, the start condition of the door is shown, which has the thickening only on the left side.

After the extrusion of the edges, which are marked red, we get double points and edges on the left side of the object. These points are marked in red and moved a little bit on purpose to show them better.

Activate the STITCH AND SEW command in the STRUCTURE menu in order to combine these points to only one.

Two points can be combined by pulling the mouse from one to the other when this command is active. First, only a connection line is shown, which is also displayed in Figure 3.46. After releasing the mouse the point that was clicked first will snap to the second point.

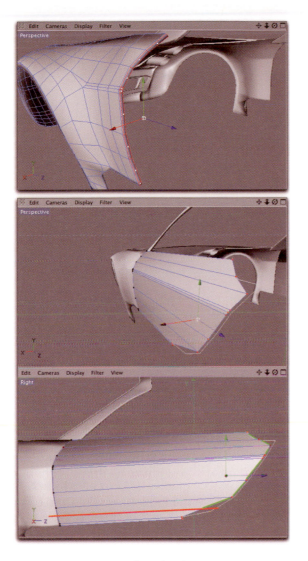

— Figure 3.44: Extruding the door.

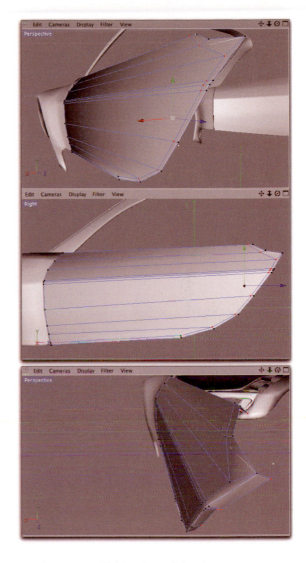

— Figure 3.45: Thickening of the door.

An automatic optimizing is executed that leaves us with only one of the two points. Finally, the finished door is shown in Figure 3.47.

3.6 The Rear Bar

Next to the fender starts the supporting structure of the car, which is extended under the door to the right and upward. The upper part forms another bar. This structure can be devel-

oped out of two splines similar to the front bar (see Figure 3.48).

We will use even fewer subdivisions in the U direction. I used nine subdivisions in the U and three in the V direction in the LOFT NURBS object.

This time we have to convert the LOFT NURBS object, as we will add additional cuts and model the shape more exactly in the lower part.

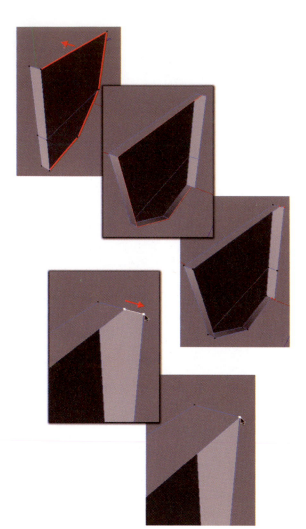

— Figure 3.46: Optimizing points manually.

My extra cuts are shown in red in Figure 3.49.

Because the crease of the fender and door is also visible in the bar, adjust the position of the edges accordingly.

The part of the bar that is at the fender does not just stop there but disappears behind the car body. Thus, bring this end of the bar far enough under the fender.

The lower image of Figure 3.50 shows the desired shape of the bar. There the bar has a fold that runs parallel to the crease in the door.

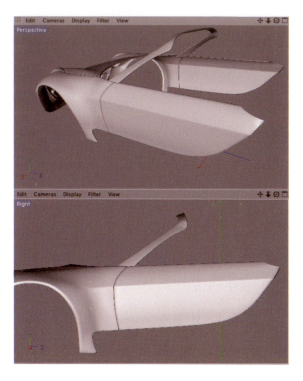

— Figure 3.47: The finished door.

Now only the typical HYPERNURBS rounding of the edges at the lower end of the bar needs to be addressed.

In EDGE mode, the outer edges could be selected with a RING SELECTION and be parted with EDGE CUT or we can use the KNIFE tool in LOOP mode.

The new edges should run close to the outer edge of the bar. Figure 3.51 shows this in an example with arrows and in the middle with red marks.

Then, thickening of the shape is followed by the extruding of the outer edges.

As before, the faces have to be deleted that are on the symmetry axis.

The thickening of the shape can be seen, marked by arrows, in the lowest image of Figure 3.51.

A look at the created objects shows that the car is slowly taking shape (see Figure 3.52).

As with all complex modeling jobs, the split into small component groups and the model-

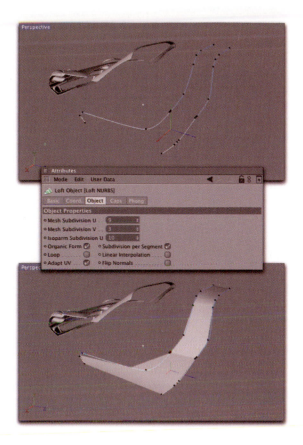

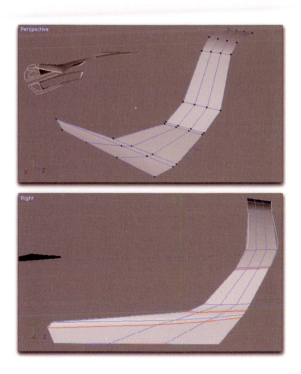

— Figure 3.49: Adding new subdivisions.

— Figure 3.48: The rear roll bar.

ing of one part after the other yields, in the end, a very good result.

Also, the number of tools and functions used can be reduced to a minimum, as you might have noticed. So far we have modeled almost all parts with only the Extrude and Knife tools.

3.7 The Rear

We will continue with the rear of the car. This shape rises around the wheel housing. Therefore, it makes sense to start with the edge of the housing and to work outward from there.

This shape can start out with a basic Disc object. Because this object offers the possibil-

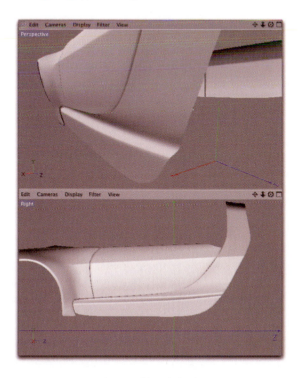

— Figure 3.50: The profile of the bar.

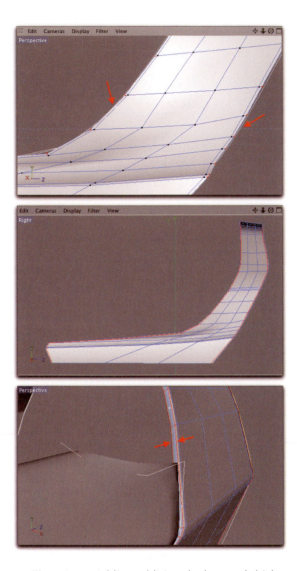

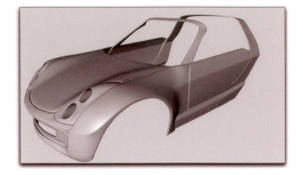

— Figure 3.52: The model of the car so far.

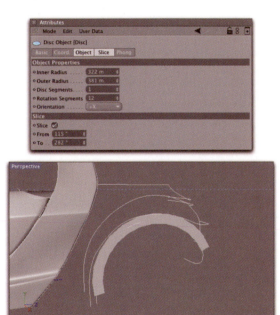

— Figure 3.51: Adding additional edges and thickening of the shape.

— Figure 3.53: Cutout of a disc object.

ity to determine an inner radius as well as a slice, it can be used to model the edge of the wheel housing without much effort (see Figure 3.53).

Subsequently, we need to convert the object because the points of the bent polygon strips have to be snapped precisely to the splines. Furthermore, new polygons will have to be created at the edges of this object.

Add a new face to the right edge of the converted polygons and lead them along the template spline around the wheel housing up to the rear apron.

Create two additional cuts so this area can be rounded three dimensionally, as shown in the bottom image of Figure 3.54. This is done quickly with the EDGE CUT function, as the desired number of cuts can be specified there.

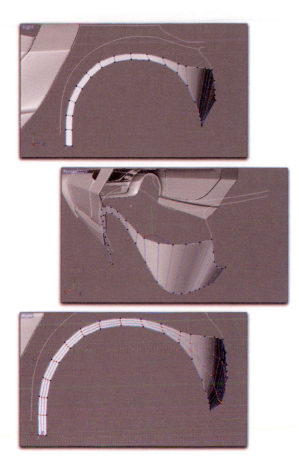

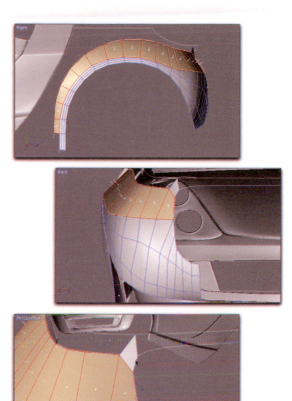

— Figure 3.54: Shaping the rear apron.

— Figure 3.55: Transition to the upper part of the rear apron.

Bridge the distance to the next help spline with another polygon row. Figure 3.55 shows these polygons in red.

These faces do not have to be made by hand. Just extrude the outer edges of the existing shape, move them, and let their points snap via 3D snapping at the spline.

Figure 3.55 also shows, in the bottom image, how the polygons can be created up to the small strip above the hood.

Bridge the gap to the rear roll bar and the upper template spline with a new polygon strip. Figure 3.56 shows this marked in color.

Note the ellipse-shaped opening between the bar and the rear apron. This is the area for the lateral air ducts, which we will close later with a grid.

Because the area above the wheel housing of the original car has a round shape, we need to create more edges by selecting them with the RING SELECTION and parting the edges two times with the EDGE CUT tool. The result is shown in Figure 3.57. The cut edges are marked in red.

Use the new points to create a bulge above the wheel housing. Note that this bulge has to be reduced at the left and right sides. In practice it should look like Figure 3.58.

The arrows mark the two distinctive edges of the components. At this point we should be working with the HyperNURBS object to smooth the object in order to better evaluate the effect when moving the points.

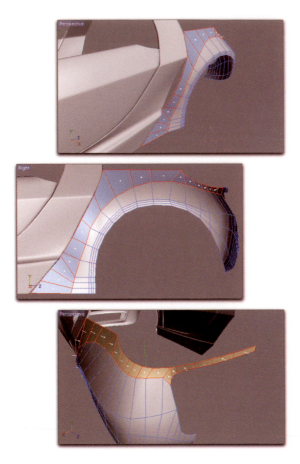

— Figure 3.56: Finishing the shape.

Remember to deactivate the snapping when the points should not snap to the splines.

As with most of the components, a continuous subdivision has to be added close to the outer edge so that important corners are not smoothed too much by the HYPERNURBS object.

We can use the KNIFE tool in LOOP mode. When the line of the cuts is not as we envisioned, it is possible to move the new points onto the edges with STRUCTURE>SLIDE. Figure 3.59 shows in red how the path of the new edges should be.

As with all component groups, use the EXTRUDE function for all continuous edges to simulate a volume of the component.

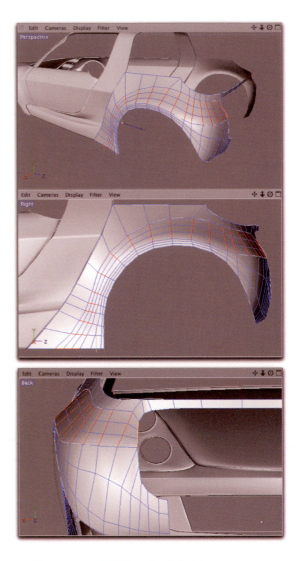

— Figure 3.57: Additional subdivisions.

After subordinating the rear apron under a SYMMETRY object and a HYPERNURBS object, the result could look like Figure 3.60.

3.8 The Rear Side Window

The upper part of the rear consists of a tailgate and a side window. These windows are (from the perspective of a modeler) very dif-

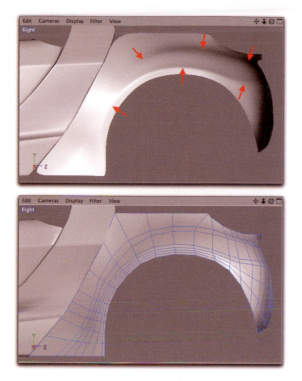

— Figure 3.58: The desired bulges and edges.

ficult because these faces have relatively complex curvature.

For modeling we have two template splines at our disposal. I was able to create these because the edge of the window had another color, making it possible for me to trace it with a spline.

We start the modeling process with a PLANE basic object, which has three subdivisions along the height and five in width (see Figure 3.61).

It is not recommended to start with many subdivisions, as every point has to be moved manually and partially placed without the aid of the spline snapping.

Align the plane so that it is parallel to the innermost template spline and convert the PLANE object.

Use the 3D snapping to splines to place the corner points of the plane onto the spline. Concentrate the points in the corner of the splines as shown in Figure 3.62.

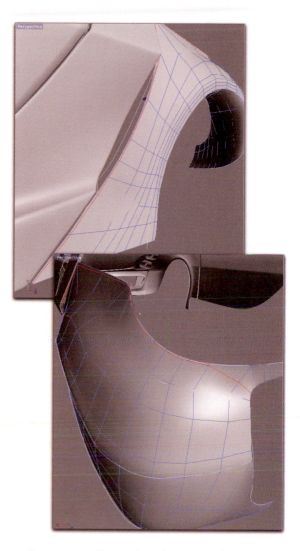

— Figure 3.59: Sharpening the outer edges.

Next add an encompassing polygon ring by extruding the outer edges. The result is shown in the first image of Figure 3.63. Additional cuts can be seen in the following images of Figure 3.63.

Because we want to keep the subdivisions of the inner part of the object to a minimum, it is better to create local subdivisions. This means not cutting through the whole structure. This is often possible with EXTRUDE INNER, as is shown in the bottom image of Figure 3.63.

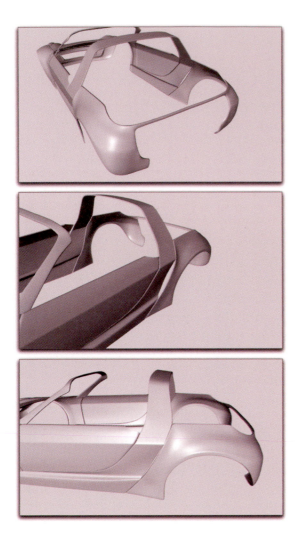

— Figure 3.60: The finished rear part.

Faces in the edge area then have to be deleted and open points need to be snapped to the splines.

Additional points can be used to form the wedge-shaped right part of the window. This will need special care because of the curvature in this area. The described steps after the inner extruding are combined in a series of images shown in Figure 3.64.

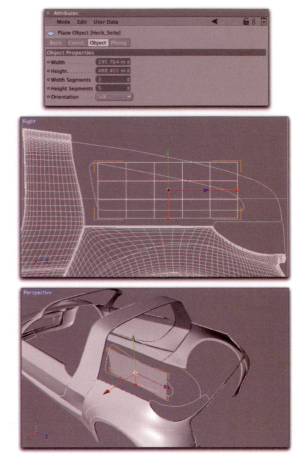

— Figure 3.61: The rear side window.

Ironing out Irregularities

Even with the most careful placement of points in the window, it is almost impossible to create a perfectly rounded surface. For this reason we will use the IRON tool in the STRUCTURE menu (see Figure 3.65).

Figure 3.65 demonstrates the mode of action of the IRON tool on a wrinkled plane. As Figure 3.65 shows, this tool smooths out irregularities. The strength of the effect is determined by way of the PERCENT VALUE.

I recommend working with small PERCENTAGE values and using the tool multiple times until the desired smoothness is achieved.

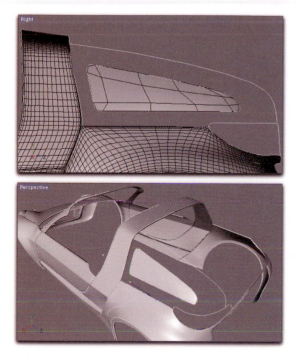

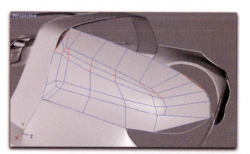

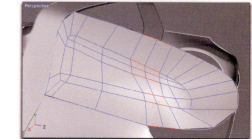

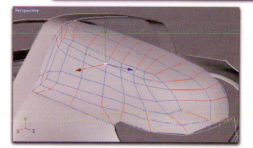

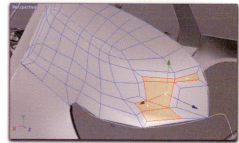

— Figure 3.62: Snapping the corner points of the plane.

The IRON tool can also be restricted to selections. This will be helpful, as the edge points of the window should remain snapped to the spline.

Thus, select only the inner points of the window, as shown in the upper image of Figure 3.66. Then use the IRON tool to reduce the irregularities of the surface.

Add the familiar subdivisions close to the outer edge to sharpen the profile with the HyperNURBS smoothing.

We need to model this object as a volume this time, as it will get a transparent material. Only then will the REFRACTION value of the transparency work realistically.

Therefore, switch to polygon mode and use the EXTRUDE function with the active CREATE CAPS option to thicken the object. Extrude it toward the inside of the car so that the outer dimensions remain.

— Figure 3.63: Adding subdivisions.

If problems occur with the extrusion, control the direction of the surface normals. As we already know, when polygons are created manually, it is possible for the normals to be turned around. This should be checked on all models and then fixed automatically with the ALIGN NORMALS function.

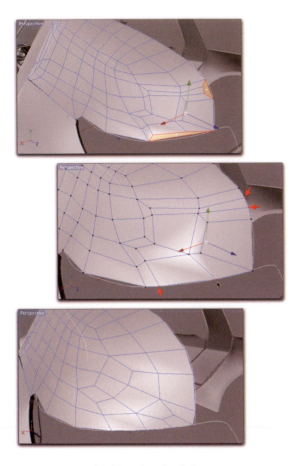

— Figure 3.64: Adding local subdivisions.

3.9 The Tailgate

In order to model the tailgate we need only a spline to provide us with the profile.

This spline is widened in the direction of the symmetry plane with an EXTRUDE NURBS. Set the interpolation of the IMMEDIATE POINTS to UNIFORM because the subdivision of the EXTRUDE NURBS depends directly on the number of INTERMEDIATE POINTS in the spline. A value of three SUBDIVISIONS should be enough. Then the EXTRUDE NURBS can be converted (see Figure 3.67).

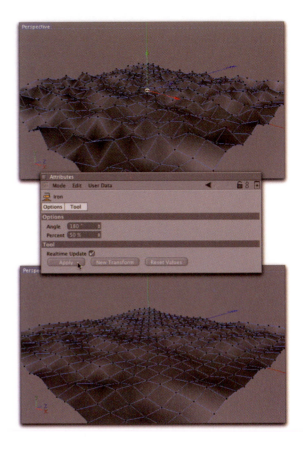

— Figure 3.65: The iron tool.

Select the right edge of the converted EX-TRUDE NURBS and in the COORDINATE MANAGER set the expansion of these points in the X direction to 0. This will assemble the points into a vertical line, as shown in Figure 3.68.

In the COORDINATE MANAGER the value for the X position can also be set to 0 and confirmed with APPLY as long as the points are still selected. It places the edge of the object exactly onto the symmetry plane.

Activate the SCALE tool and move its MOD-ELING AXIS to the lower end of the POINT SELEC-TION (see Figure 3.68).

Adjust the upper edge of the tailgate to the shape of the rear roll bar by scaling the points at the right edge of the object.

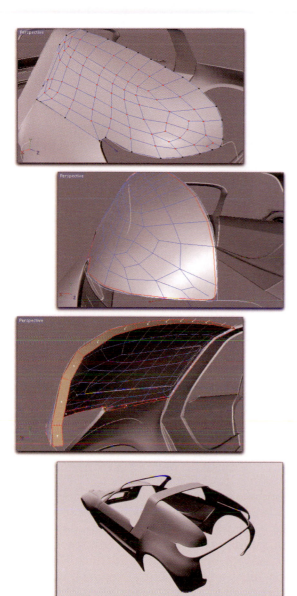

— Figure 3.66: Finishing the window.

Add another vertical subdivision, which will be adjusted the same way. The result is shown in the upper image of Figure 3.69.

Then we add the obligatory subdivision along the edge and thicken the whole object. The faces on the symmetry plane then get deleted (see Figure 3.69).

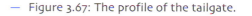

— Figure 3.67: The profile of the tailgate.

Now we will model the small rear spoiler of the tailgate (see Figure 3.71).

Select a few polygons above the ridge of the tailgate and extrude them upward. Be sure to select faces only on top of the tailgate. Rotate the polygons by entering a value of 0 for the Y rotation on the plane in the COORDINATE MANAGER.

In the view from above move the points so that an arc is created from the outside inward. This shape is also shown in Figure 3.70.

Do not forget to remove the faces in the symmetry plane that were created by extruding the rear spoiler.

The bottom image of Figure 3.70 shows the opening that is visible again after the deletion of the faces.

Add a continuous subdivision to the rear wing. This can be done, like in Figure 3.71, with the EDGE CUT tool.

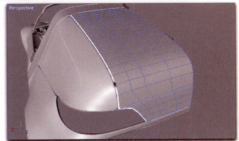

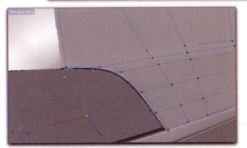

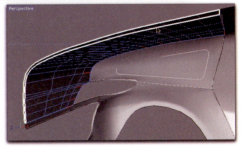

— Figure 3.68: Adjusting the profile in the middle.

Use the new points to shape the wing further. A possible result is shown in the two lower images in Figure 3.71.

In the middle of the rear wing there is a brake light, as shown in the photo of the rear in Figure 3.72. The light could be shown with a simple projection of the right material, but I would like to add this brake light as its own object. This saves us the use of UV coordinates and high-resolution textures in order to create the required edge sharpness of the object.

Start by selecting polygons of the rear edge of the spoiler and extrude them inward as a group. This will sharpen this area of the spoiler

— Figure 3.69: Additional steps.

in the HYPERNURBS object, as can be seen in Figure 3.73.

Then select a C-shaped area in the middle of the spoiler as also shown in Figure 3.73.

Extrude these faces inward to get additional points within the faces.

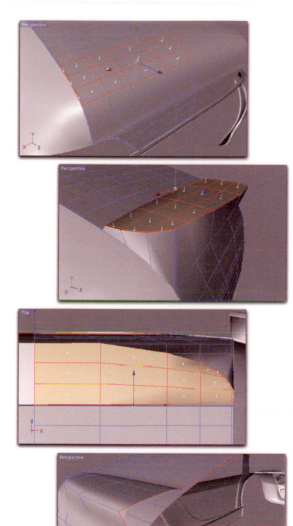

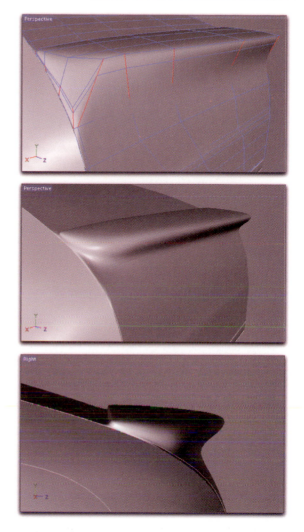

— Figure 3.70: The rear spoiler.

— Figure 3.71: Shaping the rear spoiler.

Move these new points so that the edges border the shape of the brake light (see Figure 3.73).

Afterward select the faces in the area of the light and separate them with the SPLIT command into a new object.

Depending on how exactly this object should be modeled, the faces of the separated

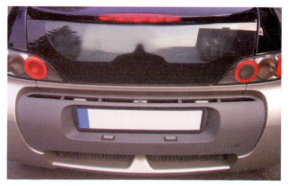

— Figure 3.72: The rear of the car.

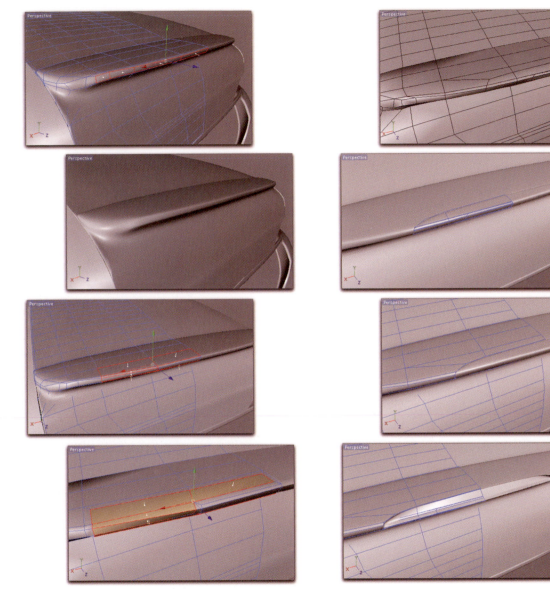

— Figure 3.73: Sharpening the profile of the spoiler.

— Figure 3.74: Separating the brake light.

brake light can be thickened by extrusion, and the original faces of the tailgate can be shaped into a depression by extruding and moving them. However, it would be enough to delete the original faces of the spoiler and to close the resulting hole with the separated brake light. The results are shown in Figure 3.74.

3.10 The Tail Cover

A plastic part covers the engine in the center of the tail. This part can be seen well in Figure 3.72.

Two splines are enough for defining the shape. One spline describes the outer profile and the other one the shape of the opening where the license plate is located.

We can start with a PLANE object with a height of nine segments and one width segment. Convert this plane and let the points snap to the outer spline as shown in Figure 3.75.

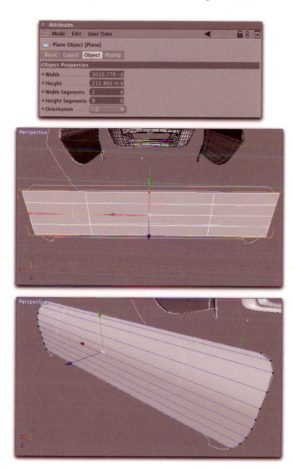

— Figure 3.75: A plane as the start object.

We need additional subdivisions to model the shape of the recess and the downward turning corners of the lower area of the cover.

Select all horizontal edges of the object and split them one time with the EDGE CUT tool. Additional vertical cuts, at the height of the

corners and where the recessed area starts, can be added with the KNIFE tool.

Use the added points to contain the outer shape and the edge of the recess in the middle (see Figure 3.76).

— Figure 3.76: Adding subdivisions.

These steps have to be done only on one side of the object. The other half will be supplemented later by the symmetry object.

Select the faces that are within the inner spline and extrude them a bit; in a second step, extrude the faces inward to the desired depth of the recess. Scale the extruded faces along the Z axis to a value of 0 so that a vertical face is created.

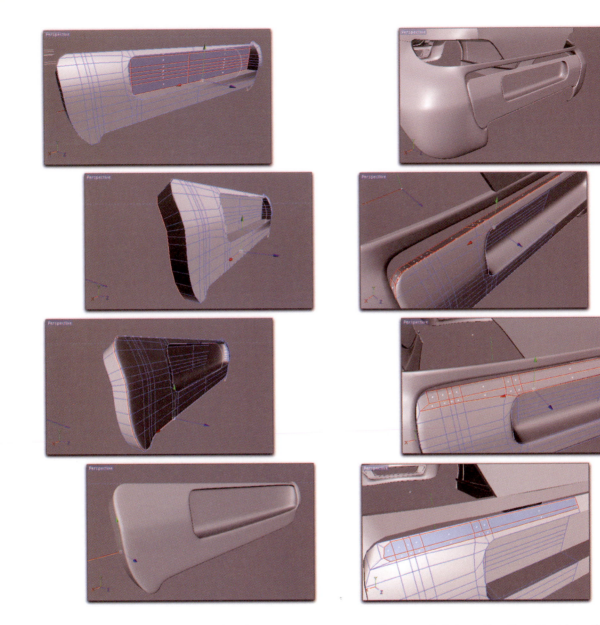

— Figure 3.77: Adding depth to the object.

— Figure 3.78: Integrating the object into the tail.

The surrounding edge of the cover will also be extruded inward with the EXTRUDE tool (see Figure 3.77).

Now we can concentrate on the accurate fit of the already modeled tail (see Figure 3.78).

Therefore, delete all points to the right of the center of the plastic cover and subordinate it under a smoothed SYMMETRY object.

Check if the cover fits well into the tail at the sides.

A recess with air vents is still missing above the cover. These will be extruded directly out of it. Therefore, select the upper faces, including the rounded upper corner. The second image from the top shows this selection in Figure 3.78.

Extrude these faces in one step upward and select the faces at the front where the opening is to be created. This step can be seen in the third image of Figure 3.78.

Extrude these faces slightly inward and use these small faces to frame the edge of the desired opening. This is shown in the last image of Figure 3.78.

This precisely shaped polygon group will be moved into the cover with the Extrude command and then deleted. What is left is a narrow gap in the cover, which is shown in Figure 3.79.

The gap is stabilized by five slim supports. We need two complete supports and half of one, as all objects are mirrored by a Symmetry object.

These elements could be modeled directly out of the engine cover, but then we would have to make many additional cuts. It is easier to just use small cubes that are subordinated to the cover as separate objects. This works well without having to connect the two objects as shown in Figure 3.79.

Just remember to convert the third set of cubes and delete the right half of their points, as they will be mirrored and merged in the middle.

Now the rear apron has to be pulled down along the upper edge of the motor cover so that the objects are snug.

The arrows in Figure 3.80 indicate the movement of the points of the tail object. For a better understanding, take another look at Figure 3.72.

This completes this part and we can continue with modeling of the lower bracket.

3.11 The Rear Bracket at the Tail

The lower part of the tail is closed in by two grids and one bracket. These parts are shown in detail in Figure 3.81. We will start with mod-

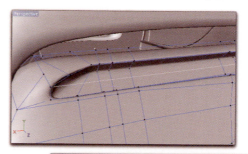

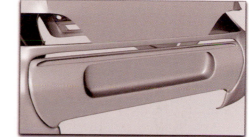

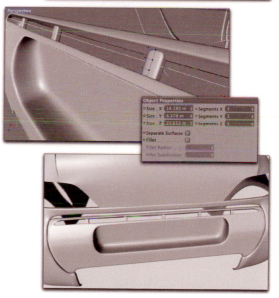

— Figure 3.79: Modeling the gap and the supports.

eling the bracket and later we will put the grids into the openings.

As a basis for the model we will use a slim cube with four subdivisions in the X direction and three subdivisions in the Y and Z directions (see Figure 3.82).

Place the cube parallel to and under the engine cover. Then convert the cube and move

— Figure 3.80: Adjusting the tail to the cover.

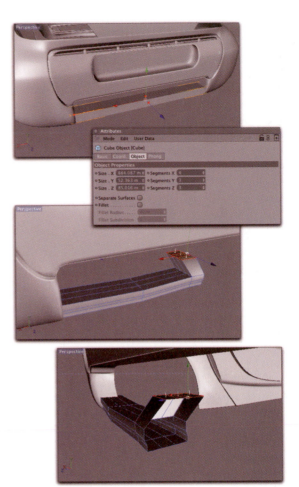

— Figure 3.82: Modeling the bracket.

— Figure 3.81: The lower bracket at the tail.

the segments in such a way that the vertical braces can be extruded from the middle portion. Figure 3.82 shows the desired shape in the lower image.

Align the points in the center so that they are placed exactly on the symmetry plane. Then the right part of the cube can be deleted.

This part will be added again by the SYMMETRY object.

Now extend the vertical part of the bracket in the center until it reaches into the lower part of the engine cover plate. The polygons on top of the bracket can then be deleted.

Subordinate the half bracket under a SYMMETRY object and HYPERNURBS object to see how it looks.

The model can be subordinated under an already existing SYMMETRY object so as not to create a new symmetry for each object (see Figure 3.83).

The visible crease around the vertical bracket can be achieved by making horizontal

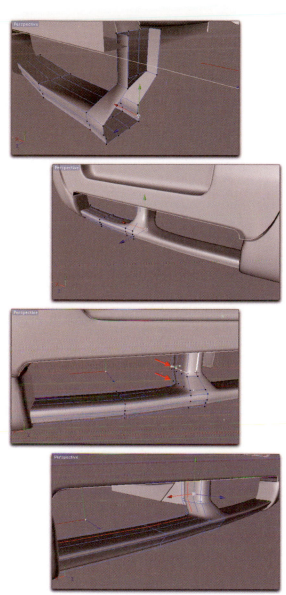

— Figure 3.83: Extending and smoothing the shape.

cuts at the base and in the middle of it. The areas for the cuts are shown with arrows in Figure 3.83.

The Grid Areas

We will use a stylized grid to close the space between the bracket and the engine cover. This grid will also be used in other areas of the car.

First, the area has to be closed with an object. This can be done with the cap of an EX-TRUDE NURBS object.

In order to generate the necessary spline that fits into the opening, we will convert an EDGE SELECTION into a spline by using the command STRUCTURE > EDIT SPLINE > EDGE TO SPLINE. Figure 3.84 demonstrates this with an EDGE SELECTION at the edge of the bracket.

— Figure 3.84: Extracting splines from edges.

This spline then has to be set to 0 along the Z axis so that all spline points are on one plane. This step is repeated with the EDGE SELECTION along the bottom of the engine cover. This edge will also be converted into a spline. Connect both splines with FUNCTIONS > CONNECT. The result is combined into a single spline with

JOIN SEGMENTS and will then be closed with the CLOSE SPLINE option.

Subordinate the spline under an EXTRUDE NURBS object and activate FILLET TYPE EN-GRAVED to create the front cap. The result can be seen in Figure 3.85.

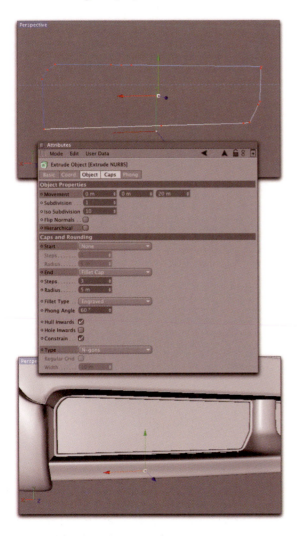

— Figure 3.85: Closing the area with an Extrude NURBS object.

The imprinted grid structure will be completed with duplicated cubes. Therefore, create a cube with an edge length of 8 units in the X and Z directions. The height can be kept at 200 units for the moment.

Rotate the cube so that it lies partly submerged in the plane created by the EXTRUDE NURBS and only shows one edge (see Figure 3.86).

— Figure 3.86: A crossbar of the grid.

Move the cube into the upper left corner of the EXTRUDE NURBS plane where the first crossbar of the grid is supposed to be.

Create a linear two-point spline starting from the current position of the cube to the lower right corner of the EXTRUDE NURBS plane. The course of this spline is also shown in the middle image of Figure 3.87.

Select the grid cube and select FUNC-TIONS>DUPLICATE. Choose the ALONG SPLINE mode in the dialog and pull the path spline into the SPLINE field of the dialog. Now create 14 real copies of the cube by pressing the APPLY button (see Figure 3.87).

Unfortunately, duplication along the spline does not offer an interactive mode where the course of the spline could be changed afterward. When duplication of the cubes is not the

Work in the opposite direction and repeat this procedure with a second cube. Duplicate it along the spline from the upper right to the lower left. A possible result is shown in Figure 3.88. This component is now complete.

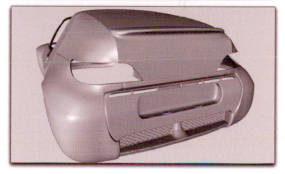

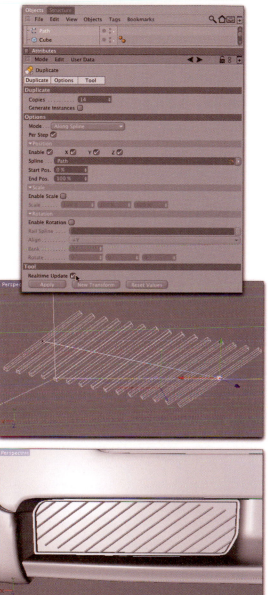

— Figure 3.88: The finished grid.

— Figure 3.87: Duplicating the cube along a spline.

way it should be, use the UNDO command, change the course of the spline, and use the DUPLICATE function again.

The only thing left is the individual adjustment of the length of each cube copy so that the EXTRUDE NURBS is always covered.

3.12 Tail Lights

The tail lights are framed by the tailgate, the side rear windows, and on the bottom by the rear apron (see Figure 3.89).

The basic shape of the tail light can be put together by separating polygons from these already modeled parts. Therefore, use the SPLIT command to separate the necessary polygons from the named components and connect these faces with the CONNECT command into one object.

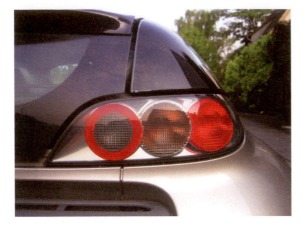

— Figure 3.89: The tail lights.

Delete unnecessary points in this object and connect the remaining faces to a closed polygon ring, as shown in Figure 3.90.

Use the CREATE POLYGON function to close the front of the tail light as evenly as possible with polygons.

Select these new faces and extrude them a bit inward so that the outer edge is sharp when smoothed by the HYPERNURBS object (see Figure 3.90). Then make new faces at the rear of the lights using the same principle. These new faces do not have to be extruded inward.

Create three basic cylinder objects with a radius of 47 units each and arrange them as shown in Figure 3.91.

Use multiple BOOLE objects to merge the first two cylinders to each other and then to merge this BOOLE object with the remaining cylinder into one unit.

This group will then be combined with the tail lights in INTERSECT mode. The result can be seen in Figure 3.91.

Because the shape has many hard edges, we need to duplicate the boole group and convert it into a POLYGON object.

Select a continuous edge loop at the converted object and convert it to a spline. Now the spline type can be changed to BEZIER and the shape of the spline can be adjusted with the

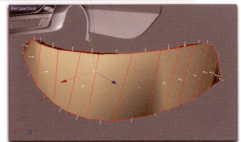

— Figure 3.90: The glass cover of the tail lights.

tangents. Then subordinate the spline under an EXTRUDE NURBS object with rounded caps. These steps can be seen again in Figure 3.92.

The spline diameter is automatically extended by the rounding of the caps. The original cylinders can therefore be subtracted from this shape with a BOOLE object.

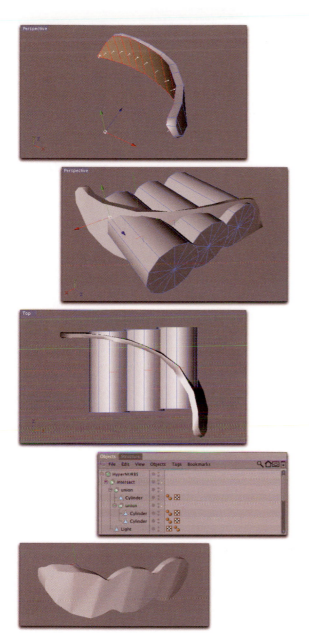

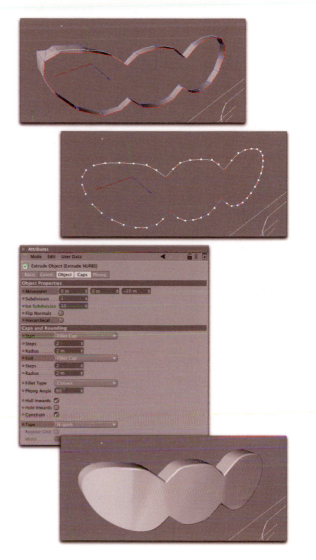

— Figure 3.92: The shape of the lights.

— Figure 3.91: Booling the basic shape of the lights.

As a first step we will need three cylinder objects as shown in Figure 3.93. There the blue cylinder will be subtracted from the green one.

The result of this action, together with the red cylinder, is again subtracted from the Ex-

TRUDE NURBS object. The resulting shape is also shown in Figure 3.93.

Now only the third light is missing. First, its yellow cylinder, shown in Figure 3.94, will be combined with a cube in a way so that it does not penetrate the rear of the light. The white cylinder is also subtracted from the yellow one, creating the same crescent-shaped recess that we produced with the green cylinder.

This BOOLE object will then also be subordinated under the red cylinder. Therefore, this

— Figure 3.93: Booling the light shafts.

shape will also be subtracted from the shape of the tail light and leaves the desired recess.

Adjust the first model of the tail light so that the three lights have enough space to fit inside (see Figure 3.95).

Make a POLYGON SELECTION of the rear faces of the tail light. These faces will later get a reflective material, whereas the front will be covered with a transparent material.

Then convert the BOOLE hierarchy of the tail lights and select the faces that represent the actual lights. These faces are marked in red in Figure 3.96.

Extrude these faces in the world Z direction toward the glass and use the CREATE CAPS option of the EXTRUDE tool.

By extruding the faces of the brake light inward, its ring-shaped structure can be recreated.

Take a look at the real photo in Figure 3.89. Create polygon selections for the surfaces of the lights that will get the same material.

Later we will have to deal with three colors of light lenses in white, red, and yellow.

— Figure 3.94: Additional Boole actions.

I already applied a transparent material to the light lens, as shown in Figure 3.96, so that the position of the lights can be seen more easily. I will talk about the material used at the end of this example.

3.13 The Gap Size

Maybe you already noticed in the photo that this type of car has large gap sizes, which means that the components are separated from each other by a large gap.

We will simulate this by a small movement of the points in the edge areas of the compo-

— Figure 3.95: Shaping the tail light.

nents. The desired effect is marked with ar-rows in Figure 3.97.

Figure 3.97 also shows that simple cube ob-jects with an extrusion at the upper end were integrated into the indentation of the engine cover. They simulate the license plate lights.

We will continue with the air vents on the side of the car. These also have to be closed with the stylized grids.

The technique we will use here is identical to the one used at the tail bracket. Therefore, it is not necessary to go into detail here.

The result is shown in Figure 3.98. There the following steps can be seen as well. These are modeling of the air vents in front of the wind-shield and the mount for the windshield wipers.

— Figure 3.96: The finished tail lights.

3.14 Front Air Vents and the Windshield

In front of the windshield there is a complex shaped plastic part that, aside from other things, contains the air vents for the fan on the inside of the car.

We will construct this shape primarily with the help of splines. Start with placing two paral-lel spines in the area in front of the windshield.

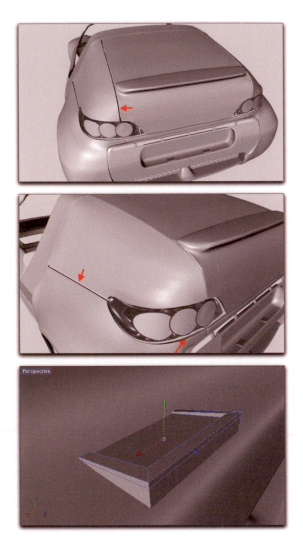

— Figure 3.97: Adjusting the gap sizes.

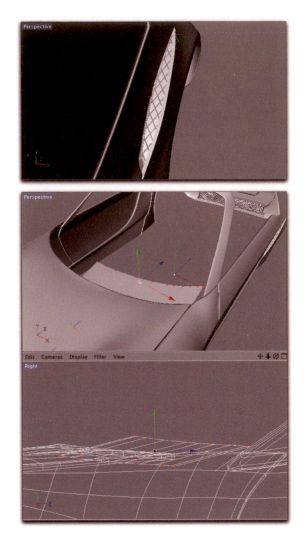

— Figure 3.98: Preparation for modeling of the air vents.

Extract an EDGE SELECTION as a spline from the edge of the trunk lid and duplicate the spline. We do this so that the shape of the spline fits exactly to the trunk lid.

Combine both splines with a LOFT NURBS object as shown in Figure 3.98.

In order to achieve the curvature of the plastic part, create another copy of the spline and move it so that the LOFT NURBS takes on a shape that is slightly upward. This shape can be seen quite well in the side view of Figure 3.99.

The shape can now be mirrored and completed with a SYMMETRY object. Now some of the faces of the object have to be moved up and down.

The shape of the part that has to be moved upward can be recognized as a dark spline curve in Figure 3.99. This curvature is shown in the photos of Figure 3.100. There, at the driver and passenger sides, the part of the component can be seen that is moved upward. The elliptical air vents are also in that area.

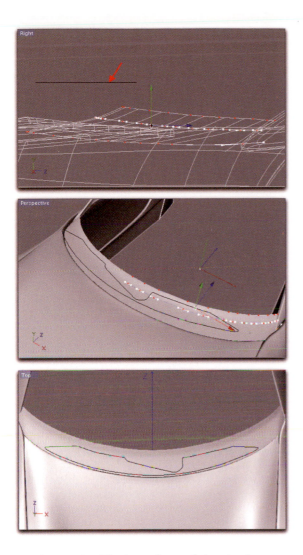

— Figure 3.99: The base shape of the plastic parts.

— Figure 3.100: Images of the area in front of the windshield.

Place the spline parallel to the ground above the surface that was generated by the LOFT NURBS. The arrow in Figure 3.99 shows the position of the spline in the side view.

Subordinate the spline under an EXTRUDE NURBS object that extrudes the shape vertically downward and creates caps. This shape is marked in red in Figure 3.101.

Then create a copy of the SYMMETRY object, which has the LOFT NURBS object subordinated, and convert this copy to a POLYGON object.

Finally, use a BOOLE object in INTERSECTION mode to combine the EXTRUDE NURBS and the new POLYGON object. The result is shown in the middle of Figure 3.101.

Activate the HIDE NEW EDGES option in the BOOLE object before this object is converted to a POLYGON object. This changes the face automatically into an N-GON.

Extrude the N-GON upward until it is at the same height as the trunk lid. The upper edge can then be rounded a bit with the BEVEL function. The result is shown in Figure 3.101.

Now we will cut out the slits in the air vent. This is done by subtracting a series of distorted cylinders from the previously extruded object with a Boole operation.

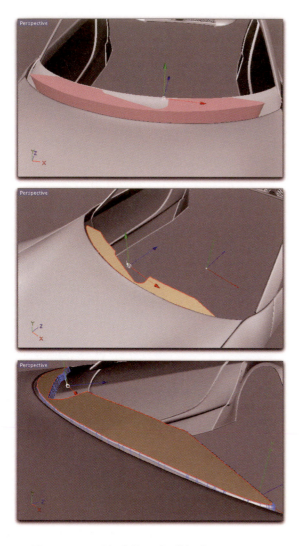

— Figure 3.101: Modeling the lifted part.

In a moment we will discuss the additional steps that are necessary to end the holes at a certain distance from the edge of the object. First, objects have to be created that have a suitable shape for the air slits.

Therefore, we use slim cylinders that will be distorted along the axis. Open a basic cylinder object with a radius of 5 units and a height of 200 units. A circumference of 12 segments should be enough so that the boole operation will not create too many faces.

In object mode (see the icon in Figure 3.102) we can now distort the cylinder by scaling it in the local Z direction. The advantage of this method of scaling is that the cylinder does not have to be converted and therefore keeps all parametric properties.

When the size and the height of the cylinder are set, we will make two copies and place them on a slight angle to simulate the air vent slits. Figure 3.102 shows the placement in different perspectives.

Now the moment has come to convert these cylinders, because they will have to be duplicated along a path. Then combine all three cylinders to a new object by using the CONNECT command in the FUNCTIONS menu.

Use the command STRUCTURE>AXIS CENTER> CENTER AXIS TO to place the local axis system in the center of this object.

In the AXIS CENTER menu there is another mode for putting the axis system into a new place. For example, the axis system can be moved to the position of the parent object or detailed settings for the alignment of the local axis system can be made in the AXIS CENTER... entry. This function is especially helpful when working frequently with imported 3D data.

The axis systems of 3D data are often far outside the actual geometry, which makes it difficult to edit the objects, such as rotating or scaling them evenly.

We will use a spline again to allow the copies of the cylinder to follow the plastic part in a slight bow. This step should be familiar from the creation of the grid structure at the tail and the sides of the car.

My settings for the DUPLICATE tool can be seen in Figure 3.103. The number of copies depends on the size of your cylinder and the length of the used spline and can therefore differ.

Note the activated SCALE function of the duplicates. This way the copy can be scaled down toward the end of the spline path. Ideally, the cylinder copies will be parallel to the lifted shape until the end of the plastic cover.

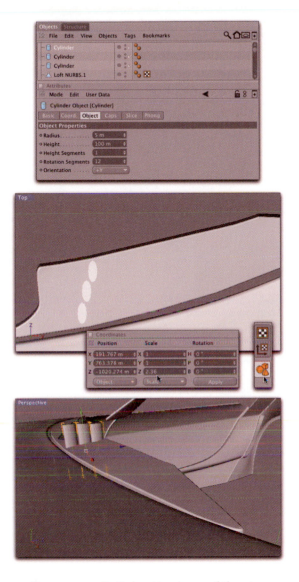

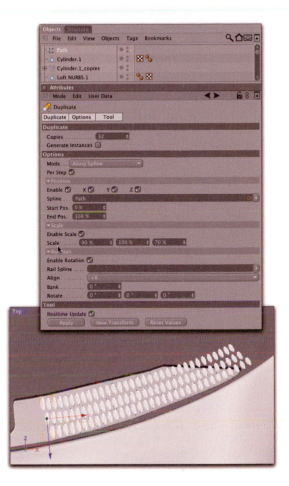

— Figure 3.103: Duplication of the cylinder.

— Figure 3.102: Defining the shape of the air vents.

Actually, we could subtract the copies from the plastic part with a BOOLE object, but then we would get holes in the right part that would extend into the wall of the plastic cover.

Therefore, our goal must be to first confine the cylinder group so it is located entirely within the cover.

Create a copy of the spline of the lifted parts and pull this spline higher than the up-permost edge of the plastic cover. All points of the spline that represent the left part of the cover can be deleted. Of interest to us is the area around the air vent slits only.

Subordinate the spline under an EXTRUDE NURBS object and extrude the spline vertically downward.

The lower end of the EXTRUDE NURBS should be located under the cover. The resulting object is shown in a view from above in Figure 3.104.

Scale the spline of this shape a bit at all sides. The shape of the EXTRUDE NURBS object should not cover or breach the plastic cover at the outside.

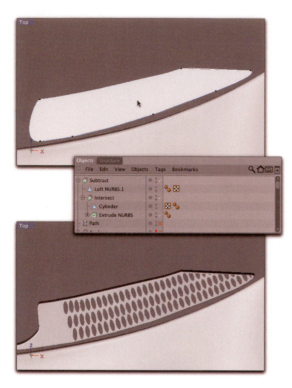

— Figure 3.104: Booling the air slits.

Create a BOOLE object in INTERSECT mode and subordinate it together with the duplicated cylinders under the EXTRUDE NURBS object. For clarity reasons, the cylinders should all be combined to one object with the CONNECT command.

Only the cylinders that are placed within the EXTRUDE NURBS and are located within the cover should be left over. These cylinders can then be subtracted with another BOOLE object from the lifted cover to create the air slits (see Figure 3.104).

Convert this group of BOOLE objects to get a POLYGON object of the lifted cover, including the air slits.

In EDGE mode the edges of the air slits can now be selected with a LOOP SELECTION, as shown in Figure 3.105. Activate the SELECT BOUNDARY LOOP option in the LOOP SELECTION dialog to avoid errors in the selection. This way only the open edges of the holes can be selected.

— Figure 3.105: Shaping the cover.

When all hole edges are selected they can be extruded downward to simulate a material thickness. This effect can also be seen in Figure 3.105.

To the left and right of the lifted cover are dents in the surface. We will draw splines following their contours as shown in Figure 3.105.

With an Extrude NURBS object these splines can be moved downward until the cover is pierced. Then close all caps.

Use a new Boole object in subtract mode to subtract this Extrude NURBS from the converted original shelf. As you remember, we created a copy of the upward bent shelf at the beginning. Two openings in the shelf are left over.

Extrude the open edges of these holes downward and close the holes with the Close Polygon Holes function. The result can be seen on the bottom of Figure 3.105.

Select multiple polygon rows at the upper edge of the former shelf. This selection is shown in Figure 3.106.

These faces are supposed to be a kind of seal for the windshield. Thus, extrude these faces together a bit upward and then activate the rotate tool.

In the rotate tool's settings for the Modeling Axis, choose Normal for the Orientation and select the Along Normals option. This setting forces the faces to rotate only where nonselected faces are bordering.

Because of this, the faces at the edge of the windshield arch upward and, at the front edges, downward. This is the shape of a typical seal.

It is almost done, as the actual windshield can be created easily by overlaying it with simple splines and a polygon skin.

Therefore, we can create simple two-point splines as in Figure 3.107. When 3D snapping is activated, they can be snapped to polygons at the front roll bar and on the bottom to the recently modeled seal.

Switch the interpolation to B-Spline and add a point to the spline with Add Point at about the middle of every curve. This additional point is used to bend the profile of the window outward.

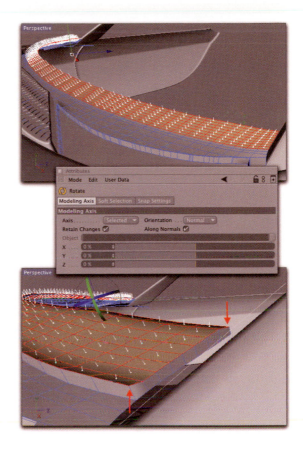

— Figure 3.106: Rotating faces.

Then subordinate the splines in the right order under a Loft NURBS object. The splines have to be created only for one-half of the windshield. The missing half can be added with a Symmetry object as long as the middle spline is placed exactly on the symmetry.

For a seal along the upper part of the windshield, we can either use a polygon strip separated from the roll bar with the Split command and extruded with the Create Caps option or change the encircling edges of the converted windshield to a spline and subordinate it along with a circular profile under a Sweep NURBS object. The result could, in any case, look like the bottom image in Figure 3.107.

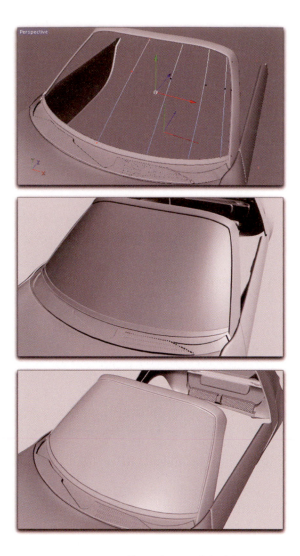

— Figure 3.107: Installing the windshield.

3.15 The Windshield Wiper

The windshield wiper contains separate segments that are connected to each other with moveable joints. This allows the wiper to follow the curvature of the windshield and to cover the largest possible area.

 We will start with a simple cube that is adjusted to the angle of the plastic cover and

placed to the right of the air slits. Model two creases into the cube so that it runs parallel to the base and then moves away a bit from the window at the upper end (see Figure 3.108). Then select all faces at the bottom and front and delete them.

— Figure 3.108: The first segment of the windshield wiper.

The remaining faces will be thickened with the EXTRUDE command and its CREATE CAPS option. The result is shown on the bottom of Figure 3.108.

Put a simple cube at the base of the wiper arm. The HYPERNURBS smoothing will turn it into a sphere that penetrates the wiper arm on top, thus serving as a pivot (see Figure 3.109).

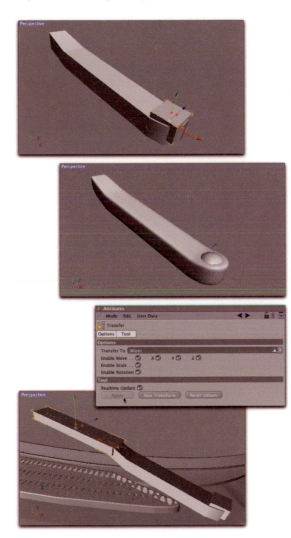

— Figure 3.109: The second segment of the wiper.

Another slim cube should now extend the arm and represent the second segment of the wiper. In order to have the same direction as

the first wiper cube we can use the TRANSFER function in the FUNCTIONS menu.

Therefore, select the new cube and use the TRANSFER function. Pull the modified cube of the first wiper segment from the OBJECT MANAGER into the TRANSFER TO field.

With the diverse options in the dialog of the TRANSFER tool, it can be determined which properties will be transferred to the selected object. We leave everything activated and apply it with the APPLY button. The new cube will then jump to the position of the first wiper segment and also takes over its direction. Now the new cube can be moved along one of its axes in the direction of the tip of the first cube.

Use of the TRANSFER command is especially helpful when the objects in the OBJECT MANAGER are not sorted in a hierarchy. In our case, we could have subordinated the new cube under the first segment and set the local position and rotation values to 0 in the COORDINATE MANAGER. The result can be seen in Figure 3.109.

Adjust the shape of the new cube to the first wiper segment so that a joint is created. A suggestion on how to model it can be seen in the series of images in Figure 3.110.

With multiple extrusions, the end of the second segment can be shaped into the small holding strip where the actual wiper will be attached.

Position a new cube across the end of the second wiper segment, as shown in Figure 3.111, and shape the rocker of the attached wiper out of this cube.

An even subdivision of the edges of this rocker allows the deletion of single faces on the top in order to achieve the characteristic look of the holes (see Figure 3.112).

Select the faces on the bottom of the wiper, extrude them a small amount inward, and then delete them. These faces are marked in red in Figure 3.112. That way, the rocker is opened up on the bottom and, at the same time, gets a massive outer edge that will help with the HYPERNURBS smoothing.

— Figure 3.111: Modeling the rocker of the wiper.

Place slim cubes at the end of the rocker and give them a slightly bent shape as seen in Figure 3.113.

Be sure that no part of the wiper will pierce the windshield. Adjust the tilt of the second wiper segment if necessary. When this element and the two cubes for the wiper blade connection are subordinated under the rocker,

— Figure 3.110: Shaping the second segment.

Again, we need a new cube that will represent the connection points for the wiper blade.

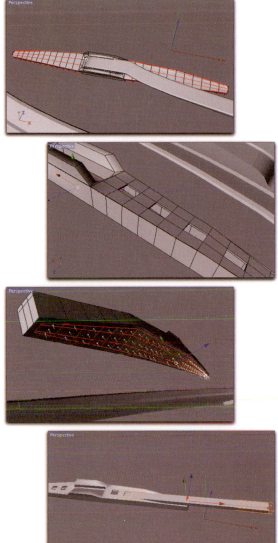

— Figure 3.112: The rocker of the wiper.

— Figure 3.113: The rocker of the wiper.

then the whole wiper can be removed from the windshield.

Finally, create a simple spline and, with activated 3D snapping, snap its points to the edges and polygons of the wiper frame.

In connection with a triangular profile, which can be created with an N-Side spline, generate the rubber lip of the wiper blade

with a Sweep NURBS. This object is indicated by an arrow and a slightly darker coloring in Figure 3.113.

Figure 3.113 also shows the duplicated second wiper, which was moved to the center of the plastic cover. There the length and tilt of the wiper might have to be adjusted so that this wiper lies snugly on the windshield.

3.16 The Door Handle and Exterior Mirror

We already created a small recess at the upper right corner of the door. There the door handle and the whole side guide for the window will be placed. Then we will model the exterior mirror.

The shape of the door handle can be defined by two splines for the outer contour and the transition to the recess under the handle.

After these splines are drawn we will create a basic disc object and place it on the plane of the template splines.

The disc should have at least two segments so that its points can be snapped to the two splines after the conversion. Figure 3.115 shows the already converted and adjusted shape of the disc. As a comparison, Figure 3.114 shows the real images of the door handle and the exterior mirror.

Because the triangle in the center of the disc will not look good when smoothed with a HYPERNURBS, we will delete these faces and add two loop cuts to the remaining faces, as shown in the uppermost image in Figure 3.116.

Pull these edge loops a bit outward to show the bulge of the object.

The inside will be closed with the CLOSE POLYGON HOLE function. We scale the resulting face in the center of the disc with the EXTRUDE INNER function in two steps and move these faces in the direction of the car interior.

In order to gain more control over the kind of closing faces in the center of the recess, we will use the FUNCTIONS > REMOVE N-GONS command and adjust these faces if necessary. If possible, only rectangular polygons of equal size should be used. The result is shown in the third image of Figure 3.116.

A new cube object will be placed across the front of the recess and reshaped into a handle. Now this area already has enough details.

Next, in edge mode, select the outer edge loop of the door handle recess and extrude it a bit toward the car interior.

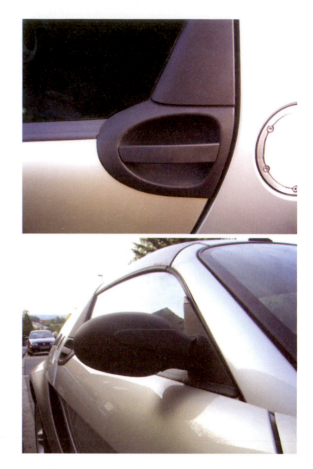

— Figure 3.114: Door handle and exterior mirror.

The door handle recess will therefore acquire a thickness and we can select and extrude the faces at the upper edge in order to model the triangular area above the handle.

Figure 3.117 shows the used selection of the edge faces and the tapered shape of the triangle after extruding them in the upper part.

In the same manner, select the faces at the side of the door handle recess and extrude them toward the front of the car, parallel to the upper edge of the door. This creates the seal between door and side window, as is shown in Figure 3.117.

The exterior mirror will be modeled from a cube (see Figure 3.118).

After we have placed the cube at the correct spot next to the door, we convert it, add

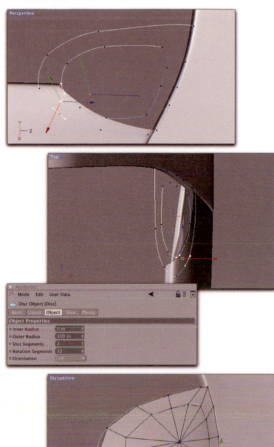

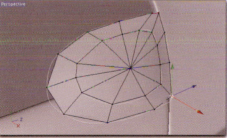

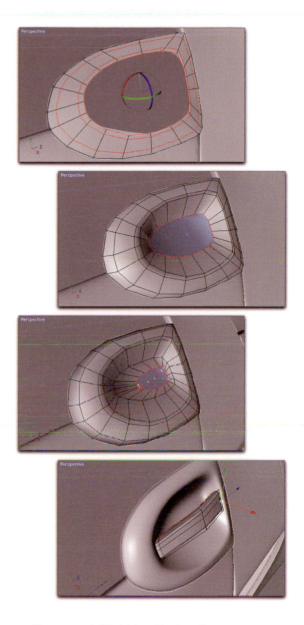

— Figure 3.115: A disc as a base object for the modeling.

new cuts, and move points to create the characteristic shape.

The actual mirror surface is created with inner and normal extrusions. Afterward, separate the faces from the object and save the selection as a POLYGON SELECTION tag for the application of materials later on.

At the side of the object extends an area toward the door. This represents the hinge of the mirror and can be seen in the upper image in Figure 3.119.

— Figure 3.116: Finishing the handle recess.

The distinctive arrow shape of the back of the exterior mirror can be created by constricting some points and then extruding them toward the outside. The corresponding faces are marked in red in the middle of Figure 3.119.

The exterior mirror itself is connected to the door with a simple triangular face.

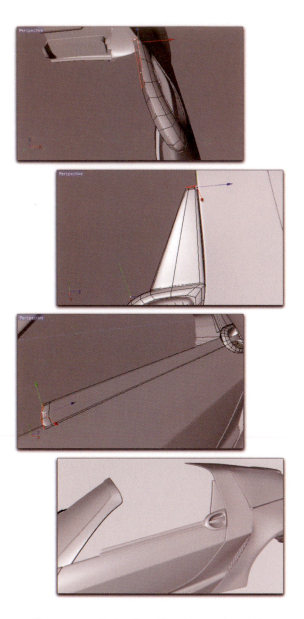

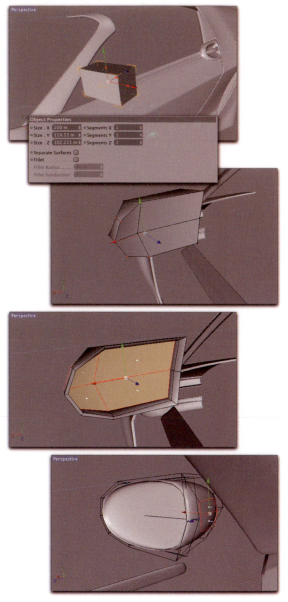

— Figure 3.117: Extruding the door seal and the upper triangle.

— Figure 3.118: Modeling the exterior mirror.

Adjust a simple flat cube to the tilt of the front roll bar above the door and create a raised area starting from the center. There, the external mirror can be attached as in Figure 3.120. A more elaborate creation would only be necessary for close-ups.

3.17 The Roof and Side Window

We will create a POLYGON SELECTION along the front roll bar above the mirror triangle. Then this selection is separated into a new object

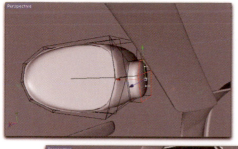

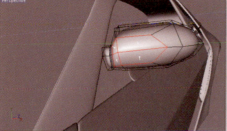

— Figure 3.119: The exterior mirror.

— Figure 3.120: The mirror triangle.

and extruded, which results in a simple seal, as shown in Figure 3.121.

Afterward we will define one part of the roof with some splines in a LOFT NURBS object. Then we will convert the LOFT NURBS object and thicken the shape by extrusion with CREATE CAPS option.

This car has two separate roof halves that can be removed to change the car into a convertible. Between these roof halves is a seal.

For its modeling we could use the first spline of a roof half subordinated together with a profile spline under a SWEEP NURBS object. Another possibility would be to separate a polygon strip from a roof half and to extrude it.

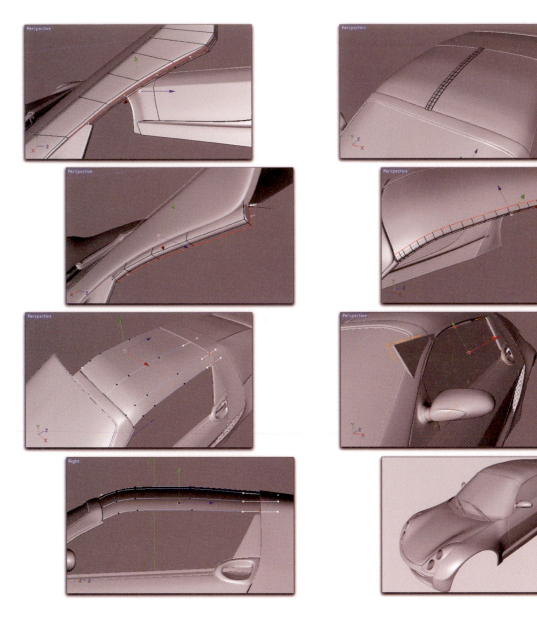

— Figure 3.121: Seal and roof.

Create another seal the same way with the edge of the roof above the side window.

Finally, use a small cube as the window and adjust it after the conversion to the available space. The result can be seen in Figure 3.122.

— Figure 3.122: Finishing the roof and side window.

3.18 The Tailgate Hinge

The tailgate is held by two complex hinges (see Figure 3.123). We will not model their shape up to the smallest detail but will rather show only the most important features.

— Figure 3.123: A hinge at the tailgate.

The best way is to start with a cube and adjust it with cuts and extrusions to the desired shape.

Place the scaled cube, as shown in Figure 3.124, at the edge of the rear roll bar and shape the converted cube to a wedge- or teardrop-shaped object. This shape would already be enough to show the hinge.

When more details are needed, then the component groups of the hinges can be separated from each other by means of extruding small polygon strips (see Figure 3.125).

The button-shaped connection element can be placed as a separate cube in a recess at the head of the hinge (see Figure 3.126).

3.19 Adding Various Small Parts

Depending on each person's own aspirations, we could spend a long time modeling various small parts, apart from the complete interior. However, because I would like to discuss other projects, I will talk only about additional parts of the car worthy of being modeled.

The grid in the mouth of the front end is still missing and can be modeled using the same method as the tail grid.

— Figure 3.124: The hinge.

The only difference here is that this grid needs to be bent in order to adjust to the shape of the bumper. The BEND deformer should be subordinated under the group of cubes shown in Figure 3.127.

A tapered cube will replace the side turn signal on the fender in the HYPERNURBS object.

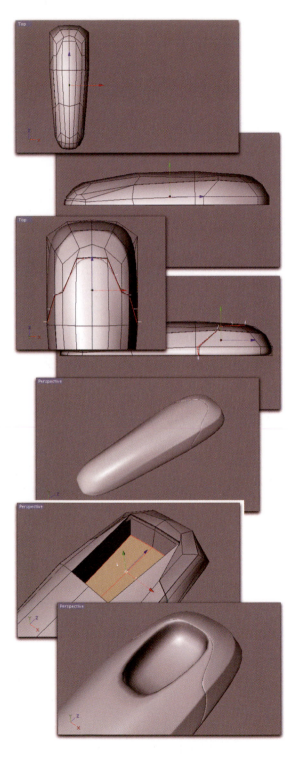

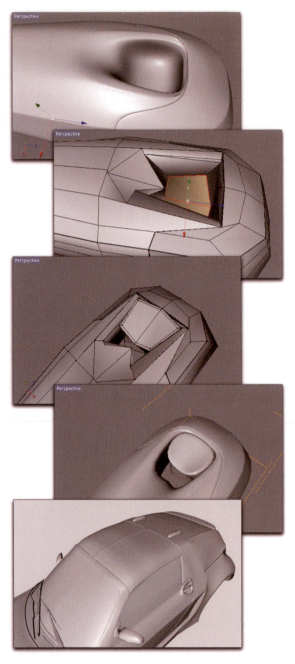

— Figure 3.126: The finished hinge.

— Figure 3.125: Details of the hinge.

The antenna can be modeled out of a slim cylinder. Its points at the bottom would have to be adjusted to the shape of the body. Then add a loop cut above the adjusted points and extrude the newly created faces at the lower

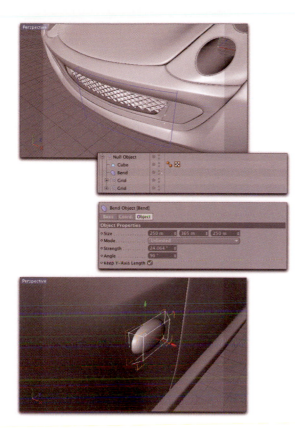

— Figure 3.127: Front grid and turn signal.

end of the cylinder outwards. This step is shown in the first two images of Figure 3.128.

Afterward the faces at the upper end of the cylinder are extruded to shape the actual antenna. The finished shape is also shown in Figure 3.128.

The gas cap is made out of a TUBE object, which has holes cut into it with a boole operation. I used spheres in an ARRAY object so that the holes automatically get a beveled edge.

Cylinders with six subdivisions at the circumference become the hexagonal screw heads, which can be placed in the recesses of the TUBE object with another ARRAY object.

A DISC object, which is placed in the middle of the TUBE object, represents the actual gas cap. A clip at the edge can be separated by adding points at the edges manually.

— Figure 3.128: The antenna.

These additional points, which form a semicircle, and the clip created by lifting the edge points at the disc can be seen in Figure 3.129.

Next, the wheel housing will need to be closed. Separate a continuous polygon strip from the fender and extrude inward an EDGE LOOP of these separated polygons.

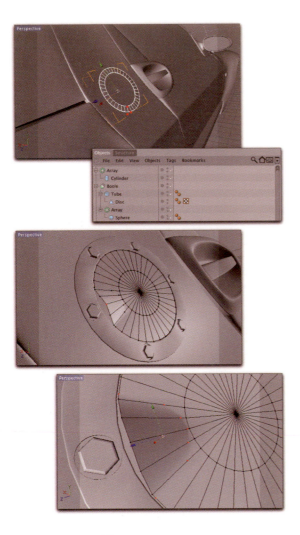

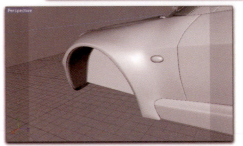

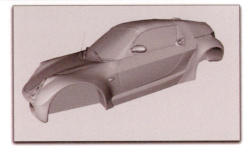

— Figure 3.129: The gas cap.

A manually created polygon borders the arched opening at the end of the wheel housing. This opening can then be closed with the CLOSE POLYGON HOLE function.

These steps are shown in Figure 3.130. It also shows that the same procedure is used for the rear wheel housing.

— Figure 3.130: Closing the wheel housing.

3.20 Tires

The tires of the car can quickly become a polygon trap, what with all the complex rim and

profile structures, and could easily use more polygons than the whole car.

Therefore, we need to find a compromise. This automatically excludes the use of displacement maps for simulating a tire profile because the whole tire would be subordinated unnecessarily high.

I start by searching the Internet for a useful image of a profile. These kinds of images can be found, for example, directly at a few tire manufacturer's websites (see Figure 3.131).

In a graphics program, I convert the image to a black and white one with high contrast and load it into a VECTORIZER object, which is found at the spline objects.

The TOLERANCE value of the VECTORIZER object determines the maximum deviation of the created spline from the contours of the loaded image template. We will use a value of 0 for the most accurate result.

The WIDTH value determines the scale of the calculated spline. The VECTORIZER object could also be converted and the resulting spline could then be scaled manually.

Basically, the VECTORIZER spline could be subordinated directly under a NURBS object like a regular spline. However, I want to use the calculated spline only as a base for the simplified modeling of the profile.

The loaded profile image already portrays a segment of the tire profile that can be tiled. Therefore, we can place multiple copies of the VECTORIZER object on top of each other to get a better idea of the structure of the profile. One copy of the VECTORIZER object is enough, as shown in Figure 3.131.

Create an empty POLYGON object from the OBJECTS menu and fill it with simple polygons to cover the most important shapes of the tire profile.

Copy the created POLYGON object and move the copy so that the desired distance between the profile segments is shown.

Then combine both profile segments to a new object and create the missing polygons to close the gaps between the segments. The result is shown on the bottom of Figure 3.132.

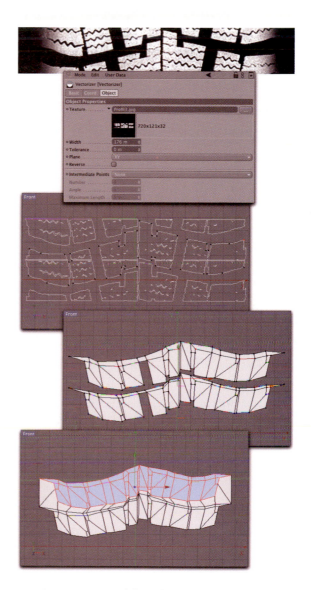

— Figure 3.131: Modeling the tire profile.

After this, delete the duplicate faces of the object. This leaves us with a segment of the tire profile that can be put next to each other multiple times (see upper image of Figure 3.132).

Use the BEVEL and EXTRUDE command to create the raised profile areas out of the segment. Then find out how high the segment exactly is. This can be done by selecting the highest and lowest points and then finding the distance between these points in the COORDINATE MANAGER.

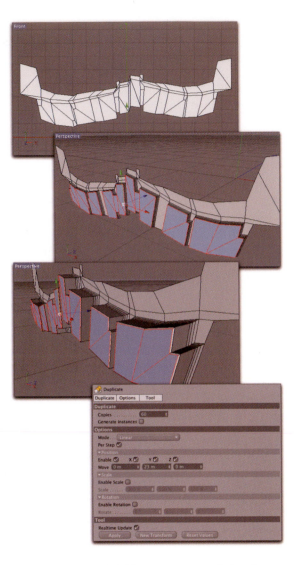

— Figure 3.132: Finishing a segment of the tire.

The resulting value can be entered into the DUPLICATE dialog to determine the movement along the height. The number of copies can be set to 60 for now, while real copies and not instances have to be created.

The result is a long profile strip that looks like a tire track. Check if the edges of the profile segments are placed exactly next to each other. If not, then the MOVE vector has to be checked in the DUPLICATE dialog.

We will use the CONNECT object in the OB-JECTS>MODELING menu so that the separate profile segments can later be merged into one continuous object.

This object works like the OPTIMIZE command. The TOLERANCE value determines the area around each point where elements merge when the WELD option is activated.

This is an advantage, especially when the objects grouped under the CONNECT object are going to be smoothed as well by a HYPERNURBS object. The result is a connected surface.

Subordinate the NULL object group with the copies of the profile segments under the CON-NECT object, as shown in Figure 3.133. Also pull the original profile segment under the NULL object so that it can be connected and optimized.

Set the PHONG mode of the CONNECT object to MANUAL. This way, we can assign a PHONG tag to the CONNECT object later and influence the surface shading ourselves.

Now the profile strip needs only to be bent into a ring. This is not a problem for the already familiar BEND object.

Open a new BEND deformer and subordinate it under the null object along with the copies of the profile segments. Adjust the position and height of the BEND object so that the upper and lower borders of the BEND cube are placed as exactly as possible on the points of the profile strip. The points should meet after being bent. These places are marked with arrows in Figure 3.133.

When the BEND object is set to a strength of 360° in the right direction, then the upper and lower edges of the profile strip should fit exactly on top of each other and become merged by the CONNECT object.

When this does not work at the first try, zoom in to the area where the ends meet. Change the height of the BEND object in small steps until the edges are close enough to each other to be merged by the CONNECT object.

Now the most difficult part of the job is done and we can concentrate on the outward bend and the walls of the tire.

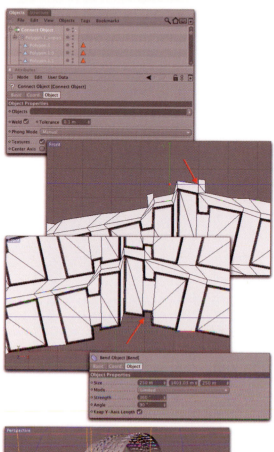

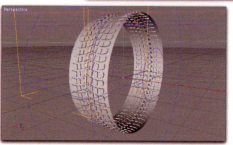

— Figure 3.133: Bending the tire profile.

Deactivate the BEND object with a click on the checkmark in the OBJECT MANAGER and create two new BEND objects, which will be placed in the group of profile copies.

It is important that the two BEND objects appear first in the order of the group because these bends have to be calculated before others.

As shown in Figure 3.134, deformers are used to bend the sides of the tire. In order to

not pull the profile too far around the corner, we can select the sides of the profile parts that stick out and scale them down a bit.

Use the MODELING AXIS and move them to the position of the profile faces that are not raised. That way, it can be comfortably scaled along the Z direction, as shown in Figure 3.134.

After this, activate the third deformer again to see the complete tire.

Select the CONNECT object and convert it when you like the resulting shape. We now have one polygon object that contains the optimized structure of the whole tire.

With a loop selection of the edges at the side openings of the tire, make two edge extrusions to further round the hull of the tire along the walls and to bend the tire in the direction of the rim that still needs to be modeled. This is shown on the bottom of Figure 3.134.

3.21 The Rim

For the rim we need a basic OIL TANK object as the hub and two slim cubes, which will be placed as shown in Figure 3.135.

When you like the shape of the cubes, then combine them into one object and create two additional copies.

These copies will be rotated 120° and placed so that a three-pointed star-shaped rim is created (see Figure 3.135).

Group the two connected cubes under the OIL TANK so that the placement of the cube spokes is exact. Then create two copies of the OIL TANK group and turn these in the COORDINATE MANAGER, always by 120°.

Now these three rotated CUBE objects can be combined into a new POLYGON object and the two additional OIL TANK objects can be deleted again.

Delete all faces in the converted OIL TANK object that are not located directly under the end of the cubes. What's left is a slightly funnel-

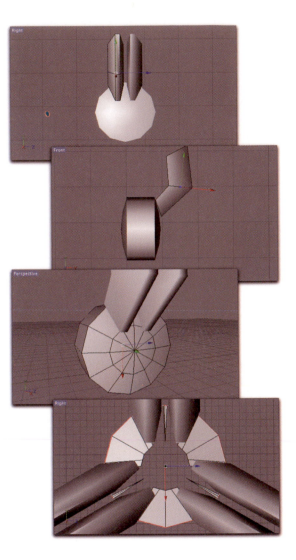

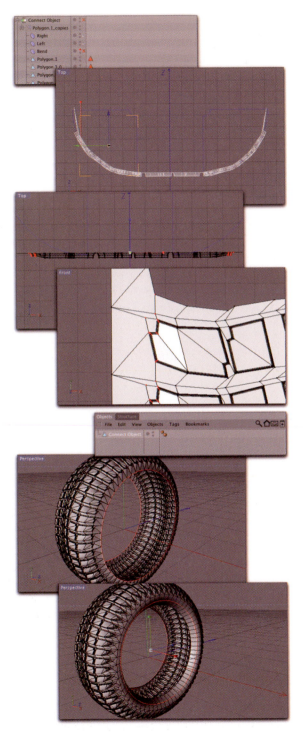

— Figure 3.134: Finishing the tire.

— Figure 3.135: The inner rim.

shaped ring surface, as shown on the bottom in Figure 3.135.

Add edges with the KNIFE tool in SINGLE LINE mode at the remaining OIL TANK faces where the cube spokes should connect later on. Place the cuts as exactly as possible along the contours of the CUBE objects.

The goal is that polygons with the exact same shape are placed where the cube meets the OIL TANK faces. When the faces at the OIL TANK are deleted, it will then look as shown in Figure 3.136.

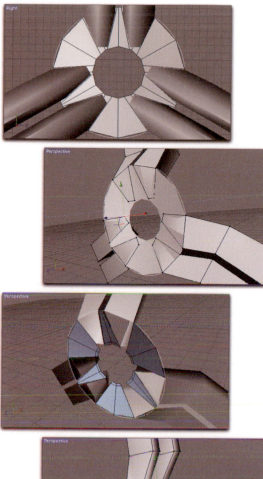

— Figure 3.136: The rim star.

For easier orientation, the faces of the former OIL TANK object were colored in blue. The openings created by deleting the faces are clearly visible. The cube spokes fit exactly into these holes.

Now all objects of the rim can be combined into one new object, and with the STITCH AND SEW function, the points of the spokes can be snapped to their corresponding locations on the OIL TANK faces. The result can be seen on the bottom of Figure 3.136.

The outer edge of the rim will be edited similarly. We will use a basic DISC object, convert it, and add fitting cuts parallel to the spoke ends (see Figure 3.137).

In order to place the points, which were created by the cuts, exactly on the radius of the DISC later on, select the two edge loops at the outer and inner openings of the disc. Create two curves with STRUCTURE > EDIT SPLINE > EDGE TO SPLINE before adding the cuts.

Switch the interpolation of these splines to CUBIC. Then the points can be snapped onto the circular splines with 3D snapping.

Add an additional subdivision in the outer area of the DISC and pull it slightly to the front of the rim. This creates the typical beading at the transition between rim and tire as shown in the first two images of Figure 3.138.

Then connect the ends of the spokes with the corresponding openings at the outer ring of the rim. For this reason, the spoke cubes need to be open at the end. This procedure is the same as the connection of the spoke cubes with the hub of the rim.

Now it is time to match the size and position of rim and tire so that we have a unit. This is shown in the third image of Figure 3.138.

In order to avoid being able to see the inside of the tire when looking through the spokes, we have to give the rim some depth. Therefore, select the open edges between the spokes of the rim and extrude them in the direction of the symmetry axis of the car. The result is shown on the bottom of Figure 3.138.

Gaps behind the spokes have to be closed manually, as shown on top of Figure 3.139. This will create a continuous drum.

In order to attach the rim to the axle, we will need to add bolts and the necessary holes for them.

Create an ARRAY object and subordinate a circle under it. Align the ARRAY object in a way that the circles are parallel to the hub of the rim. We need three mounting bolts and there-

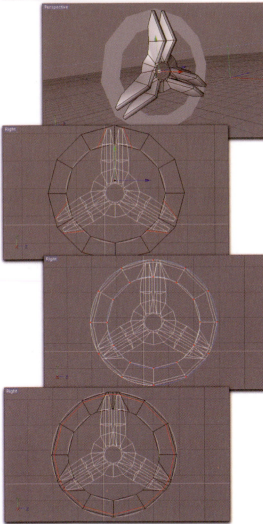

— Figure 3.137: The outer rim.

fore have to create only three circles with the
ARRAY object.

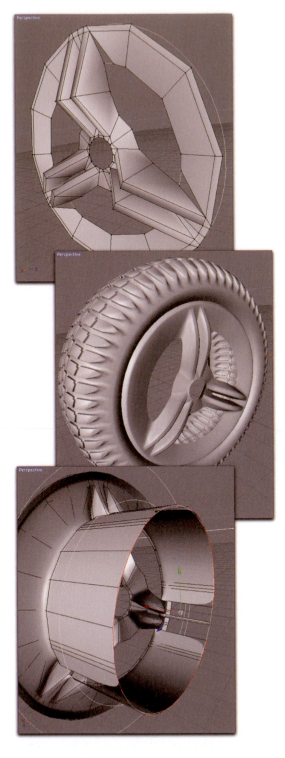

— Figure 3.138: Creating depth at the rim.

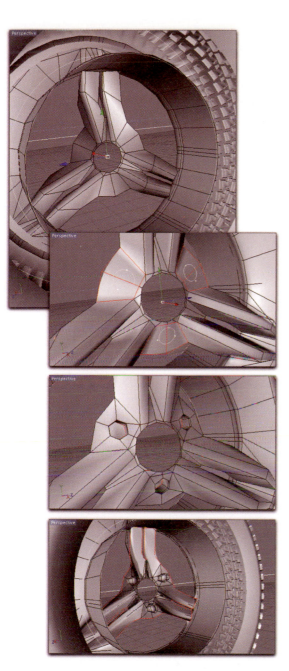

— Figure 3.139: Adding holes.

Duplicate the ARRAY object and convert the copy. Normal splines will be created, which we will now project onto the surface of the hub.

Activate the editor viewport where the hub and circles can be seen from the front and se-lect all three circle splines that were created by converting the ARRAY object.

Select the EDIT SPLINES>PROJECT in the STRUCTURE menu and set the MODE to VIEW in its dialog in the ATTRIBUTE MANAGER. This will project the selected splines along the line of sight onto the next object behind the spline. The result can be seen in the second image of Figure 3.139.

Now the selected faces shown in Figure 3.139 can be extruded together toward the in-side and the newly created points can be snapped to the three splines.

All polygons that lie within the circles will then be extruded toward the inside of the rim to create the holes.

Subordinate basic cylinder objects under the still existing ARRAY object and set their number of circumference segments to 6. This is enough to show the bolt heads.

The ARRAY object has to be moved far enough into the rim so that the cylindrical bolts can be placed in the holes of the rim.

Close the center of the hub with the CLOSE POLYGON HOLE function and extrude the open edges of the hub and spokes just a bit. This will give more volume to these parts, as shown in Figure 3.140. There, the bolts can be seen in-side the holes in the center.

Now all the parts of the wheel have to be grouped together in a NULL object and copies placed inside the wheel housings.

At the rear axle of the car, the wheels can be mirrored to the other side with a SYMME-TRY object. This does not work with the front axle, as the wheels will eventually be rotated as if the driver were turning the steering wheel. Thus we need two independent copies of the wheel.

This concludes the modeling of the car. We could certainly build more details and finish the interior of the car.

You should by now know the process enough to finish these parts yourself, and you have probably realized how quickly complex geometry can be created from simple, basic shapes. For example, the steering wheel could

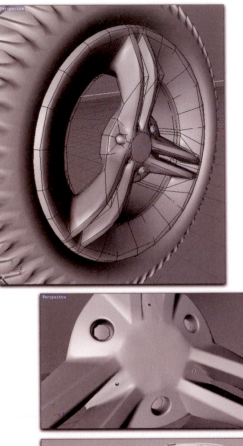

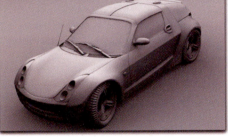

— Figure 3.140: Finishing the rim and the whole car.

be easily made out of a basic TORUS object or the seats out of a cube and placed in a HYPER-NURBS object.

In my opinion though, the car is ready to be displayed as a look at Figure 3.141 proves. I added a FLOOR object from the OBJECTS > SCENE menu to simulate the floor.

An AREA light with AREA shadows and a dome shape light the scene. The car would look even better with the appropriate finishes. Let us take a short look at this subject.

3.22 Materials for the Car

We will need only a handful of materials for the car. The main goal is to simulate the high gloss finish.

The properties of this paint are the display of clear and high-contrast colors and strong reflections. The reflective aspect of the paint can especially be used as the base for the material itself. Objects that will be reflected in the paint have to be added to the scene as well.

I have chosen a bicolor paint job with different beige tones. As is common with these flip-flop paints, the color changes depending on the curvature of the surface. This effect can be simulated easily with the FRESNEL shader.

Create a new material and load the FRESNEL shader into the COLOR channel. The right edge of the FRESNEL gradient represents the color that will be visible when the viewing angle is extremely flat.

The color value of the left edge of the gradient will be applied to all surfaces that are perpendicular to the line of sight.

I used a gradient from dark orange to a warm yellow tone, as shown in Figure 3.142. I also used the FRESNEL shader in the REFLECTION channel so that the intensity will be reduced depending on the severity of the curvature of the surface.

This is not really correct physically, but it will create a soft fading of the reflections on the body.

By multiplying the brightness in the RE-FLECTION channel, the intensity of the reflections can be controlled without having to change the settings in the FRESNEL shader.

Apply this material to all objects that have to be painted.

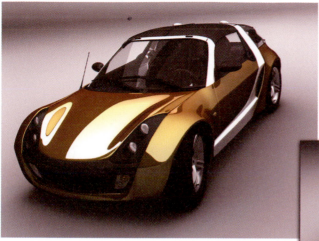

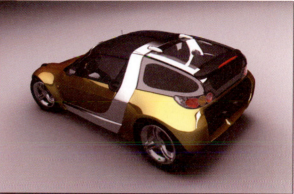

— Figure 3.141: The finished car with textures.

Another difficult material to create is the one used for the rims or other reflective metal surfaces such as chromed parts.

We will try a combination of distorted highlights and reflective properties.

Create a new material and reduce the brightness in the COLOR channel to 10%. Many metals generally have a small surface brightness. Exceptions are colored metals such as gold or copper, where the color value can be set higher. We should mainly work with the reflective properties and the highlights.

We therefore use the LUMAS shader, in the LUMINANCE channel of the material, to gain more control over the size and shape of the highlights.

Deactivate the ACTIVE option in the SHADER PROPERTIES of the LUMAS shader because we do not want to create additional surface shading.

We will use only SPECULAR 1 and SPECULAR 2 to create a diffuse light, with an intense highlight in the center. The reason for using the LUMAS shader is the ability to calculate anisotropic highlight distortions. Therefore, acti-

vate the ANISOTROPY with SHRINK WRAP PROJECTION.

The direction of the projection of the anisotropy has to be checked with test renderings. However, we should wait until the light sources are set within the scene.

We will need reflective properties as the third component of this material.

Also, I would like to use the FRESNEL shader, but this time with a reversed gradient. As a result, surfaces that are bent farther away from the viewer have a stronger reflection than surfaces placed perpendicular to the line of sight.

I will set the brightness of the gradient to 50% so that it's possible to see reflections on the front surfaces, too. All these settings can be seen in Figure 3.143.

Nonreflective Surfaces

There are also many finishes on the car that are made of materials without reflective prop-

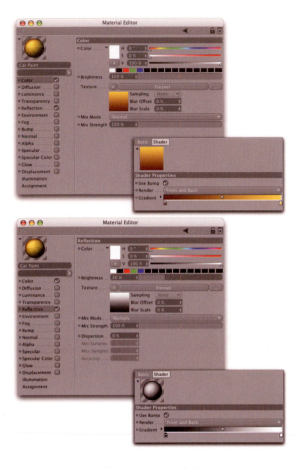

— Figure 3.142: The material of the coated surfaces.

erties. These are, for example, the roof of the car, the engine cover, and the bumper in front.

I will still apply reflective properties to these materials, which might seem strange at the beginning.

By dispersion of the reflections though, these reflections will be blurred so much that they look more like light effects on the surface. This creates a more harmonious image overall, especially when light objects are placed around the car in order to create reflections on the car.

In a photo studio, real light sources would do this job and therefore also light the matte parts of the car.

The washed-out reflections help simulate this effect. The only disadvantage is the sometimes drastically increased render time for this material effect. This effect should not be used when working on a slower computer.

Figure 3.144 shows an example of how the settings for the black plastic material should look.

The NOISE shader in the BUMP channel will let the material look rough, thereby creating a nice contrast to the painted surfaces.

Using Individually Shaped Faces in Materials

It does not happen often, but it can cause problems in some situations. I am referring to the restriction of materials to clearly separated areas.

We already learned about the ability to restrict materials to POLYGON selections. What happens, though, when the polygon structure of an object has a direction that is different from the area to be textured?

Normally we cannot avoid having to create ALPHA maps. However, there is a more attractive option: using the SPLINE shader.

For its function we need a spline curve in our scene that surrounds the area of the object. This spline should already exist in your scene. This refers to the curve in the rear side windows that separates the dark frame from the clear glass part (see Figure 3.145).

Load the SPLINE shader into the COLOR channel of a new material. This shader can be found in the EFFECTS group.

Pull the restricting spline of the rear side window from the OBJECT MANAGER into the SPLINE field of the shader.

Now the difficult part begins because we have to properly set the OFFSET and SCALE values so that the spline is completely visible in the preview of the SPLINE shader. Figure 3.146 shows the desired result.

Be sure to set the PLANE setting in the shader to the same plane as where the spline

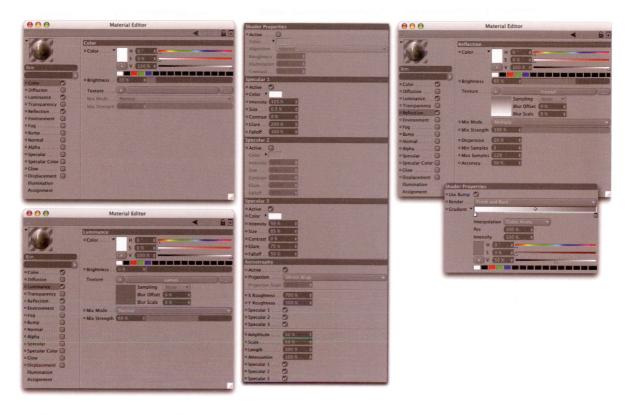

— Figure 3.143: Settings for the material of the rims.

curve is placed in the local axis system of the spline object.

Our spline is not 100% in one plane, but the setting XY for PLANE is precise enough.

Not only is a contour line created, the width of which can be controlled with the WIDTH value, but the FILL option has to be activated as well. This option fills the spline with a color that can be set in LINE TEXTURE. A simple COLOR shader with the color set to white is sufficient.

The standard black background of the COLOR shader is already the one we need and thus does not have to be changed.

A copy of this SPLINE shader is also used in the TRANSPARENCY channel, as shown in Figure 3.147. As a result, only areas contained by the spline will be calculated as transparent.

The REFLECTION channel is supposed to work exactly the opposite way. I want only the dark area of the window to be reflective.

For that reason, using COPY/PASTE, load another copy of the SPLINE shader from the COLOR or TRANSPARENCY channel into the REFLECTION channel. Set the COLOR shader in the LINE TEXTURE entry of the SPLINE shader to black.

Load another COLOR shader into the BACKGROUND TEXTURE entry and set it to white. This will invert the result of the SPLINE shader. The changes of this shader can be seen in Figure 3.147.

It is common with this kind of tinted car window that they are made with a coating on the inside of the glass.

Because we modeled the window to be double-walled, we can apply a transparent material to the entire object, as shown in Figure 3.148, and let the material affect only the inside of the window using the SPLINE shader. Consequently, save a selection of the inside of the window as shown in Figure 3.148.

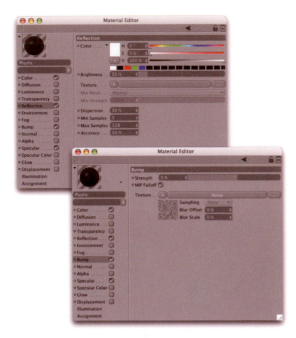

— Figure 3.144: The properties of matte surfaces.

— Figure 3.145: Toned area of the rear side windows.

Assign the SPLINE shader material to the side window with a FLAT projection. Adjust the position and size of the texture projection in TEXTURE AXIS mode to the object. This is shown in Figure 3.149.

Now the saved polygon selection only needs to be entered in the TEXTURE tag. Be sure that the SPLINE shader material is placed to the right of the window material in the OBJECT

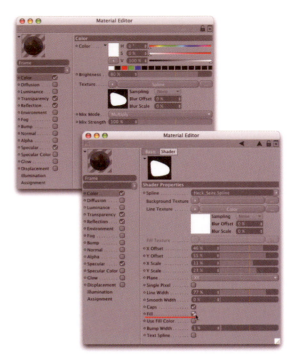

— Figure 3.146: Settings of the spline shader.

MANAGER. This ensures that the tint of the window is not overwritten by the transparency of the window material.

Headlights

In order to make the headlights look more interesting, I would like to apply a glowing material to them, as if they were turned on.

This effect is achieved mainly by intense brightness in the COLOR and LUMINANCE channels along with similarly strong transparency, as shown in Figure 3.150.

This material will be applied to two very flat OIL TANK objects. These I placed as glass lenses into the front shafts of the headlights.

In order to reproduce the complex shape of the reflectors on the inside of the headlights, we will place reflective rings behind the lenses. They could be shaped out of DISC objects with an inner radius.

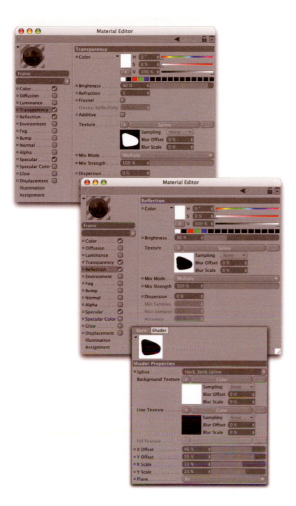

— Figure 3.147: Additional material settings.

— Figure 3.148: The window material.

The desired effect has already been achieved with the glowing properties of the lenses, as their brightness is reflected in the plastic parts. This will look like there is actual light coming from the headlights, as shown in Figure 3.151.

We can increase the effect by adding a real light source to the front of the headlight.

This should be it for the most important materials of the car. Now we will take a look at the possible placement of the light sources.

3.23 The Lighting of the Car

The lighting of the car should resemble, in this first example, the typical studio atmosphere. As a result, we will have hardly any scattered lighting.

Just like the studio setup in the last chapter, I would like to use area light for the whole scene in order to create basic lighting and diffuse shading on the floor.

Create a new area light and set the shape on the DETAILS page of the dialog to HEMISPHERE. This saves us the application of real polygon geometry. This light source should also cast an area shadow.

Set the radius of the light source large enough for our model and place it slightly above the floor. Figure 3.152 shows the posi-

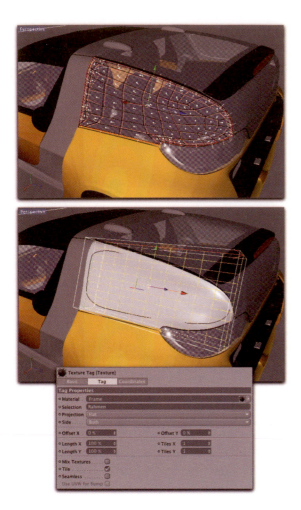

— Figure 3.149: Applying a material.

— Figure 3.150: The material of the headlights.

tion marked with the number 1 and the settings of this light source.

The light source marked number 2 is also an area light, but this time it is shaped like a rectangle.

I would like to use this light mainly for creating distinctive reflections on the car's finish and therefore activate the SHOW IN REFLECTION option with a multiplier of 200% at the DETAILS page of the dialog.

The light is placed as a long stripe at the side, above the car.

Another rectangular area light is located on the other side of the car. The brightness of this light is reduced to 50%, but because the SHOW

— Figure 3.151: The headlights.

IN REFLECTION option is set to a high multiplier of 1000%, this light source also creates strong reflections.

In addition, this light source also calculates an area shadow. The settings and position of this light source are also shown in Figure 3.152

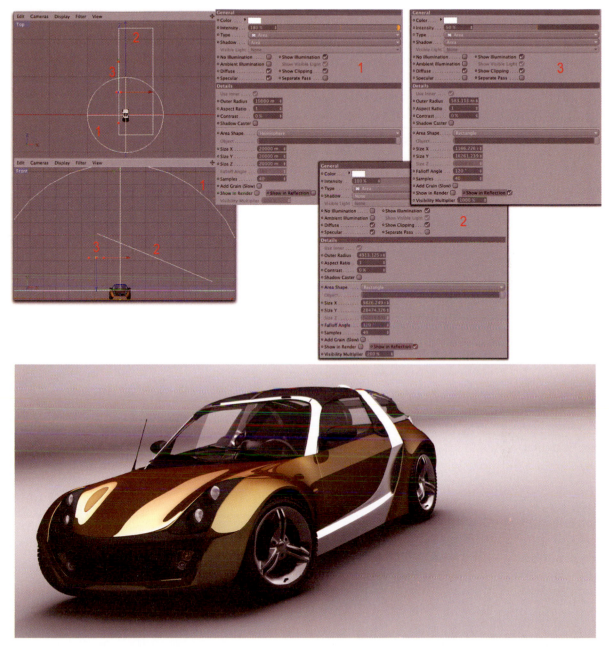

— Figure 3.152: The lighting of the model.

at number 3. There too you can see the car rendered under these light conditions.

The shadow under the car is amplified by the AMBIENT OCCLUSION shader in the material of the floor.

The place and strength of the two rectangular area lights depend on your line of sight of the car. The path of the reflections on the car paint cannot be predicted easily and therefore should be checked with test renderings.

The same scene would look totally different under the sky. For this reason, we will try to simulate this sort of lighting and learn more about the sky object and lighting with global illumination.

3.24 Creating Virtual Surroundings

In almost all cases, when objects are to be shown outside, a sky panorama is needed. Of course there are several sources for fitting image textures, but it can take time to find the right sky for our purpose.

Therefore, it is worthwhile to become familiar with the SKY module of CINEMA 4D, which is part of the ADVANCED RENDERER module.

A SKY object can be created in the OB-JECTS > SKY > CREATE SKY menu. A double click on the SKY object in the OBJECT MANAGER opens the SKY MANAGER, which controls the look of the sky (see Figure 3.153).

— Figure 3.153: The dialog of the Sky object.

Depending on how much control over the sky is needed, activate the SIMPLE, INTERMEDI-ATE, or ADVANCED mode in the OBJECT page of the SKY MANAGER.

In the SIMPLE setting, only the date, time, and place from where the sky can be seen are entered (see Figure 3.153).

The sun will move realistically over the sky, corresponding to the time set. It will even disappear over the horizon when a later time is set. Then, the starry night sky will appear.

With the CONTENT MANAGER an assortment of sky and weather presets can be used. When a sky is needed quickly for a scene, this becomes especially useful.

There are several sunrises and sunsets, as well as thunderstorm clouds, clear skies, and surreal panoramas that could come from other planets.

Because the setup of your own sky provides the most fun and the most control, we will now create our individual sky ourselves and, in a later step, combine it with our car.

This generated sky will not only be a background image but is also able to light our scene. Remember, the sun of the SKY object is an actual light source.

Let us start with a new scene and create a SKY object. Switch its mode to ADVANCED so that we have access to all settings (see Figure 3.154).

Our job will be to create an atmospheric sunset. Our first setting should determine the right time, when the sun is barely visible above the horizon.

We will use the settings on the DATE AND TIME page of the dialog and choose an appropriate time. When the UPDATE EDITOR option at the OBJECT page is activated, then we can see every change in the sky. In addition, the preview in the SKY MANAGER is also seen directly in the editor.

Rotate the view in the editor so that the sun and its movement can be seen when the time is changed.

Note that the position of the sun not only depends on the time but the season and the

— Figure 3.154: Settings of the sky object.

chosen place on earth. When we follow the display in the editor, nothing should go wrong.

After the right spot for the sun is found, we will continue with the composition of the atmosphere. It determines the scattering of sunlight in the air and the influence it has on the color of the whole sky.

By fine-tuning these values, any kind of atmosphere can be simulated, regardless of whether the place is on earth or on a fictitious planet. This effect is controlled mainly by the values for Turbidity and Atmosphere Strength.

Atmosphere Strength controls the transparency or density of the atmosphere. The

stars can be seen during the day when these values are too small.

The Turbidity value controls the water content in the atmosphere and influences therefore the scattering of light. High values create an increased scattering and let the sky appear bright even if, for example, the sun has already disappeared behind the horizon.

Figure 3.155 shows some examples. The uppermost image shows our sky without Turbidity but with 100% Atmosphere Strength.

In the image in the middle of Figure 3.155 the Turbidity is raised to 100%. The sunlight is scattered more and thus loses its intensity quickly and the stars appear.

The bottom image in Figure 3.155 uses a combination of 20% for Turbidity and 40% for Atmosphere Strength. This could be used for our atmospheric sunset.

In order to set the colors of the sky individually, we must activate the Custom Horizon option in the General settings and use the Color gradient to create the desired color gradation from the horizon (the left edge of the gradient) up to the zenith of the sky (this is represented on the right side of the gradient).

I set the gradient going from red, over yellow and blue, and up to black, as shown in Figure 3.154.

The Max Altitude value determines how the gradient will be applied to the sky. The first part of the color gradient will be applied to the angle range set in the Max Altitude value and the rest of the gradient will be stretched up to the zenith.

The Horizon Start value lets us move the horizon in the sky upward and downward. This makes sense when the floor does not correspond with the height of the horizon.

I lowered the horizon, as shown in Figure 3.154, so that it does not appear as a disturbingly colored line.

Of course, you can play around on your own and set the color scheme and placement of the sun to your own liking.

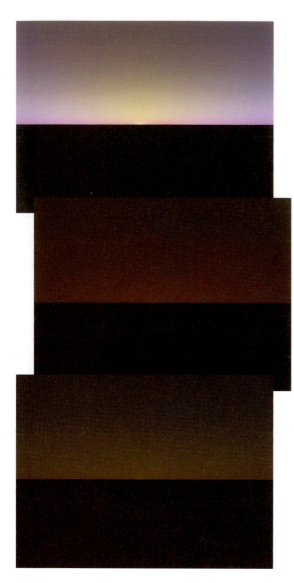

— Figure 3.155: Setting examples.

With the instant update of the display in the preview and the editor, the Sky Manager can be used intuitively and invites us to experiment.

Creating Clouds

The Sky object offers two ways of creating clouds. Clouds can be created with pattern generators in different layers or volumetric clouds can be painted directly into the sky. We will work with the automatically generated clouds, as they can be calculated faster later on.

Several noise types are offered for the cloud pattern we already partly used when we talked about shaders.

It is amazing how widespread these noise patterns can be used. With the right scaling, these artificial structures actually look like familiar cloud formations.

We should do this step by step, as we have up to six layers at our disposal and do not want to lose the overview. For that reason, deactivate first the visibility of all cloud layers with a click on the eye symbol in front of each cloud layer.

We will start with the creation of clouds in Layer 1 and need to activate the eye symbol again. As a Noise, I will use the Naki pattern and dark blue as color.

The Density and Coverage values control the contrast and density of the cloud cover.

Thickness controls the interaction of the clouds with light. Large values result in dense clouds that are less influenced by light. The Transparency value refers to the calculation of the shadow of clouds when the sun is behind a cloud. Higher Transparency values make the shadow disappear entirely.

With the Height value we determine how high the cloud is placed above the floor and scale the noise pattern with the Scale N-S and Scale W-E values.

The Pos N-S and W-E values can be used to move clouds across the sky, such as during an animation.

My settings for Layer 1 can be seen in Figure 3.156. The red arrow indicates how the settings of one layer can be transferred to another as a result of pulling the preview image of one layer to the other one. All settings will be copied automatically.

I reduced the height of the second cloud layer to place it slightly under the first cloud cover.

I set the color in Layer 2 more toward rust red and cut the Thickness value in half. This

— Figure 3.156: The upper two cloud layers.

— Figure 3.157: Additional cloud layers.

strengthens the interaction of these clouds with the sunlight.

By reducing the SCALE N-S value, the cloud layer will be shifted. This will add some variation to the clouds without having to use a different NOISE.

Figure 3.156 shows the change of the clouds in a rendered image. There we can see how layered cloud covers can simulate real volumetric clouds.

Layers 3 and 4 will be edited using the same principle (see Figure 3.157).

I reduced the height of the clouds step by step and increased the intensity of the red color with every layer. At the same time, I varied the position and size of the clouds a bit. The goal is to achieve the intense red on the bottom and blue on top of the clouds as in a typical sunset.

So far we have used the same NOISE pattern and stacked the same clouds on top of each other.

The following steps will take the remaining two cloud layers to activate another type of NOISE and to add completely different clouds.

We will decide on the NOISE ELECTRIC in dark blue colors and compress this NOISE in a north–south direction. Because the height of these clouds is far below the rest of the clouds, they will cover parts of the first cloud layers. This can be seen in the lowest image in Figure 3.157.

The lowest cloud layer uses the same settings, but is not distorted, so the size will be 100% in all directions. These settings and the final result are shown in Figure 3.158.

— Figure 3.158: The last cloud layer.

3.25 Baking Textures

We could load our car directly into this scene and light it accordingly. I would like to introduce an alternative way of baking a texture.

This is the calculation of properties of materials and saving them as an image. That way, different material properties, such as surface shading and reflections, can be calculated.

The advantage is that the calculated images can be loaded, for example, into the LUMINANCE channel and applied to the same object again.

In this way, calculation-intense properties of a surface can be loaded as a simple image, which can speed up the rendering of the object tremendously later on. This often only makes sense for animations, when many images of an object have to be rendered.

In our case, in order to bake the whole image, we will need an object that will interact with the sky. We will create a simple basic sphere object and apply a material that has reflective properties only.

The surface of the sphere will then show a perfect copy of the entire sky, as it will be reflected on the sphere.

Select the sphere and its TEXTURE tag in the OBJECT MANAGER and select BAKE TEXTURE… in the RENDER menu. A BAKE TEXTURE… tag appears whose many settings can be edited in the ATTRIBUTE MANAGER.

First look for the settings to be used for rendering the image of the material in the OPTIONS column.

In our case we are only interested in the reflection of the sphere surface. Therefore activate only the REFLECTION option.

In the tag column dialog we will determine how large the rendered image will be. The size of the image is determined with the WIDTH and HEIGHT values.

Then the format of the image has to be set. In addition to choosing between the standard formats, there are also some exotic ones to choose from, such as RADIANCE (HDR). This image format is able to save images with indefinitely high bit depth and is therefore the first choice when we want a lossless display of lighting situations.

This kind of *High Dynamic Range*, or HDR, images is perfect for the creation of reflections or the lighting of scenes. For this reason, there are multiple vendors for these kinds of images.

In the best-case scenario, we can achieve results as if the rendered 3D object was actually at the place where the photo was taken. Different images of the same subject are taken with different light settings and put together, for example, in Photoshop, to an HDR image.

We have it easier with the creation of such images because CINEMA 4D automatically calculates internally with a high bit depth and can therefore save every rendered image also as an HDR image. Just choose the RADIANCE format as the format in which to save in the RENDER SETTINGS.

The only disadvantage is that not all graphics programs can utilize this high bit depth. This format is therefore of limited use for continuous editing or compositing. This should not bother us though, as we will use this image only within CINEMA 4D.

The reflection of the sphere can be started with a click on the BAKE button. This is done after an appropriate path is set to save the image in the tag settings of the BAKE TEXTURE tag (see Figure 3.159).

A small preview window shows the actual rendering process of the image. The image will be at the determined path as soon as the rendering is complete.

You can take a look at the saved image if you have the latest version of Photoshop.

First, the image looks like a normal 24-bit image with a color depth of 8 bit. The advantage of this image is shown when, for example, the EXPOSURE tool is used in Photoshop to change the gamma curve or to change the brightness of the image.

Even extreme brightness or contrast changes do not affect the image much, as shown in Figure 3.160. The brightness and all colors stay balanced to each other.

Figure 3.160 shows the upper half of the original HDR image as it was taken from our reflective sphere. Underneath is the same image with the exposure settings that were changed in Photoshop.

— Figure 3.159: The Bake Texture tag.

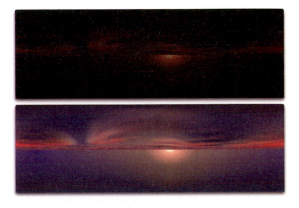

— Figure 3.160: Manipulating HDR images.

3.26 Lighting with Images

The fascinating fact of these HDR images is that they can produce an exact copy of the actual lighting situation.

The sun in the HDR image has, for example, not only a brightness of 100%, but maybe 1000% and would be in proper relation to the brightness of the sky.

This abundance of information can be used in CINEMA 4D to directly create light and thus to light the scene.

Let us get back to the scene with our car. Create a new material and load the HDR image of the sky into the COLOR channel.

In order to get more control over the brightness and contrast of the image, open the FILTER shader in the shader list of the COLOR channel. This does not delete the loaded HDR image but loads it automatically into the FILTER shader.

The FILTER shader allows us to control, for example, the gamma value of the image individually (see Figure 3.161).

— Figure 3.161: Material of the visible sky.

Now we will want to use this material as a background or visible surrounding for our car. Create a basic sphere object big enough to enclose the car and the floor. Assign the material with the sky panorama to this sphere.

In addition, apply a COMPOSITING tag to the sphere. The tag can be found after a right click on the sphere in the OBJECT MANAGER in the category CINEMA 4D TAGS.

Deactivate the options CAST and RECEIVE SHADOWS and SEEN BY GI because we will light the scene later with GLOBAL ILLUMINATION and normal light sources. The shortcut GI stands for global illumination (see Figure 3.162).

— Figure 3.162: Compositing settings of the sphere.

The deactivated SEEN BY GI prevents the material of the sphere from radiating GI light or prevents the sphere from casting GI shadows. You have to know that at the GLOBAL ILLUMINATION calculation of scenes (for which the ADVANCED RENDERER module is needed), in addition to normal light sources, materials can

also radiate light. That way the luminous property of a surface, for example, can be used to light all objects in the near vicinity.

We want to take advantage of that with a second sphere that is a bit larger than the first sky sphere.

Create a COMPOSITING tag also for the new sphere and deactivate in it all properties except SEEN BY GI.

The surface of the sphere will now only be used for creating light and will not appear in reflections, behind transparencies, or in the camera (see Figure 3.163).

Create a new material and again load the image of the sky panorama. This time though we will use the image in the LUMINANCE channel, as this channel creates an even brightness independent from the lighting of the object.

Experience tells us that the size or resolution of the image does not really matter in order to create a harmonious lighting. Actually, slightly blurred images can often deliver a better result. We will simulate this with an increase of the BLUR OFFSET value in the LUMINANCE channel.

Now the basics for the creation of the GI lighting and the separate display of the background are set. By splitting these two effects into two spheres, we gain more control.

It is now also possible to use a different background image for the lighting than for the visible background or, as we currently do, adjusting the properties of an image individually with the FILTER shader.

Let us get to the material of the floor. Despite the size of the spheres, the horizon line where the floor and sky meet is still very close to the viewer. In reality the horizon is often not clearly visible and is covered by haze. We should therefore try to soften the transition between floor and sky. This is accomplished with a new material for the floor (see Figure 3.164).

As shown in Figure 3.164, I used a circular GRADIENT shader to generate a gradient ranging from warm earth tones to a dark violet.

— Figure 3.163: Material and settings of the GI sphere.

In the DIFFUSION channel the AMBIENT OCCLUSION shader is used, which additionally darkens the floor under the car.

In order to diffuse the edges of the floor close to the horizon, we will use the ALPHA channel of this material and copy the GRADIENT shader from the COLOR channel into it.

— Figure 3.164: The floor material.

Change the gradient to white in the center and black at the edges, as shown in Figure 3.165.

The increase of the TURBULENCE value in the GRADIENT shader allows the transition between the different levels of brightness to look less even.

In the ILLUMINATION settings of the material it can be determined how much this material will interact with the GI calculation.

The strength of the GENERATE GI option sets how much light will be reflected or radiated from this material.

RECEIVE GI determines how much the material will be lit by incoming GI lighting. I have set the STRENGTH value to 60%, as I want to keep the floor rather dark.

The SATURATION setting sets the color saturation of the incoming GI light. That way, the coloring of the object by colored GI light can be restricted.

The surface will then keep its preset color and will only be brightened in extreme cases.

Assign the material to the floor. When there is no floor, create a simple square surface or polygon and scale it so that the plane under the car reaches up to the horizon in all directions.

Try not to use the FLOOR object of CINEMA 4D. It extends automatically up to the horizon of the CINEMA 4D scene and as a result cannot be textured as accurately.

After the material has been applied to the floor, it might look like the view from above in Figure 3.166. Both sky spheres were made invisible in order to clarify the view. The lower part of Figure 3.166 shows the camera line of sight that I chose for the scene.

Here is another advantage of using the baked sky texture on the spheres. Contrary to the original SKY object, these spheres can be turned, which means that we can turn the desired sky segment toward the camera.

Be sure that both spheres are adjusted the same way so that the GI lighting will correspond later with the position of the sun in the background image.

— Figure 3.165: Additional material properties of the floor.

— Figure 3.166: The finished scene.

Global Illumination

All these preparations and settings in the materials do not have any influence on the lighting yet as long as the GLOBAL ILLUMINATION option in the RENDER SETTINGS is not activated (see Figure 3.167).

There are two basic methods for the calculation of global illumination: standard and stochastic.

For a better understanding of these effects, I would like to explain how this kind of calculation works.

So far, we have used light sources to light objects directly. The light hits a surface in a straight line and brightens it. In reality though, the light would be scattered after hitting the surface and then hit other surfaces in the vicinity.

Imagine a small room with a window. By lighting with traditional light sources, we

— Figure 3.167: Settings for the global illumination.

would put a source representing the sun in front of the window and send the light through the window. Then, maybe the floor or the wall across from the window would be lit, but the rest of the room would remain completely dark.

In the real world, sunlight would reflect from the floor to the ceiling and then to the wall and so forth until the whole room is lit, even though the sunlight only hits a small area of the interior.

Global illumination takes care of this disadvantage with the 3D lights and guides light from one surface to the next. Because this kind of light scattering causes the creation of many other light rays, certain mechanisms make sure that the render time does not increase indefinitely.

We have some parameters at our disposal that contain the number of reflections and the amount of light rays.

Let us start with the settings of the STOCHASTIC mode.

The Stochastic Mode

This mode can be controlled easily because there are only a few settings.

The STRENGTH value controls the intensity of the GI lighting. Higher values result in a brighter image.

The ACCURACY setting defines how many samples will be calculated in the scene. Samples are the number of test calculations used to determine the lighting situation in the scene. When the image is rendered, it interpolates between these samples.

More samples cause a more exact simulation of the light situation, but also need more calculation time. Values between 40 and 80% for ACCURACY are normally sufficient for a good result in a reasonable time.

DIFFUSE DEPTH sets the number of reflections that will be calculated for one light ray. When we think about the room that is lit from the outside through the one window, then this scene would represent a DIFFUSE DEPTH value of 0 due to only one normal light source being calculated. The light then hits the floor and wall and will not be reflected any further.

Already, an increase of the DIFFUSE DEPTH to 1 will give us a much better result because now the light ray can bounce off the floor and hit another element in the room.

The higher the DIFFUSE DEPTH is set, the more faces can be lit by the same light ray.

The scene will become continuously lighter all over and need more calculation time with every DIFFUSE DEPTH increase. Therefore, it makes more sense to use a small DIFFUSE DEPTH and to support the GI calculation with real light sources.

The value of the STOCHASTIC SAMPLES defines the number of calculation rays that will be sent out for every pixel in order to collect the brightness and color values from the vicinity of the pixel.

The more rays that are sent, the more exact the lighting of the pixel can be calculated. Again, the situation is that these rays can take a long time to calculate. This is especially true

for the STOCHASTIC mode, which applies a calculation less optimized toward objects.

Because every pixel is treated the same way, we are forced to use fewer rays to keep the calculation time down. Values between 10 and 50 are fine.

This small quantity of rays is not, most of the time, enough to render a clean and noise-free image. If an animation were to be calculated with GLOBAL ILLUMINATION, the noise pattern would be recalculated from image to image and the animation would eventually flicker.

The option IDENTICAL NOISE DISTRIBUTION can avoid this by using a similar distribution of the stochastic rays in every image. This is only interesting for animations and does not have any influence on the result of a still image rendering.

The Standard Mode

In this mode, CINEMA 4D creates an additional prepass. This means that the image or scene will be scanned and, according to the preset, the samples will be set (see Figure 3.168).

— Figure 3.168: Sample display during the prepass.

In the second part, the actual rendering, these samples will be read and interpolated for calculation of the light distribution.

The accuracy of the prepass depends on the image size. In PREPASS SIZE the size of the prepass can be determined depending on the size of the image to be rendered.

In setting 1/1 the prepass is exactly the same size as the picture to be rendered and gives the best result. In order to save render time, the PREPASS SIZE can be gradually reduced. The interpolation of the samples can even out the loss of sample information.

Basically it is recommended to make the PREPASS SIZE as big as possible and only reduce it during test renderings.

The accuracy of the rendering is also, in this mode, controlled by the ACCURACY parameter. It can be adjusted to the complexity of the calculated surfaces with the MIN and MAX RESOLUTION values.

MIN RESOLUTION sets the number of samples for simple surfaces. Areas where objects get close to each other or cast shadows onto each other are part of complex surfaces that are controlled by the MAX RESOLUTION value.

The system is therefore the same as the one used for diffuse reflections or transparencies in materials.

The ACCURACY value determines the number of pixels that are used as samples, and the MIN and MAX RESOLUTION values determine how many samples will be calculated for each pixel.

This kind of optimizing of the number of samples allows us to use much higher numbers for STOCHASTIC SAMPLES than was possible in STOCHASTIC mode.

The calculation in STANDARD mode is normally noise free and of better quality, but requires more experience and more test renderings in order to find the right settings for all parameters. However, the rendering is done much faster than in STOCHASTIC mode.

In the lower part of the dialog are options and settings for the use of the prepass in STANDARD mode. This prepass can be saved to the hard drive with the SAVE SOLUTION option. Depending on the setting in the RECOMPUTE menu, the saved solution can be used without having to recreate the prepass with every image calculation.

This only makes sense when the objects and the camera remain unchanged between test renderings and nothing changes with the lighting setup of the scene.

In this case use the SAVE SOLUTION together with the RECOMPUTE setting FIRST TIME. The prepass will then be saved at the first rendering of the image and loaded automatically with every test rendering that follows.

In the RECOMPUTE setting ALWAYS a prepass is calculated every time, independent from any saved solutions.

The NEVER setting looks for a saved prepass setting and uses it. When there is no saved prepass we will see an error message.

In order to get an impression of the lighting in the scene we can also activate the SHOW ILLUMINATION IN PREPASS option. Then, not only will the GI lighting be shown during prepass, but also the real light sources. This can be helpful when test images are calculated, as we do not have to wait until the end of the rendering to estimate the lighting in the image.

The other parameters of the standard mode not mentioned work just like those in the STOCHASTIC mode.

Preparation for Global Illumination Calculation

In addition to the general strength setting in the GLOBAL ILLUMINATION parameter, every material can be controlled individually with the ILLUMINATION properties. We already learned about the GENERATE and RECEIVE GI values (see Figure 3.169).

In order to strengthen the light radiation of our GI sky, values above 100% can be entered. We will try a STRENGTH value of 400%. The receiving of GI lighting of the sphere is not needed; thus the RECEIVE GI can be deactivated.

The material of the visible sky should neither emit nor receive GI lighting. There too the GI options can be turned off to speed up the GLOBAL ILLUMINATION calculation.

— Figure 3.169: The Illumination strength of a material.

We can do this with the sky material, but only when the COMPOSITING BACKGROUND option in the COMPOSITING tag of this sky sphere is activated.

Only then will the influence of incoming light on the shading of surfaces be prevented. The color properties of a material then work like a luminescent material.

When this option is not active, a light source restricted to this sphere would have to take care of its lighting. There are currently no other light sources in the scene.

Well, actually this is not correct. Even without light sources, our objects were lit by the DEFAULT LIGHT, which was automatically activated by CINEMA 4D. This light will also have an effect on the GI calculation and would cause additional lighting when no other light sources are in the scene.

When only luminescent materials are used as light sources, as in our case, would this automatically activated light disturb the current setup.

— Figure 3.170: Deactivating the Auto Light.

So in these cases, deactivate the AUTO LIGHT option in the RENDER SETTINGS (see Figure 3.170).

Finally, add another COMPOSITING tag to the car. If not already done, group all objects of the car under a null object and apply the COMPOSITING tag to it.

There, deactivate the SEEN BY GI option (see Figure 3.171). This prevents the car from casting a shadow on the floor. We already used the AMBIENT OCCLUSION shader in the material for the floor and thus do not need an additional shadow.

— Figure 3.171: Compositing settings of the car.

The lighting of the car with the GI light will not be influenced because of that.

Now all preparations are made and we can try to begin our first image rendering. We will first use the easily controlled STOCHASTIC mode with 20 STOCHASTIC SAMPLES and a DIFFUSE DEPTH of 1.

Then we will try the STANDARD mode with the settings 10 and 30 for MIN/MAX RESOLUTION and 1000 STOCHASTIC SAMPLES.

Figure 3.172 compares both results. On top

— Figure 3.172: Different GI modes in comparison.

is the STANDARD and on the bottom the STOCHASTIC mode. Both took about the same time to render, but the STANDARD mode delivers, contrary to the STOCHASTIC mode, a noise-free result.

The brightness of the lighting can now be controlled with the luminescent sky material and its GENERATE GI value. However, the STRENGTH value could be raised directly in the RENDER SETTINGS.

Note how the luminescent material of the headlights actually radiates light and could, in

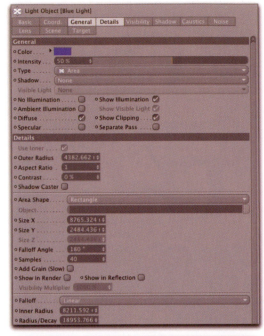

— Figure 3.173: The sunlight source.

an extreme case, illuminate objects in front of the car.

The values for MIN and MAX RESOLUTION in the GLOBAL ILLUMINATION settings were determined by test renderings.

In order to do this, set both to the same values and then raise both values step by step until the result of the test renderings resembles your expectations. The MIN value can then be cut to a third. Basically, a ratio of 1 to 3 is enough for this value pair.

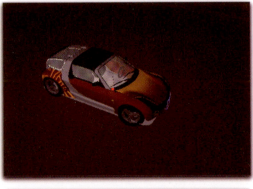

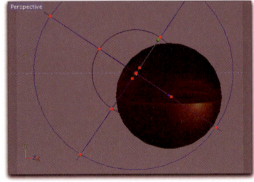

— Figure 3.174: The sky light.

One of the most important disadvantages of the GI lighting is that no realistic looking highlights can be produced. This was reduced in our case by the reflective properties of the paint and the reflected sky. A bit more shine and brightness wouldn't hurt the car though.

Therefore I would like to use two real light sources, in addition to the GI lighting, to complement the lighting of the car.

Create an area light and place it to the side of the car in the direction where the light of the sun comes from. When you are not sure, orient yourself to the position of the sun in the material of the sky sphere.

Add an area shadow to the light so that the car casts an appropriate shadow.

I chose as the shape for the area light a large disc on the DETAILS page of the dialog. It will reflect in the car parts with the activated SHOW IN REFLECTION option.

Figure 3.173 shows my settings of this light source and shows the light source's viewing angle of the car.

A second area light will be placed across from the sun on the other side of the car. This light is supposed to strengthen the diffused light of the sky and, as a result, gets a blue coloring. This light source also does not need a shadow or reflection.

Because I would like to restrict the light effect on the rear part of the scene, I will activate a linear reduction of the light intensity at the DETAILS page of the dialog.

As the lower image of Figure 3.174 shows, I will set the radii of the reduction so that the light intensity stays constant up to the center of the sky sphere, which is also the location of the car. Then the light gets reduced to o when it reaches the horizon.

This prevents the floor in front of the camera from being lightened too much and therefore colored in blue. Also, we have to watch that both light sources are placed within the spheres. This is especially important for the shadow casting sunlight. Depending on the intensity of the sunlight, the result could look like Figure 3.175.

There you can see that GI and real lighting can complement each other without problems. This is especially true for realistic calculations of outside scenes, which usually need a significant amount of time for the calculation of the GI effect so this combination is a big help.

In addition, the area lights also offer, in combination with the AMBIENT OCCLUSION effect, high quality and can be used often for the simulation of GI calculation.

Please also take a look at the other workshops, which discuss, among other things, working with image templates for modeling a figure. These can be found in PDF format and as a movie on the DVD of this book.

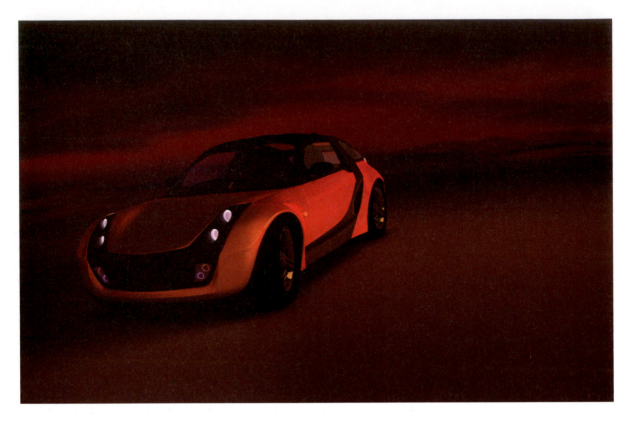

— Figure 3.175: The finished scene.

Animation

n the last couple of chapters you have learned the basics of modeling, texturing, lighting, and rendering in CINEMA 4D.

Animation has been saved for last. The basics of animating objects are easy to explain and understand through practical examples. Making a good animation is a different story though because experience plays an even more important role with this subject than with the others.

Do not be scared by that. Animations are some of the most exciting things that can be done with 3D programs.

4.1 The Basics

Before taking a look at the animation tools, let us talk about the most important animation terms.

Each animation is made up of a series of single images. The number of images used within a second determines how smooth the movements will be later on.

Therefore, there are several standard settings for the most common output media. Animations for television are shown at a rate of 30 images per second in the NTSC system and 25 images per second in the PAL system. Big-screen movies usually use 24 images per second.

Newer media, such as the Internet with its multiple data types, are not standardized. There, the frame rates are mostly set to between 10 and 15 images per second in order to achieve an optimized data rate.

Reformatting a completely rendered animation is possible, but can cause jerky movements when played back. The quality is even worse when the animation is converted from a low frame rate to a higher one.

In any case, it is recommended to set the desired frame rate in the EDIT>PROJECT SETTINGS menu in CINEMA 4D before creating the animation.

To make it unnecessary to set up and animate every single image like in a traditional animation, CINEMA 4D works with so-called *keyframes*. These can be imagined as small data packages that, at a certain time in the animation, save the brightness of a light source or the position of a cube in the scene.

When multiple stages of parameters or objects are saved as keyframes, an interpolation can be created within the time between two keyframes.

The values of the keyframes will be approximated to each other and an animation of the keyframe values will be created.

Similar to a spline curve, interpolation of the values can be displayed and controlled by tangents. That way, for example, the movement path of an object can be controlled individually between keyframes.

4.2 The Powerslider

There are many specialized managers available for working with interpolation and keyframes, but many animations can be created in the standard layout of CINEMA 4D with the so-called *Powerslider*.

This is the small string of numbers under the viewports, which can be seen in Figure 4.1. Let me talk about the most important elements in Figure 4.1.

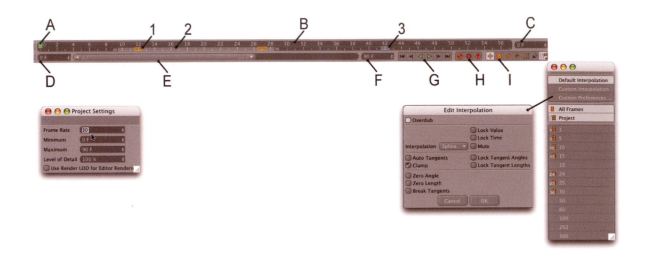

— Figure 4.1: The Powerslider.

As mentioned previously, the frame rate should be set in the PROJECT SETTINGS before starting an animation. This dialog is also shown in Figure 4.1.

In addition to the frame rate, MINIMUM and MAXIMUM values define the time frame of the animation, or how long the animation will be.

The length does not have to be set right away, as these values can be changed again later.

The preset values of 0 and 90 in combination with a frame rate of 30 mean that the animation will be only 3 seconds long. Thus, most of the time, the value of the maximum frame number will be increased drastically in order to get more space for setting the keyframes.

The area to be rendered can be set separately in RENDER SETTINGS so that only a portion of the images could be rendered as an animation.

The length of time available for animating cannot only be set in the PROJECT SETTINGS, but also with two values, as marked with the letters D and F in Figure 4.1.

The area in between (letter E) can be scaled within the preset of the minimum and maximum frame numbers by moving the left and right arrows with the mouse.

The preview area defines the frame numbers, which will be shown in detail in the area at letter B.

The point in time where you are currently is indicated by the green time slider at letter A and as a frame number at letter C in Figure 4.1.

The time slider can be moved directly with the mouse or positioned exactly by entering a value. When the Alt key is held while moving the time slider, the editor viewports are not updated.

The animated objects will not move, even though the time slider is moved within the animation.

When an object is selected, its set keyframes for position, rotation, and scaling can be seen at the rectangular markings in the Powerslider. Such a keyframe marking can be seen at number 3 in Figure 4.1.

Manipulating Keyframes

In order to move a keyframe, it is enough to just hold the mouse button while over it.

Multiple keyframes first have to be selected when they are to be moved or changed in any way. Therefore, hold down the mouse button in the lower part of the Powerslider

time bar and move the mouse to the upper right or left. A selection frame will be created as shown at number 2 in Figure 4.1.

Keyframes within the selection will now be displayed in orange (see number 1 in Figure 4.1).

These selected keyframes can now be deleted with the delete key of the keyboard or with the common Cut, Copy, and Paste commands. These commands can be used with a right click on the powerslider.

The selected area, including keyframes, can be moved by clicking and holding the mouse button in it.

Pulling the slightly lower end pieces of the selection area scales the distances between the enclosed keyframes and therefore speeds up or slows down the animation between these keyframes.

The included keyframes will stay in position when the Shift key is held while moving the whole selection. This way, the selection can be moved to another place in the time bar.

When the Shift key is used to move the end of the selection area or the time slider, they jump to the position of the next keyframe. The Shift key may be used only after the end of the selection or after the time slider starts to move.

Creating New Keyframes

There are different methods of creating animations with keyframes. When the goal is moving, rotating, or scaling of an object, then use the icon buttons marked with the letter I in Figure 4.1.

The first three icons should look familiar. From left to right they represent recording of movement, rotation, and scaling values of the selected object.

When the actual position of an object should be saved as a keyframe, activate the position icon at the letter I and then click on the red icon at the letter H. This creates for the active object a new position keyframe at the current location of the time slider.

It is more flexible to create the chosen keyframe type directly by clicking Ctrl in the time bar of the powerslider. That way, new keyframes can be created independent of the position of the time slider. The interpolated value of the neighboring keyframe, when other keyframes are available, will automatically be assigned to the new keyframe.

The animation will not change, but through the tangent interpolation of the new keyframe, we have more control over the interpolation at this point in the animation. An example will clarify this in a moment.

Multiple keyframe types can be created at the same time. Just select all icons in the group at the letter I for which a keyframe is to be created.

In addition to the often used icons for position, rotation, and scaling, it is also possible to record parameter keyframes or PLA keyframes.

The recording of parameters by means of the P icon is rarely used. It is easier to do this in the Attribute Manager. We will learn more about this later.

The PLA icon shows a group of points. The abbreviation PLA actually stands for Point Level Animation and is therefore used to save point coordinates of an object. That way, the shape of an object can be animated by moving its points. However, the size of the scene would increase considerably because each keyframe contains all point coordinates of the object.

We will learn about a better way to morph objects later.

Finally, the loudspeaker icon plays loaded sound tracks and has nothing to do with the creation of keyframes. This function is quite useful though if a movement has to be synchronized with a sound or music.

The Navigation within an Animation

We already learned how to navigate within the animation by moving the time slider. There is another function shown at the letter G in Figure 4.1.

These icons not only look like buttons on a VCR or DVD player, but also work the same way. From left to right, these icons stand for moving the time slider to the first frame, going back one frame, and playing the animation in reverse.

The functions of the next three icons are the same, but work in the other direction. These are playing forward, going forward one frame, and moving the time slider to the last frame of the animation.

Depending on the complexity of the calculations for the animation, it can be that the animation cannot be shown at the same speed as it will be after the final rendering, when it is played in QuickTime or Media Player.

Thus, a separate frame rate can be set for playing animations in the editor.

Use the bottom icon on the far right in the powerslider. This opens a list of options as seen in Figure 4.1.

The options ALL FRAMES and PROJECT are active by default. These options make CINEMA 4D take over the frame rate of the PROJECT SETTINGS, as long as the video card can display the data fast enough in the editor viewports.

When the animation cannot be shown in the set frame rate because of complexity, then the ALL FRAMES option will go into effect and force CINEMA 4D to show all images of the animation, one after the other, even if the frame rate decreases.

With ALL FRAMES deactivated, CINEMA 4D will skip some frames if necessary to keep the original timing of the animation.

In order to determine another frame rate, deactivate the PROJECT option and choose a frame rate from the list below.

The upper part of this list of presets has the settings for the interpolation between keyframes. When DEFAULT INTERPOLATION is ac-

tive, then smooth transitions between the values saved in the keyframes are calculated. This would not be as useful when a mechanical animation is to be created.

In these cases the interpolation can be set individually. Choose CUSTOM PREFERENCE... in the list. The appearing EDIT PREFERENCES dialog is also shown in Figure 4.1.

Almost all options there can be set separately for every keyframe.

The Keyframe Interpolation

Let us start with the OVERDUB option. When it is active, an existing tangent at an interpolation curve will be kept, even if the keyframe is overwritten.

The INTERPOLATION menu set the kind of interpolation between the keyframes. SPLINE can be compared with the tangents of a bezier spline. In this mode the value change between the keyframes can be individually set.

Not always is such control necessary. In these cases the LINEAR interpolation can be helpful. The transition between the values of the keyframes is then linear.

The interpolation STEP keeps the value of the keyframe constant up to the following keyframe and then changes the animated parameter instantly when reaching the next keyframe.

The options LOCK VALUE and LOCK TIME can be used to avoid future errors when editing the animation. They lock the point in time of a keyframe in the powerslider or prevent a change of the value saved in the keyframe.

The MUTE option deactivates completely the interpolation following a keyframe. This function only makes sense in the individual setting of a keyframe, which we will learn about later.

When INTERPOLATION SPLINE is used, the option AUTO TANGENTS sets automatic tangents to create a smooth transition between the animated values.

The deactivated Auto Tangents option allows individual scaling and adjusting of the tangents.

The Clamp option makes sure that no smoothed interpolation is calculated between two keyframes with identical saved values. This avoids the so-called overshooting of values. The interpolation between keyframes is therefore always linear.

Lock Tangent Angles and Lock Tangent Length lock the direction and length of tangents in order to protect them from accidental manipulation.

The option Zero Angle aligns all tangents horizontally. Zero Length also causes a linear course of the interpolation curves between keyframes at the spline interpolation. Break Tangents allows a separate scaling and direction of each arm of the tangents.

In order to use the settings created in the Edit Interpolation dialog for new keyframes, Custom Interpolation must be selected or else the Default Interpolation will be used again.

This is it for the directly visible elements and options. We will now create a small animation as an exercise in the practical use of the power-slider and keyframes. For that reason we will model a soccer ball and bring it to life.

4.3 Modeling a Soccer Ball

Start with a new scene and create a basic Platonic object, which is located in the same group as the cube and the sphere.

Set the Type of the object to Bucky in the Attribute Manager (see Figure 4.2).

The surface of the Platonic object is built out of pentagonal and hexagonal faces and already resembles the basic shape of a soccer ball.

As a preparation for the next steps, the pentagonal and hexagonal faces need to be converted into N-gons. Therefore, select the two polygons of a panel of the converted ball and use the U key followed by the Z key. Alter-

— Figure 4.2: Combine polygons to N-gons.

natively, the Melt command in the Functions menu can be used instead. Figure 4.2 shows this step in the example of a panel.

When all panels are converted to N-gons, use the Extrude command. Be sure that no faces are selected and extrude them by two units. The Preserve Groups option should be deactivated. This step can be seen in Figure 4.3.

Then we subdivide the ball one time. For this step, use the Subdivide command in the Functions menu. Here too, make sure that no faces of the ball are selected so that all polygons are subdivided.

The result can be seen on the bottom of Figure 4.3. Because of the N-gons, there is now a point in the center of each patch.

Select all of these center points and expand the selection by using the Grow Selection command in the Selection menu. These points will later be moved in the direction of the sphere radius to shape a perfect ball.

In order to automate this task, we will give weight to the selected points with the Set Vertex Weight of the Selection menu to 100%. The points will then turn yellow, as shown in Figure 4.4.

At the same time, a Vertex Map tag appears behind the ball object where the weighting of the points is saved.

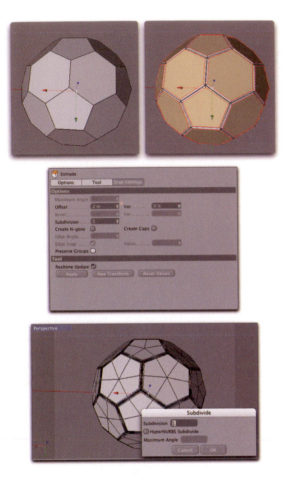

— Figure 4.3: Subdividing the ball.

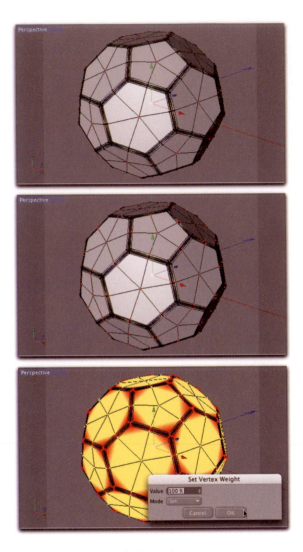

— Figure 4.4: Weighting points.

Luckily there is a deformer object that can expand sphere-shaped objects. Add the appropriately named SPHERIFY deformer to the scene and subordinate it under the ball.

The radius of the SPHERIFY object should be the same as the radius of the original PLATONIC object. Enter 100 for the radius and set the STRENGTH to 100%. The deformer still influences all the points of the ball and pushes the seams outward as well.

This is the why we created the vertex map. It can be connected with the deformer by means of the RESTRICTION tag.

Apply a RESTRICTION tag in the TAGS>CINEMA 4D TAGS menu in the OBJECT MANAGER to the SPHERIFY object and pull the VERTEX MAP tag into the uppermost NAME field (see Figure 4.5).

From now on, depending on their weighting strength, only the weighted points will be influenced by the deformer.

Apply a PHONG tag, which can also be found at TAGS>CINEMA 4D TAGS, to the PLATONIC object so that the surface is softly shaded. The ANGEL LIMIT option in the PHONG tag should be activated as well.

When the ball is subordinated under a HYPERNURB object it could look like Figure 4.5. This is already quite good, but the seams are very wide because of the extra smoothing.

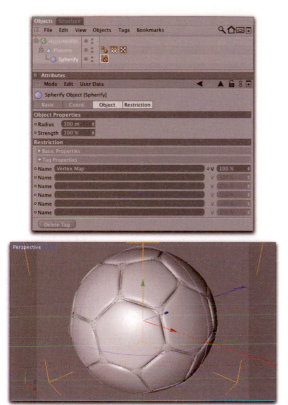

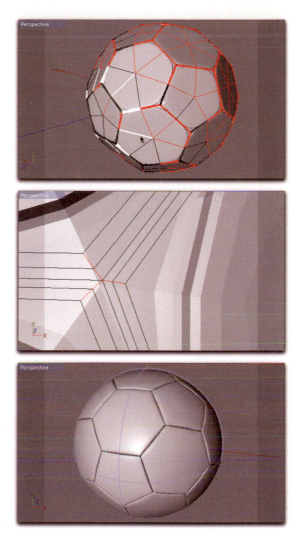

— Figure 4.5: Shaping and smoothing the ball.

To correct this we will use weighted edges. At first glance it appears to be difficult to select the right edges and not miss one. However, the RING SELECTION makes it easy for us.

With the RING SELECTION, large areas of panel edges can be selected, as we can see on top of Figure 4.6, and thus the whole ball selection is done quickly.

Only at first sight are all the edges of the ball selected. When we invert the selection with the SELECTION>INVERT command, then the selected edges of the panels are visible when we look closely at the corners of the panels.

These edges are weighted in the HYPER-NURBs object by holding the Period key and moving the mouse to the left or right. As a re-

— Figure 4.6: Selecting and weighting edges.

sult, these edges attract the HYPERNURBS surface more.

The lowest image in Figure 4.6 shows a possible result. The pentagon-shaped panels can now be saved as a POLYGON SELECTION and have a black material applied to them (see Figure 4.7).

Now the ball is done and we can start with the animation.

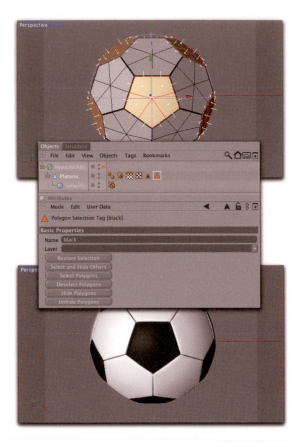

— Figure 4.7: Coloring the patches.

4.4 Animating the Ball

Let us first try to get the ball bouncing up and down. Add a flat cube, which will represent the floor, and put it under the ball.

Place the cube so its uppermost face is exactly at the XZ plane of the world coordinate system.

The ball can then be moved to the height Y=100 in order to be positioned exactly on the floor (see Figure 4.8). There might be small deviations since the HYPERNURBS object, because of the smoothing, may have shrunken the ball. We will ignore that for now.

The bounce of the ball should start at a certain height above the floor. Therefore, pull the

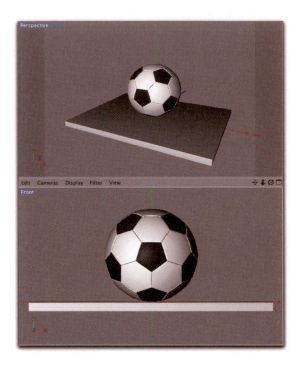

— Figure 4.8: Setup of the scene.

ball to the Y position of 400 and make sure that you are at frame 0 of the animation.

The green time slider in the POWERSLIDER has to be at frame 0. Then activate the keyframe icon for the recording of movements and click on the record button in the POWER-SLIDER. This is shown in the upper half of Figure 4.9.

Now move the time slider to frame 15. The next keyframe should be created here.

Move the ball to a height of 100 by entering this value directly into the COORDINATE MANAGER and use the keyframe record button again.

Congratulations on your first animation! To view it, move the time slider manually between the blue keyframes back and forth or let the animation play automatically by clicking on the play button in the POWERSLIDER.

The blue line in the editor probably caught your attention. It indicates the interpolated animation curve between the keyframes.

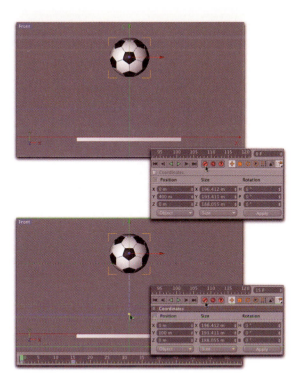

— Figure 4.9: Keyframe animation of the ball.

On this blue curve there are dark blue bumps. These represent the keyframes, the positions of the animation set by us.

These bumps can be clicked on directly in the editor and their data can then be seen in the ATTRIBUTE MANAGER (see Figure 4.10).

Because a keyframe saves multiple values, such as the X, Y, and Z aspects of a position, the ATTRIBUTE MANAGER cannot show all the saved values at the same time.

In Figure 4.10 we can see this in the field for KEY VALUE. It only shows the information <<Multiple Values>> because this field is not made for the display of vectors.

When the time slider is moved to the position of the keyframe, the COORDINATE MANAGER can then be used to read the saved values.

In addition to the time position of the selected keyframes and the saved value, the AT-TRIBUTE MANAGER shows additional options that mainly concern the interpolation of the animation, which follows the keyframe.

— Figure 4.10: Settings of one keyframe.

Most of these options were already mentioned when I covered the CUSTOM PREFER-ENCES and its EDIT dialog. The only new aspects are the settings for LEFT TIME and RIGHT TIME and LEFT VALUE and RIGHT VALUE, which are used to control the two tangent arms of the interpolation curve numerically.

The TIME values control the length of the tangent arms, whereas VALUE specifies the angle of the tangent. These values are only accessible when AUTO TANGENT is turned off and no restrictive values are activated, such as ZERO ANGLE or ZERO LENGTH.

Because we want to continue to fine-tune our ball animation, select the keyframe in frame 15. This can be done by making a selection in the powerslider or by clicking on the lower keyframe point at the interpolation curve in the editor.

For this keyframe, activate the ZERO LENGTH option. This will remove the tangent from the keyframe. The ball will now speed up while falling and will stop abruptly. This is more like the behavior of an object that hits an obstruction.

We will duplicate the keyframe in frame 1 so that the ball can bounce up again. This works like the duplication of objects in the OB-JECT MANAGER by holding the Ctrl key.

Click on the keyframe in frame 0 of the POWERSLIDER and simultaneously hold the Ctrl key and the mouse button while moving the keyframe to frame 30.

Changing the Timing

After the release of the mouse button we have created a complete animation cycle. The ball falls down, bounces back, and returns to its initial height.

Maybe you realize now that the animation is set right but the timing could be improved. Our next job is to get the animation to play at twice the speed.

First all keyframes have to be selected. Because the first keyframe is in frame 0, it might be difficult to select it in the POWERSLIDER.

Just widen the available time frame into the negative area, as shown in Figure 4.11, and move the slider for the preview area to the left stop. Frame 0 will now be at a safe distance from the left edge of the POWERSLIDER and the keyframes can be easily selected with a selection frame in the POWERSLIDER.

When the Shift key is held while the handlers at the edge of the selection are moved, they snap exactly to the outer keyframes. The result is shown in the upper half of Figure 4.11.

— Figure 4.11: Scaling the animation.

Now click on the right handler of the selection and move it to the left until you reach frame 15.

The keyframes included in the selection will be set automatically and keep their relative position to each other.

Because this does not change the values saved in the keyframes, the animation is now

shortened to half its length and therefore runs twice as fast. The result is shown in the lower half of Figure 4.11.

I actually liked the original speed of a 30 frame cycle at a frame rate of 30 images per second. Thus I scaled the three keyframes again to the area between frames 0 and 30.

What could be improved is the behavior of the ball at its uppermost position. I prefer that it reach this point slowly and also that it hangs there for a longer time. This will mean that the tangents of this keyframe need to be extended.

First select the keyframe in frame 0 and change the tangents to −8 and +8. Repeat this for the keyframe in frame 30.

I also activated the option ZERO ANGLE for this keyframe, as shown in Figure 4.12. This will automatically create a horizontal path of the tangents and lock the VALUE fields, preventing accidental value entries.

![Figure 4.12 interface screenshots showing keyframe timeline and Value Key properties panel]

— Figure 4.12: Adjusting the tangents.

The ball now stays longer in the upper portion of the movement, falls more dynamically in the lower part, and accelerates. This requires a bit of imagination, as the curves and tangents are not visible in the POWERSLIDER. We will learn about a new window in a moment that allows us to see them.

— Figure 4.13: Copying keyframes.

First let us extend the animation so that the ball bounces multiple times. Create a selection of the last two keyframes. These represent the lower and upper positions of the movement.

Hold the Ctrl key while the selection is moved, and therefore duplicated, with the mouse to the right in the POWERSLIDER.

Move the keyframe copies until they are on frames 45 and 60. The animation is now extended by one cycle (see Figure 4.13).

Repeat this procedure until the end of the POWERSLIDER time bar is reached or until the ball bounces up and down a few times.

Animating Parameters

Similar to the animation of the position of the ball, almost all parameters in CINEMA 4D can be animated as well. I would like to demonstrate this with a light source (see Figure 4.14).

We will create a small lighting setup with a dome-shaped area light, a radial emitting main light, and a spotlight placed above the ball that shines vertically down on the floor.

In order to avoid brightening the floor too much, we will give the floor an almost black color and a slight reflection, as shown in Figure 4.14.

With this setup I would like to create a bright spotlight on the floor whenever the ball hits it. During the upward movement of the ball the spot light should expand to the whole floor and lose brightness at the same time.

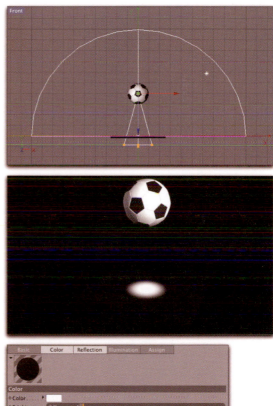

— Figure 4.14: The lighting setup.

This light effect should be accomplished easily by animating the brightness and the opening angle of the spotlight.

Take a look in the ATTRIBUTE MANAGER when the spotlight is selected. Notice the small circles in front of the parameters. A Ctrl click on these circles creates a keyframe for the current point in time for the value and colors the circle red. With another Ctrl click on the red circle the keyframe will be deleted again.

There are cases where there is a red circle in front of a parameter that is not entered yet. It means that the parameter is animated by keyframes, but at this point in time no keyframe exists.

A Shift/Ctrl click on the circle of an animated parameter removes the complete animation with all keyframes from this value.

You surely see the scope of this action because these circles are placed at almost every object, material, or shader and at many settings in dialogs.

We will now create two different keyframes for the spotlight, as shown in Figure 4.15. The keyframe indicated with the letter A gets an INTENSITY of 50% for the light and an OUTER ANGLE of 90˚.

This keyframe will be created in frame 14 of the animation, exactly one frame before the ball touches the floor.

In frame 15 increase the INTENSITY to 5000% and lower the OUTER ANGLE to 10˚. Create keyframes again for both values. The spot light then generates a small intense circle of light on the floor.

The high intensity of the light is necessary because the dark material of the floor absorbs a lot of light.

The brightness should now be lowered step by step to 50% and the OUTER ANGLE should be increased to 90˚. This corresponds with our keyframe values in frame 14.

Click on this keyframe, hold down the Ctrl key, and pull the keyframe with the mouse in the powerslider to frame 30. This is the point in time where the ball reaches its highest point.

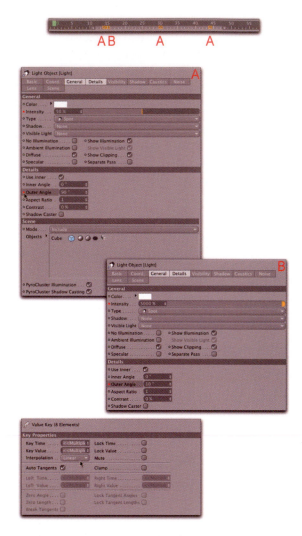

— Figure 4.15: Parameter keyframes of the spotlight.

Because these values will not be changed until the ball hits the floor again, we can copy this keyframe and move the copy to frame 44, one frame before the ball hits the floor. This results in the order of keyframes shown in Figure 4.15.

To avoid an overshooting of the values because of the automatic smoothing of the curve, we have to select all keyframes with a selection frame in the powerslider and change their INTERPOLATION in the ATTRIBUTE MANAGER to LINEAR.

An alternative would be to activate the CLAMP option, which automatically prevents the overshooting of the curves of two consecutive keyframes.

Of course we could create and move additional copies of this keyframe sequence to get a continuous animation of the spotlight. However, there are more elegant tools at our disposal that cannot be reached in the POWER-SLIDER. We would have to work in the so-called TIMELINE, which can be opened in the WINDOWS menu of CINEMA 4D or is directly integrated in the ANIMATION layout of CINEMA 4D.

Before we direct our attention to the elements of the TIMELINE, we will take a look at the SCENE settings of the spotlight, which are shown in Figure 4.15. The spotlight should be limited to the floor cube only. This way the ball does not get any additional light and the light will not be covered by the ball.

Also check the brightness and angles of the spot light saved in the keyframes of your scene. You might need to use different values, depending on if your spot is placed closer to or further away from the floor.

The Timeline

The TIMELINE works like a hybrid of the OBJECT MANAGER and POWERSLIDER.

At the left side are the familiar listings of all objects and tags. Figure 4.16 marks this column with the letter A.

At the letter B there is a separate column with up to three symbols for each animated object. From left to right, the first circle shows the color of the layer in which the object or tag is grouped.

The second icon looks similar to a filmstrip and shows if an animation should be calculated for this object.

With a click on this symbol, single objects can be made temporarily motionless in order to save render time or to concentrate more on the movement of other objects.

The third symbol activates the solo mode. When animated objects are marked with the solo symbol, only these are shown animated in the editor and all other animations are disabled. In a sense this is an inversion of the function of the filmstrip symbol.

On the right side of the TIMELINE is the time bar with the time slider. Also the keyframes of the animated objects or parameters can be seen there as rectangles.

The area marked with the letter C in Figure 4.16 shows by way of its lighter color that an animation is happening between the keyframes.

It is necessary to understand that the graphical display of an animation is shown multiple times in the TIMELINE. This allows us to move the keyframes, even if the hierarchy of the objects is not unfolded on the left side. This can be seen at the HYPERNURBS object in Figure 4.16, which has the PLATONIC object of our ball subordinated under it.

Even though the HYPERNURBS object itself does not have any keyframes, the keyframes of the subordinated ball appear behind the HYPERNURBS object.

What kinds of keyframes and values are animated can only be seen by unfolding the whole hierarchy. Then we see that there is a position folder under the PLATONIC object with the X, Y, and Z coordinates of the ball animation.

The track hierarchy of the animation of the position can be unfolded too. It then reveals the interpolation curves between the keyframes. These curves are shown in Figure 4.16 and are marked with the letter D.

The linear curves of the INTENSITY and OUTER ANGLE parameters next to the spotlight source can be seen clearly, as can the curves of the position animation of the ball in the upper area.

The tangents of the curves can be clearly seen and changed with the mouse as long as the keyframe of the POSITION.Y track is selected by a frame selection or by clicking on it.

The selection, deletion, or copying of keyframes works just like in the POWERSLIDER.

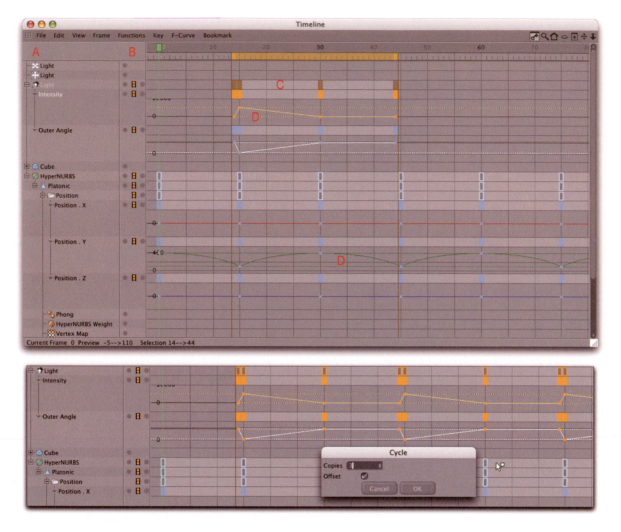

— Figure 4.16: The timeline.

Therefore, select the four keyframe rectangles of the INTENSITY and OUTER ANGLE tracks with a frame selection. Simply hold down the mouse button and pull a frame around the keyframes.

In order to not have to copy and move the keyframes multiple times, use the CYCLE command in the KEYS menu of the TIMELINE. A small dialog then asks how many copies are to be created. Enter a number according to the length of your ball animation.

In addition, activate the OFFSET option in the dialog so that an automatic transition be-

tween the original sequence and the copies is created.

The dialog and the result of the action can be seen in the lower part of Figure 4.16. The animation was added multiple times and therefore lengthened.

Optimizing Keyframes and Working with F Curves

Let us take a look at the curves for the X and Z portions of the position of the ball. We can see

that there are no changes because the ball only bounces up and down.

Because every keyframe and interpolation create more render time, we should make sure that unnecessary tracks are deleted.

Select the POSITION.X track by clicking on its name and delete it with the Delete key of your keyboard. Then do the same with the POSITION.Z track (see Figure 4.17).

— Figure 4.17: Deleting unnecessary tracks.

The animation did not change but the clarity of the TIMELINE was improved greatly.

Take note of the icons in the upper right corner of the TIMELINE. Some, like the icons for zooming and moving, are already familiar from the editor viewports.

They work using the same principle as the TIMELINE and are restricted to the right part with the tracks, curves, and keyframes.

We have seen other symbols in the ATTRIBUTE MANAGER, such as the window icon to open a new manager. Also familiar are the icons in the CONTENT BROWSER for showing a search field, to jump to the uppermost hierarchy level, or the eye icon for defining the visibility in the managers.

Completely new is the first icon. It can make keyframes and tracks temporarily invisible, instead showing an enlarged version of the curves of selected elements. This makes working with tangents much more comfortable and easier, as shown in Figure 4.18.

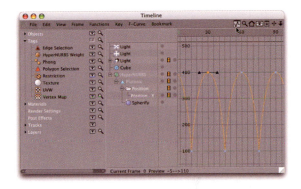

— Figure 4.18: F Curves and additional settings for visibility.

Furthermore, we can select several elements with Ctrl clicks and show their curves in a window. This makes it easier to synchronize the so-called F CURVES, which is another name for interpolation curves.

An extra listing was added on the left that uses the eye icon, as shown in Figure 4.18. With the familiar eye symbols we can control the visibility of an element type in the TIMELINE or prevent the search function from finding certain elements. This works the same as in the OBJECT MANAGER and clarifies the TIMELINE.

In Figure 4.18, for example, all tags were made invisible that did not contain any keyframes. Alternatively, we can use the TIMELINE in another mode.

By default the TIMELINE works in AUTOMATIC MODE and lists all elements regardless of whether they are animated or not.

In the VIEW menu of the TIMELINE we could also add the SHOW ANIMATED option, which then lists only the animated elements.

When the AUTOMATIC MODE is deactivated in the VIEW menu of the TIMELINE, then the objects to be shown in the TIMELINE have to be pulled in from the OBJECT MANAGER. It is then

up to you which elements should be shown in the TIMELINE.

The element can be removed from the TIMELINE again by right clicking on it and selecting REMOVE SELECTED OBJECTS.

4.5 Rendering and Saving the Animation

Now is the time to render and save the animation (see Figure 4.19).

— Figure 4.19: Rendering the animation.

Basically, the only necessary change to the settings in RENDER SETTINGS is the FRAME and FRAME RATE setting in the OUTPUT page of the dialog.

The FRAME values determine the first and last image of the animation. The FRAME RATE can be different, but should correspond with the value used in the PROJECT SETTINGS for the frame rate of the animation.

As described previously, the animation can be rendered as a series of single images. This is the most common procedure in order to be able to continue the editing in a compositing or video effect program using the highest quality material.

However, we want to render a movie that can be played instantly. Therefore, we should choose a compressed film format in the SAVE page of the RENDER SETTINGS. I selected the QuickTime format, which has more options available behind the OPTIONS button. There, for example, the full screen frame rate can be determined or the codec for the compression.

The rendering of the animation can then be started as usual with the RENDER TO PICTURE VIEWER command. There you can watch how one image after the other is rendered. Figure 4.20 shows parts from the finished animation.

Motion Blur

With moving objects our eyes work differently than with static scenes. The faster an object moves, the blurrier it appears to us. The reason is the sluggishness of the light receptors in the eye.

Modern cameras also recognize this phenomenon, especially when there is not enough light. The recording is shaky and blurry because the shutter has to be open longer to receive enough light.

During this time, when the shutter is open, a fast-moving object changes its position and, as a result, the image appears blurry.

Because cameras and our eyes experience this effect, we should take this into account when rendering fast-moving objects in order to be more realistic.

Various methods use different render times.

The result with the highest quality and the longest render time is accomplished with the SCENE MOTION BLUR effect. This effect

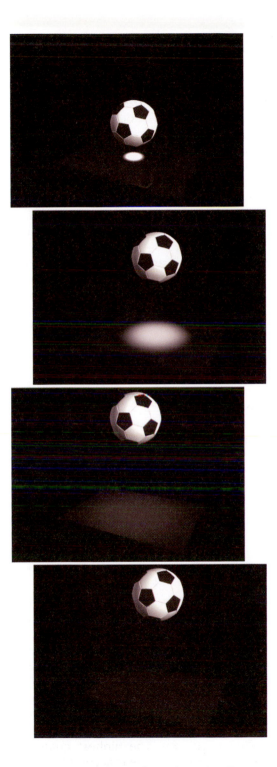

— Figure 4.20: Images from the animation.

can be activated in the EFFECTS page in the RENDER SETTINGS.

The most important setting is the SAMPLES value. It determines how many single images will be calculated to render one image of the animation. With this effect, images are calculated between normal images and are incorporated into the result. That way, a nice realistic effect can be achieved with high SAMPLES values.

However, because the SCENE MOTION BLUR increases the render time immensely, there are alternatives to this method.

There is the OBJECT MOTION BLUR. This effect has the advantage that it can be restricted to single objects. Therefore the whole image does not have to be calculated multiple times.

Also, this post effect analyzes former object positions and calculates a blurry effect from the current and last positions. This has some disadvantages, such as rotating movements that cannot be captured realistically. The effect is also not visible in reflections or behind transparencies. This can only be done with the SCENE MOTION BLUR. This kind of motion blur is calculated very quickly.

The third kind of motion blur is more precise. The VECTOR MOTION BLUR analyzes movements and rotations and can calculate a somewhat realistic effect in a short amount of time.

Just like the OBJECT MOTION BLUR, this effect can be assigned to single objects with a MOTION BLUR tag. The weighting of the blur is set with the SHUTTER ANGLE value, which indirectly controls the exposure time of every image. It does not control the brightness but rather the distance over time between two images, which should be included into the result.

A SHUTTER ANGLE of 360° takes the whole movement of an object between two images into account. We want to use this effect for our animation and decide on the VECTOR MOTION BLUR with a SHUTTER ANGLE of 180°.

The ball also has to have a CINEMA 4D TAGS> MOTION BLUR tag, as shown in Figure 4.21, so the effect will be calculated. The image

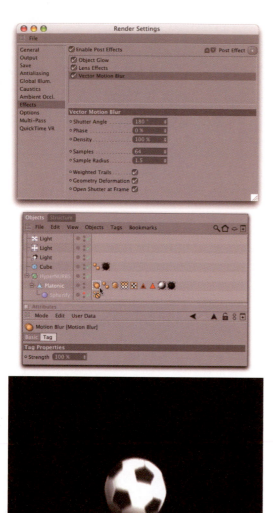

— Figure 4.21: Vector motion blur.

on the bottom of Figure 4.21 shows the effect in one image of the animation.

4.6 Connecting Parameters with XPresso

Another powerful tool in CINEMA 4D is the XPresso gateway. This is a kind of graphical programming language where mathematical calculations or connections between objects and parameters can be put together like in a toy construction kit.

For people who are more interested in programming there is also a script editor to create macros, small programs, and functions and a C.O.F.F.E.E. port.

C.O.F.F.E.E. is, in addition to being the C++ port for plug-ins, the programming language of CINEMA 4D.

Since I know from many training courses and discussions that only a fraction of graphics designers are interested in programming, I will talk only briefly about this subject.

CINEMA 4D makes it easy to create our own expressions and XPresso setups, as we will find out in a moment.

At the point when you want to work with the Thinking Particles module, it is necessary to learn how to work with the XPresso system. The particle systems are controlled exclusively by XPresso.

As an example of the use of XPresso, I would like to let the ball bounce within a helix that will then be deformed by it.

Open a HELIX spline, a CIRCLE spline, and a SWEEP NURBS object.

Scale the radii of the helix so that the ball does not have enough room inside it and create a massive spiral spring by subordinating the splines under the SWEEP NURBS object.

Move in the POWERSLIDER to the point in time where the ball is completely positioned inside the HELIX and then subordinate a BULGE deformer under the helix. Increase its effect until the helix is widened enough to place the ball within.

Figure 4.22 shows the setup of the scene and the desired deformation of the helix by the BULGE object.

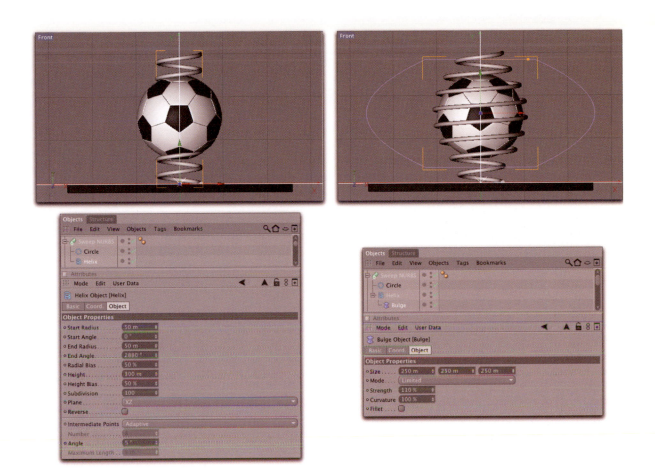

— Figure 4.22: The deformed helix.

In order to make this effect believable, the BULGE object always needs to be at the same height as the ball. The simplest possibility would be to copy the POSITION.Y track of the ball to the BULGE object. However, this could cause two problems.

You should know that all keyframe values for the position, rotation, and size are always saved in the local coordinate system. This could cause problems when we exchange animated objects within hierarchies: the position of the superior object is changed within the three-dimensional space and the animated object jumps to another place.

Because the BULGE object and the ball are sorted into separate hierarchies, this means that the copying of keyframes from one object to the other does not necessarily result in the same position.

Also, when changes are made on the tangents or values of one object, then the other object has to be changed as well to synchronize the animation again.

In these cases it is better to transfer the animated values of one object to the other with an expression. Then we only have to deal with the keyframes, and the BULGE object will take over the animation of the ball.

CINEMA 4D makes such connections very easy because they can be directly accessed through menus.

Choose a parameter in the ATTRIBUTE MANAGER that should be transferred to another object. In our case, because only the POSITION.Y

of the ball is of interest, click one time on the Y ending in Coordinate of the properties of the Platonic object.

After a right click on the Y ending, choose the entry Animation>Set Driver in the context menu.

In a second step, it has to be determined which parameter this value should be assigned to. Basically this would be every parameter that can handle floating point numbers.

You can, for example, use the X position of an object to control the radius value of a Circle spline or use the rotation vector of an object as a color vector in a material.

Thus, we again choose the Y ending of the Bulge object position in the Attribute Manager and select in the context menu Animation> Set Driven (Absolute).

This simple action is also shown in Figure 4.23 and has automatically created an XPresso expression behind the Bulge object.

This expression ensures that the height of the ball is always transferred to the Bulge object. As a result we do not have to worry about this part of the animation anymore. This is also the case when changes are made to the animation of the ball later on.

XPresso Nodes

When you are curious to know how the expression works, simply double click on the XPresso tag behind the Bulge object. Then the XPresso Editor with the automatically created expression opens (see Figure 4.24).

As promised I will not bother you too much with this subject of programming. Therefore, here is a short explanation on how the XPresso Editor works.

Basically these expressions can be built very easily by us. We only need the XPresso tag, which can be assigned to any object. This tag can be found in Tags>CINEMA 4D Tags in the Object Manager.

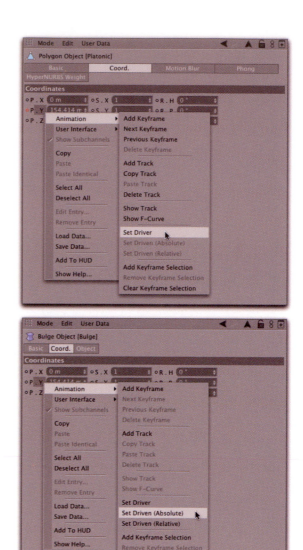

— Figure 4.23: Connecting parameters.

With a double click on the tag the familiar XPresso editor opens. The expressions are created within this editor.

The elements of these expressions are called *Nodes* and are all built similarly. Next to the headline with the name is a red and blue field.

One click on the blue field opens a list with the existing entries of the node. The red field stands for the outputs. Use the blue input field

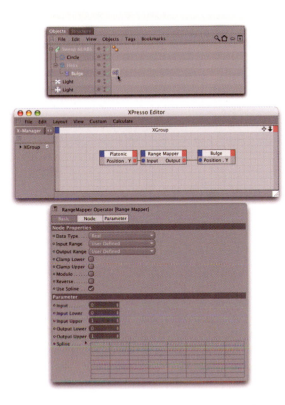

— Figure 4.24: Setup of the XPresso expression.

when a value needs to be assigned to an object. For reading the values use the red side of the node.

For every selected input and output in the lists, a colored circle is created on the corresponding side of the nodes. These are the so-called *Ports*.

The ports of the different nodes can be connected directly with the mouse. Just pull a line between the ports while holding the mouse button. This connection line then transfers the value from an output port to an input port.

One click on the line or a double click on the ports deletes the line again.

CINEMA 4D will, if necessary, make a format change of the values between the nodes. Consequently the result of a mathematical calculation can be transferred to a text entry of a text spline. Normally though, value conversions should be avoided.

Note that an output port can be connected to several input ports. An input port can re-

ceive data from only one output port. It is also not allowed to connect an input and output port at the same node.

Object nodes are created by pulling the object from the OBJECT MANAGER into the open XPRESSO EDITOR.

All other nodes needed for mathematical calculations can be found in the context menu. This menu opens with a right click in the XPRESSO EDITOR.

Probably the most often used node is the RANGE MAPPER node, which was automatically created in our expression (see Figure 4.24).

This node works like the mathematical rule of proportion, which means that value ranges can be converted. For example, the movement of an object between the Y coordinates 0 and 100 can be converted into an angle between 50° and 90°.

Simply use the INPUT and OUTPUT values of the RANGE MAPPER in the ATTRIBUTE MANAGER to define the two value ranges. There is even a spline curve available to make a nonlinear conversion.

To use our example of the position values and angles, it would mean that the values of 0 and 100 have to be entered into INPUT LOWER and INPUT UPPER. OUTPUT LOWER then should be 0.87 and OUTPUT UPPER should be 1.57.

These weird values are generated by default because all angles are shown as radian in the expressions.

For conversions of the degree angle they have to be multiplied with Pi and divided by 180. This results in 90° = 90 × 3.1415/180 = 1.57 radian.

Modify the Expression

We have connected the local Y positions of the objects with the set driver/set driven action. However, the global values are not shown within the ATTRIBUTE MANAGER.

In our case the expression works anyway, as the coordinate systems for the ball (the HYPERNURBS object) and the BULGE deformer (the SWEEP NURBS object) happen to be at the

same position in the three-dimensional space and also have the same direction.

To be sure, the global position should be transferred here. This will make the participating objects independent from their place in the hierarchy.

Thus, delete the RANGE MAPPER node with a click on its headline and use of the Delete key. Then delete the two ports at the remaining nodes with one double click on each.

At the output side of the ball node select the port for the global position. Do the same with the input port of the BULGE node.

Finally connect the two new ports with the mouse to activate the expression (see Figure 4.25).

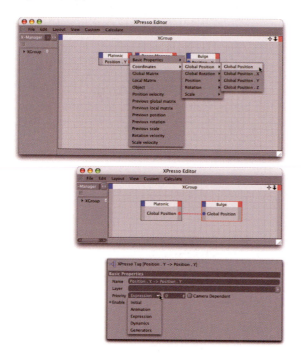

— Figure 4.25: The actualized expression.

Adjusting Priorities

The priority in which the calculations will run is another thing to watch for when working with expressions.

It is important that current data always be available and not data from the previous im-

age of the animation. This is especially significant when current data from animated objects are read and transferred to other objects or parameters .

When current data is to be used in the expression, then the expression may be executed after rendering the animation.

The chronology of calculations is controlled with the PRIORITY menu of the XPRESS tag in the ATTRIBUTE MANAGER (see Figure 4.25).

The lower the selected priority is placed in the menu listing, the later the expression is calculated. At the very least, EXPRESSION would have to be selected as priority for the calculation right after reading the keyframes.

Adjusting the Scene

In order to show better the deformation of the SWEEP NURBS spiral we will assign a red, slightly glowing material to it.

To add to the illusion that the spiral emits light, we need to create a new helix with settings identical to the existing one. The only difference is the radius of the helix. It should be big enough on top and bottom so that the ball has enough space inside the spiral without causing any deformations.

This helix spline will now be used to illuminate the ball. Therefore, open the dialog of the dome-shaped area light in our scene and change the AREA SHAPE entry on the DETAILS page to OBJECT/SPLINE. Now pull the new helix into the OBJECT field below (see Figure 4.26).

In addition, set the mode in the SCENE part of the dialog to INCLUDE and pull the HYPER-NURBS object with the subordinated ball into its field.

Change the color of the light to an intense red so that it matches the color of the deformed helix. The brightness of this light source then has to be checked with test renderings.

Figure 4.27 shows two single images from the finished animation. This concludes this example.

— Figure 4.26: Settings of the light source.

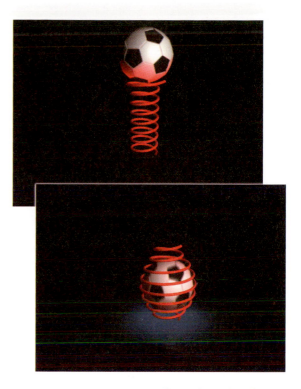

— Figure 4.27: Impressions from the animation.

the comic character that we will now prepare for an animation.

You have learned to set keyframes for movement and parameters, to work with F curves, and to use parameter connections with XPresso. Now you have a solid basis for your own animation projects.

A large number of changes were made in the MOCCA module in the actual version of CINEMA 4D. For this reason, I would like to introduce this module in detail with an example.

The MOCCA module only deals with the subject animation. It offers specialized tools and objects for the movement of complex hierarchies and object structures used for the animation of figures.

Because we want to animate a figure in this workshop it would be a good time to work through the bonus chapter on the DVD. There you create, along with other things,

4.7 Character Animation with MOCCA

The MOCCA module offers a large number of new tools and tags, which make working with inverse kinematics and morphing much easier.

With the example of the karate master, which we model in the bonus chapter, I would like to demonstrate the process of rigging the character.

Rigging is the creation of a bone and joint hierarchy, applying weightings and determining constraints.

You will see that we have a series of new terms and techniques. The subject itself is complex and fascinating; it alone could fill sev-

eral books. Therefore, we will not be able to show all possibilities of the MOCCA module in detail. Instead we will concentrate on several crucial points.

Bones and Joints

Experience shows that working with bones and joints is the way to animate organic objects. Both kinds of objects are supported by the MOCCA module, but the use of each of them only looks similar at the beginning.

Bones are deformers and will be, just like a BEND deformer, subordinated under an object. Joints, however, are just positions in space. Because of the hierarchical structure of joints, chains can be built along which object surfaces can be deformed. However, because joints are not deformers, they do not have to be subordinated under the object.

Instead the connection between the polygons to be deformed and the joints is achieved by weighting the objects and by the SKIN deformer. This allows more flexibility with regard to the objects that have to be animated. As a result, it is not a problem moving several characters with just one joint skeleton.

Creating a Joint Skeleton

Start with a new scene and load the character from the bonus chapter into it.

First, put the joints into the character that will be used later to move it. Basically we build a virtual skeleton.

Because it lies on the symmetry plane of the character, start with the spine. The other extremities can be deviated from it.

To create the chain of joints, use the JOINT TOOL in the CHARACTER menu (see Figure 4.26).

The settings in the JOINT TOOL should always be checked before you work with them. There are not many settings to change, as shown in Figure 4.28.

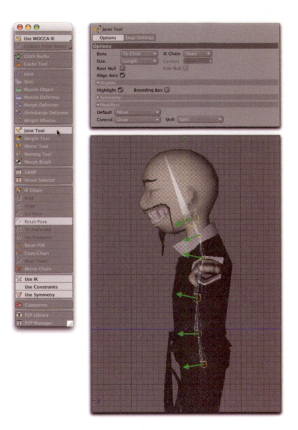

— Figure 4.28: Creating a joints chain.

The BONES menu determines how the separate joints will be connected later. This has an impact on how the joints affect the geometry to be deformed and how the automatic weighting of the geometry will be calculated.

The standard setting TO CHILD always calculates the weighting starting from the parent and going to the child joint. The setting TO PARENT weights in the opposite direction.

Even though the deformation stays the same, this setting is important when the character is to be prepared for further use in a program. The standard of the external program should be followed.

The setting of AXIS works similar to the familiar bone system of older CINEMA 4D versions.

Also here the bone goes from the parent to the child joint, but its length can be set individ-

ually. That way gaps can be created between the bone and the joints.

Most of the time, the standard setting of TO CHILD will not have to be changed.

The following IK CHAIN menu automatically creates reference objects after finishing with the JOINT TOOL. The joint hierarchy can then be used immediately. Normally the reference points for the joints have to be adjusted for each joint of the character. Therefore this is only usable for simple setups.

A choice can be made between 2D and 3D solutions. This determines the restrictions of the joint chain movement. In many cases, like at the knee or elbow, the movements are only possible in one plane. There it is helpful to calculate using only a 2D solution to rule out possible errors.

In addition to this mode there is the setting SPLINE, which connects each joint with a point on a spline. The joint chain can then be animated by moving the spline points, which could be helpful for animating the tail of an animal or a spine.

Because we want to determine the IK relations individually, leave this menu turned off in the setting NONE.

The SIZE menu sets the bone length between the joints. In the CUSTOM setting the bones can be scaled separately. Otherwise the bones adjust automatically to the distance between the joints. This is typically the mode that makes more sense.

The option ROOT NULL creates an additional null object as the starting point of the hierarchy. The use of this null object makes sense only in the BONE mode AXIS.

The ALIGN AXIS option should always be active because it makes sure that the Z axis of the bones is automatically aligned to the subordinated joint.

The POLE NULL option only works in connection with the active IK CHAIN menu. Then another help object is created with which the

movement plane of the hierarchy can be controlled.

The settings in the DISPLAY group only determine the display of the bones in the editor. Selected bones can either be highlighted or shown with a bounding box.

The SYMMETRY settings are interesting when, for example, the joints of an arm are created and the arm on the other half of the body is simultaneously built. We will get back to this later.

In the MODIFIER group is a key combination for certain actions. The preset keys are the Ctrl key, which creates a new joint, and the Shift key for parting a bone and creating a new joint in its center.

The MOVE function is set by default. As a result, joints can be moved directly with the mouse.

In general, we can take over all settings except the unnecessary ROOT NULL and start to create, using Ctrl clicks, a joint chain from the pelvis up to the skull in the side viewport.

Figure 4.28 shows this finished chain. The JOINT TOOL is then deselected by selecting, for example, the MOVE tool.

All joints should now be turned in one direction, as indicated by the green arrows in Figure 4.28, so that all Y axes are placed in the symmetry plane. This will ease the alignment of these bones during the animation.

The Jawbone

In order to animate the jaw later, simply by rotating a joint, we will create a JOINT object in the CHARACTER menu and subordinate it under the duplicated joint for the head.

Also place this new joint on the symmetry plane at the edge of the lower lip.

It would now make sense to take some time to name the joints. This eases the assigning of help objects for the inverse kinematics.

Figure 4.29 shows the placement of the jaw joint and the names chosen for the joints.

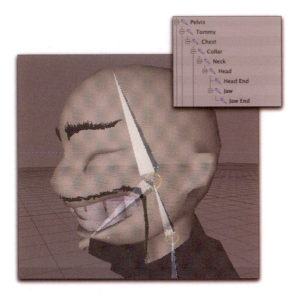

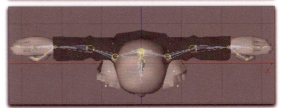

— Figure 4.29: Inserting a jawbone.

The Arms

Use the JOINT TOOL again for the arms, but this time with activated SYMMETRY function. Restrict the symmetry to the DRAW mode to get two independent joint chains (see Figure 4.30).

We can use WORLD YZ for the ORIGIN of the reflection, as our character is at the origin of the world coordinate system.

With Ctrl clicks create a joint chain from the shoulder down to the fingertips.

Then select the JOINT object of the wrist in the OBJECT MANAGER and create three more joints for the thumbs. These joints are automatically subordinated and connected the right way because of the previous selection of the wrist.

Move the joints with the mouse to the correct positions. Figure 4.30 shows the joints for the left arm and its hand from different perspectives.

The automatic order of the thumb joints did not work on the other symmetry side. A separate hierarchy was created for the three mirrored joints in the OBJECT MANAGER, which we now have to subordinate by hand. This can be done quickly.

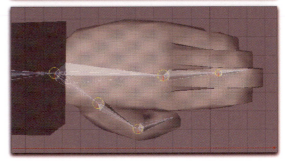

— Figure 4.30: The joints of the arms.

Group the two arm chains under the chest joint.

Take the time to name the individual joints again. The joints of the left and right half of the body could be marked, for example, by adding the letters L and R in the name (see Figure 4.31).

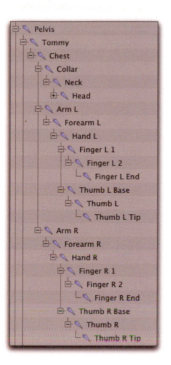

— Figure 4.31: The hierarchy of the joints and their names.

The Legs

The joints of the legs are created the same way. In order to recreate the complex movements of the feet (the rolling motion, for example), the ankle, center of the foot, and the toes should have their own joint.

Usually it is not necessary to create a joint for each toe. This would only make sense if the character is a highly detailed barefoot model or one wearing sandals.

The two joint chains of the legs are then subordinated into the hierarchy under the pelvis joint.

Figure 4.32 shows the number and placement of the leg joints. The bone connections between the pelvis and the hips are created automatically after the subordinating.

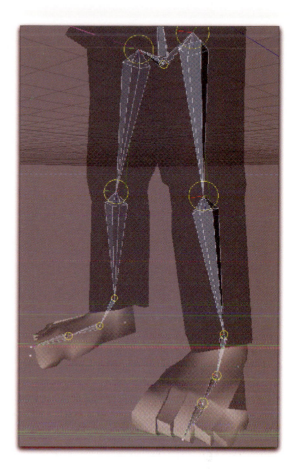

— Figure 4.32: The joints in legs and feet.

Assigning Weightings

In order to get a connection between joints and the geometry to be deformed, we have to assign weightings.

Because this has to be done for each object of the character separately, we will start with the HEAD object, work toward the clothing, and end with the feet.

Objects that are not being worked on should be set invisible so that we have a better overview.

Assign to the head a WEIGHT tag, which can be found in TAGS > CHARACTER TAGS in the OBJECT MANAGER.

In the dialog of the tag make the settings for the JOINTS visible. These settings consist of an empty list. The JOINT objects, which should have an influence on the object, have to be pulled into this list.

Select the joints for the collar, neck, head, and jaw in the OBJECT MANAGER. The last joint of a chain does not matter for the weighting that follows since we use the setting TO CHILD for the joints. It will only be used to determine the direction and length of the bones between the joints.

For this reason this last joint in the hierarchy can be ignored when listing the WEIGHT tags.

Now the geometry knows which joints are supposed to have an effect on it. Still unknown is which area of the geometry will be controlled by which joint. The weighting will take over that job.

The WEIGHT tag offers several functions in the tag settings themselves.

Especially easy is the AUTO WEIGHT button. It measures the distance between the points of the geometry and the bones between the joints and assigns weightings accordingly.

It will not always result in a perfect weighting, but we can save a lot of time and correct them ourselves.

In addition to that there is the SET POSE function. It works like the fixing of bones in older CINEMA 4D versions and saves the current position and rotation of the assigned joints internally.

This function is executed automatically when the joints are assigned. When the joints are adjusted after they are assigned, then the SET POSE function should be activated again manually for all WEIGHT tags.

With RESET POSE, the joints can be put back into their saved basic position anytime and the geometries will then be shown without deformations.

The Weight Tool

So far the weightings have been an abstract factor. After activating the WEIGHT tool in the CHARACTER menu and the selection of a joint, at the same time the weighting is then visible in the editor as a color gradient.

Basically it is in most parts the way the familiar vertex maps work. Every point of an object can have a value assigned between 0 and 100%.

The obvious difference between weightings and vertex maps is that weightings are assigned to the geometry and not to the joints. CINEMA 4D then searches in the existing WEIGHT tags for the correct joint and can create a relationship between the weightings and the points. That way, a joint object can carry weightings for several objects. A vertex map cannot do that, as it is assigned to one object only.

Let us go back to the dialog of the WEIGHT tool. In addition to the display of existing weightings in the editor viewports, this tool offers a variety of functions for assigning weightings. I would like to show the most important ones.

The Options

This part of the dialog deals with the value for the weighting. This percentage value is set with the STRENGTH slider.

The MODE menu defines what should happen with this value when the geometry is painted. The STRENGTH value can be added, subtracted, or used as an absolute value. There is also an ERASE function available to delete existing weightings. Holding the Ctrl button when painting weightings also deletes them.

The NORMALIZE option ensures that other joints with weightings are balanced when a joint is painted. This option determines that the sum of weightings for a point is either 0 or 100%. This means that each point is deformed or moved with the same intensity.

External programs, which are specialized in the animation of characters, often work with this system. Therefore, it is recommended to use it in CINEMA 4D in order to save us extra work in the external program.

The Painting Settings

The radius of the brush and the intensity gradient of the weighting at the edge of the brush are set here.

Similar to the SELECTION tools, the state of the VISIBLE ONLY option has to be watched. Depending on the state of the option, only visible points and the points hidden by faces are painted.

The Display Settings

These settings determine the display when painting the joints. In some situations the option DRAW ALL JOINTS can be helpful. It displays the weightings of all joints at once. That way, gaps in the weighting can be detected and weighting gradients between the joints can be checked.

The Joints Settings

This shows a list of all POLYGON objects influenced by a selected joint.

Single objects can be selected here and locked with the LOCK button to protect it from accidental changes.

The Weights Settings

This list shows in a table all weightings of the participating objects.

Points with a weighting higher than 0% can be highlighted in color in the editor with the HIGHLIGHT POINTS option. This can also be helpful for finding weighting errors.

Weighted points can then be selected or weightings can be assigned to point selections.

Auto Weight

Similar to the function of the WEIGHT tag is the AUTO WEIGHT function, but with more detailed setting possibilities. Here the maximum number of joints can be determined that affect one point.

The MODE menu set the criteria for the calculation of the weightings. In the DISTANCE setting, the distance between the joint bones and a point is measured.

A set joint will then split the weighting proportionally between the closest and second closest bone.

These two options restrict the weightings to selected joints and points.

All together I hardly had to change anything in the automatically set weightings of the character.

The most obvious change at the head was necessary in order to get more contrast out of the smooth transition between the weighting of the jaw and the head.

For that reason I selected the joint of the head and used the NORMALIZE option to strengthen the weightings on the upper lip and the nose. This way the joint located at the chin does not have influence on that area anymore. This can be seen in the images in Figure 4.33.

In addition I also adjusted the area under the arms of the jacket. I strengthened the weighting of the points for the chest joint under the beginning of the arm. This prevents the jacket from being pushed into the chest when the arm joints are lowered.

Work on all objects, one after the other, with the WEIGHT tag and its AUTO WEIGHT function. Then control and adjust the weightings with the WEIGHT tool.

Dynamic Cloth Simulation

It hardly makes sense to apply a cloth simulation to the jacket or pants. The fabric is too close to the body. It would be useful though

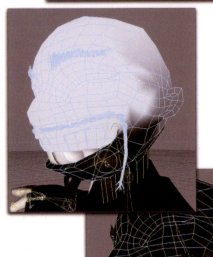

— Figure 4.33: Weightings at the head.

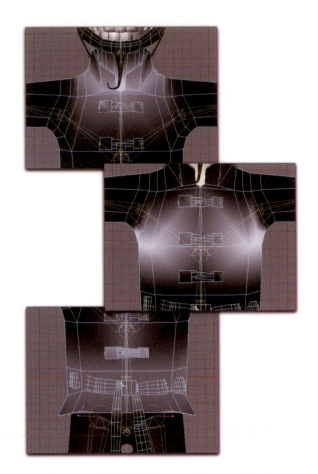

— Figure 4.34: Weightings on the upper body.

for the ends of the belt that hang down from the hip. This job can be done with the Clothilde module.

The belt object needs to be split, as only part of the belt is needed as dynamically animated clothing. For this reason, convert the SWEEP NURBS object and separate the polygons of the hanging ends into a new object.

To form one single object, connect with the stylized cube object the part of the belt that goes around the body.

Then check the weightings of the belt. Normally the weightings should all be intact since only faces were deleted.

The hanging belt ends do not need weightings anymore and will be connected with the hip of the character. Thus remove the WEIGHT tag from the separated belt ends and pull it out of the hierarchy.

This is necessary because the belt will get its own NURBS object for the smoothing and should not be additionally smoothed by the HYPERNURBS object of the character.

Assign a CLOTH tag to the belt ends. It can be found in the OBJECT MANAGER in TAGS > CLOTHILDE TAGS.

Select the points at the upper end which will be fixed to the character later. These points are highlighted in color in Figure 4.35.

The CLOTH tag contains all necessary settings for the behavior of the object. They

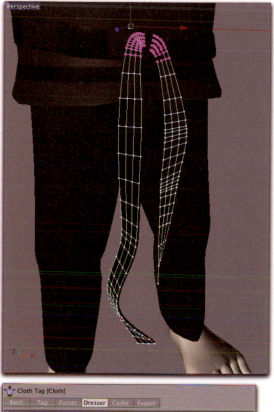

— Figure 4.35: Fixing the points of the clothing.

range from the elasticity of the material to the simulation of wind or collisions.

Again, I will only go into detail about, for us, important settings.

We will start with the DRESSER column. Here, certain dynamic forces can be applied to the cloth to define a start condition for the animation that follows.

First we will exclude the selected points from the fabric simulation so that they will not be pulled down automatically by gravita-tion. Therefore, use the SET button in the FIX POINTS column (see Figure 4.35).

When the DRAW option is active, the fixed points will be permanently colored and remind us about the fixing.

Now we can work on the behavior of the fabric. Raise the STIFFNESS value in the TAG page of the dialog and reduce the MASS value at the same time.

A higher STIFFNESS value allows the belt to appear less light and thin. The object will not react to outer forces and movements.

This is supported by a reduction of the MASS value. This value controls the speed with which the fabric reacts to the dynamic effects. This value does not have much to do with the weight of the material, but rather with its in-ertness.

In the FORCES area of the dialog additional forces can be defined that could affect the ob-ject. The gravitation should remain active in any event, while the wind should not be acti-vated. The wind is only of interest for outdoor scenes, such as when a flag or a curtain flutter-ing in the breeze is to be animated.

Reduce the GRAVITY value to 5 so that the belt can react quicker to the collision with it-self and the pants.

Then activate the SELF COLLISION option in the EXPERT part of the dialog. It requires more render time, but the danger of interpenetra-tion of the belt pieces is high and should be avoided.

The collision detection with other objects is activated with a separate COLLIDER tag which should be assigned to the jacket and pants. The dialog of this tag can be seen in Figure 4.36. There you only have to activate the USE COL-LIDER option.

In order to check the simulation of the fab-ric, the RELAX button in the DRESSER area of the CLOTH dialog can be used. The simulation of the forces is then calculated for the number of images set in STEPS.

This function can be clicked multiple times. The SHOW button in the INIT STATE column will always bring us back to the original shape of

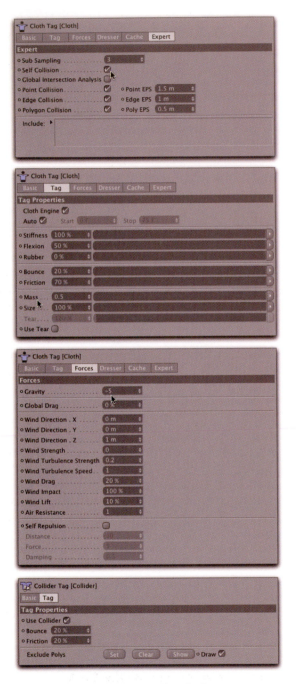

— Figure 4.36: Settings in the Cloth tag.

the object. When the parameters and behavior of the fabric are satisfactory, then we can go a step further and simplify the object.

They are only two polygon strips with a wall thickness. These kinds of shapes can be created with the help of a CLOTH NURBS object, which saves us render time and automatically prevents pervasions of the front and rear side of the belt pieces.

Therefore, delete all side and back faces of the belt ends. Then we are left with only the front faces of the belt parts. Optimize the object to get rid of the needless points and use the SET INIT STATE button again in the CLOTH dialog to save the new shape.

Open a CLOTH NURBS object in the CHARACTER menu of CINEMA 4D and subordinate the belt strips under it (see Figure 4.37).

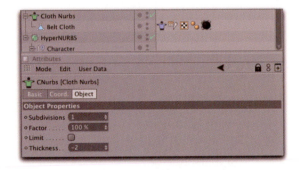

— Figure 4.37: Thickening and smoothing the fabric.

The CLOTH NURBS works similar to the HYPERNURBS, but the smoothed faces always run through the existing points. In addition, there is a function for thickening of the objects. This is helpful when simulating the thickness of fabric.

Use this THICKNESS value to give the belt its original depth.

Now the fixation of the points has to be cancelled again. The reason for this is that the upper points of the belt should not be static in the room but rather move along with the character.

To do this, use the CLEAR button in the FIX POINT column of the CLOTH tag (see Figure 4.38).

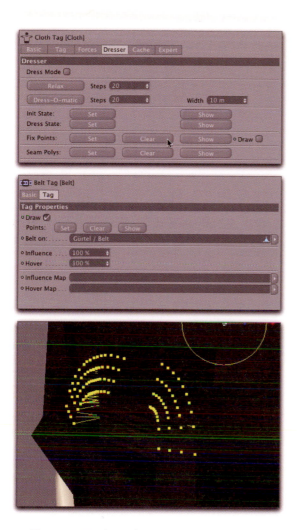

— Figure 4.38: The Belt tag.

The attachment at the waist of the just-released points is done with a separate BELT tag, which can be found in TAGS > CLOTHILDE TAGS.

When the upper points of the belt are still selected, use the SET button in the POINTS column of the BELT tag. Assign the BELT object, which is wrapped around the character, to it by using the BELT ON field.

With the activated DRAW option in the BELT tag, the highlighted points and connection lines between the belt and the loose belt ends should be visible.

The BELT tag looks by itself for connection points to the assigned BELT ON object and attaches the selected points of the belt ends to them. These points are not moved but keep their distance from the body.

Inverse Kinematics

I already mentioned *Inverse Kinematics* a couple of times, but did not explain it.

With the help of inverse kinematics, the movement at the end of a joint chain can have an influence on the upper part of the hierarchy. In practice it means that moving the foot will raise the knee and angle the leg all at the same time.

Otherwise, the animation of natural movements would turn into a test of our patience. The rotations of the joints would have to be done individually starting from the parent and going toward the child.

We would angle the thigh and bend the knee only to discover that the foot is placed in the wrong position. Then we would be forced to rotate the knee and thigh again until the foot is placed, for example, exactly on a stair step.

Inverse kinematics (IK) can significantly speed up an animation and ease the workflow. A requirement is the exact setup of the inverse kinematics chains.

Inverse kinematics can only be calculated between two defined objects. Help objects can be inserted that, for example, affect single joints such as magnets or define movement planes. This makes sense with the knee joint, which can rotate around one axis only.

In order to create the IK we can use the IK CHAIN tool in the CHARACTER menu or assign the IK manually with TAGS > CHARACTER TAGS. We will use both methods.

Inverse Kinematics for the Back

I would like to use a spline for creating the spine. Its points will control the position of the joints.

First we need a spline object with the right amount of points. Because we have five joints in our model for the area between the pelvis and the neck, create a linear spline that also has five points and let these points snap with 3D snapping to the axes of the existing joints.

The corresponding joint objects are marked with a red dot in Figure 4.39.

— Figure 4.39: Assigning IK-Spline.

Now we can assign an IK-SPLINE tag to the first joint of the hierarchy and pull the previously created spline into the SPLINE field.

In order to calculate inverse kinematics, an end point has to be assigned to the chain. In our case the IK chain ends with the joint at the neck so pull this point into the END field in the IK-SPLINE tag in the OBJECT MANAGER.

Through the TYPE menu it can now be controlled how the joints are sorted on the spline.

In FIT mode all bones keep their original lengths, whereas in EQUAL mode their lengths will be adjusted to the spline. There might be some shortening or stretching of the chain, which can be helpful for extreme deformations of comic characters.

When the Twist option is active, the joints can be rotated with a separate twist curve in the tag.

This rotation can also be controlled by external null objects which can be assigned to single spline points. This has the advantage that only the position of these NULL objects has to be animated. Thus, the point coordinates of the spline do not have to be animated with PLA.

Therefore, create HANDLES for all spline points. This can easily be done directly in the SPLINE IK tag.

For this use the ADD button and then the CREATE button in the HANDLES part of the dialog. This creates a new NULL object for the point with the corresponding INDEX number of the spline (see Figure 4.39).

Repeat this procedure until five NULL objects have been created. Check if the INDEX numbers have been assigned consecutively from the first to the last point.

With the TWIST option of each handler the rotation of this NULL object can also be transferred to the joints.

OFFSET creates a small distance between the handles and the connected points of the spline.

When the spline is a bezier spline, the OFFSET can also be changed with the DEPTH VALUE. The HANDLE object is then located at the end of the tangent at the spline point and can influence the course of the curve more precisely.

In our case I do not want to use a bezier spline and I will pass on the use of the OFFSET option. Only TWIST should be activated, in case we have to twist the spine during the animation.

As TYPE I use FIT so that the character cannot be accidentally compressed or stretched. Now the movement of the back can be con-

trolled sufficiently and we will move on to the legs and feet.

The Setup of the Legs

We will use another approach for the IK relationship of the legs and feet. With Ctrl clicks in the OBJECT MANAGER, select all joints of one leg that need external control objects.

Continue holding the Ctrl key when the IK CHAIN function is chosen in the CHARACTER menu. The selected joints will then receive IK tags and control objects automatically.

For the IK tag of the uppermost joint of this chain, activate an additional pole vector.

With the position of this object the movement plane of the whole leg can be controlled and, for example, a tight bending laterally at the knee will automatically be avoided.

Use the ADD POLE button in the IK tag to create this additional NULL object for the pole vector (see Figure 4.40).

As an alternative, all kinds of control objects can be created manually and pulled by drag and drop into the corresponding fields in the IK tag. That way, other objects can also be used as NULL objects if you think this is necessary.

Apply the same procedure to the other leg and then pull both pole vector objects far in front of the hip.

The color lines in Figure 4.40 show the end positions of the pole vectors.

The Setup of the Arms

The assignment of the IK tags is even simpler for the arms since we do not need pole vectors. Therefore, select only the first three of the arm joints with Ctrl clicks and use the IK CHAIN function again.

This creates new IK tags for the first two joints of the arms as shown in Figure 4.41.

The original joint selection is marked again with red dots in Figure 4.41.

This determines the IK chains. Now we have to sort the external objects in order to

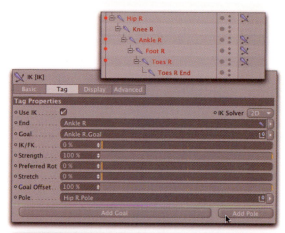

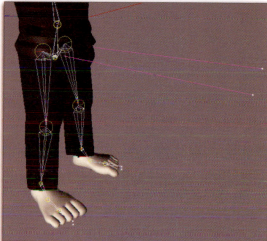

— Figure 4.40: Automatic leg setup.

achieve the desired pose faster. I will talk more about that in a moment.

First I would like to talk about the subject of morphing.

Morphing

This term usually means the change of a shape. The locations of points within an object change. As a result, it is normally not possible to morph two objects, with different numbers of points, in a controlled manner.

For this reason the MOCCA module provides the SHRINKWRAP deformer, although it

— Figure 4.41: The IK tags of the arms.

will not be so helpful with the animation of characters.

We consequently use traditional morphing. MOCCA also offers a variety of tools for this. We will talk about several possibilities and use them.

One possibility is to create a copy of the object to be morphed and to adjust this copy to the desired shape. There should not be any additional subdivisions, even though MOCCA can recognize and incorporate these changes by now.

As shown in Figure 4.42, I created three copies of the head and modified them.

The three target states have an open left eye, an open right eye, and a different shape of the mouth.

The nice thing about morphing is that we are not forced to go all the way to the end shape of the morph target. The states can be mixed and then, for example, an eye is opened just halfway.

With only a few selected target states, very complex facial expression animations can be created. However, I want to stop with these few target states. If you wish, you can add multiple facial expressions. These should be re-

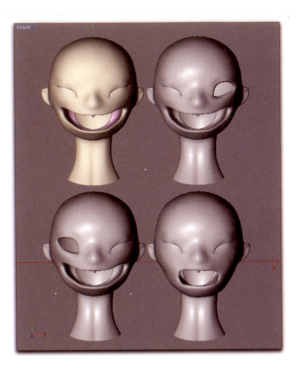

— Figure 4.42: Morph targets of the head.

stricted to single changes such as a frown or a raised corner of the mouth. This way there will be more freedom to mix the target states later.

After finishing the desired target objects, add a MORPH tag to the original head object with TAGS > CHARACTER TAGS. Its dialog offers us all the parameters needed for creating, saving, assigning, and mixing of morph target states (see Figure 4.43).

The tag has two modes. In the EDIT setting the target states are assigned and edited, and in the ANIMATE setting they are mixed with each other.

We will start in the EDIT mode and take a look at the list of morphs. Here there are the entries BASE MORPH and already the first MORPH TARGET. However, since we do not want to create the target states with the MORPH target but rather have them as separate objects, delete the MORPH TARGET in the list by right clicking on it and choosing the REMOVE command.

— Figure 4.43: The Morph tag.

Then select the objects with the modeled target states and pull these from the OBJECT MANAGER into the MORPHS list of the MORPH tag.

You will now be asked if the morphs should be calculated relative or not. When this question is answered with no, then only an internal reference to the existing target states will be created. This has the advantage that even after the start of the animation, the target objects can be changed. The morphing will be adjusted automatically.

The disadvantage is that the target objects have to be kept in the scene. When one of these objects is deleted by accident, then the morphing of this target state will not work anymore through the MORPH tag.

More useful is the relative assigning of the MORPH TARGETS. Then the change of the basis object to the MORPH TARGET is saved in the MORPH tag itself. The original object of the target states can then be deleted without problems.

Now all necessary target states of the head are defined. They can be activated separately

in the list of the MORPHS by clicking on them and with the STRENGTH slider they can mix with the original state.

Also, when relative morphs are used, improvements can be made at the target states. Select the morph to be adjusted in the MORPH list and set the STRENGTH slider to 100%.

Now the points can be changed directly on the head and these changes will be transferred automatically to the selected morph target. The basic state of the object will remain unchanged.

As we can see at the two options below the STRENGTH slider, the MORPH tag has more to offer.

In addition to the standard mode MORPH GEOMETRY, the activated MORPH PARAMETERS mode allows the morphing of any parameter. This also includes the radius of a cube rounding or the brightness of a light source.

The MORPH tag can also be used, for example, to morph different light source settings or the focal length of a camera. Note that in this operating mode, pulling the objects into the morph list does not always work. Then the MORPH TARGETS have to be created by using the ADD MORPH TARGETS button.

We can continue to assign MORPH tags and MORPH TARGETS to other objects.

In Figure 4.44 we can see how the lower teeth can be slightly shortened by a morph target.

This time I did not simply create extra copies of the teeth, but also created and saved the morphing directly in the MORPH tag.

Just change the already existing MORPH TARGET, for example, by making changes on the object with the MAGNET or BRUSH tool.

Use the ADD MORPH TARGET button to create new MORPH TARGETS. Even the eyebrows are not spared. I created two target states for each eyebrow, one for an elevated position and one for a lower position. Both target states are shown in the example of the left eyebrow in Figure 4.45.

These MORPH TARGETS were created in POLYGON mode. I selected all polygons of the eye-

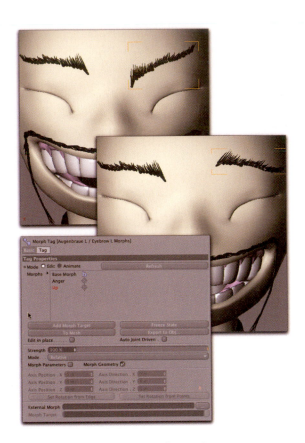

— Figure 4.44: Morphing the lower teeth.

— Figure 4.45: Morphing the eyebrow.

brow and moved the MODELING AXIS to the edge of the brow above the nose. Now the eyebrow can be comfortably rotated around this spot and moved up and down.

It is important to change the position of the points of the brow and not just move the whole object.

The MORPH tag only remembers the changes of points.

Now that we are at the moustache we need to take into consideration the different shapes of the mouth.

Choose the different shape of the mouth in the MORPH tag of the head and create a new MORPH tag for the moustache. In this tag change the standard MORPH tag so that the moustache fits again (see Figure 4.46).

Here I used the MODELING AXIS and then, after the polygons of one side of the moustache were selected, moved it to the center of the upper lip.

From there the moustache can simply be scaled down and rotated until it fits again.

Group Target Objects

Basically our character is prepared for the animation, but we can make the animation work more simply by grouping the external target objects in a smart way. As a result we will start with the foot, which is very important for the animation.

When the inverse kinematics is not working properly, then a sliding of the foot over the

— Figure 4.47: Additional null groups at the feet.

— Figure 4.46: Morphing of the moustache.

floor can occur and the illusion of a living character is ruined.

Furthermore, a foot can execute a series of complex movements from standing on the toes to the natural forward rolling motion when walking or climbing stairs.

In the first step we will create three additional NULL objects, which are placed at the typical contact points of the foot. These would be in front of the toes, under the ball of the foot, and finally in the back under the heel. Figure 4.47 shows the position of these three additional objects marked by arrows.

Group the external target objects of the ankle and the middle of the foot under the NULL object of the ball (see Figure 4.48). That way, a rotation around the ball NULL object lifts the foot, but leaves the toes flat on the floor.

— Figure 4.48: Hierarchy of the ball rotation.

Of course, this has to be done for each foot. These steps always have to be executed separately for each side of the body.

This group of the ball of the foot then has to be subordinated under the NULL object, which is used for standing on toes (see Figure

— Figure 4.49: Subordination for standing on toes.

4.49). Place the external target object of the toes under this NULL object too.

The last grouping will be created under the NULL object of the heel. Subordinate the NULL object of standing on the toes and the NULL object for the pole vector of the leg. That way, with the rotation of the heel NULL object, the direction of the knee and the lifting of the foot are controlled. In addition, the whole leg will be angled by moving the heel object.

With the animation of these separate objects the whole leg can be animated. Figure 4.50 shows this object hierarchy again.

— Figure 4.50: Hierarchy of the Heel object.

In order to be able to move the toes independent of the rest of the foot, subordinate its external target object under a copy of the ball of the foot target object (see Figure 4.51). That way, the toes can be lifted and lowered by rotating the toes around the ball of the foot.

— Figure 4.51: The complete hierarchy.

Also, this group has to be subordinated under the heel object so that the whole foot will be moved when the heel is lifted. The finished hierarchy of a leg can also be seen in Figure 4.51.

The Help Objects of the Arms

The target objects of the arms should also be organized in groups. These groups will be less complex, though, than the ones for the feet.

The hand and fingers will be animated later with a different technique. We will first concentrate on working with the few target objects of the upper arm and the forearm.

Here we will create three new NULL objects. One is placed at the position of the chest joint, from which the bone runs toward the shoulder.

The second new NULL object is placed at the position of the shoulder joint and the third at the elbow joint.

The TARGET object for the hand joint is then subordinated under the new HELP object of the elbow. The original target object of the elbow

needs to be placed under the hierarchy of the new shoulder NULL object.

The correlation between the participating objects and their hierarchy is documented in Figure 4.52. There, colored markings are an additional aid for seeing the positions on the character.

— Figure 4.53: The Skin deformer.

— Figure 4.52: The HELP objects of the arm.

Do not get confused by the different position of the arms. In your scene they should still be stretched out at both sides of the body.

In the next step you will learn how the rotation of the HELP objects results in deformation of the character.

The Skin Deformer

As you might have discovered, the joints and bones can be moved by rotating or moving the HELP objects and TARGET objects. This is possible through the assigned IK and IK-SPLINE tags.

The actual connection between the joints and the WEIGHT tags of the objects has to be done through an additional deformer, which then actually deforms the character with the joint movement. This deformer is called SKIN and can be opened directly in the CHARACTER menu of CINEMA 4D.

This object works, like the other already familiar deformer objects, by subordination. This means that the SKIN object has to be subordinated under the NULL object (which contains

the parts of our character) so that it can affect these objects (see Figure 4.53).

As an alternative, the SKIN deformer can also be used outside the hierarchy, but then it has to work in a different mode.

In this case all objects to be deformed have to be listed in the INCLUDE portion of the SKIN dialog, and the FORCE option has to be activated.

The advantage of this mode is that multiple characters can be animated with a single joint skeleton. The disadvantage is that MORPH tags cannot be used any longer.

Basically, this mode is meant for the deformation of parametric objects and splines.

Because we use the SKIN deformer directly in the hierarchy, we hardly have to worry about additional settings. Only the TYPE menu should be mentioned here. It is used to determine the radius of the deformation in the joints.

A choice can be made among LINEAR, SPHERICAL, or BLENDED, where BLENDED is a proportional mix between LINEAR and SPHERICAL.

The LINEAR mode matches the bone deformation of older CINEMA 4D versions and, without any preparations, can cause constriction of the geometry at the joints. This cannot happen with SPHERICAL because it guarantees to maintain almost all the volume.

Unfortunately, better quality is a trade-off for longer render times. However, because the TYPE can be changed anytime in the SKIN ob-

ject, the animation can be set up in the faster LINEAR mode and later be switched to SPHERICAL or BLENDED.

In addition to the continual mixing of both calculation methods, vertex maps can also be created that, with the weighting of the points, allow an individual course over the whole surface of the object.

The vertex map just has to be pulled into the MAP field in the SKIN dialog.

Morph Poses with PoseMixer

I mentioned previously that, in addition to the MORPH tag, there are other tools for changing the geometry. One of them is the POSEMIXER, which was available in older CINEMA 4D versions.

The advantage of this object, compared to the tag, is that whole hierarchies of objects can be morphed. That way, for example, different joint positions of the hands can be created, controlled, and mixed with sliders.

The procedure is to create two copies of the part of the hierarchy that is to be animated with POSEMIXER. In our case, create two copies of the hand joints, including the subordinated joint objects.

Change the name of the joint copies so that they can be separated more easily.

Change one of the two joint hierarchies in order to show a fist instead of a flat hand. This has to be done separately for both sides of the body.

Now assign a POSEMIXER tag to the hand joint of the original joint hierarchy, which can be found in TAGS > CHARACTER TAGS.

This is not strictly necessary, as the POSEMIXER tag can be used on multiple objects. However, it improves the overview of the scene since we will use several of these tags.

In this tag assign the first joint to be changed in the original hierarchy to the DESTINATION field. In our case this is the first joint of the finger.

Position the joint from the copied, unchanged hierarchy into the DEFAULT POSE field. This object will be needed so that POSEMIXER can return to the original position of the finger.

Finally, pull the corresponding joint of the joint hierarchy, which was changed to a fist, into the lowest drag and drop field.

The options in the upper dialog determine which attributes of the objects will be used for the morph. Basically, this also controls the morphing of the face, or the eyebrows, when the POINTS option is activated.

The only disadvantage to the MORPH tag is that real copies with target states have to be created.

We only need the option ROTATION for morphing the joints. I also activated the POSITION option in case we have to stretch or compress the hand later on when the joints are moved. Otherwise this is not necessary.

The exact same procedure then needs to be done for the thumb joint. This allows us to morph the thumb and finger at different times and stages. This can help avoid an overlap of the finger when the hand is closed.

All settings and the two joint copies can be seen again in Figure 4.54.

Controlling XPresso Expressions with User Data

You have already learned how XPresso expressions connect parameters and therefore simplify the animation procedure.

It will be even more interesting when user data is included in the expression by way of USER DATA entries. That way a custom interface for the control of object properties could be built.

Select the SPLINE object that is connected with the spine joints and assign a value field to this object with the entry USER DATA > ADD USER DATA in the ATTRIBUTE MANAGER.

A dialog opens, as shown in Figure 4.55, where the name, type, and optical appear-

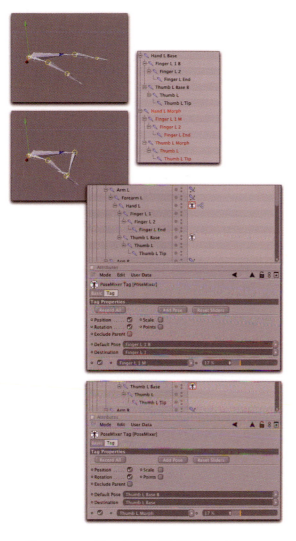

— Figure 4.54: Morphing with the PoseMixer.

ance of the value can be set in the ATTRIBUTE MANAGER.

The maximum values can also be determined in case value entries only within a certain range are allowed. This way, assign two USER DATA values with a value range of 0 and 100%. These values should control the morphing of the left and right hands. Choose fitting names for these values.

In case you have already closed the USER DATA dialog but want to change some settings, just right click on the name of the USER DATA

— Figure 4.55: Creating user data.

value in the ATTRIBUTE MANAGER and choose EDIT ENTRY in the context menu.

Two other USER DATA entries for each side of the body get the same value range, −100 to +100%, and should be used for the rotation of the forearms.

In order to cause an effect with the USER DATA entries, they have to be connected with other parameters in an expression (see Figure 4.56).

Consequently, add an XPRESSO tag to the hand joint and open it with a double click.

The XPRESSO tag can be found as usual in TAGS>CINEMA 4D TAGS in the OBJECT MANAGER.

Pull the SPLINE object from the OBJECT MANAGER into the open XPRESSO EDITOR. At the output port of the appearing node, activate the ports with our USER DATA values for the corresponding hand.

Then pull the two POSEMIXER tags of the corresponding hand into the expression, too. At the input port side of these nodes, the ports for the morphing value can be placed.

These ports will then be connected directly with the output port of the spline nodes where the user data value for closing the hand is located. Figure 4.56 also shows this expression.

Pull the JOINT object of the hand into the expression and activate the input port for the rotation with the P and B angle.

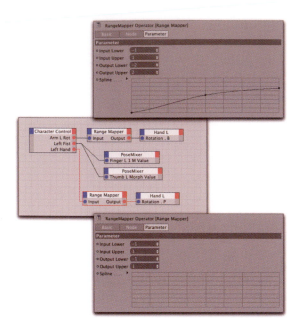

— Figure 4.56: XPresso expression for arms and legs.

Be sure to use the ports for the local and not the global rotation. These ports are connected with two RANGE MAPPER nodes to the user data values for rotating of the hand and arm.

The RANGE MAPPER node can be found with a right click in the XPRESSO EDITOR in the NEW NODE > XPRESSO > CALCULATE menu.

Connect the user data port for rotating the forearm around its length axis with the input port of a RANGE MAPPER node and connect its output port to the input port for the B rotation of the hand.

The input range in the RANGE MAPPER node has to be set to −1 and +1, as the user data value of 100% is interpreted as 1.0 in XPresso expressions.

The output range of the RANGE MAPPER nodes depends on the mobility allowed for the forearm and hand.

Remember that the values on the output side of the RANGE MAPPER are angles that have to be entered as radian.

Set the user data value the same way for raising and lowering the hand, and the P rotation of the hand joint.

The finished expression then has to be created again for the other hand and its user data so that both hands can be animated separately from each other. That way, other properties of the hands can be controlled too. As shown in Figure 4.57, I also added a slider to bend the head or to open the mouth by rotating the jaw joint.

— Figure 4.57: Further user data values.

As we already know, user data values can be saved as keyframes and thus animated with a Ctrl click on the circles in front of the value.

Of course all these parameters and joint rotations can be made directly at the objects and saved with keyframes. This way saves us from having to scroll through the hierarchies and search for the right objects or tags. In the best-case scenario, we could even leave the hierarchies closed during the animation.

This concludes the rigging of the character and the preparation for the animation. You could now sort all the external HELP objects under the spline for the back to obtain more

order in the OBJECT MANAGER. Only the two groups with the TARGET objects of the feet remain separate at the top hierarchy level (see Figure 4.57).

This allows us to let the character kneel, when the SPLINE object is pulled down, while at the same time the feet remain fixed on the virtual floor.

We have come to the conclusion of this chapter. Figure 4.58 shows you a few possible poses as inspiration, which are now easy to accomplish with a few steps, thanks to our preparations.

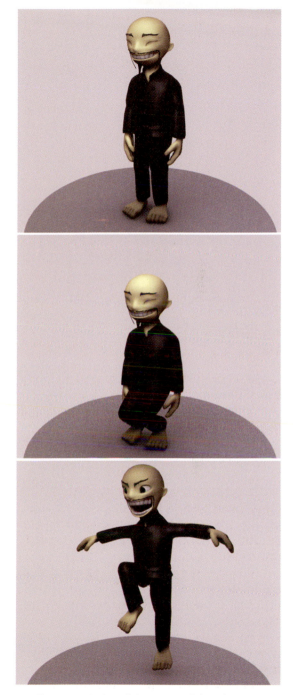

— Figure 4.58: Possible poses of the character.

Index